EDITED BY KAREN MULHALLEN

Blake in Our Time

Essays in Honour of G.E. Bentley Jr

UNIVERSITY OF TORONTO PRESS
Toronto Buffalo London

© University of Toronto Press Incorporated 2010
Toronto Buffalo London
www.utppublishing.com
Printed in Canada

ISBN 978-1-4426-4151-8 (cloth)

Printed on acid-free, 100% post-consumer recycled paper
with vegetable-based inks.

Library and Archives Canada Cataloguing in Publication

Blake in our time : essays in honour of G.E. Bentley Jr / edited by
Karen Mulhallen.

Includes bibliographical references and index.
ISBN 978-1-4426-4151-8

1. Blake, William, 1757–1827 – Criticism and interpretation.
I. Bentley, G.E. (Gerald Eades), 1930– II. Mulhallen, Karen

N6797.B57B53 2010 769.92 C2010-902394-3

University of Toronto Press acknowledges the financial assistance to its
publishing program of the Canada Council for the Arts and the Ontario
Arts Council.

 Canada Council Conseil des Arts ONTARIO ARTS COUNCIL
for the Arts du Canada CONSEIL DES ARTS DE L'ONTARIO

University of Toronto Press acknowledges the financial support of the
Government of Canada through the Canada Book Fund for its publishing
activities.

BLAKE IN OUR TIME: ESSAYS IN HONOUR OF G.E. BENTLEY JR

For G.E. Bentley Jr, our 'own master dear'

Contents

Contents

List of Illustrations with Permissions

Colour Plates, Section One *(following p. 16)*

1 and 2 'The grand Style of Art' restored: William Blake's 1809 Exhibition, Tate Britain, April–October 2009, curated by Martin Myrone. Photo: © Tate 2009

3 William Blake, *The Body of Christ Borne to the Tomb* (c. 1799–1800), tempera on canvas, now mounted on cardboard, 26.7 × 37.8 cm, B426, T39, Tate N01164, in a frame quite possibly chosen by Blake himself. Photo: © Tate 2009

4 William Blake, *The Bard, from Gray* (1809?), tempera heightened with gold on canvas, 60.0 × 44.1 cm, B655, T60, Tate N03551. Photo: © Tate 2009

5 and 6 *Blake at Work*, Tate Britain, 2004–5, curated by Joyce Townsend and Robin Hamlyn. Photo: © Tate 2009

7 William Blake, *The Agony in the Garden* c. 1799–1800, tempera on tinned iron with chamfered corners, 27.0 × 38.0 cm, B425, T38, Tate N05894. Photo: © Tate 2009

8 Detail of paint delamination in foreground, William Blake, *The Agony in the Garden*. Photo: © Tate 2009

9 George Richmond, *Abel the Shepherd*, 1825, 9 × 12 in. (22.9 × 30.5 cm). Photo: © Tate 2009

10 George Richmond, *The Creation of Light*, 1826, 18½ × 16¼ in. (47 × 41.3 cm). Photo: © Tate 2009

11 George Loader, Map of Chichester. Scale: 20 in. to 1 mile. Engraving. 1812. West Sussex Record Office (PM.154)

12 Lambert Barnard, *Henry VIII Confirming to Bishop Sherbourne His Protection of Chichester Cathedral*. Dean and Chapter of Chichester Cathedral

Colour Plates, Section Two *(following p. 272)*

All images in this section courtesy of Victoria University Library in the University of Toronto.

Half-tones

Abbreviations

B Martin Butlin, *The Paintings and Drawings of William Blake* (London and New Haven: Yale University Press, 1981)

BB G.E. Bentley Jr, *Blake Books: Annotated Catalogues of William Blake's Writings in Illuminated Printing* (Oxford: Clarendon, 1977)

BBS G.E. Bentley Jr, *Blake Books Supplement: A Bibliography of Publications and Discoveries about William Blake, 1971–1992, Being a Continuation of Blake Books (1977)* (New York: Oxford University Press, 1995)

BCLT G.E. Bentley Jr, *The Blake Collection of Mrs. Landon K. Thorne* (New York: Pierpont Morgan Library, 1971)

BR G.E. Bentley Jr, *Blake Records* (Oxford: Clarendon, 1969)

BR2 G.E. Bentley Jr, *Blake Records*, 2nd ed. (New Haven and London: Yale University Press, 2004)

E William Blake, *The Complete Poetry and Prose of William Blake*, rev. ed., edited by David Erdman, with commentary by Harold Bloom (New York NY; London: Doubleday: Anchor Books, 1988)

Acknowledgments

A study of this complexity is indebted to the skills of many individuals. I would like to thank the anonymous readers for their helpful suggestions, the staff at the University of Toronto Press, especially our editors, Richard Ratzlaff and Barbara Porter, for continuous care and attention to the minute particulars, and our copy-editor, Mary Newberry, for her astonishing eye, knowledge, and patience.

I have been supported throughout the process by my collaborators, Robert N. Essick, Joseph Viscomi, Joyce Townsend and Bronwyn Ormsby, David Bindman, Mark Crosby, Mary Lynn Johnson, Angus Whitehead, Martin Butlin, Morton Paley, Keri Davies, Jerome McGann, and Robert Brandeis. Their brilliant scholarship, energy, and willingness to meet an onerous schedule have made possible this work, a tribute to the enduring legacy of G.E. Bentley Jr.

My teaching department, the Department of English, Ryerson University, funded my research assistant, Karim Wissa, during the initial preparation of the manuscript. Karim has stayed with the project and I have relied in all ways on his commitment, his editorial eye, and his love of scholarship and of the art of William Blake.

Many repositories have responded swiftly to our requests for materials and images and I wish to thank them all. They are listed in our notes and cited with our illustrations. Most particularly I want to thank the staff at the E.J. Pratt Library, Victoria University in the University of Toronto, and its chief librarian, Robert Brandeis, for prompt and continuing response to all requests.

I wish also to acknowledge various funding which has made the production of this book possible, from the Department of Fine Art, University of Toronto, from the School of Graduate Studies, University of

Toronto, from my dear friend and school mate Valerie Elia, as well as two generous subventions, one from Victoria University Library, in the University of Toronto, and the other from Victoria University Senate Research Committee.

Last but by no means least, *primus inter pares*, Alexander Gourlay, of the Rhode Island School of Design, has answered my every query at all hours. His encyclopedic knowledge of the literature, his scholarship, and his patience have been indispensable.

BLAKE IN OUR TIME

Introduction:
Blake in Our Time – Minute Particulars

KAREN MULHALLEN

He who would do good to another, must do it in Minute Particulars
Jerusalem, plate 55

In the fifth chamber were Unnamed forms, which
cast the metals into the expanse.
There they were receiv'd by Men who occupied
the sixth chamber, and took the forms of books &
were arranged in libraries.
The Marriage of Heaven and Hell 'A Memorable Fancy,' plate 15

In exploring the material and cultural contexts of the work of the English poet, printmaker, and painter William Blake, contributors to *Blake in Our Time* celebrate the irresistible force that has shaped what is now the most productive field of inquiry in Blake studies. More than fifty years ago, G.E. Bentley Jr almost single-handedly shifted the focus of Blake criticism from formalism and symbolism to the 'Minute Particulars' of Blake's life and work, right down to the metals and papers of his 'books … arranged in libraries.' The biographical, bibliographic, and chalcographic foundations established by Bentley support the pillars of contemporary Blake scholarship. Beginning with essays in the 1950s, and his facsimile edition of *Vala or The Four Zoas*,[1] and continuing in scores of books and articles, including his 2001 award-winning biography of Blake, *The Stranger from Paradise*[2] – finalist for the *Los Angeles Times* prize for the best non-fiction book published in America – Bentley has continued to influence generations of scholars by his meticulous editing, his incomparable sleuthing, and his complete bibliographies

and reviews of works by and about William Blake. Beyond that, Bentley's salutary emphasis on the dialectic between work and context, revealing that Blake's multivalent imagery is always grounded in the local and the contemporary, has led to a deeper understanding of the complex realities of Blake's epoch and our own.

Bentley's earliest work as a student was interpretive, a study of Blake and the alchemical tradition.[3] Even then, Bentley understood that sound interpretation depends on sound facts. Having assembled such facts into essential tools for the study of Blake, as in his editions of Blake's writings and his reference works such as *Blake Records*, *Blake Books*, and his annual Blake bibliography, Bentley has also demonstrated how these materials can lead to new interpretations, new understandings. Hence the culmination of the great diversity of his exploration is his biography of Blake, *The Stranger from Paradise*, where the facts serve the fiery and fierce understanding which Bentley has brought to Blake, his life, and his works. In the most moving of acknowledgments, in a space usually reserved primarily for institutions and spouses, Bentley begins by confessing his intimate relationship with his chosen subject:

> For half a century I have been wrestling with the spirit of William Blake, with the protean shapes of Blake's myth and the factual Laocoön of his life. And I have enjoyed it all. If I could believe that this biography is worthy of him, I would feel that I had won his blessing.[4]

Bentley has indeed passed his own test. Reviewers of *The Stranger from Paradise* have hailed the biography as 'generous,' 'extraordinary and moving,' and 'outstanding,' notable for the 'clarity of context' and the 'sober critical eye' he cast on its subject. One reviewer commented that Bentley's is the first biography of Blake that does not blur the focus; its scholarship is 'one of love and devotion'; Bentley's 'sense of balance is impeccable.'

In all his work Bentley's dedication to accuracy, to the material conditions under which Blake produced his art, is warmed and animated by his passion, his love for his subject. His rigour is not without a wonderful sense of humour, as can quickly be seen in the titles of two of his most recent publications, 'Blake's Heavy Metal: The History, Weight, Uses, Cost, and Makers of His Copper Plates,' in *University of Toronto Quarterly* and 'Blake's Murderesses: Visionary Heads of Wickedness,' in *Huntington Library Quarterly*.[5] His passion for his subject is also seen in

his legendary generosity to his students and to other scholars. His own collection of original works by Blake and works on Blake has always been available for scholars' use. Recently he has donated this immense and important Blake collection to Victoria University Library, in the University of Toronto, where it is now available to the public. Meanwhile Bentley himself has continued, almost yearly, to publish essential monographs for the study of Blake. He has made us all his students.

One anecdote of Bentley as a teacher must suffice. While working on my own doctoral dissertation on Blake's illustrations to Young's *Night Thoughts*, supervised by Bentley, I came upon a pencil drawing on a sheet of paper on which there was also a single printed letter followed by a printed semi-colon. Always needing to be frugal, Blake had obviously used a scrap of paper for his sketch. But I asked myself what was the origin of the orphaned bit of type and I took the photograph of the sketch to Bentley. He promised me if I found more examples than he already had, he would give his examples over to me, and I could write the article on them. I won, and my article, '"For Friendship's Sake": Some Additions to Blake's Sheets for Designs to a Series of Ballads (1802),' was subsequently published by Fredson Bowers in *Studies in Bibliography*.[6]

The concept of the ideal community of scholars has always found its chief practitioner in Bentley, who continuously enables the work of others and acknowledges the friendships which have come to him from that community. It is a fitting tribute to his generosity, as well as his influence, that an international group of scholars, spanning several generations, has come together to celebrate his scholarly munificence. Not only do their essays speak to one another in the areas which Bentley has defined, but also the essayists themselves, superb detectives all, conversed throughout the process of the preparation of this book, helping each other in their creation of new work. Our topics include the town of Chichester and its impact on Blake's poetry and visual art (Morton Paley), the material processes of Blake's paintings and what we can learn from them (Joyce Townsend and Bronwyn Ormsby), and forgeries which have been perpetrated in Blake's name, and how they can be discerned (Joseph Viscomi). New biographical materials have been unearthed on Blake's patrons: Thomas Butts (Mary Lynn Johnson), the Reverend A. S. Mathew and his wife Harriet (David Bindman), and William Hayley (Mark Crosby); on his friends and fellow artists: John Flaxman (David Bindman), George Cumberland (Angus Whitehead), and George Richmond (Martin Butlin); and on the impact

of the processes of industrialization, and most particularly paper man-
ufacturing, on his imagination (Keri Davies). Essays on collecting Blake
and scholar-collectors (Robert N. Essick), with an overview of Bentley's
own collection of Blake materials (Robert C. Brandeis), as well as the
changes to the engravings for William Hayley's *The Triumphs of Temper*
(Mark Crosby), and an analysis of the creation of two forged plates for
one of Blake's illuminated books, *America* (Joseph Viscomi) expand the
conversation and move this anthology into the chalcographic area of
book history, as well as the areas of production and reception.

Blake in Our Time demonstrates that the locus of a work, and of Blake's
work, lies in the elements which are historically particular. Although
there have been many individuals working on Blake in an historical-
material vein, and books have been published in this tradition – includ-
ing those by Jacob Bronowski, *William Blake, A Man Without a Mask*
(1944), Ruthven Todd, *Tracks In the Snow* (1946), Mark Schorer, *William
Blake, The Politics of Vision* (1946), and David Erdman, *Blake, Prophet
Against Empire* (1954), and more recently Robert N. Essick, *William Blake
Printmaker* (1980), Joseph Viscomi, *Blake and the Idea of the Book* (1993),
Joyce Townsend, ed., *William Blake, The Painter at Work* (2003), and Mei-
Ying Sung, *William Blake and the Art of Engraving* (2009) – there have
been no wide-ranging collections which demonstrate the importance of
this historical-material analysis for understanding Blake's work.

The titles of our three sections and the titles of the individual essays
scarcely hint at the rich composite of human worlds which lie within
them. Anatomy museums, fossils, and auction houses overlap with vis-
its between old friends; vignettes of vivid characters emerge from per-
sonal journals, digital records, and revisited manuscripts; paintings are
found executed on tin, on copper; bankrupts and entrepreneurs with
the gift of persuasion build monuments to industry and carry the inno-
cent with them as they fall; wayward sons are sent off to the continent
for military service in the hopes of disciplining them; passionate collec-
tors display their treasures while dangerously long ashes depend from
their cigarettes; another hitherto unknown, multi-skilled collector and
inventor, whose story will be uncovered in this book for the first time,
fills in the missing pages from his copy of a Blake illuminated book so
skilfully that it will take generations to discover his forgeries. The fash-
ions of the period, the literary salons, the craze for home decorating in
the Gothic style, the impact of one artist on another, all bring us closer
to Blake the man, who will also be seen in the country south of London
riding a pony named Bruno. Biography, history, science, sociology, phi-
losophy, and art all intermingle.

The respondent to these collected essays, Professor Jerome McGann, critic, editor, and theoretician, is the founder of the Institute for Advanced Technology in the Humanities at the University of Virginia. As editor and author, he has shown in his ongoing work the importance of material analysis. McGann's *The Romantic Ideology*[7] is often cited as marking the shift from formalism to a new historicism. In *The Textual Condition*, McGann acknowledges Bentley's *Blake Books* as an 'indispensable guide both to Blake's own works and to subsequent materials about him and his works, including editions, criticism, etc.' He calls Bentley's *Blake Records* 'Also indispensable.'[8] In his discussion of literary pragmatics and the editorial horizon, McGann reminds us that every part of the productive process is meaning-constitutive. All work is produced under specific social and institutional conditions. In the case of Blake, the physical constitution – the variety of sequencing of his plates, the formatting of text, the physical appearance – makes each copy of his printed work (even those produced in the same printing session) in effect unique.

I Minute Particulars, Materials for the Study of William Blake

Before 1863 and the publication of the first edition of Alexander Gilchrist's biography, *William Blake, Pictor Ignotus*, there was virtually no reception – no readership or viewership – for Blake's work. He lived, as he himself put it, 'by miracle,' supported mainly by a few patrons, and his works have been preserved only through the dedication of some remarkable collectors. Since each of Blake's works is unique, the task of preserving, the business of collecting, is more pressing perhaps than with other artists. We begin our narrative and lay our foundation with Robert N. Essick's account of the heroic passions of the major collectors and scholar-collectors who have preserved Blake's work for our time. Essick lays out the crucial building of collections and examines the complex relationship between collecting and scholarship and some of the principles underlying meaningful collecting. The perception and appreciation of the 'material base' and its relationship to historical knowledge is a leitmotif throughout the essay, interspersed with Essick's personal recollections and his own experiences as a collector of Blake since the mid-1960s.

Beginning with Blake's lifetime patrons and their heirs, and other early nineteenth-century collectors, including Thomas Butts, John Linnell, and Isaac D'Israeli (father of the future prime minister), Essick asks why these collectors were interested in Blake at a time when few

considered him a significant poet or artist. Similarly, he explores the motivations of nineteenth- and early twentieth-century British collectors, particularly W. Graham Robertson, who formed the largest collection of Blake's drawings and paintings ever assembled, and the influence of Gilchrist's *Life of Blake* (1863), the Pre-Raphaelites D.G. and W.M. Rossetti, and the Burlington exhibition of 1876 on Blake's reputation. In America, Essick investigates the tastes of W.A. White, Henry E. Huntington, Lessing J. Rosenwald, and Paul Mellon, offering insights into the relationship between the perception of Blake's works and the wider spectrum of aesthetic trends. He recalls conversations with Rosenwald and observes how dealers, particularly A.S.W. Rosenbach, have shaped collections. As a scholar-collector himself, Essick is perfectly positioned to open up this world for the novice. He writes with great charm and intimacy about the collecting practices of both Keynes and Bentley and reflects on his own experiences, citing previously unpublished documents in the Rosenbach Foundation and in his own collection. The question is inevitable: Is it still possible to collect Blake, despite the soaring prices? Yes, it is, says Essick, and he presents some timely collecting strategies.

As Blake's techniques of printing were unique and his works are scarce and now increasingly valuable, they present a challenge to reproduction. The urge to reproduce a work has many aspects: a forger might be motivated by money, by the desire to study, by an exercise of skill, or simply by the wish to fill a gap in a collection. How do we distinguish a skilled forgery and what do we learn from the study of an artist's choice of materials and his variant plates? As a printer, a curator, and a scholar, Joseph Viscomi brings a formidable arsenal of skills to bear on his investigation of an apparent forgery of two sheets in a copy of Blake's *America*. Using current digital resources, Viscomi's hunt is expanded as he searches for the forger, who turns out to be a brilliant and colourful collector of Blake and a scientist and inventor of great stature as well. Over the last thirty years, Viscomi has himself reproduced Blake's methods in illuminated printing and facsimiles and has detected facsimiles which were misidentified as well, identifying works which were intended to deceive. He has examined prints and drawings supposedly printed or executed or drawn or coloured by Blake for Christie's, Sotheby's, Houghton Library, Morgan Library, and many private owners. Such cases read like detective stories and they also provide insight into Blake's techniques and what constitutes bibliographical evidence.

The intensity with which Blake worked as a painter and his search for individual methods which would accommodate both his straitened financial circumstances and his extraordinary independence of mind have received little attention until the pathfinding collection of essays, edited by Tate Britain senior conservator Joyce Townsend, *William Blake, The Painter at Work* (2003).[9] Townsend and her fellow senior conservator at Tate Britain, Bronwyn Ormsby, consider what can be known of the mind of an artist by analysing his materials. Are the materials commonplace for the time? How does the artist strike out in new directions? How did finance affect material decisions? What have been the material consequences over time of some of these decisions? How does this study enable audience understanding? Studies of artists' materials and technical art history open a door to the understanding of an artist's creativity and personality, when they are linked to the working method and chosen lifestyle of the artist. The case of Blake is a good example: his innovative practices include chalcographic printing processes that permitted both text and image to be reproduced in multiple copies, with subtle to significant variations in each 'copy.' His printing processes for limited copies of the large colour prints and the colour-printed pages of the illuminated books are disputed to this day, and the most insightful studies have used practical printing, as well as close studies of Blake's prints, to shed light on their production, and to show up impractical ideas as untenable. Townsend and Ormsby see G.E. Bentley Jr as a scholar in this modern tradition – indeed the earliest exponent in the case of Blake. Bentley's life's work has constantly demonstrated the value of studying the work of art in as much detail as one studies the artist's writings, in order to gain a holistic and deeper understanding and appreciation of his work. Bentley has also paid attention to Blake's writings, and to all other facets of Blake's life: this unique depth of study makes possible the grand synthesis that takes scholar, specialist, and art lover alike closer to Blake the man and the genius.

II 'For Friendship's Sake': Friends and Patrons

Blake's production methods were highly individual and his work, lacking a wide audience, was financed by a small group of loyal patrons and a few publishers who employed him in engraving, the occupation in which he was trained. Art historian David Bindman presents new material on Blake's earliest patrons, the Reverend A.S. Mathew and his wife Harriet. The importance of eighteenth-century salons in the

intellectual life of Europe has been much studied lately and Bindman works very specifically with the developing concept of the Gothic – a major fad in late eighteenth-century and nineteenth-century Europe. As young artists, Blake and his close friend the sculptor John Flaxman were struck by Gothic fever, distinctly evident in some previously unexplored drawings associated with the Mathews' salon of the 1780s. It was Bentley who first identified the Mathews as important patrons both of Blake and of Flaxman in their youth. In *Nollekens and His Times* (1828), John Thomas Smith gives a detailed account of Blake's and Flaxman's visits to the Mathew family, and Smith notes that Flaxman decorated their home in a Gothic style. Bindman reports on a newly discovered drawing by Flaxman which shows, among other things, a Gothic chair that appears to correspond with the one mentioned by Smith. The theme of Blake's Gothicism recurs in the third part of our volume, in Morton Paley's essay on Chichester.

On 18 September 1800, Blake left London for the first and only time in his life and spent three years in a country village, Felpham, under the care, and at times the unwanted supervision, of his patron William Hayley. Investigating that troubled period of Blake's life through manuscripts and printed works, Mark Crosby considers the implications of printing, publishing, and patronage in Blake's 1802 engravings for 'a ladys book,' the twelfth edition of Hayley's *The Triumphs of Temper*. Hayley sent copies of the book, published the following year, to various female friends with manuscript dedications. Blake's engravings, after drawings by Maria Flaxman, half-sister of John Flaxman, also appeared in an 1807 edition of the poem, the same year as another and more popular edition appeared with seven engravings after Thomas Stothard. Four of Stothard's engravings were also reproduced in the 1817 edition, which was the final edition published in England before Hayley's death. Following the methodology of G.E. Bentley Jr in his reconstruction of Hayley's ballad project, 'William Blake as a Private Publisher,'[10] Crosby uses contemporary correspondence and Hayley's manuscript dedications to explore some of the reasons behind Hayley's decision to replace Blake's engravings in 1807.

The most loyal of all Blake's patrons, over many years, was a civil servant of modest means. Why was this man, Thomas Butts, so committed to Blake and his work? Mary Lynn Johnson has used new electronic sources to trace the genealogy and religious affiliations of Butts and his extended family and to provide a wider historical context for Butts's commitment to Blake and his work. Her essay extends and

occasionally corrects Bentley's early work on Butts, published when he was only twenty-six years old, as well as that of Joseph Viscomi in the mid-1990s. Who would have thought, Johnson seems to ask, that there was anything left to discover? Only very recently – with the last decade's online publication of additional newspapers, books, parish registers, wills, law cases, censuses, financial statements, military records, private papers, accounts of charitable institutions, and house-to-house street maps providing indications of square footage, plus the recent deposit of Mary Butts's papers in the Beinecke Library of Yale University – has it become possible, from one's own armchair, argues Johnson, to find evidence of the religion of Butts's maternal grandparents and the occupation of his wife's family, not to mention Butts's 1802 dissolution of a partnership with his associate clerk, William Woodman; Thomas, Jr's 1827 dissolution of his partnership as a 'mill sawyer' in Kent, followed by his 1828 bankruptcy, only months before his marriage that year, at forty, to Mary Ann Barrow (twenty years his junior); details of baptismal records; of the military records of Butts's grandsons (via Thomas, Jr) Frederick John Butts (Capt. Butts) and his younger brother Aubrey Thomas Butts; of the bailing out, in 1834, of Butts's grandsons upon their failure as linen-drapers; and even an undated privately printed catalogue of Blake's work exhibited at the Salterns, home of Captain Butts. There is much more to be learned from what Johnson herself terms a 'glittering heap of factual nuggets.' Overwhelming as the 'heap' is, it brings us closer to an understanding of Butts's patronage and the descent of Blake's work through the Butts family.

Despite his reputation in the nineteenth and even twentieth centuries as an eccentric and bizarre individual, William Blake maintained fierce and loyal friendships throughout his entire life. He loved good company, and was deeply sociable. His art is informed by this sociableness in every way. And his capacity for friendship included not only his peers and contemporaries but also the coming generations. In examining the private journals of Blake's lifelong friend and fellow artist George Cumberland, Angus Whitehead builds upon Bentley's groundbreaking work on Cumberland's unpublished MSS pocketbooks in the British Library manuscripts collection, published in *Blake Records* (1969), as well as his *A Bibliography of George Cumberland (1754–1848)* and his carefully annotated edition of Cumberland's novel, *The Captive of the Castle of Sennaar*.[11] Whitehead investigates an important period in Blake's and Cumberland's friendship, circa 1813–20, one that

reveals a fascinating aspect of the intellectual milieu of Blake's time. In this period the English were fossil mad, and scores of texts, scientific, historical, and literary, depict their searching of the beaches and quarries of England for evidence of earlier life forms. It is not surprising that this mania would have impinged on Blake in his later years, years of poverty and years in which he produced some of his most magnificent works, such as his illustrations to the Book of Job and his illustrations to Dante. Returning to Cumberland's MS sources, principally his set of Letts pocketbooks, Whitehead presents evidence of previously unrecorded encounters between Blake and Cumberland and sheds new light on the relationship between the two artists, their respective milieux, and Cumberland's apparent abandonment of art collecting and connoisseurship for geology. Ultimately, Whitehead illustrates a major tenet of Bentley's work: a fertile collaboration between archival and interpretative scholarship.

Blake's influence on following generations has been substantial. Art historian Martin Butlin, author of the two-volume catalogue raisonné of Blake's works, *The Paintings and Drawings of William Blake* (1981), and former Keeper of the Historic British Collections at The Tate Gallery, London (now Tate Britain), looks at the young painters who followed Blake. In his last years, Blake was supported by a group of at least nine young followers who called themselves 'The Ancients.' One can imagine the great pleasure he took in the eagerness and talent of these young artists, who included Samuel Palmer, George Richmond, Edward Calvert, and John Linnell. Not only does Butlin bring us up into the twentieth century, but he also takes a radically different position from other art historians, who have seen Blake's influence running from his wood engraving illustrations to Thornton's *Virgil*, through 'The Ancients,' and then, by way of the early engravings of Paul Nash and Graham Sutherland, on through the visionary landscapes of British artists working during the Second World War to the ruralists. Butlin argues cogently that the only artist to have appreciated and to have been directly influenced by Blake's central achievement in the visual arts, which were his illustrations to the Bible, history, and mythology, was George Richmond. Unlike the work of his fellow 'Ancients,' the work of Richmond springs from the style, technique, and subject matter of Blake's most important late works. Even when his main output in later years was portraiture Richmond continued to paint subject paintings, though in a totally different Italianate style. At least one of the works by Blake in Richmond's own collection

played a distinctive part in influencing his own style, and one of his paintings, argues Butlin, was worthy of the master himself.

III 'What I both See and Hear': Architecture and Industry

The three years Blake spent out of London were in a village close to the cathedral town of Chichester. They were productive and difficult years for both Blake and his wife. They were each visited by physical illness and Blake was himself tried for sedition. Despite these extraordinary years for the Blakes, contemporary Blake scholarship almost makes it seem that Chichester, only six miles from Felpham, made no significant impression on Blake at all. Mindful that many tasks would have taken Blake into the prosperous nearby city during the Felpham period (1800–3), Morton Paley revisits Chichester, graced by both medieval and Georgian architecture, and considers its impact on Blake's visual art and his writings. He scrutinizes the city's layout, its history from pre-Roman times to the early nineteenth century, its cathedral and its sculptures, its decorations, and other architectural monuments. Taking up a suggestion in Thomas Wright's 1929 *Life of William Blake*, a book now virtually ignored, Paley argues that the structure of Blake's city of Imagination, Golgonooza, takes its original impetus from the urban layout of Chichester. He also suggests that Blake's extensive use of the ogee arch in his art of the early nineteenth century is related to the extensive use of this architectural element in Chichester cathedral, thereby demonstrating the profound impact on Blake's mind and art of the city itself.

Blake returned from Felpham to London in 1803 with hopes of establishing himself as a publisher. By this time, a large-scale paper manufactory had been established in London and had failed, but its grandiose buildings still stood on the Thames. In his essay on papermaking, Keri Davies investigates manufacturing in London in the early nineteenth century and the poignant micro-histories of men who attempted to establish large-scale production facilities there. Although some Blake scholars have argued that as a Londoner Blake could not have witnessed at first hand the heavy manufacturing plants of the Industrial Revolution, and that Blake's 'Satanic Mills' were entirely metaphorical, London did have its heavy industries. While it is true that the crucible of manufacture was in the Midlands and the North, Davies argues that in the 1790s Blake could have witnessed industrial papermaking not far from his home in Lambeth, at the Neckinger Mill in Bermondsey.

He would also have seen at Millbank the remains of the Straw Paper Manufactory set up by Matthias Koops. Finally, Davies suggests some ways in which the paper manufacturing process enters Blake's poetry, particularly in his allegories of manufacturing in *The Four Zoas*.

Having begun with an essay on the importance of collecting, we conclude our celebratory collection by returning in the final essay to the material of the material base – paper itself. And in our Appendix, 'William Blake in Toronto,' we look ahead to the continuing influence of G.E. Bentley Jr's vibrant legacy in 'The Bentley Collection' at Victoria University, University of Toronto. Within this framework, solidly anchored to the material and historical basis of Bentley's monumental body of accomplishment, and inspired by his passions as teacher, scholar, and friend, we offer a series of new and important contributions to Blake studies, and to cultural history and the history of the book. As Bentley has done with the spirit of Blake, we have wrestled not only with Blake's spirit, but with the character and example of Bentley himself. And like Bentley, we have enjoyed it all. In the end, if we can believe that this collection is worthy of him, we shall feel that we have won his blessing.

NOTES

1 William Blake, *Vala or The Four Zoas*, facsimile edition, ed. G.E. Bentley Jr (Oxford: Clarendon, 1963).
2 G.E. Bentley Jr, *The Stranger from Paradise* (New Haven: Yale University Press, 2001).
3 Bentley, 'William *Blake and the Alchemical* Philosophers' (B. Litt. thesis, University of Oxford, 1954).
4 Bentley, *The Stranger from Paradise*, xvi.
5 Bentley, 'Blake's Heavy Metal; The History, Weight, Uses, Cost, and Makers of His Copper Plates,' *University of Toronto Quarterly* 76, no 2 (Spring 2007): 714–70; 'Blake's Murderesses: Visionary Heads of Wickedness,' *Huntington Library Quarterly* 72, no 1 (2009): 69–105.
6 Karen Mulhallen, '"For Friendship's Sake": Some Additions to Blake's Sheets for Designs to a Series of Ballads (1802),' *Studies in Bibliography* 29 (1976): 331–41.
7 Jerome McGann, *The Romantic Ideology: A Critical Investigation* (Chicago: University of Chicago Press, 1983).

8 McGann, *The Textual Condition* (Princeton: Princeton University Press, 1991), 44.

9 Joyce Townsend, ed., *William Blake, The Painter at Work* (Princeton: Princeton University Press, 2003).

10 Bentley, 'William Blake as a Private Publisher,' *Bulletin of the New York Public Library* 61 (1956), 539–60.

11 Bentley, *Blake Records* (Oxford: Clarendon, 1969); *A Bibliography of George Cumberland (1754–1848)* (New York and London: Garland, 1975); Bentley, ed., *The Captive of the Castle of Sennaar: An African tale in Two Parts: Part 1 The Sophians (Printed in 1798 and 1810), Part 2 The Reformed (Manuscript of c. 1800)* (Montreal, Kingston, London, Buffalo: McGill-Queen's University Press, 1991).

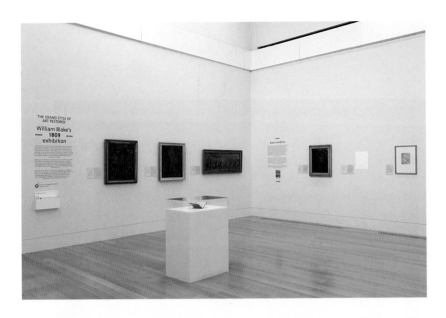

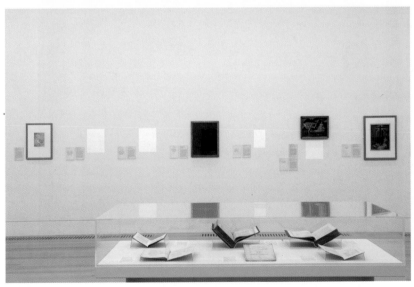

1 and 2 *'The grand Style of Art' restored: William Blake's 1809 Exhibition*, Tate
Britain, April–October 2009, curated by Martin Myrone. Photo: © Tate 2009

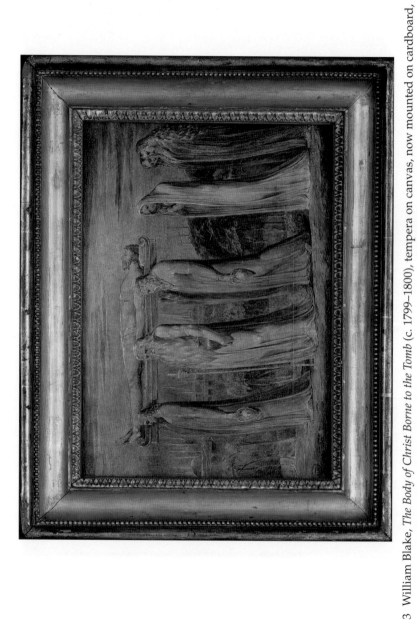

3 William Blake, *The Body of Christ Borne to the Tomb* (c. 1799–1800), tempera on canvas, now mounted on cardboard, 26.7 × 37.8 cm, B426, T39, Tate N01164, in a frame quite possibly chosen by Blake himself. Photo: © Tate 2009

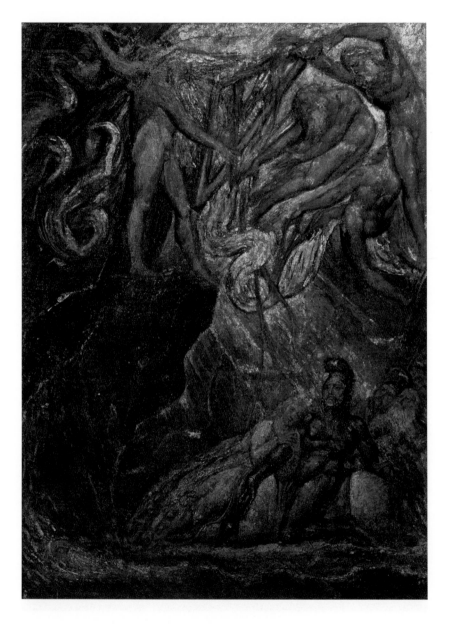

4 William Blake, *The Bard, from Gray* (1809?), tempera heightened with gold on canvas, 60.0 × 44.1 cm, B655, T60, Tate N03551. Photo: © Tate 2009

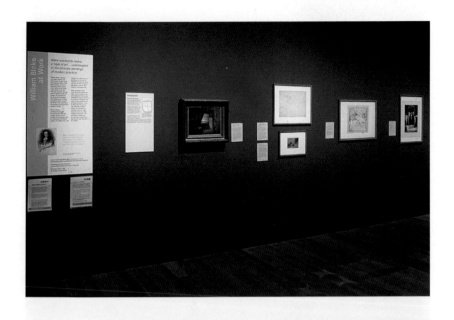

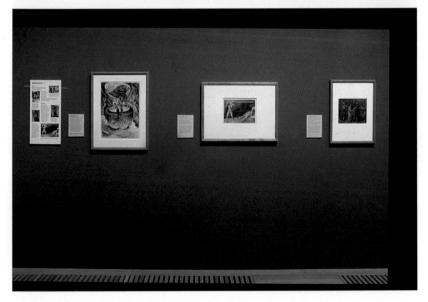

5 and 6 *Blake at Work*, Tate Britain, 2004–5, curated by Joyce Townsend and Robin Hamlyn. Photo: © Tate 2009

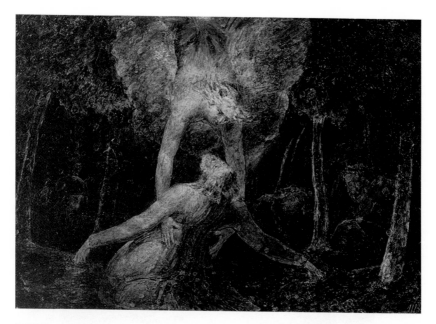

7 William Blake, *The Agony in the Garden* c. 1799–1800, tempera on tinned iron with chamfered corners, 27.0 × 38.0 cm, B425, T38, Tate N05894. Photo: © Tate 2009

8 Detail of paint delamination in foreground, William Blake, *The Agony in the Garden*. Photo: © Tate 2009

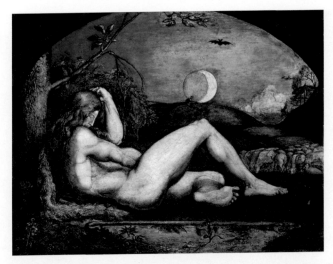

9 George Richmond, *Abel the Shepherd*, 1825, 9 × 12 in. (22.9 × 30.5 cm).
Photo: © Tate 2009

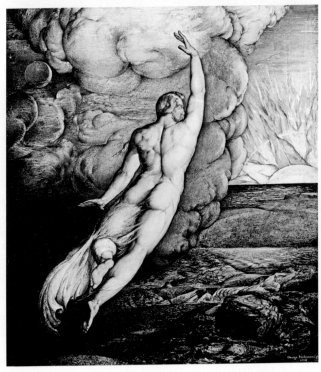

10 George Richmond, *The Creation of Light*, 1826, 18½ × 16¼ in.
(47 × 41.3 cm). Photo: © Tate 2009

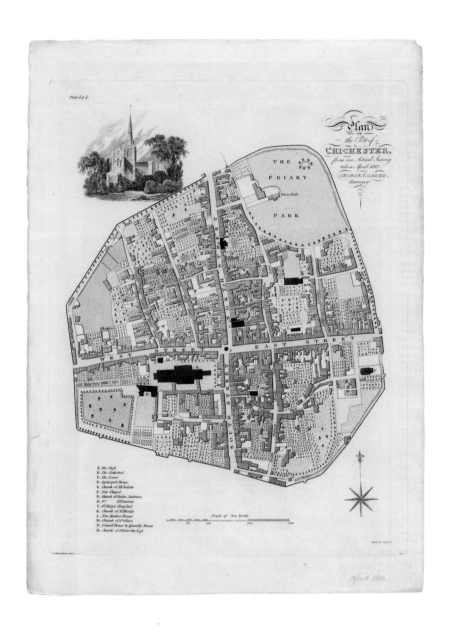

11 George Loader, Map of Chichester. Scale: 20 in. to 1 mile. Engraving. 1812.
West Sussex Record Office (PM.154)

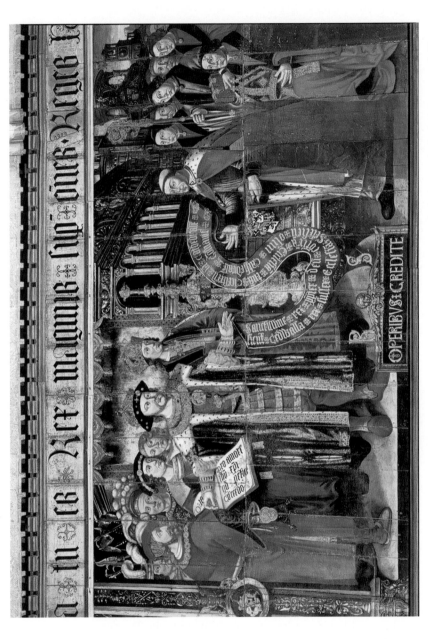

12 Lambert Barnard, *Henry VIII Confirming to Bishop Sherbourne His Protection of Chichester Cathedral*. Dean and Chapter of Chichester Cathedral

PART ONE

'Every Minute Particular Is Holy': Materials

1 Collecting Blake

ROBERT N. ESSICK

John Keats's *Poems* of 1817 is a rare and valuable book. What would be the scholarly consequences if eight copies were destroyed? A major loss for their owners, but little if any impact on our access to and understanding of Keats's poetry. There are enough copies of this letterpress book to suffer some losses. What would be the scholarly consequences if eight copies of William Blake's *The Marriage of Heaven and Hell* were consumed by flames? We would have only one complete copy left. We would lose Blake's own variants in inking, printing, and colouring found in nine complete copies from five printing sessions over the course of thirty-seven years. What if just one copy of Blake's first illuminated book, *All Religions are One*, was washed away in a flood? We would have none.

My bibliographically apocalyptic tale indicates the importance of preserving each original copy of Blake's writings. Like an artist's drawings and paintings, each copy of Blake's etched writings bears a more important relationship to his canon than what we generally find with an author's works. Even Blake's two letterpress texts published in his lifetime, *Poetical Sketches* (1783) and *A Descriptive Catalogue* (1809), are rare enough (twenty-three and eighteen traced copies respectively), and have a sufficient number of autographic emendations, to make the loss of any one copy significant.[1] Further, the material features of Blake's works and the means of production they record are part of their meaning. The vast majority of authors have nothing approaching Blake's role in the evolution of graphic and printing technologies. These special (in some cases unique) characteristics of Blake's productions in several media place particular responsibilities on their owners, both private and institutional. Thus, the history of Blake collecting and its relation-

ship to scholarship play a particularly important function in the study of the editing, reception, and interpretation of his contributions to the visual and literary arts.

Blake's first great collectors were his two major lifetime patrons, Thomas Butts (1757–1845) and John Linnell (1792–1882). Although neither was wealthy, both were instrumental in the commissioning and preservation of Blake's works. Why Butts, a clerk in the office of Britain's Commissary General of Musters, was so interested in Blake has yet to be fathomed.[2] Without Butts's patronage, however, we would not have over two hundred of Blake's biblical watercolours and tempera paintings, at least four sets of watercolour illustrations to John Milton's poetry, the first series of illustrations to the Book of Job, and the finest group of the large colour prints, first printed in 1795 and specially prepared for Butts circa 1805. These last are considered by many to be Blake's finest works as a pictorial artist. Butts also acquired some of Blake's writings, including copies of *The Marriage of Heaven and Hell*, *Songs of Innocence and of Experience*, and *Milton a Poem*.

There is no documentary evidence about the nature of Butts's interest in Blake. I suspect that, like many later collectors, Butts was more attracted to the visual than the literary component of the illuminated books. My sense that his interests focused on Blake's pictorial art is based on his patronage of Blake's watercolours and paintings more than his writings, as well as the general lack of interest in Blake's poetry in his own time. Most of Blake's pictorial works take their subjects from the Bible and literary texts, but that was true of many so-called history paintings of the late eighteenth and early nineteenth centuries. It is also possible that Butts had a special interest in the Bible and its illustration.

The Butts collection was inherited by his son, Thomas Butts Jr, who offered many of Blake's works in four auctions in 1852–4.[3] At this time, Blake's reputation was at its nadir, and most lots fetched no more than one or two pounds. Many works remained in the collection and passed into the hands of Captain Frederick Butts, the grandson of Blake's patron. The final Butts auction of 1903 was more successful, but most of the large colour prints were not sold until 1906.[4]

Linnell's patronage had a somewhat different character. A fine artist himself, Linnell enlisted Blake, shortly after their meeting in 1818, as a partner in engraving projects. A few years later, Linnell commissioned the two masterpieces of Blake's final years, the Job engravings and the illustrations to Dante's *Divine Comedy*. Linnell's financial arrangements for these endeavours were a mixture of business acumen, patronage,

and charity. Linnell was probably also instrumental in gaining for Blake the commission to illustrate R.J. Thornton's student edition of the *Pastorals of Virgil* (1821), a project that resulted in Blake's only wood engravings.[5] These are now considered to be among the finest British works in the medium and a major influence on several generations of artists from Edward Calvert to Graham Sutherland. Linnell also acquired many of Blake's writings, including *Jerusalem* and the manuscript of Blake's longest poem, *The Four Zoas*. The Linnell collection remained in the family's possession until its dispersal at auction in 1918, a sale that laid the foundation for several twentieth-century Blake collections.

Although neither a patron nor a collector except by bequest, Frederick Tatham (1805–78) played a leading role in the preservation, dispersal, and, alas, the destruction of Blake's works. At his death in 1827, Blake's remaining stock was inherited by his wife Catherine. All but a few items passed at her death in 1831 to Tatham, with whom Catherine had lived as a housekeeper in her final few years. The remaining group included a great many sketches and watercolours, books owned and annotated by Blake, the now-lost copperplates of the illuminated books, and masterpieces such as the only complete coloured copy of Blake's illuminated epic, *Jerusalem*. Tatham soon fell under the influence of the preacher Edward Irving and, apparently based on Irvingite doctrines, destroyed an unknown number of Blake's manuscripts and notebooks, believing them to be 'unclean' or inspired by Satan.[6] But many works remained intact, including the *Jerusalem*, and Tatham slowly sold them privately, or to the dealer Joseph Hogarth (possibly on consignment), or anonymously at auction in 1862, a sale that included over seventy drawings by Blake.

A few late eighteenth-century collectors, and numerous collectors through the nineteenth century, acquired important works by Blake. The earliest included Blake's friends George Cumberland, John Flaxman, and George Romney, and contemporary patrons such as Ozias Humphry and the Reverend Joseph Thomas. They were soon followed by men such as James Vine, Isaac D'Israeli (father of the future prime minister), P.A. Hanrott, and William Beckford (of Fonthill Abbey fame), and at least one woman, Rebekah Bliss.[7] By the end of the nineteenth century, choice collections had been formed by Sir Charles Dilke, Thomas Gaisford, Bernard Buchanan Macgeorge, Richard Monckton Milnes (first Lord Houghton), and the artist William Bell Scott.[8] Most of these early collectors – indeed, most collectors to the present day – came to Blake because of an interest in books rather than drawings

and paintings. Copies of his illuminated books were generally the fea-
tured treasures. It was not until 2004, when the large colour print of
The Good and Evil Angels Struggling for Possession of a Child brought $3.9
million at auction (all amounts expressed in dollars are U.S. unless oth-
erwise specified), that one of Blake's purely pictorial works set a record
which exceeded prices for his illuminated books. Several factors have
inhibited the reception of Blake's pictures among major art collectors,
including the fading of his watercolours from overexposure to light,
the sad condition (and in some cases clumsy restoration) of his tem-
pera paintings of 1799–1800, and the opinion of many art historians
that Blake 'couldn't draw or paint,' as I've heard more than one scholar
pronounce ex cathedra.

The outstanding exception to the emphasis on the illuminated books
was the Blake collection formed by W. Graham Robertson (1866–1948).
His manuscript collection catalogue includes 140 drawings, paintings,
and colour prints – by far the most representative selection of Blake's
pictorial art assembled by an individual collector since Butts's patron-
age.[9] The collection began heroically on 30 June 1886 with the acquisi-
tion of forty drawings from the book dealer Bernard Quaritch, all once
in Tatham's possession. Between 1904 and 1907, Robertson comple-
mented this initial group with some of Blake's finest watercolours and
temperas from the Butts collection. Two of Blake's large colour prints
were acquired in 1905; seven more joined the collection in one fell
swoop in April 1906. Robertson's final acquisition added a tenth colour
print, *Christ Appearing to the Apostles after the Resurrection*, in 1938.

The auction of Robertson's collection in 1949 created a controversy,
particularly among dealers hoping for easy pickings. The executors of
his estate placed high reserves on the more important works with the
intention of distributing any unsold lots to British museums through
the National Art Collections Fund. It appeared to potential bidders that
the vendor was also a competitor and that the auction had been rigged.
But there was no illegality, and several institutions benefited greatly.[10]
London's Tate Gallery (now Tate Collection at Tate Britain) received
twenty-one works, including all the large colour prints.

While in Robertson's personal possession, his collection of Blake's
works was seen by only a select few. Simply by preserving (and in some
cases restoring) these many treasures, Robertson provided an inesti-
mable service to Blake scholars – and to the general public. After their
sale and the acquisition of major works by public institutions, some of
Blake's finest paintings, drawings, and colour prints became accessible

to all scholars and available for exhibitions. Without Robertson's enthusiasm as a collector, Blake studies in our own time would suffer from a dearth of original materials.

North America's first and greatest Blake collector was William Augustus White of Brooklyn, New York. White collected Renaissance emblem books; he may have been attracted to Blake's illuminated books because of their emblem-like pictorial iconography. Between 1890 and 1908, White acquired nineteen copies of fourteen illuminated books. Quaritch, apparently acting as White's agent, was the winning bidder on eight of the thirteen illuminated books from the Monckton Milnes collection sold at auction by his son, the Earl of Crewe, in 1903. But White did not limit the collection to Blake's books. He acquired Blake's Notebook in 1887, and in 1906 added Blake's 537 watercolours illustrating Edward Young's *Night Thoughts*, to create the largest Blake collection ever assembled by a private owner.

After White's death in 1927, his heirs apparently enlisted the book auctioneer Arthur Swann and America's greatest book dealer, A.S.W. Rosenbach (always called 'Dr. Rosenbach' by lesser mortals), to evaluate and sort out the collection. Their records, now in the Rosenbach Museum and Library, Philadelphia, are terse and somewhat confusing, but they indicate that many of the illuminated books were 'desired' by members of the White 'family.' Perhaps after a few missteps, most of the Blakes went to White's daughter, Mrs Frances White Emerson. She later repatriated the *Night Thoughts* watercolours and Blake's Notebook, generously giving the former to the British Museum in the winter of 1928–9 and bequeathing the latter to the British Library at her death in 1957.

Two famous American book collectors, active in the early twentieth century, deserve mention, even though neither was centrally interested in Blake. Both men founded institutions to maintain their collections and make them available to scholars and, through exhibitions, to the public. J. Pierpont Morgan began to collect Blake's works when he purchased two copies of *Songs of Innocence and of Experience* and one of *Jerusalem* from a London dealer in 1899. Three more illuminated books were added in the first decade of the next century. At the 1911 auction of Robert Hoe's enormous book collection, Morgan was the successful bidder on a particularly fine copy of *The Marriage of Heaven and Hell*. After its founder's death in 1913, the Morgan Library continued to make substantial additions to its Blake holdings. Twelve splendid watercolours illustrating Milton's 'L'Allegro' and 'Il Penseroso' came

to the institution in 1949; a copy of *There is No Natural Religion* followed in 1952. The collection of illuminated books more than doubled in 1973 when Mrs Landon K. Thorne bequeathed eleven to the Morgan.[11]

The Morgan Library continues to be one of the more active institutional collectors of Blake's works. Unusually, it has also been a seller. With the addition of thirteen plates from *There is No Natural Religion* from the Thorne collection, it appeared to the Morgan's staff that they had at least six duplicates. There is no such thing as a 'duplicate' impression from one of Blake's relief-etched plates, but nonetheless the Morgan sold six prints at auction in 1977. It later became evident that the supposed duplicates retained by the library are early facsimiles, but the ones sold are originals printed by Blake.[12] All six are now in my collection, the only plates from *There is No Natural Religion* remaining in private hands.

Henry E. Huntington made headlines with his many successful bids at the 1911 Hoe sale. Among these were three of Blake's illuminated books, including *Milton a Poem*, a copy of *Poetical Sketches* (one of two now in the collection), and a copy of J.C. Lavater's *Aphorisms on Man* (1788) extensively annotated by Blake. The Linnell auction of 1918 offered equally tempting opportunities: the unique copies of *All Religions are One* and *The French Revolution*, Blake's annotated copy of R.J. Thornton's *The Lord's Prayer* (1827), and fourteen letters by Blake to Linnell. Huntington was famous for buying whole collections, a strategy that resulted in boxes full of inconsequential volumes but also great treasures. His copy of *Songs of Innocence and of Experience* came in 1912 as part of the Beverly Chew collection; *The Song of Los*, splendidly colour printed by Blake and one of only six known copies, came with the Frederic R. Halsey collection in 1915.

Huntington was one of Rosenbach's major customers. A copy of *The Book of Thel* came from that source in 1911, but more important was the acquisition of three magnificent suites of Blake's watercolour illustrations to poems by Milton: *Paradise Lost* (ten of twelve designs in 1911), *Comus* (eight designs in 1916), and 'On the Morning of Christ's Nativity' (six designs, with the large watercolour of *Satan, Sin, and Death*, in 1916). Huntington completed the *Paradise Lost* series with the acquisition of the two fugitive designs in 1914. The total payment of $44,200 to Rosenbach was an enormous price at the time, but now seems like a considerable bargain.[13] When combined with his copy of *Milton a Poem*, Huntington's collection had become, within less than six years, the world's most important repository of Blake's direct responses to

the writer who more than any other influenced his endeavours as both poet and artist.

Since Huntington's death in 1927, the multifaceted institution he created has made only one major Blake acquisition, the colour print of *Hecate* (or *The Night of Enitharmon's Joy*) in 1954. Yet, thanks to its founder, the Huntington Library, Art Collections, and Botanical Gardens continues as an important centre for the study of Blake, his contemporaries, and followers. As the resident 'Blake nut' haunting its halls, I have been asked occasionally why Huntington, a practical businessman not known for flights of imagination, was attracted to Blake. Huntington was interested in both British literature and art, and particularly fine printing, illustrated books, and drawings based on literary texts. I doubt that he spent hours perusing *Milton a Poem*, but Huntington surely appreciated the power of Blake's pictorial imagery and the unusual bibliographic and chalcographic features of the illuminated books.

America's most formidable Blake collector in the first half of the twentieth century was Lessing J. Rosenwald of Philadelphia. He began, circa 1925–6, to collect old master and contemporary engravings and illustrated books; it was almost inevitable that he would become interested in Blake's etched illuminated books and other graphic productions.[14] In 1929, Rosenwald acquired from Rosenbach an outstanding group of Blake's works formerly in the White collection, including ten illuminated books, for the then princely sum of $115,000.

Rosenwald's other major purchases of Blake's works followed apace whenever the market presented opportunities. The remainder of the Linnell collection, including the progress proofs of the Job engravings and the copperplates of the Dante engravings, was acquired from the London dealer Philip Robinson in 1937. The British collector W.E. Moss, like Rosenwald, had a particular interest in Blake's printmaking techniques. At the Moss auction in 1937, Rosenwald spent $20,849.18 on ten lots, including copies of *Songs of Innocence* and *Songs of Innocence and of Experience*. The New York collector George C. Smith had assembled a first-rate collection of Blake's illuminated books in a remarkably short time. When these were sold at auction in 1938, Rosenwald was the successful bidder on eighteen lots at a total cost of $23,287.75.[15] By the next year, Rosenbach had purchased, or had on consignment, a copy of *Songs of Innocence and of Experience*, beautifully hand coloured by Blake in 1826, and one of only four copies of *Milton a Poem*, both from the Frank B. Bemis collection. These quickly entered Rosenwald's collection. The legendary 1941 auction of the collection formed by the

bibliophile and raconteur A. Edward Newton gave Rosenwald the opportunity to acquire one of Blake's most powerful essays in the apocalyptic sublime, the watercolour of *The Great Red Dragon and the Woman Clothed with the Sun*, and two illuminated books. Unfortunately, one of the latter, *There is No Natural Religion*, proved to be yet another copy of the early facsimile. Even the most astute collector can make mistakes.

The aesthetic exemplified by *The Great Red Dragon* and other designs based on the apocalyptic events of the Book of Revelation raises some tantalizing questions about responses to Blake's art. The sublime, as famously defined by Immanuel Kant in the late eighteenth century, involves a two-step process.[16] The first reaction includes confusion, the result of the senses (or the sensibilities) being overwhelmed by powerful, even horrific, images. In the case of the apocalyptic sublime, such images, pictorial or verbal, represent the destructive events that characterize St John's vision of the end of the world as we know it. Kant's second step is a counter-movement as the mind of the viewer/reader restores itself to balance and becomes fascinated with its own ability to comprehend the power of the sublime without being destroyed by it. Connoisseurs, curators, and art scholars who find Blake so distasteful would appear to take the first Kantian step and remain there. Those who are immediately, almost instinctively, drawn to Blake's art move on to the second stage. Not all of Blake's art and poetry embodies the sublime or the apocalyptic, but those works that represent either or both have become his most popular – and at the same time his most disliked.

Rosenwald gave his collection, including some 22,000 prints by 250 artists, to the people of the United States in 1943. At his death in 1979, these were divided by prior arrangement between the Library of Congress and the National Gallery of Art. In the intervening years, the collection remained at Rosenwald's Alverthorpe Gallery, a converted Quaker meeting house near his home in the leafy Philadelphia suburb of Jenkintown. He continued to add to the collection, including Blake's tempera painting of *The Last Supper* in 1951. At the auction of Mrs Emerson's collection in 1958, Rosenwald bid on none of the seven illuminated books; he already had copies of equal quality. His Blake collection was rivalled only by the British Museum's.

Rosenwald joined knowledge, connoisseurship, considerable wealth, and the hunting instincts of the born collector. There was a hint of sadness in his voice when, in the early 1970s, he told me that he 'could find nothing more to buy.' He visited his gallery almost every day, eager to

welcome scholars. I was surprised to find, on first visiting Alverthorpe, several ashtrays placed strategically about the gallery. These were for the exclusive use of Mr Rosenwald. One day in the summer of 1973, while measuring some of Blake's commercial book illustrations in the collection, I felt a large but gentle hand on my shoulder. It was Mr Rosenwald, leaning over the prints with a shockingly long ash dangling from his cigarette. I put my hand out, palm up, fearing an accident. He told me not to worry, that I had come a long way to study such mundane engravings, walked away (I trust to visit one of those ashtrays), and returned with his copy of *The Book of Urizen*. 'Have a look at this – something a little better from Blake,' he said.

As Rosenwald's collecting activities were winding down, Paul Mellon's were beginning. Unlike most of his Blake-collecting predecessors and contemporaries, Mellon was principally interested in British art, rather than books, but his strong pictorial instincts led him to illustrated books and hence to Blake. The collection began in 1941 with a copy of *There is No Natural Religion* (a genuine one), followed later in that decade by copies of *Songs of Innocence and of Experience*, *The Book of Thel*, and *Europe*. Mellon bought judiciously at the Emerson sale in 1958, acquiring *Songs of Innocence* and *America*. His greatest treasure, the complete copy of *Jerusalem* hand coloured by Blake, had been secured by private treaty six years earlier. Mellon knew full well the advantage of collecting multiple copies of each illuminated book; by 1972 he had two copies each of *Songs of Innocence and of Experience*, *The Book of Thel*, and *The Book of Urizen*.

Mellon's collection, now at the museum and library he founded, the Yale Center for British Art, extends well beyond the illuminated books to include four tempera paintings, numerous drawings and watercolours, and Blake's 116 watercolour illustrations to Thomas Gray's poetry, the last acquired from the Duke of Hamilton in 1966. Although Mellon lived until 1999, I never had the opportunity to meet him – and thank him for his generosity. In November 1971, Christie's brought to auction two of Blake's nine extant wash drawings for *Tiriel*, his only finished drawings illustrating one of his own poems. I asked the London dealer John Baskett to bid on my behalf on the first *Tiriel* lot and, if outbid, try for the second. At the time I did not know that Baskett was a close associate of Mellon's and had received similar instructions from him. After Baskett told him about the potential conflict, Mellon proposed that we divide and conquer: he would not bid against me on the second lot if I did not bid against him on the first. This was a lion offering to share the

feast with a mouse; he could have easily outbid me on both lots. I leapt at the opportunity and we both gained our prizes. I had to pay over the high estimate, but I should record this acquisition in my collection catalogue as 'Gift of Paul Mellon.'

In the context of this volume, a survey of Blake collecting raises questions about its relationship to scholarship. The ideal is of course mutual interchange, and that has generally been the pattern in Blake studies. W.A. White made his collection available to America's first significant interpreter of Blake's writings, S. Foster Damon. Both Rosenwald and Mellon lent illuminated books to the Trianon Press in Paris for extended periods so that they could be meticulously reproduced in collotype and stencil for the Blake Trust series of facsimiles. Collectors can also be scholars; both W.E. Moss and Graham Robertson pursued their own researches into Blake's printing methods.[17] But it is two remarkable scholar/collectors, Sir Geoffrey Keynes and Professor G.E. Bentley Jr, who best exemplify a symbiotic relationship between these pursuits.

Early in the last century, Keynes began to collect Blake comprehensively – not just the few major works he could afford, but a host of Blake's commercial book engravings, individual pages from the illuminated books, and separate plates, often costing shillings rather than pounds. While American millionaires were gathering up the masterpieces, Keynes would pick up neglected scraps and sketches that helped him assemble a complete picture of Blake's activities as poet and artist. It took a Mellon to acquire the complete coloured copy of *Jerusalem*; Keynes could only afford a rather odd-looking frontispiece to the book with a plate from Blake's *Europe* printed on the verso.[18] This, however, was an unrecorded proof, the only impression that includes all the inscriptions above and on the doorway through which Blake and his readers enter into the depths of the epic poem that follows. Keynes's collection provided part of the material base for his publication of the first comprehensive Blake bibliography (1921), the first complete scholarly edition of Blake's writings (1925), and essays on specific aspects of Blake's life and work gathered into a volume of *Blake Studies* (1949, 1971). At his death in 1982, age ninety-five, Keynes's collection was divided by bequest between Cambridge University Library and the Fitzwilliam Museum, with a few prized works remaining in a family trust.

Visiting Lammas House, Sir Geoffrey's home in the Suffolk village of Brinkley, was a magical experience, like stepping back to an earlier era. Blake's works filled the walls and bookcases in several rooms. The large colour print of *Naomi Entreating Ruth and Orpah* hung over the mantle in

the front drawing room, with two of the *Tiriel* drawings almost hidden in a recess next to the fireplace. From my customary seat at the dining table, I could turn to the right and view Blake's large preliminary drawing for his *Newton* colour print. The entry hall displayed two of Blake's most powerful separate engravings, both states of the *Job*, the first state acquired in 1935 for £10 and the second at the Moss auction in 1937 for £13, and the *Ezekiel*, bought for £19 at the Moss sale. These were joined in 1969 by one of Keynes's last major acquisitions, one of only two recorded impressions of the second state of *Chaucers Canterbury Pilgrims* and the only example completely coloured by Blake and/or his wife. Sir Geoffrey allowed me to rummage through various cabinets and drawers where I would come upon everything from colour-printed plates from *Songs of Experience* to clippings from sales catalogues, the latter no disappointment because of their value in tracking down provenances.

One of Sir Geoffrey's favourite activities, at least with this would-be scholar/collector, was to roam around the house and pluck Blake-related volumes off the shelves. He would ask me if I had the book. If I said 'yes' (accompanied by a sheepish grin), he would ask how much my copy cost, and then tell me the pittance he paid for his (usually superior) copy. If I said 'no' (accompanied by a sigh), he would comment that I should try harder to find a copy if I expected to assemble even a modest Blake collection. Competitive habits were on display by both parties in this thoroughly enjoyable game. My infrequent triumphs, such as owning a book not at Lammas House (for example, Stuart and Revett, *The Antiquities of Athens*, with four engravings by Blake), were tempered by my host telling me that the only reason he didn't have such large folios was because they 'took up too much room.'

Geoffrey Keynes was resolutely not an other worldly, mystically minded, or 'poetical' person. Why was he so interested in Blake? Keynes was a professional surgeon and amateur woodcarver; both activities require a seamless intercourse between mind, eye, and hand as they engage with recalcitrant materials. I suspect that Sir Geoffrey found similarly fruitful alliances between desire and work, in their struggles with the natural world, as a theme in Blake's poetry and as a key component in his creative process as artist, engraver, and printer.

When Keynes was most active, he could acquire some of Blake's finest prints and drawings at modest prices. The situation was very different for Professor G.E. Bentley Jr. Dealers had become all too aware of the value of even single pages from the illuminated books. Blake's

commercial book illustrations, however, were still under appreciated and under collected. When Bentley began his searches for these volumes in the 1950s, I suspect that he discovered what I found still to be true in the 1970s: Book dealers would have volumes on their shelves without knowing that they contained plates engraved by Blake. Shipping charges from Britain to America would sometimes cost more than the books. Bentley was able to build a superb collection of Blake's commercial engravings, including even such rare and important works as *Designs to a Series of Ballads Written by William Hayley* (the first ballad acquired 'in the late 1950s ... for a couple of pounds') and the Virgil wood engravings (acquired in 1968 for £7.10s.).[19] A true bibliographer, Bentley could not resist acquiring multiple copies for comparison. Unlike more fashionable collectors, he cared little for the external condition of the books as long as the contents were intact. Many shabby bindings lined his shelves.

On several occasions in England and Los Angeles, I accompanied Bentley and his wife, Elizabeth, on book-hunting expeditions. Jerry would roam the shelves taking mental notes about likely prey. He rarely ventured to ask the dealer, 'Do you have any Blake?' No need to clue him in. Beth and Jerry would then consult, sometimes even leaving the shop to insure privacy. Beth would then return to open negotiations. Few dealers could resist her mixture of charm and hard bargaining. It was a perfect team effort.

Keynes and Bentley shaped my own attempts to become a scholar/ collector. I learned from them the values of a documentary collection, narrowly focused but comprehensive within that focus. Original materials needed to be accompanied by all the relevant scholarly works, broadly defined. By concentrating on what Blake called 'minute particulars' and placing these within a broader context, discoveries can emerge. Let me offer just one out of several possible examples.

I confess to loving books uncut in original boards. This is precisely the sort of attitude criticized by less materially minded literary scholars as making a fetish of the object. Ignoring such views, in 1976 I acquired a copy in original boards of Charles Allen's *New and Improved Roman History* (1798) with four plates engraved by Blake after designs by his friend Henry Fuseli. In most illustrated books, the plates are placed throughout the volume to face, or at least to be near, the passages illustrated. This copy had all the engravings printed on a single leaf, folded and bound at the front. A continuous platemark ran along the top and bottom margins of the leaf, with no platemarks intervening between

each design. Blake had engraved the images on a single copperplate, thereby allowing them to be inked as a unit and printed economically in one pull through the press. This procedure was used by other engravers of the late eighteenth century, but this copy of Allen's book is the only known direct evidence that Blake executed multiple designs in intaglio on a single plate. Years later, Joseph Viscomi determined that four relief-etched plates in *The Song of Los* (1795) were executed as pairs on two pieces of copper.[20] A technique Blake had learned as a commercial copy engraver became part of his most personal graphic and literary activities. The material objects and their analysis have given us insights into Blake's ways of thinking and working.

Collecting Blake and understanding Blake go hand in hand. The scholar must attend to the object – whether a scribbled document or a finished work of art – preserved by the collector, first *as* an object, then as the record of its production in time, then as a product of its multiple technological, biographical, and social contexts. We can then return to the object with a richer understanding of its meaning and significance. With Blake, the visual and the literary, the chalcographic, the bibliographic, and the textual meet and mingle inseparably.

Coda: A Prophecy

Even in the late 1960s I was told by more than one person in the book and art trade that I was a fool to try to collect Blake, that all the interesting pieces were in institutional collections, that anything good that came to market would be snapped up by millionaires, and so on in a similar vein. I didn't believe it then and I don't believe it now. Collectors adjust their strategies with changes in both scholarship and the marketplace, as Keynes and Bentley have demonstrated. Young scholar/collectors such as Mark Crosby can build productive careers in both areas by concentrating on a single period in Blake's career. Further, treasures keep coming to light. Just in the past few years, nineteen of Blake's watercolours illustrating Robert Blair's *The Grave* re-emerged after being lost since 1836. An unrecorded group of eight colour prints of designs from the illuminated books, each bearing a manuscript legend by Blake, and an unknown early state of the rare *Job* separate plate were brought to London museums by their owners for identification. Two tempera paintings, several drawings, Blake's only lithograph (one of four recorded impressions), an unpublished letter, and hand-coloured leaves from the illuminated books, some with gold highlights,

have come to auction. Important book illustrations, the suites of Job and Dante engravings, and Blake's more mundane (but always interesting) copy prints are frequently available from specialist dealers such as John Windle of San Francisco. The future of Blake collecting is bright, and with it the future of Blake studies.

NOTES

1 Blake's *The French Revolution* was printed in letterpress in 1791, but apparently never published. The unique copy (of page proofs?) is now in the Huntington Library.

2 The foundational study of Butts's patronage is G.E. Bentley, Jr, 'Thomas Butts, White Collar Maecenas,' *PMLA* 71 (1956): 1052–66.

3 For the complexities of the Butts auction of 26 June 1852, see Joseph Viscomi, 'Blake in the Marketplace 1852: Thomas Butts, Jr. and Other Unknown Nineteenth-Century Blake Collectors,' *Blake/An Illustrated Quarterly* 29 (1995): 40–68. The ownership of the Blake lots is uncertain, including a few bought by Butts. He may have been buying-in works he owned or, if he was not their vendor, attempting to support the market for his own goods. The Butts family probably sold many works privately or through dealers from at least the 1850s to the early twentieth century.

4 For charming recollections of the 'Blake Room' at the Butts family home, Salterns, see Mary Butts, *The Crystal Cabinet* (London: Methuen, 1937), 41–2, 151, 163–5.

5 Linnell introduced Blake to Thornton in September 1818. For the circumstantial evidence concerning Linnell's involvement in the Virgil project, see Bentley, *Blake Records*, 2nd ed. (New Haven and London: Yale University Press, 2004), 343, 371–2.

6 For the several accounts of this tragic episode, see ibid., 558–9.

7 For information on acquisitions by Romney and D'Israeli, see Joseph Viscomi, 'The Myth of Commissioned Illuminated Books: George Romney, Isaac D'Israeli, and "ONE HUNDRED AND SIXTY designs … of Blake's,"' *Blake/An Illustrated Quarterly* 23 (1989): 48–74. For Bliss, see Keri Davies, 'Mrs Bliss: A Blake Collector of 1794,' in *Blake in the Nineties*, ed. Steve Clark and David Worrall (Basingstoke: Macmillan, 1999), 212–30.

8 The contents of these and many other nineteenth-century collections are often known only from their sale at auction. The Macgeorge collection was not sold until 1924.

9 Robertson's manuscript catalogue, now in my collection, was published as

The Blake Collection of W. Graham Robertson, ed. Kerrison Preston (London: Faber and Faber for The William Blake Trust, 1952).

10 The lead executor, Kerrison Preston, offers a brief explanation of the estate's arrangements in 'The Blake Collection of W. Graham Robertson,' in *William Blake: Poet, Printer, Prophet*, catalogue of the exhibition, Whitworth Art Gallery, 14 May–21 June 1969, p. 32.

11 See *The Blake Collection of Mrs. Landon K. Thorne*, catalogue by Bentley, introduction by Charles Ryskamp (New York: Pierpont Morgan Library, 1971).

12 For convincing evidence concerning the facsimiles, see Joseph Viscomi, *Blake and the Idea of the Book* (Princeton: Princeton University Press, 1993), 198–217.

13 Payments to Rosenbach are based on his receipts in the Huntington archives; see Robert N. Essick, *The Works of William Blake in the Huntington Collections* (San Marino, California: Huntington Library, 1985), 4, 24, 58.

14 For information on Rosenwald as a collector, see Lessing J. Rosenwald, *Recollections of a Collector* (Jenkintown, Pennsylvania: Rosenwald, 1976); Ruth E. Fine, *Lessing J. Rosenwald: Tribute to a Collector* (Washington, DC: National Gallery of Art, 1982); and *Vision of a Collector: The Lessing J. Rosenwald Collection in the Library of Congress*, ed. Larry E. Sullivan (Washington, DC: Library of Congress, 1991).

15 The expenditures at the Moss and Smith sales include Rosenbach's 10 per cent commission as Rosenwald's agent. This discussion of Rosenwald's Blake acquisitions is based on copies of invoices and other records in the Rosenbach Museum and a thirty-five-page typescript description of the Linnell materials sent by Philip Robinson to Rosenwald, or his curator Elizabeth Mongan, in 1937 and now in my collection.

16 See *Kant's Critique of Aesthetic Judgement*, trans. James Creed Meredith (Oxford: Clarendon, 1911), bk. 2, sec. 25–6. For modern studies pertinent to the sublime in Blake's works, see Thomas Weiskel, *The Romantic Sublime: Studies in the Structure and Psychology of Transcendence* (Baltimore: Johns Hopkins University Press, 1976); Morton D. Paley, *The Apocalyptic Sublime* (New Haven and London: Yale University Press, 1986); Vincent Arthur De Luca, *Words of Eternity: Blake and the Poetics of the Sublime* (Princeton: Princeton University Press, 1991); and Essick, 'Representation, Anxiety, and the Bibliographic Sublime,' *Huntington Library Quarterly* 59, no. 4 (n.d. [1998]): 503–28.

17 In a letter of 22 October 1919, White told Damon that 'I shall be glad to show you my Blakes.' Evidently White invited Damon to give a lecture, for he thanked Damon in a letter of 9 December 1919 and included a cheque

to cover his 'expenses.' Both letters and examples of Robertson's experiments with Blake's method of planographic colour printing are now in my collection. Robertson also edited Alexander Gilchrist's *Life of William Blake* and added an essay on Blake's colour-printing techniques; see Gilchrist, *The Life of William Blake*, ed. Robertson (London and New York: John Lane, 1907). For Moss's investigations and his correspondence with the scholar Ruthven Todd, see Bentley, 'Ruthven Todd's Blake Papers at Leeds,' *Blake/ An Illustrated Quarterly* 16 (1982): 72–81; and Mei-Ying Sung, *William Blake and the Art of Engraving* (London: Pickering & Chatto, 2009), 26–31. Moss also wrote the first census of coloured copies of Blake's *Night Thoughts* engravings, posthumously published in *Blake Newsletter* 2 (15 September 1968): 19–23.

18 Acquired at a London auction in 1942. For a list of all but a few of his Blake holdings, see Keynes, *Bibliotheca Bibliographici* (London: Trianon, 1964), 50–81. For his fine autobiography, very much the man in tenor and tone, see Keynes, *The Gates of Memory* (Oxford: Clarendon, 1981).

19 Bentley, *GEB Books*, typescript catalogue compiled 2000–5 (quotation from the introduction, p. vii). A copy is in my collection. Bentley gave his Blake collection to Victoria University Library, University of Toronto, Toronto, in 2005; see *William Blake and His Contemporaries: An Exhibition Selected from the Bentley Collection at Victoria University*, 30 October–15 December 2006, catalogue and introduction by Robert C. Brandeis.

20 Viscomi, 'Blake's "Annus Mirabilis": The Productions of 1795,' *Blake/An Illustrated Quarterly* 41 (2007): 52–83.

2 Two Fake Blakes Revisited; One Dew-Smith Revealed

JOSEPH VISCOMI

> Let the collector of prints be cautioned … to beware of buying copies for originals. Most of the works of the capital masters have been copied, and many of them so well, that if a person be not versed in prints, he may easily be deceived.
>
> William Gilpin, *An Essay on Prints*, 4th ed., 1792

An undetected forgery is an original. I recall realizing so in 1975, not in any ontological or philosophical sense, but in the most practical circumstances. I was a curatorial assistant at the Museum of the City of New York working on an exhibition of nineteenth-century paper toys, from pull-tab books to optical and pre-cinematic devices, like zoetrope strips and phenakistoscope discs, to toy theatres, 'pantins' (jumping jacks), and constructions. Constructions were printed on large sheets, first as etchings and later as chromolithographs, and their many parts had to be cut out, like paper dolls, and assembled. Constructed, such toys are fragile and extremely rare; uncut sheets are collector items and the museum had a fine collection of them. Of course, cutting the sheets to assemble the artefact – a harlequin, a proscenium theatre, a backdrop – was out of the question. But displaying them as mere two-dimensional prints left too much to the imagination. Displaying the paper models in front of their uncut sheet was the ideal, but this required making the construction look authentic in every way, to form a one-to-one relation between its parts in three dimensions and its parts in two dimensions. In building the models I was engaged in the process of making facsimiles; in aging them so they appeared contemporaneous with their sheets and showing them without acknowledging that they were facsimiles,

I was engaged in the act of making forgeries. An unacknowledged fac-
simile is a forgery, and, as noted, an undetected forgery is perceived
and experienced as an original. For viewers of the exhibition the fakes
retained the original's 'aura,' that historical authenticity that reproduc-
tions are not supposed to have or convey or capture, so Benjamin tells
us.[1] Believing a fake is the real thing ensures that it is experienced as
such by the believer. Just ask Blake about Chatterton and Ossian.[2]

This early experience in making facsimiles and doctoring them into
forgeries served me well when, in 1976, at Columbia University, I began
studying Blake's illuminated books, which led to the Pierpont Morgan
Library where I soon put practice into theory – or at least into a work-
ing hypothesis. I discovered that plates 4 and 9 in *America a Prophecy*
copy B were fakes.[3] Actually, my hand made the discovery in turning
the pages, which were noticeably different from the other leaves in the
book, five of which were watermarked '1794/WHATMAN.' At first,
with plate 4, I did not think much of this difference, thinking that may-
be the leaf was 'E & P' or 'I TAYLOR,' other wove papers Blake used
around this time. But coming upon a second leaf of the same paper, for
plate 9, made me pause and check *The Marriage of Heaven and Hell* copy
F and *Europe a Prophecy* copy G, both in the Morgan, for their E & P and
I Taylor papers respectively. No match. *America* plates 4 and 9 (figs. 2.1
and 2.2) were printed in black ink and touched up in an opaquish black
wash, like the other impressions, but they were printed on thicker and
stiffer paper, which, unlike the other leaves in *America* copy B, showed
no bleed-throughs. The paper's feel, weight, and texture called to mind
an etching paper I had recently used to print some aquatints. In short,
the paper, not the image, made me suspicious enough to measure the
plates.[4]

As in most copies of *America*, the last five lines of plate 4 have been
masked out, that is, covered with (probably) a strip of paper so the
inked or uninked lines could not transfer to or emboss the printed leaf.
Unlike all other copies, however, the bottom platemark is only 2.4 cen-
timetres from Orc's foot, instead of the usual 4.1 centimetres. If this
bottom platemark was caused by the material used to mask out the five
lines, then, because a 2.4 centimetre mask is not wide enough to cover
the five lines, the bottom half of line 3 and all of lines 4 and 5 would have
printed. If the bottom platemark was caused by the copperplate itself,
then the plate had been cut in about the middle of the third line and
printed with a mask to cover the two lines under Orc's foot. Although
all posthumous pulls of this plate, in copies N, P, and Q, print the last

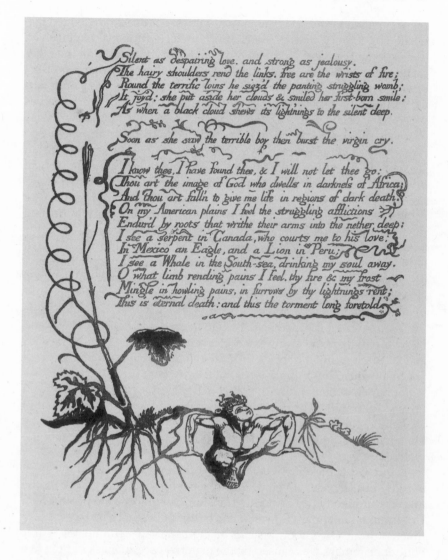

2.1. *America a Prophecy*, copy B, plate 4. Used with permission. Morgan
Library and Museum, NYC, PML 63938

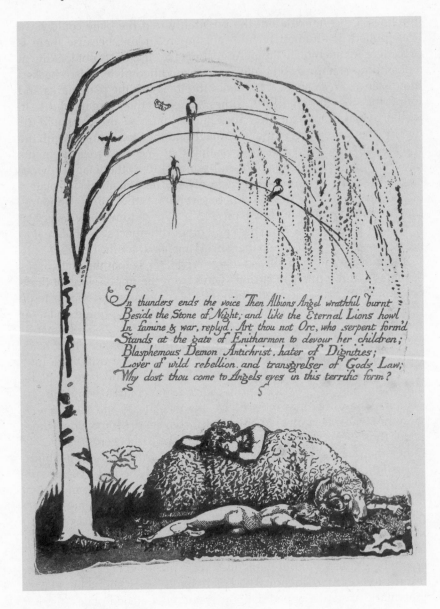

In thunders ends the voice Then Albions Angel wrathful burnt
Beside the Stone of Night; and like the Eternal Lions howl
In famine & war, replyd. Art thou not Orc, who .serpent form'd
Stands at the gate of Enitharmon to devour her children;
Blasphemous Demon Antichrist, hater of Dignities;
Lover of wild rebellion. and transgresser of Gods Law;
Why dost thou come to Angels eyes in this terrific form?

2.2 *America a Prophecy*, copy B, plate 9. Used with permission. Morgan Library and Museum, NYC, PML 63938

five lines, I did not rule out the possibility that the plate could have been pulled posthumously from a tampered plate, because there is precedent for such plate tampering.[5] To make sure I was not looking at a posthumous impression pulled from a modified plate, I also checked the distances from specific points in the image to the platemarks and found that they differed from copies A, also in the Morgan, and L, in the Berg Collection at the New York Public Library. I also measured the distance between parts within the image and they too differed, with the B plates slightly larger.[6] More revealing than incorrect measurements between image and platemarks and points within the image, however, are the plate measurements themselves. The platemarks of plate 4 of copy B are 22.9 × 16.9 centimetres versus 23.8 × 16.6 centimetres (*BB* 70), and of plate 9 of copy B are 24.9 × 17.5 centimetres versus 23.5 × 16.8 centimetres (*BB* 70). These and other differences are too great to have been the result of one paper shrinking less than the others.[7]

But most revealing of all, as I discovered later, is that the platemarks of plates 4 and 9 differ in curious ways from the impressions of these plates in Robert Essick's collection. His two impressions appear to be proofs for the *America* copy B impressions; they were printed on larger sheets (40.3 × 28.5 centimetres for plate 4, and 44.5 × 28.5 centimetres for plate 9, vs. 36.3 × 26.1 centimetres), on different paper ('thin, hard, ivory coloured, machine made' he tells me), and in a dull black ink.[8] They share with the Morgan impressions the top and bottom platemarks, but neither of Essick's prints has *side* platemarks, while the side platemarks are the ones most noticeable in plates 4 and 9 of copy B, with the right side in plate 4 being slightly bevelled. Moreover, on those plates the side and top platemarks forming the corners cross each other rather than terminating at their intersection, a physical impossibility. This slight crossing of plate lines in copy B and the fact that the side platemarks are heavier while absent in Essick's two prints mean that the side platemarks in plates 4 and 9 of copy B are faked, most likely produced with a stylus indenting the paper along a bevelled ruler and inadvertently crossing the top and bottom platemarks. The top and bottom platemarks were also deliberately made, since planographic images can be printed without them; they were included because the other impressions in *America* copy B had platemarks, albeit slight. But Blake's platemarks were the wiped flat borders of relief-etched plates (fig. 2.3) and not the sharp edge or side of the plate as seen in etchings.

Except for the platemarks, plates 4 and 9 are free of the embossment – the slight indent of the letter forms – that is characteristic of type,

2.3 *America a Prophecy*, copy B, plate 16, embossment of bottom right plate border into paper, detail. Photograph by Mark Crosby. Used with permission. Morgan Library and Museum, NYC, PML 63938

relief-etched texts and designs, and line blocks. Instead, the ink lies flat and unreticulated on the paper, which is characteristic of lithography. Although the overall dimensions are slightly distorted, or elongated, the images are exactly right, indicating the work of a camera. The plates appear certainly to be photolithographs pulled from zinc plates. The top and bottom platemarks were probably created by the scraper bar of the litho press coming deliberately onto and off the zinc plates. The side platemarks in the copy B impressions were probably added with a stylus. However created, the platemarks were made to deceive, to make a flat image appear slightly embossed like a relief etching. The intention to deceive appears to make plates 4 and 9 forgeries, not facsimiles. Printed with platemarks in good solid black ink (and not the thinner greyish black of tonal lithography) and touched up in black watercolour (like the other prints in copy B, though less opaquely), it is little wonder they escaped detection for so long.

Once doubts were raised, however, identifying the *what* of the impressions was relatively straightforward, as was speculating on *why* the fakes were executed, presumably to complete an otherwise incomplete copy of *America*. Nor was identifying their probable model difficult. Because an image on stone or zinc could be altered in subtle ways, absolute verification may not be possible, but plates 4 and 9 of *America*

copy F, in the British Museum since 1859, were most likely the prints photographed by or for the forger. *When* and *by whom*, however, were and remain far more difficult questions.

America copy B sold in 1878 with the library of A.G. Dew-Smith at Sotheby's for £16.5 (lot 247) to the book dealer John Pearson. Its description in the Sotheby catalogue needs to be given in full:

> BLAKE (W.) AMERICA, A PROPHECY. *Engraved throughout by this extraordinary artist.* EXCESSIVELY RARE, *presentation copy with author's autograph inscription, splendidly bound in citron morocco, ornamented with variegated leathers and gold tooling, g[ilt]. e[dges]., by F. Bedford; two leaves said to be wanting, but Blake's original prospectus says* – 'America, a Prophecy in illuminated printing,' folio, with 18 designs, Lambeth, W. Blake, 1793
>
> *** This copy, unbound, sold for £18 in 1874.[9]

This catalogue description is the only evidence of an 1874 sale, and it is evidence that the copy when sold had eighteen plates. In my first report, I commented on the possible ambiguity of the word 'design,' for in the prospectus Blake used it to mean picture, not page or plate, describing *The Marriage of Heaven and Hell* as being 'with 14 designs' (counting top and bottom illustrations on one plate – probably plate 3 – as separate designs), and not twenty-seven plates, and the *Visions of the Daughters of Albion* as being 'with 8 designs,' not eleven plates or pages. But, as will become clear below, the Sotheby cataloguer counted pages, including plates 4 and 9. Concluding an end date of 1878 for the fakes would seem reasonable, but plates 4 and 9 are not sewn into the binding along with the other pages; they are tipped in, glued to plates 5 and 10. Moreover, plates 4 and 9 are slightly lower than the rest of the pages (noticeable only when looking along the fore-edge) and their edges are not gilt. The fakes clearly entered copy B *after* the binding described in the 1878 Sotheby's catalogue (which is still on the book), forcing these questions: were the fakes present when copy B sold in 1878? Or were genuine plates part of that '18 designs' only to be removed later? In my first report, I argued that they were in the book when it sold in 1878; Lange arrived independently at the same conclusion.[10] I will reargue in this essay for the same conclusion, using new and stronger evidence.

But first, I need to examine G.E. Bentley Jr's reading of the bibliographical evidence. In *Blake Books Supplement*, he agrees that plates 4 and 9 are fakes, but he thinks they were inserted *after* 1878 (54). As noted, Pearson acquired *America* copy B at the Sotheby sale; it appears

next in Thomas Gaisford's collection, sold at Sotheby's in 1890 to Quaritch, then in B.B. Macgeorge's collection, selling at Sotheby's in 1924 to Maggs, then in George C. Smith's collection, selling at Parke-Bernet in 1938 to Rosenbach, then in the collection of Mrs Landon K. Thorne, who gave it to the Morgan Library in 1973 (*BB* 100).[11] In placing the fakes in *America* copy B after 1878, Bentley raises important issues about *America* copy B that I failed seriously to consider: were there initially eighteen genuine designs and were two of them cleanly extracted sometime between 1878 and 1973 and replaced by fakes?

Bentley comments perspicaciously about the persuasiveness of plates 4 and 9, which he refers to as photolithographic 'facsimiles': 'These facsimile plates were sufficiently persuasive to satisfy the credulity of, *inter alia*, Keynes (*A Bibliography of William Blake* [1921]), Keynes & Wolf (*William Blake's Illuminated Books*: A Census [1953]), and Bentley (*Blake Books* [1979]), and they evidently persuaded as well the cataloguers of Sotheby, Quaritch (who described it as "perfect" in 1890), and Parke Bernet. Consequently, the description of copy B as having 18 plates (or designs) does not indicate clearly whether pl. 4 and 9 there were Blake's originals or facsimiles.' Indeed, the involvement of so many experts supports the idea that some of them might have seen originals and not been fooled at all. This jury of expert bibliographers and the fact that the fake plates 4 and 9 were *tipped in*, 'narrower than the others,' and 'not gilt like the genuine leaves,' leads Bentley to speculate that 'some time after 1878, the two genuine pl. 4 and 9 were removed, perhaps because of damage, and replaced with the facsimile leaves on shorter, narrower, stiffer paper with false plate marks, which were pasted to pl. 5 and 10 to perfect the copy.'[12]

As I noted in my first report, three of the post-1878 owners of *America* copy B had access to facsimilists and to models and had reason enough to 'perfect' an incomplete copy. Pearson published in 1877 the excellent photolithographic facsimile of *Jerusalem* copy D and was William Muir's first agent, issuing four of Muir's Blake facsimiles in 1884–85. Bernard Quaritch, who owned *America* copy B in 1890, was Muir's agent in 1885–94 and published *Facsimiles of Choice Examples selected from Illuminated Manuscripts* (London, 1890), which included William Griggs's eight coloured lithographs of Blake's *Comus* designs (*BB* 505). Griggs also executed photolithographic facsimiles of Blake's *Poetical Sketches* (1890) and *The Book of Ahania* (1892). Quaritch also owned *America* copy R, which he lent Muir for his 1887 facsimile. The collector Bernard Macgeorge, of Glasgow, owned the copy from 1892 to 1924 and also knew

Muir; Macgeorge lent Muir *Europe* copy A, which was then missing five plates, and which were 'all supplied in facsimile by Muir.'[13] Macgeorge also owned *Songs of Innocence and of Experience* copy A, which entered the British Museum in 1927 with photolithographs of plates 51, 52, 53, and b. Apparently, more than one collector 'perfected' an incomplete illuminated book with photolithographic facsimiles.

That originals might have been extracted and replaced after 1878 is certainly feasible. Bentley supports this scenario by pointing to a possible early description of copy B as having eighteen designs, and to its plate numbers. He states that copy B 'was presumably complete (pl. 1–18, e) when it passed from Blake to [C.H.] Tatham in 1799, and all subsequent descriptions of it which mention its extent say that it has 18 plates or designs' (*BBS* 54).[14] Bentley suggests that copy B may have been 'the copy "with Eighteen singular Designs, *printed in tints by the artist himself*" sold anonymously at Sotheby's on 5 July 1852 with the remainder of the Library of Edward Vernon Utterson, Lot 251 [for £2.7.0]' (*BBS* 54). Utterson's copy of *America* appears certainly to have been the copy W.T. Lowndes had in mind, when he described it as: '*America*, a Prophecy, 18 designs, Folio, Lambeth, 1793, Sotheby's, 1855, £2.7.'[15] Lowndes got the date of the auction wrong but the vendor and price right. But was Utterson's copy really copy B? If so, then it had eighteen designs before the invention of photolithography and Bentley is right to assume that copy B left Blake complete and that two genuine plates were removed (and are now untraced). But as Bentley also notes, in *Blake Books*, 'the copy [Lowndes] referred to could alternatively be copies C, E, I, or L' (100n3). In fact, it was almost certainly copy R, which, resurfaced in 1987, fits the description of 'printed in tints' better than all other copies, and has no known provenance before 1880. Bentley describes it as being printed in blue, pale blue, bluish black, and green (*BBS* 52, 53n3). A possible early sighting of copy B is the Puttick and Simpson auction of 25 May 1854, Lot 95, though there is no mention of number of designs (*BBS* 55). The first known description of copy B as having eighteen plates, then, is the 1878 Sotheby's catalogue, which by itself cannot answer the question of whether all the plates were genuine.

Bentley's hypothesis that copy B once had eighteen genuine plates is also predicated on the first of two sets of plate numbers. The first set is 2–16, written just below the platemark on the left-hand side (fig. 2.4). At least nine of these numbers were erased and remade by the same hand, as is evinced by the erased 5 and redrawn 5, and erased 7

2.4 *America a Prophecy*, copy B, numbers from set 1: '4' and '14' on plates 5 and 16, placed just below the left corner of the plates. Used with permission. Morgan Library and Museum, NYC, PML 63938

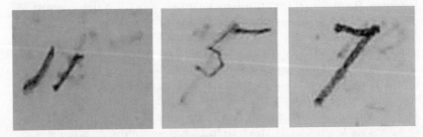

2.5 *America a Prophecy*, copy B, numbers from set 1: '11' over an erased '5'; '5' shaped the same as erased '5,' over erased '7'; '7' over erased mark, same shape as erased '7.' Numbers computer enhanced. Used with permission. Morgan Library and Museum, NYC, PML 63938

and the redrawn 7 (fig. 2.5). The second set is 1–18, written at the top right corner of the leaf (fig. 2.6). Both sets are in pencil; the first set counts but does not number plate1, the second set numbers all eighteen plates; the two sets are in different hands. The second set is almost certainly by 'J.T.', an assistant to Quaritch, who bought the book at Thomas Gaisford's Sotheby sale of 24 April 1890.[16] The first set is not by C.H. Tatham, the first owner of copy B.[17] Neither is it by Dew-Smith, who owned *America* copy B when it sold in 1878, as is confirmed by my comparison of his numbers as formed in letters to Charles Darwin and the numbers of the first set.[18] Neither set of numbers is recorded

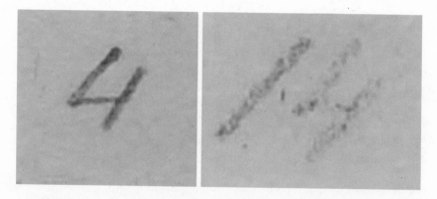

2.6 *America a Prophecy,* copy B, numbers from set 2: '4' and '14' on plates 4 and 14, placed top right corner of leaves. Used with permission. Morgan Library and Museum, NYC, PML 63938

in *Blake Books,* since neither is by Blake (88). In *Blake Books Supplement,* however, Bentley states that the first set of numbers, 2–16, are 'Blake's page-numbers' and that they start on plate 3 (54n23), which would make sense, since this is exactly how copy A, which was printed with copy B, was numbered, as was copy M, and they are the only copies of *America* paginated other than the last copy printed (1821), copy O, which is paginated 1–18. Bentley believes the numbers in copy B are '1, 3–6, 8–16 on pl[ates] 3, 5–8, 10–18,' which 'imply' eighteen genuine plates. The problem here is that the numbering starts with plate 1, not plate 3, and is sequential and without gaps. Plate 1 is counted but not numbered; plate 2 is numbered '2' and plate 3 is '3' and plate 5 is '4,' plate 6 is '5,' plate 7 is '6,' plate 8 is '7,' plate 10 is '8,' plate 11 is '9,' and so on to '16.' Most important, the pattern of erasures among the first set of numbers does not reveal the extraction of plates 4 and 9; instead of a new '5' over an erased or altered '6,' we see a '5' over a '7,' a '7' over a '10,' a '6' over a '3,' an '11' over a '5' (fig. 2.7), and other numbers over no erasure at all. Hence, *America* copy B once existed with only sixteen plates, which was not its condition when sold in 1878 with eighteen designs. Plates 4 and 9 are included in the 1–18 sequence but not in the 2–16 sequence. The person who first numbered the plates had only sixteen plates to number; moreover, this person is almost certainly not Blake, who formed his numbers differently (for example, Blake's '4' is closed and not open, as is the '4' [on plate 5] and '14' [on plate 16], fig. 2.4), and who, to my knowledge, never numbered pages under the lower left corner of the image or in pencil.

2.7 *America a Prophecy*, copy B, numbers and erasures in set 1. Numbers computer enhanced. Used with permission. Morgan Library and Museum, NYC, PML 63938

Although there once being eighteen *unnumbered* leaves can not be ruled out, clearly, when the leaves were first numbered, there were only sixteen to number and plates 4 and 9 were already missing. Who numbered them and when are not known, though we do know it was not Dew-Smith and must have occurred before or by 1874, when he acquired the book. Nor do we really know *how* it was numbered. As Bentley notes, the copy B impressions were stabbed together through two holes (*BB* 100), no doubt by Blake or Mrs Blake, who regularly tied the leaves together with string through stab holes knowing that the buyer would have them professionally bound.[19] The fact that most of the numbers in the first set are over erased numbers suggests their order was unknown to their owner, which in turn indicates that the stabbing was undone and the leaves were loose, or 'unbound,' as noted in the Sotheby catalogue. As figure 2.7 shows, numbers 3, 4, 5, 6, 7, 10, 11, and possibly 13, and 15 are over erasures, and numbers 6 and 8 are very light. The first order *might* have been: 1, 2, 6, 3? 11, 4, 5, 8, 9, 7, 10, 12, 13, 14, 15, 16. But whatever the order, the *attempt to order* the plates is revealing. The mixture of erased and unerased numbers, light and dark numbers, reveal an unsure hand – which in turn reveals just how strange a book *America* must have appeared to anyone seeing it for the first time. There are no catchwords or, like *Visions* and *Thel*, etched numbers; no transcriptions or reproductions of *America* were available to consult until after January 1878, when *Works by William Blake* was published (*BBS* 169).[20] In short, arranging loose pages of *America* in the proper order is not self-evident. Reading the text would solve

nothing, particularly if the owner shared Crabb Robinson's view that it was 'Sheer Madness' (*BB* 101n2). Nor would it be clear in an unnumbered and unbound set of impressions that two plates were missing. To know that, you would have to know either another copy of *America* to compare your own to, or Lownde's description from 1857 that there should be eighteen designs, or Gilchrist's transcription of Blake's prospectus, which states eighteen designs. To know *which* designs were missing would require actual examination and comparison of original copies. But then, so would correctly paginating the plates. Apparently, this unknown owner who numbered the plates '2–16' consulted another copy of *America* to get his copy in the proper plate order, but appears not to have been bothered by the two missing plates and made no attempt to complete or 'perfect' the copy.

In my initial report I focused exclusively on exposing the plates as fakes and failed to ask the important questions raised by Bentley regarding the condition of copy B *before* their insertion. Bentley forces us to ask: Did Blake 'cast into the expanse' a copy of *America* with only sixteen impressions? Is this something he would do? We know that he let another illuminated book, *Urizen*, out of the studio with various plates missing in different copies, including plate 4, the only plate in which Urizen actually speaks, present in only three of eight copies extant. Bentley's earliest provenance of *America* copy B provides a clue to the possible initial condition of the book: 'Tatham's acquisition of *America* in 1799 may be connected with the fact that "Mr. William Blake" subscribed to Tatham's *Etchings, Representing the Best Examples of Ancient Ornamental Architecture* (1799–1800)' (*BB* 100n1). I suspect that this is exactly right and that Blake gathered the impressions that were to make up copy B as a gift copy. These impressions were all second pulls from the 1795 printing of copy A and assembled four years later.[21] It is conceivable, particularly with the precedent of copies of *Urizen* in 1794, that Blake stabbed sixteen impressions and not eighteen, finding the second pulls of plates 4 and 9 damaged in some way or missing for some reason. It is interesting to note, in this context, that the frontispiece is damaged, having been folded in half, creating a visible crease across the middle of the leaf. If, however, plates 4 and 9 were present when the other plates were stabbed, then they were extracted before the leaves were numbered and thus before 1874, when they were acquired by Dew-Smith unbound but, as noted, already numbered. And if extracted, then we will recognize them immediately should they turn up, because, as second pulls of copy A, plate 4 will have its five lines under Orc and plate 9 will have its bottom plate border printed to form

2.8 *America a Prophecy*, copy B, description of book on front flyleaf. Used with permission. Morgan Library and Museum, NYC, PML 63938

a stream under the ram and sleeping figures. They will be only the third such impressions with these design elements.[22]

While no internal evidence exists to prove or disprove the presumption that *America* copy B was complete when given to Tatham, bibliographical evidence indicates that two different people numbered the impressions and that each person had a different number of impressions to paginate; the first person had only sixteen impressions and the second had eighteen. As noted, that second person was Quaritch's assistant in 1890. Initially, I thought the person who paginated 1–18 might have been the person responsible for a much smudged pencilled description of the copy on its first flyleaf (fig. 2.8):

> Lowndes gives 18 designs.
>> There are 2 more in some copies
>> but I believe these to be a supplementary number
>> & that the book as published had only 18–

I thought this because of the similarity of the top loop in the '8' of the second '18' to the 8s used in the numbering (fig. 2.9), but upon closer inspection made possible only through digital imaging and enhancement, I came to see that they are not by the same hand. Both styles of 8 have unclosed top loops, but the 8 in the description is formed by slanting down to the right from the top and then down in a curve or hook, rather than slanting up to the right and then straight down, as in the page numbers. Moreover, it makes no sense for Quaritch's collator to describe copy B in such a manner, so unlike the three terse, business-like lines: description/date/source, a style so very different from the voice in the four allusive, inquisitive, and assertive lines in which a person speaks in the first person ('but I believe …'), an authoritative voice

2.9 *America a Prophecy*, copy B, number '8' in description (top) and in set 2 (bottom). Numbers computer enhanced. Used with permission. Morgan Library and Museum, NYC, PML 63938

characteristic of a collector and not a collator, especially a collator who has already spoken and kept his lines to the point and as unobtrusive as possible.

Nor is the description in the hand responsible for the first set of numbers. One expects logically for it to be the hand of its owner at the time of the sale, Dew-Smith. A comparison of the description's letter forms and numbers with those in Dew-Smith's letters to Charles Darwin confirm the expectation.[23] The description, then, was in place before the 1878 Sotheby sale, and its 'There are 2 more in some copies' is what the Sotheby cataloguer is alluding to when commenting that 'two leaves said to be wanting.' The idea that some copies of *America* had '2 more' designs is almost certainly a reference to Gilchrist's description of *America* as 'a folio of 20 pages,'[24] itself presumably derived from Richard

Thomas's description of *America* in J.T. Smith's *Nollekens and His Times* as having '18 plates, or twenty pages, including the frontispiece and titlepage.'[25] No copy is known to have 20 plates. But Gilchrist also transcribed Blake's prospectus, the prospectus's *only source*, which states that *America* has '18 designs,' which is to say, 'that the book as published had only 18 [designs].' The Sotheby cataloguer knew Gilchrist, as did Dew-Smith, whose explicit and implicit references to Lowndes's *The Bibliographer's Manual of English Literature* and Gilchrist's conflicting descriptions reveal a bibliophile who also knows Blake's works.

America copy B sold unbound in 1874; it was bound when it sold with Dew-Smith's library in 1878, and it had eighteen designs, but its plates 4 and 9 were tipped in. This means that only the sixteen numbered plates were bound and that the person who first numbered the plates 2–16 did not acquire the fakes after numbering but before selling the copy in 1874. This person could not have been responsible for the fakes. And it means that if two genuine plates 4 and 9 were extracted, then it had to have been before the plates were numbered and could not have been after the plates were bound and thus not after 1878, when eighteen plates were present. The fakes appear certainly to have entered *America* copy B between 1874 and 1878, when in the possession of Dew-Smith.

I Mr Albert George Dew-Smith, Esq.

The active votary of any harmless object is better than the passive critic of all, and the dullest man who lives only to collect shells or coins is worthier than the shrewdest who lives only to laugh at him.

Dr James Martineau, 'Hours of Thought,' quoted in *The Academy*, 9 February 1878

In 1982, when I wrote up my first report on *America* copy B, I knew nothing about Dew-Smith except that he was 'of Cambridge,'[26] that he owned a few other Blake works, that part of his library sold at Sotheby's, 29 January 1878, and that a smaller part – including his copy of Gilchrist's *Life of Blake* (1863) – sold at Sotheby's 27–30 June 1906 (*BB* 100, 417, 696, 644n2). He was not mentioned in the *Dictionary of National Biography*. I stated: 'Knowing nothing of the man, I cannot ascertain his handwriting or his integrity' ('Facsimile' 223n18). Since then, I have learned much. The availability of new digital databases and search engines have radically altered our scholarly horizons and deepened our research capabilities. They, along with digital imaging, have made

this essay possible and have revealed that Dew-Smith was an excellent photographer, lithographer, and facsimilist.

Bedford appears to have been one of Dew-Smith's favourite binders (he had thirty-nine other volumes bound by him in the 1878 sale), which means Dew-Smith was indeed the person who acquired Blake's *America* unbound in 1874, had it bound, only to discover afterwards that plates 4 and 9 were missing – and that *only* these two and not four plates were missing, which indicates that he examined another copy of *America*, two of which, copies H and F, were in the British Museum by that time. He probably made the photographs of *America* copy F himself, masking out the British Museum stamp on the front of the images in the development of the photograph or had it masked out in its transference to the photosensitized zinc plates, oversaw the production of the photolithographs, inserted them or had them inserted, marked both leaves in their upper right corner, now under the numbers '4' and '9,' with a symbol that resembles a European 7 (fig. 2.10) but is actually a style of cursive 'F.' Dew-Smith used this style of F, as is evinced in his letters to Darwin, for example, when referring to F[rancis] M[aitland] B[alfour] and Feb[ruary] (fig. 2.11). After inserting plates 4 and 9, marking each with an 'F,' no doubt for 'facsimile,' he described his copy in such a way to imply that it was, as Quaritch's 'J.T.' was later to attest explicitly, 'perfect,' meaning only that it was complete, missing no plates. The plates were made to complete his copy of the book and not for financial gain, and the meaning of his 'F' appears never to have registered on anyone till 1978, when the fakes were discovered.[27] His description of copy B may be a bit disingenuous, but my calling the plates fakes because they, with faked platemarks and black washes matching Blake's own, successfully deceived us for one hundred years, implies an intention to deceive that appears, upon revisiting the evidence, absent. Bentley's 'excellent photolithographic facsimiles' is the proper and just description.

Dew-Smith was born 27 October 1848 in Salisbury, son of Charles Dew; he died 17 March 1903, at Hurlingham Court, Fulham. He was educated at Harrow, admitted to Trinity College, Cambridge University in November 1868, matriculated Michaelmas 1869; passing third class in the Natural Sciences Tripos of 1872; BA 1873, MA 1876. He assumed the additional name of Smith on succeeding to some property, 21 July 1870, but was known to his friends as 'Dew.' He was independently wealthy, a collector of books, prints, and jewels, and a noted amateur photographer – by which is meant, as we will see, that he took por-

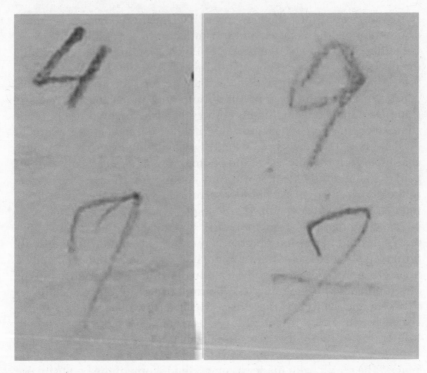

2.10 *America a Prophecy,* copy B, backward 'F' on plates 4 and 9. Used with permission. Morgan Library and Museum, NYC, PML 63938

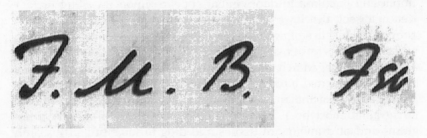

2.11 A.G. Dew-Smith's capital 'F' in letter to Charles Darwin, in initials of F.M.B, and in 'Feb.' DAR162:176. Letters computer enhanced. Reproduced by kind permission of the Syndics of Cambridge University Library

trait photographs for pleasure, not money, for their quality is extraordinary. He was also a student, friend, and benefactor of Michael Foster, the father of the Cambridge School of Physiology, and was a founding member, along with Foster and Thomas Huxley, in 1876, of the Physiology Society.[28]

By 1873, Dew-Smith had 'published a note on an insoluble ferment in *Penicillium* and a brief article proposing a new method for the electrical stimulation of nerves.'[29] In the winter of 1873–4 he went with Francis M. Balfour to 'the newly established Stazione Zoologica at Naples. The charms of Italy at once laid hold of him, and in succeeding years he paid frequent visits to that country, not so much for the purpose of continuing his researches as of enjoying the many varied pleasures which Italy alone can give.'[30] At Foster's suggestion, he conducted electrophysiological experiments on mollusk hearts. Upon returning to Cambridge, he and Foster 'collaborated on two major papers dealing with the effects of electrical currents on the hearts of mollusks (1875) and of frogs (1876).'[31] This work proved 'immensely influential in the early development of physiology at Cambridge' and in Foster's directing 'all of his energies as well as those of his students toward a solution' to the vexing problem of the 'heartbeat and its origin.'[32]

Dew-Smith abandoned his career in scientific research in 1876, but, according to Foster, who wrote a moving obituary notice in *The Cambridge Review*, 30 April 1903, 'he continued to devote himself to the interests of the physiological school, which was then rapidly developing,' and 'took a special interest in apparatus' (261). He set up 'a workshop expressly to turn out anything required in scientific laboratories as quickly as possible'[33] and 'was reputed to be unrivalled even by the best Germans' in the 'grinding and polishing of lenses at the Cambridge Observatory and of laboratory microscopes.'[34] Given the dire 'need for well-made scientific instruments, Foster was more pleased than disappointed by this turn of events, especially since he had great admiration for Dew-Smith's business capacities.'[35]

In 1878, he began to underwrite the publication costs of the *Journal of Physiology*, edited by Foster and first issued in March of that year, published by Macmillan and Company. The journal contained many lithographs, most by F. Huth of Edinburgh, of crude electrocardiograms and of drawings of tissues and cells of healthy and diseased lungs, muscles, veins, corneas, intestines, stomachs, glands, and such of frogs, rabbits, sheep, among others. By January 1881, he had enlarged his workshop into the Cambridge Scientific Instrument Company, with

Horace Darwin, Charles's youngest son, now as chief engineer and partner. In 1883, as a result of his continued involvement in the publication of the *Journal of Physiology*, he added a lithographic department to his business, 'the aim being to provide good quality illustrations for scientific publications.' He had photographed instruments for prospective clients and for reproduction, but now with reproductive facilities in house, he 'became an acknowledged expert.'[36] Indeed, according to Foster, 'to this part of the Company's work Dew-Smith devoted himself with great energy and remarkable skill. Photography brought together his love of apparatus and a love for art which was even stronger in him. For many years from the early eighties onwards much of his time was spent in photographic work; and he worked with signal success, as they well recognize who treasure the photographic portraits which he took of his friends and various distinguished men, both of this and other countries.'[37]

According to J.J. Thomson, a fellow at Trinity College in 1880 and Nobel laureate in physics in 1906, Dew-Smith 'was of a type not often found in our Society, familiar with life in London and especially with Club life.'[38] In 1878 he was a member of the Dilettante Society; in the 1880s, he was a member of the Savile Club and the Rabelais Club, and, in 1884, a member of the Photographic Society of Great Britain, at whose 1885 exhibition he showed four platinum prints.[39] At home in Cambridge, 'his large and exact knowledge of books and art stood the University in good stead when he served on the Library, Fitzwilliam Museum, and other syndicates.'[40]

In January of 1891 he amiably broke with Darwin and, in the upper floor of the same building on St Tibb's Row, 'took over the business of lithographic printing and the publication of the *Journal*, trading as the Cambridge Engraving Company,' with his 'Lithographic stock' valued at 'L589.19s.5d.'[41] In 1895, he married Alice Lloyd, a well-known journalist and novelist, and moved to 'the old-fashioned Manor House at Chesterton,' a few miles outside of Cambridge, where he revived his early interest in gardening.[42] He gave up the business side of things, transferring the commercial work to his chief assistant Mr Edward Wilson, 'and the photographic plant and skill which he had acquired was henceforth employed for his own pleasure or for special tasks undertaken for the benefit or at the requests of his friends.'[43] The excellent collotype facsimiles of Milton's manuscripts of his minor poems, 1898, was one such project for Cambridge University Press.[44] Indeed, many

books from the Press in the 1890s acknowledge Dew-Smith for plates, maps, illustrations, and facsimiles, and even one that got away reveals the quality of his late work:

> The question of producing a facsimile of the sixth-century Codex Bezae, regarded by many as [Cambridge] University's greatest treasure, was broached in 1891, but was dropped on learning of the likely costs ... In May 1896 the Syndics agreed to a facsimile to meet modern standards. In the end, the facsimile was printed by heliogravure by Dujardin, in Paris. But he was the third choice. Initially, the Syndics hoped that the Clarendon Press could produce such a work by collotype, based on photographs taken by Albert Dew-Smith, a photographer of outstanding ability and until recently the partner of Horace Darwin in the Cambridge Scientific Instrument Company. He was responsible for all photography at the University Library. Both Dew-Smith, in his capacity as proprietor of the Cambridge Engraving Company, and Oxford were reluctant to undertake the printing.[45]

Dew-Smith is still not in the *DNB* (now called the *ODNB*), but he is mentioned in all histories of the Cambridge School of Physiology, in histories of cardiology, evolutionary embryology, and histories of medical and scientific instruments.[46] Needless to say, these are not the first places one looks for a collector of literature and art. And he appears in many memoirs of Cambridge in the late Victorian era. In *Time's Chariot*, Sir John Pollock, a fellow at Trinity College, includes Dew-Smith among the memorable characters in Cambridge at that time, a list that includes Lord Acton, G.M. Trevelyan, Jane Harrison, Francis Cornford, W.W. Greg, Bertrand Russell, A.A. Milne. 'There was one senior at Cambridge in my time of whom it would be wrong indeed not to speak. Though not a don, Albert Dew-Smith, commonly called Dew, was made a member of the High table at Trinity ... To top all, he had married Alice Lloyd ... who ... had in a few years collected a record public of "fans" for her grace and fancy. The Dew-Smiths lived at Chesterton a few miles outside Cambridge in a lovely house and a lovely garden, always open to those that prized the welcome to be found there. Alas! No one will ever ... see so curious a character as Dew, nor – quite certainly – ever meet a writer of such elfin wit as Alice Dew.'[47]

Sidney Colvin (1845–1927), Slade professor of Fine Art and the director of the Fitzwilliam Museum (1873–85) and later keeper of prints and

drawings at the British Museum, was a fellow of Trinity and living in the college at the same time as Dew-Smith. They became friends and through Colvin Dew-Smith met Robert Louis Stevenson (1850–94), who wrote him a very witty letter in verse from Hotel Belvedere in Davos, Switzerland, in November 1880, thanking him for a present of a box of cigarettes. Stevenson describes himself as 'Shut in a kind of damned Hotel, / Discountenanced by God and man; / The food? – Sir, you would do as well / To cram your belly full of bran.'[48] He complains for another fifty lines to reach: 'I judge the best, whate'er befall,/Is still to sit on one's behind, / And, having duly moistened all, / Smoke with an unperturbed mind.'[49] Many of Stevenson's friends, including Colvin, who edited his letters, thought Dew-Smith's photograph of Stevenson, circa 1885, the best ever taken of him. According to Colvin: 'As a resident master of arts he helped the natural science departments by starting and superintending a workshop for manufacturing instruments of research of the most perfect make and finish; and he was one of the most skillful of photographers, alike in the scientific and artistic uses of the craft – a certain large-scale carbon print he took of Stevenson to my mind comes nearer to the original in richness of character and expression than any other portrait.'[50] According to Pollock, 'Dew was also the best portrait photographer that has ever lived, superior even to Mrs. Cameron; his portraits of Joachim and Stevenson, as well as of a host of Cambridge worthies, will live so long as their names and memories survive.'[51] The Stevenson photograph, like most of Dew-Smith's portraits, was executed as a platinum print, a technique requiring much skill and used by modernist photographers Edward Steichen, Alfred Stieglitz, Edward Weston, and Paul Strand.[52]

He was indeed an 'interesting character' and a 'man of fine tastes and of means to gratify them'[53] (figs. 2.12 and 2.13). According to the physiologist, poet, and Nobel laureate in medicine for 1932, Charles Sherrington, he 'always dressed in a velvet jacket.'[54] 'He was tall, with finely cut features, black silky hair and neatly pointed beard, and withal a peculiarly soft and silken, deliberate manner of speech. Considerable were our surprise and amusement when some dozen years later we found his outward looks and bearing, and particularly his characteristic turns of speech, with something of dangerous power which his presence suggested as lying behind so much polished blandness, evoked and idealized by Stevenson in his creation of the personage of Attwater in the grimmest of island stories, The Ebb Tide.'[55] Pollock notes much the same: 'Six foot three, a grand, mysterious appearance and a carefully

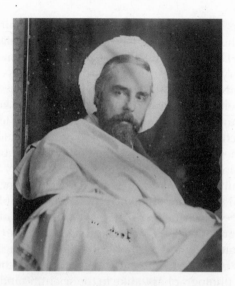

2.12 A.G. Dew-Smith, albumen print by Eveleen Myers (1888), who received technical advice from Dew-Smith. Below the image she inscribed: 'I have him as a saint – my great friend.' National Portrait Gallery, London

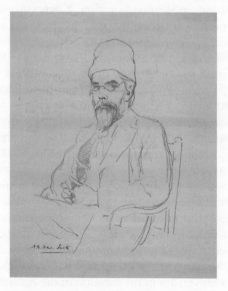

2.13 A.G. Dew-Smith, lithograph signed by him. Artist unknown. © National Portrait Gallery, London

trimmed pointed beard gave semblance to a legend that was true.'[56] Sir Walter Landgon-Brown recalls that 'Mrs. Dew-Smith told me that her husband accepted the likeness, but emphatically denied that he was ever a revivalist!'[57]

Foster notes that it was at 'the Savile Club and elsewhere' that 'he was for many years frequently in the company of the younger princes of literature and art.' In addition to Stevenson, 'he got to know most of the "coming men," and they got to know him.'[58] In the summer of 1885, Dew-Smith met Charles Fairfax Murray, another collector of Blake, as well as book dealer and painter.[59] According to Fairfax Murray's biographer, 'Dew-Smith's two great interests were collecting – books, manuscripts and jewelry – and photography,' and he and Murray 'quickly found a great deal in common.' They, together with John Middleton, 'took their dinners at the High Tables of Trinity, Trinity Hall and King's … and spent relaxed hours in the Master's garden by the Cam. Cambridge provided a congenial, masculine atmosphere in which Fairfax Murray could pursue his consuming delight in rare books among scholars of like mind, and it remained the place in England in which he was most at ease.'[60]

Dew-Smith also appears in *Period Piece* by Gwen Raverat, Charles Darwin's granddaughter and Geoffrey Keynes's sister-in-law. She recalls when 'It was understood by us children, that Uncle Horace and Mr. Dew-Smith had started a sort of concern called *The Shop*, where they made clocks and machines and things, and where we hoped that poor spelling would not matter much. Nowadays it is called *The Cambridge Scientific Instrument Company*, and is not unknown; but then it was in a very small way, and was just *The Shop*, and was considered by my father as rather a doubtful venture.'[61] Margaret Keynes, Sir Geoffrey Keynes's wife, says the following: 'She [Mrs Darwin, in a letter of 4 July 1885] enclosed a small photograph taken by A.G. Dew Smith, friend and a noted photographer.'[62]

In various online databases, Dew-Smith is recorded as 'photographer and lens maker' (National Portrait Gallery data base) and as 'bibliophile and photographer' (Library Catalogue, Archives HUB). In the *Darwin Correspondence Project*,[63] he is recorded as 'Engineer and instrument maker'; in the Pitt Rivers Museum database, he is recorded as a photographer and as having 'worked as a lens grinder at the Observatory in the University of Cambridge. His photographic portraits are close and intense and the dense black and white of the platinum printing gives his images dramatic impact.'[64]

II Catalogue of a Very Choice Library, and of A Small But Rich Collection of Ancient Engravings and Modern Drawings, the Property of A.G. Dew-Smith, Esq.

> I would venture to suggest that it is not wise to treat the passion for old, rare, or curious books with disrespect. Any pursuit of the kind has a more or less refining influence upon the mind. It may be tainted and vulgarised, no doubt, by the ignorant caprice of fashion or the mere money-grubbing spirit of speculation; but, on the other hand, it may be so pursued as to be made not only a charming but an instructive occupation.
>
> *Fraser's Magazine for Town and Country*, July 1879

Foster notes in Dew-Smith's obituary that 'there was another part of his life' that Foster had no share in, that in addition to his 'dormant love of science' there 'must have been a far stronger dormant love of art.' Foster cannot date its awakening, but recalls that 'even in the earliest days of our friendship he had already become the possessor of a large number of rare books and several valuable pictures.' The 'earliest days' corresponds exactly with Dew-Smith's inheritance in July of 1870. As noted, Dew-Smith was not a fellow of Trinity, but was 'allowed rooms in College and the privileges of the high table.'[65] Foster recalls that

> he set about – I was going to write – 'to furnish them,' but that common-place word is not the right one with which to describe the way in which he transformed the four bare walls left by a Cambridge builder into a chamber full of beautiful things, which, though each in turn drew upon itself the gaze of the visitor, produced together the dominant effect of luxurious ease and comfort. There was in it no mark of the collector. For Dew-Smith was no mere collector. He took unwearied pains and put forth unusual skill as a hunter to secure something which he sought, a rare first edition, a fine old engraving, an attractive and fantastic jewel, or some old bit of furniture, yet he sought to possess it, not simply that he might have it, but because, having it, to look at it or to handle it gave him pleasure whenever he wished.[66]

Another friend recalls 'the walls being adorned with examples of Rossetti, Burne-Jones and other favourite artists of that day.'[67] Foster estimates that Dew-Smith must have begun to 'gather together such things very early, and in gathering to have worked with unusual skill, for so early as 1878, when he told me, in his usual manner of speaking, that

he "thought about getting rid of some of his rubbish," I found that his "rubbish" was advertised with more than usual enthusiasm by Messrs. Sotheby as "a very choice library and a small but rich collection of ancient engravings and modern drawings."'[68] Indeed, it was a remarkable collection of books, bindings, prints, drawings, and paintings, 374 lots over two days, split between books (lots 1–262) and art (lots 263–374). Nearly half the books were finely bound, forty by Bedford, twenty by Riviere, forty-one by Pratt, most with gilt top edges and uncut, that is, with deckle edges on the outside and bottom of the leaves. He was also a collector of 'precious stones, of which in their uncut state he would sometimes pull a handful out of his pocket to show us.'[69]

In addition to *America* copy B, he owned another Blake illuminated book and numerous engraved book illustrations: *Visions of Daughters of Albion* copy N, *Pastorals of Virgil*, Malkin's *A Father's Memoir of his Child*, Gay's *Fables*, Hayley's *Ballads*, *Designs to a Series of Ballads*, and *Life of George Romney*, Ritson's *Select Collection of English Songs*, Salzmann's *Elements of Morality*, John Scott's *Poetical Works*, Burger's *Leonora*, Blair's *The Grave*, *Illustrations to the Book of Job*, proof impressions, and a pencil drawing, now untraced – 'Colossal Figure of a Man borne through the air, attended by many others, above, in the distance, are female figures, some with musical instruments.' He also had Blake's annotated copy of Swedenborg's *Wisdom of Angels concerning Divine Love and Divine Wisdom*.[70] Much of what remained in his library sold after he died, on the third day of a larger auction, 27–30 June 1906. Included were Gilchrist's *Life of Blake*, first edition, Swinburne's *William Blake, a Critical Essay*, a 'Scrap Book … containing illustrations by Stothard, W. Blake,' Young's *Night Thoughts* printed on vellum, the 1797 edition but 'without the illustrations by Blake,'[71] and Pearson's 1877 facsimile of *Jerusalem*. Also included was a presentation copy of Whitman's *Leaves of Grass* to 'A.G. Dew-Smith.'[72] Keynes and Wolf states that for a while he also owned *Songs* copy J.[73]

Dew-Smith's Blake collection was small but is of interest to Blakeans as yet another example of a Victorian collecting Blake after the publication of Gilchrist's *Life of Blake* in 1863. In its own day, however, his library was of great interest to bibliophiles as reflecting modern tastes and fashions in book collecting. The quality and number of first editions of Shelley and Byron and the high prices they brought were much commented upon in the press. The reviews are worth quoting extensively to give a sense of book collecting when the great Blake collections were being formed, but also because the dedicatee of this essay is a true

bibliophile, collector, and descriptive bibliographer who appreciates such minute particulars.

The Academy, for 9 February 1878, listed the highlights among the books, paying especial attention to first editions:

Byron's Works, sold for £17.; Barham's *Ingoldsby Legends*, £7. 10s.; Browne's *Religio Medici*, £4.; Fuller's *David Hainous Sinne*, £9. 15s.; Keats' Poems, £5. 15s.; Milton's Poems, £14. 10s.; Ruskin's *Modern Painters*, £25. 10s., *Stones of Venice*, £13. 15s., *Seven Lamps of Architecture*, £7. 10s.; Shelley's *Queen Mab*, £8. 5s., *Alastor*, £9., *Laon and Cythna*, £8. 15s., *Epipsychidion*, £11. 15s., *Adonais*, £42; Sterne's *Tristram Shandy*, with autograph, £11. 5s., *Sentimental Journey*, £4. 4s.; Thackeray's Comic Tales and Sketches, £5. 5s.; Burton's *Anatomy*, £19. 10s.; Milton's *Comus*, £50., *Lycidus*, £73., *Paradise Lost*, £34.; Spenser's *Complaints*, £11. 16s., *Faerie Queen*, edition of 1611, £10. 10s. Among other remarkable lots were *Aesopi Fabulae e. Vita*, Neapoli, 1485, which was knocked down to Mr. Quaritch for £131.; Shakspere's Poems, 1840, with the excessively rare portrait by W. Marshall, £62.; an Italian *Biblia Pauperum*, block book, 1510, £24.10s.; Dibdin's Bibl. Spenceriana, &c., 7 vols., £26.; Grimm's Stories, with Cruikshank's plates, £10. 10s.; Horae Beatae Mariae Virginia, MS. on vellum, 1518, £40. 10s.; another, £48. 10s.; Suffragia Sanctorum, MS., £29.; Walpole's *Anecdotes of Painting*, edition of 1826–28, £19. 10s.; Blake's *Visions of the Daughters of Albion*, £30.; Blake's *America, a Prophecy*, £16. 5s.; his illustrations of Job, £14. The whole day's sale realised £1,634. 15s. 6d.[74]

The Academy also records prize works among the 'extremely valuable collection of ancient and rare engravings formed by Mr. Dew-Smith, a known collector' that sold in the second day of the sale, and includes their buyers as well:

It contained several remarkable examples of the work of Albert Dürer as well as fine Italian prints of the Renaissance, of rare quality. By a master whose surprising merit has been fully recognised only during recent years – Jacopo de' Barbarj, the 'Master of the Oaduceus' – there was only one example, the *Judith*, sold for £10. 2s. 6d. By Domenico Campagnola, there was the *Beheading of a Female Saint*, which fetched £24. 10s. (Noseda). The greater prices were reached only with the Albert Dürers. The magnificent *St. Hubert*, from the noted collection of Mariette, realised £60. (Agnew); the *St. Jerome in the Desert*, £10. 10s. (Noseda); a rich impression of the *Melancolía*, £18. (Noseda); an impression of the *Great Fortune*, £14. (Thibaudeau):

a fine impression of *The Knight of Death*, £32. (Colnaghi). By Wenceslaus Hollar there was a rare impression of his view of *Antwerp Cathedral*, which fell for £10. 5s. Of Lucas van Leyden's engravings, known by the amateur to be hardly second to those of the great German, an impression of the print known as the *Magdalen giving herself up to the Pleasures of the World* was sold for about £20. (Danlos). By Andrea Mantegna, a rare master in this art as in the art of painting, there were the *Soldiers carrying Trophies*, £10. (Frazer), and the *Bacchanalian Scene with the Wine Press*, £20. (Thibaudeau). By Nicoletto da Modena, we find the rare print, *The Punishment of the Evil Tongue*, £22. 10s. (Davidson). Marcantonio's engravings realised the highest prices. The *Adam and Eve* was knocked down to Mr. Agnew's bid of £111.; the *Martyrdom of St. Lawrence*, after Baccio Baldini, to Mrs. Noseda for £30. 10s., and the rare *Lucretia* to the same for £61. There were but few prints by Rembrandt, and these not always of the first quality. Martin Schongauer's *Christ on the Cross* sold for £39. 10s. (Noseda).

At the end of the print sale were offered several remarkable drawings, two of them by an artist whose work very rarely comes under the hammer. Mr. Burne Jones's invention of *Pyramus and Thisbe*, in three compartments, painted on vellum with the dainty care peculiar to the designer, realised £200. It fell to the bid of Mr. Agnew. *The King's Wedding* sold to the same for the sum of one hundred guineas. There were a few sketches rightly, we believe, attributed to Turner; and an exceedingly good example of John Lewis, *Edfou, a Sheikh Encampment*, showing the valley and course of the Nile. This last was purchased for £160. (Agnew).[75]

This second day realized £1432.9.5; together, the two days realized £3067.4.11, a very considerable sum. Relative to the sales in the previous three years, even those with many more lots, Dew-Smith's brought in more money and certainly more per item. For example, the library of Philip Martineau, auctioned at Sotheby's 5 July 1875, also brought in a little more than £1600 but for 1176 lots. The library of Dr James Bird, at Sotheby's 23 August 1875, had 2027 lots that brought in £1513. Libraries with fewer than three hundred items were relatively rare, but an auction of a 'Well-known Collector,' 15 May 1877 at Sotheby's, had 273 lots that brought in £268.19.6. In other words, £1634 for 262 lots of books is very impressive, and £3067 for 374 total lots means Dew-Smith raised a lot of money quickly by selling some of his 'rubbish,' the timing of which raises the possibility that he was motivated by his commitment to underwrite the publishing costs of the new *Journal of Physiology*, the first issue of which was 11 March 1878, just six weeks after the auction.

In his 'Bibliomania in 1879' in *Fraser's Magazine for Town and Country*, July 1879, 'Shirley' closely scrutinized the sale's highlights and high prices for ominous signs of things to come.[76] He criticizes the current crop of book hunters, accusing them of following fashions and *collecting* rather than *reading* books, of not knowing their real value. He sees the Dew-Smith sale as exemplifying such fashions and the influence of the Pre-Raphaelites. But even he has to admit that Dew-Smith's collection, though an example of how collections and collectors have changed, was remarkable.

> January 29 of last year is a red-letter day in the calendar of the biblioma-niac. On that day the library of Mr. Dew Smith was sold by auction at Messrs. Sotheby's room in the Strand. There never was brought together at that classic shrine a more illustrious congregation of book-hunters. The piety which they manifested was infectious; the prices which they gave were fabulous. The very catalogue is a work of genius; it sparkles like a page of Macaulay. And, in the absence of any official handbook, it is perhaps the best guide that the critical student of the latest fash-ions in bibliography can select. In such a pursuit there cannot, of course, be any absolute standard of value, for there is no why or wherefore in liking; and when the supply of an article is inexorably limited, the healthy action of competition in equalising prices cannot make itself felt.[77]

That the Dew-Smith auction catalogue was a 'guide' for the modern bibliophile was not meant as a compliment. Shirley states that 'The old race of book-hunters ... has nearly died out ... They knew the insides as well as the outsides.' But the 'bibliomania which flourishes at present is unconnected with any genuinely antiquarian or historical instinct.' Moreover, today's buyers know only that 'an early edition which con-tains a printer's blunder at a specified page is pure and priceless, but that without the misprint it is comparatively worthless and may go for an old song. That is about the measure of the capacity of the majority of our book fanciers, though some of their number possess, in addition, a more or less intelligent appreciation of the distinction between "half morocco, uncut, top edge gilt by Riviere," and "calf extra, uncut, top edge gilt by W. Pratt," a distinction of no mean value in the auction room.' These examples of bindings come from the Dew-Smith collec-tion, noted for its splendid bindings and uncut condition of most of its books. He continues: 'The truth is, that book-buying has become a fash-

ion, and the canons which govern the buyers of books are as capricious and incalculable as those which govern the buyers of old pictures or old china. There are handbooks for the buyers of porcelain; a handbook for the fanciers of rare editions and choice "bits" for the library is not yet compiled.'[78] Dew-Smith's auction catalogue represents that guide or handbook, for better or worse.

Shirley argues that the 'prevailing bibliomania must ... be regarded as the expression, more or less intelligent, of a simply sentimental dilettantism. It is not antiquarian; it is not historical: it affects the personal and the picturesque.' He gives examples of the 'dainties on which it feeds,' all drawn from the Dew-Smith collection: 'An early illuminated missal, a "Horae Beatae Virginis Mariae" on vellum "within beautiful arabesque borders, exhibiting flowers, birds, and grotesques, richly ornamented with thirty-one large and twenty-two small miniatures, and numerous capital letters, all exquisitely illuminated in gold and colours, red morocco, silk linings (1518)," an Aldine Dante or Pindar, a first edition of "Comus" or "Lycidas," the "Adonais" printed at Pisa.'[79] And Shirley is quite sure who is to blame about the objects in fashion and their high prices:

> The influence of Mr. Ruskin and Mr. Dante Rossetti on the prices which a certain class of books command is very noticeable. The passion for 'Horae' of the fourteenth and fifteenth centuries is of quite recent growth, being, in fact, one of the offshoots of pre-Raphaelitism. These manuscript offices could be purchased for a trifle not so many years ago in many German and Italian book shops; now they are not to be met with except in the auction room, and the 'Horae' at Mr. Dew Smith's sale brought from £40 to £50 apiece. In 1850 Mr. Rossetti, Mr. Holman Hunt, and Mr. Woolner began the publication of the 'Germ,' of which three or four shilling parts were published; it was thereafter discontinued for lack of subscribers. The numbers, bound together, form a thin octavo volume, which now sells for about £5. The drawings (like the wooden figures carved among the dolomites) are delightfully archaic, though the remarkable Italian story by Mr. Rossetti is probably the main attraction. The 'Blessed Damozel,' moreover, originally appeared in the 'Germ,' and the admirers of that vivid vision are thus enabled to set side by side the original study – somewhat crude and incoherent, it must be confessed – and the finished masterpiece as it appears in the collected poems ...[80]

Shirley also blames Dante Rossetti for the high prices Blake's illumi-

nated books were bringing in, recalling the 'days when the weird and grotesque designs of William Blake were simply unsaleable – a mere drug in the market.' But then 'came Mr. Rossetti's brilliant chapter in Gilchrist's *Life*, in which justice (perhaps more than justice) was done to Blake, and to another great and unsaleable genius, David Scott; and now a copy of the "Visions of the Daughters of Albion," which twenty years ago might have been picked up for 30s., cannot be secured for less than £30.'[81]

The 'most unique and characteristic feature of the Dew-Smith sale,' however, was not his Blakes or their prices, but 'the prices obtained for the original editions of Shelley's poems,' and that 'except Mr. Ruskin's and Mr. Tennyson's works, there are not many quite modern publications which show any considerable increase in value.'[82] The mania for first editions that was exploited by the Wise and Forman forgeries of the 1880s and 1890s, as well as providing the demand for facsimile editions of literary works, is clearly present:

> The literature of what may be called the Shelley revival is becoming abundant, if not redundant, and the first editions of the poet's works are not now to be had for love or money – certainly not for love, and rarely for money. This thin quarto of twenty-five pages is the 'Adonais,' printed at Pisa in 1821; and at Mr. Smith's sale the 'Adonais' sold for exactly forty guineas. At the same time 'Queen Mab' (1813) brought £8.5s., 'Alastor' (1816) £9., 'Laon and Cythna' (1818) £8.15s., and 'Epipsychidion' (1821) £11.15s. These are extraordinary prices. Seeing that an excellent edition of the collected poems can be had for about five shillings, how comes it that the coolest bidder loses his head when a copy of the first edition of 'Epipsychidion' or 'Adonais' is 'going'?[83]

Shirley's rationale for valuing the 'original,' for going to the work's origin, appears at first to manifest the romantic idea of 'first thought, best thought,' as Ginsberg would say, attributing it to Blake, though actually misquoting Gilchrist, who stated that Blake was 'wont to affirm; – "First thoughts are best in art, second thoughts in other matters."'[84] But it is not spontaneity or the original spark, not the manuscript drafts or sketches, that he is searching for. He prizes the first and original condition of the printed artefact, believing that 'undoubtedly an early edition does bring us nearer to the writer'[85] – which is an unexamined, self-evidently good thing. He quotes Charles Lamb's declaration 'that he could not read Beaumont and Fletcher except in folio' and that 'he did

not know a more heartless sight than the octavo reprints of the "Anatomy of Melancholy."' Advocating for the primacy or 'aura' of a book's physical features, or 'bibliographical code,' to use Jerome McGann's concept in *The Textual Condition*,[86] he states: 'a man who has learnt his "Adonais" from the first edition feels that it is not the same thing in a modern dress; the virtue has gone out of it. And the first edition of the "Adonais" does bring us into exceptionally close relations with Shelley. It was printed by himself at Pisa, where he was living, in 1821, and it cannot be said to have been "published" in the ordinary sense of the word – that is, for general circulation.'[87]

But the modern bibliophile, Shirley believes, values early editions not for their historical authenticity or for bringing readers closer to writers, but mostly for 'the corruption of the early text.' He chastises the editors of Shelley the way Blake scholars – with Dante Rossetti clearly in mind – chastise Victorian editors of Blake for having '"improved" the original with such success that they may be said to have improved it out of existence … They have insisted on Shelley saying many things which in point of fact he did not say, but which in their opinion he ought to have said.' Consequently, 'it has come about that the latest editions of Shelley are no more reliable than the earliest; and the student who, so to speak, wishes to see all round him in arriving at accurate knowledge of the genuine Shelley text, must consult the original editions, which were bungled by the printers, as well as the more recent, which have been "improved" by the editors. In Shelley's case, therefore, a first edition has a real literary as well as sentimental value, and the competition of students accounts more or less for the prices which have been obtained.'[88] Whether intended or not, Shirley provides the rationale for facsimile reproduction of literary texts, including those of Blake by Pearson, Muir, Griggs, the William Blake Trust, and the Blake Archive, as well as diplomatic editing of the kind used in the Archive: 'Unless he has a very clear case indeed it is better for the able editor to leave even the commas unmolested; when he disturbs semicolons, colons, or full stops he is pretty certain to come to grief.'[89]

The source for Shirley's despairing comparison of modern book collecting with the collecting of china, the latter of which had handbooks and the former did not, is the review of the Dew-Smith sale in *Gentleman's Magazine* (January to June 1878):

FEW things are more conducive to quietude of life and length of days than the possession of a hobby, supposing always it is not, like the breed-

ing or running of racehorses or the like, of too exciting a nature. Where it takes the shape of collecting objects of interest or curiosity it forms one of the most agreeable occupations that a man whose life is not wholly occupied in the pursuit of wealth can adopt. If exercised with a moderate amount of intelligence it is likely to prove a source of profit. The recent sale of the library of Mr. Dew Smith, at which books fetched prices previously unheard of, shows that when a collection is made with judgment the investment will prove largely remunerative. A man need not wait long, indeed, to find his purchases rise in value. First editions of Byron and Shelley brought, at the sale mentioned, prices that comparatively few years ago would have been thought excessive for early Shakespeares. For the benefit of young collectors of books I give a piece of information, the importance of which it is impossible to overestimate. Pay little heed to second-rate copies, the value of which fluctuates with changing fashions; but when you come upon a first-rate copy of any rarity, secure it – it is certain to rise steadily in value. If a library is known to contain works of this description, it attracts, when it is sold, a class of buyers altogether unlike those who flock to the sale of more ordinary works, and the prices obtained are immensely increased. Meantime, as one of the chief difficulties of young collectors is to know what they can obtain at a low price with a reasonable hope of seeing it advance, let me offer them what is technically called a 'tip.' There is probably no safer investment than buying the masterpieces of modern china. Some of the works of Messrs. Minton and other manufacturers are admirable in art. In the course of comparatively few years these things are sure to rise enormously in value. Another class of purchases that may be recommended is that of works from our pictorial exhibitions in black and white. These have attracted as yet no attention at all proportionate to their worth.[90]

The idea of collecting art and books as 'investments' fails to surprise us today, but clearly the idea shocked and dismayed Shirley, for whom collecting books in particular was not a rich man's game nor a means to acquire or build wealth. Building a library reflected, ideally, a passion for knowledge, and basking in a book's historical aura or authenticity was reward enough. The prices brought in by Dew-Smith's library changed all that, or had, Shirley feared, the potential to change radically the nature and motivation of collector and collecting, with books, pots, and vases all equivalent and interchangeable. Regarding just Blake, Shirley's worst fears were realized at Sotheby's in May 2006, when a syndicate of businessmen underwrote the purchase of Blake's nineteen

Grave watercolours, recently rediscovered in 2001, and sold them individually in hopes of a substantial profit (not realized) and at the cost of splitting the set up (realized). I do not know if Dew-Smith was lucky or savvy in selling works for more than he acquired them, or if his profit merits tarnishing his motivation in collecting them or his intention in selling them, which I presume was to raise capital to help underwrite the publishing cost of *The Journal of Physiology*. What I do know is that he sold *America* copy B bound and with eighteen designs for £16.5s after investing money for binding and two facsimiles, which was nearly two pounds *less* than what he acquired it for, unbound and with two fewer designs, just four years earlier!

III Coda

While we cannot say for sure if *America* copy B ever had eighteen original designs, as Bentley supposes, we can say with confidence that if it did, it was before its plates were numbered 2–16 and thus before they were acquired by Dew-Smith. We know for sure that Dew-Smith had the sixteen plates bound by Bedford, and did not extract any original impressions. We can also state confidently that he was responsible for reproducing plates 4 and 9 to complete his incomplete copy, identified them with an 'F' (presumably for 'facsimile'), and described copy B as having the correct number of designs, eighteen. He was already a fine photographer and probably took the photographs of the model, *America* copy F; he had access to lithographers and other professional reproductive printers while running his workshop, and he had an artistic appreciation of fine reproductions as well as fine prints. His own recorded expertise just a few years after the sale as a lithographer and facsimilist is not coincidental. Perhaps his interest in these arts was stimulated by the creation of plates 4 and 9, but more likely it was already in place before the Sotheby sale.

John Pearson, who bought *America* copy B at the 1878 sale, also sold many books to Dew-Smith, including a few from the William Tite sale in 1874. Pearson produced a remarkably fine photolithographic facsimile of *Jerusalem* copy D in 1877, which was in Dew-Smith's collection sold at Sotheby's in 1906, along with a few other works in facsimile, including Linton's 'facsimile plates' in *The Life of Blake* (lot 496).[91] Though not mentioned in his manuscript catalogue of his library (no Blakes are entered), one must wonder if he had Pearson's facsimile in hand in 1877 and was inspired by it to reproduce the two missing plates in his illuminated book using the same technique.[92]

Albert George Dew-Smith was indeed 'a man of artistic tastes and mechanical genius.'[93] Collector, bibliophile, physiologist, instrument maker, business man, patron, photographer, lithographer, facsimilist. No doubt, 'To the many who knew him as Dew-Smith, and knew him little, he was a picturesque character whose ways were his own; to us who knew him as Dew, and knew him well, to whom he had often been a very present help, he was at once a delightful companion and a trustworthy, ever-ready friend.'[94] With Dew-Smith 'always to be found in the workshop at Tibbs Row,' Foster understandably could claim that 'whoever was privileged to be admitted into his studio always found some new thing of beauty, or at least of interest, to admire.'[95]

NOTES

1 Benjamin, Walter, 'The Work of Art in the Age of Mechanical Reproduction,' available at http://www.marxists.org/reference/subject/philosophy/works/ge/benjamin.htm.

2 'I Believe both Macpherson & Chatterton, that what they say is Ancient, Is so,' Blake's Annotations to Wordsworth's *Poems*. William Blake, *The Complete Poetry and Prose of William Blake*, rev. ed., edited by David Erdman, with commentary by Harold Bloom (New York, NY; London: Doubleday: Anchor Books, 1988), 665.

3 Joseph Viscomi, 'Facsimile or Forgery? An Examination of *America*, Plates 4 and 9, Copy B.' *Blake/An Illustrated Quarterly* 16 (1983): 217–23. In 1990 I discovered that the Morgan Library's impressions of *There is No Natural Religion* copy G were also unacknowledged facsimiles. See Joseph Viscomi, *Blake and the Idea of the Book* (Princeton: Princeton University Press, 1993), chapters 21 and 22.

4 I confided my suspicions to Thomas Lange, the assistant curator then in charge of books and prints at the Pierpont Morgan Library, who also noticed the difference in paper and suspected the two plates. He wrote up a report simultaneously published with mine: Thomas Lange, 'Two Forged Plates in *America*, copy B,' *Blake/An Illustrated Quarterly* 16 (1983): 212–16. Bentley seems to have been a bit puzzled by the difference too, noting that plate 9 was printed on 'stiffer paper than the rest.' G.E. Bentley Jr, *The Blake Collection of Mrs. Landon K. Thorne* (New York: Pierpont Morgan Library, 1971), 26.

5 In the posthumous pull of 'The Little Black Boy' (pl. 9), the woman's bun was removed and her back narrowed with a burin. *Songs of Innocence* copy U contains such a pull, though it is recorded as an extra impression. G.E.

Bentley Jr, *Blake Books: Annotated Catalogues of William Blake's Writings in Illuminated Printing* (Oxford: Clarendon, 1977), 366. Hereafter cited parenthetically as *BB*.

6 For example, line 4 of plate 4 is 12.6 centimetres long in copies A and L, but 13.0 centimetres in copy B. Line 7 of plate 9 is 11.5 centimetres long in copies A and L, but 11.9 in copy B.

7 Damp printing paper shrinks only 1 to 2.5 per cent of the sheet size, which could not, for example, account for the 1.4 centimetres difference between the length of plate 9 of copy B (24.9 cm) and of copy A (23.5 cm). Philip Gaskell, *A New Introduction to Bibliography* (Oxford: Oxford University Press, 1972), 13. Mark Crosby kindly rechecked these measurements for me in summer of 2009.

8 Robert Essick provided much needed information for my first visit to *America* copy B and has again been a generous reader and examiner for this my second visit.

9 Sotheby Auction Catalogue, London, 29–30 January 1878. The prospectus is punctuated incorrectly in the Sotheby catalogue, as noted by Lange ('Two Forged Plates,' 212). The end of Blake's quotation should be after '1793,' not 'printing.'

10 Viscomi, 'Facsimile or Forgery?' 222; Lange, 'Two Forged Plates,' 215.

11 Thomas Gaisford, the Greek scholar and dean of Christ Church, Oxford (Lange, 'Two Forged Plates,' 216n5; *BB* index). There are other Blake books with Gaisford's bookplate (*Songs of Innocence* copy H, *Europe* copy E, *The Book of Urizen* copy C, *Poetical Sketches* copy N), and at least three, besides *America* copy B, acquired after 1874 (*Visions of the Daughters of Albion* copy I, *Songs* copy M, *Thel* copy C). Since the scholar's dates are 1779–1855, I was puzzled by the presence of a few of these books in the collection, stating: 'Apparently, someone familiar with the collector's taste in books continued to build the library' ('Facsimile or Forgery?' 223n13). I've discovered in preparing this essay, though, that the Blake collector was Thomas Gaisford, son of the dean of Christ Church, born 1816, captain in the army, bibliophile, and a member of the Society of Dilettantes (1864).

12 G.E. Bentley Jr, *Blake Books Supplement: A Bibliography of Publications and Discoveries about William Blake, 1971–1992, Being a Continuation of Blake Books (1977)* (New York: Oxford University Press, 1995), 54. Hereafter cited parenthetically as *BBS*.

13 *A Catalogue of the Library of Bernard Buchanan Macgeorge* (privately printed, 1906), 8. Plates 1, 2, 4, 5, and 6 were extracted from *Europe* copy A before 1856 and reunited in 1906, when it was in Macgeorge's hands (*BB* 156–7).

14 *America* copy B never contained plate e, 'The Preludium,' because that

plate was printed with and above plate 3, which is present without it, as noted in *BB* 99.

15 W.T. Lowndes, *The Bibliographer's Manual of English Literature*, vol. 1 (London: Bohn, 1857), 215.

16 Quaritch's assistant wrote on the rear flyleaf 'Collated & perfect/Ap[l] 24 90/J.T.' He wrote similar annotations on *Thel* copy C (also in the Morgan Library). The initials refer to either J. Tuckett or J. Thorowgood (Lange, 'Two Forged Plates,' 216n6). The idea that 'J.T.' was responsible for the second set of numbers was suggested to me by Mark Crosby, who confirmed this by comparing the numbers to J.T.'s annotations in *America* and *Thel*.

17 On the recto of the frontispiece is the inscription in ink: 'From the author/C H Tatham Oct[r] 7/1799.' Presumably this is Tatham's hand; it is not Blake's. In any case, the '7' and '9' do not resemble the '7' and '9' in either set of numbers.

18 I checked digital photographs of four letters written by Dew-Smith to Charles Darwin on 17 January 1875, 19 January 1875, 21 February 1882, and 25 February 1882. The letters are in the Cambridge University Library and recorded in the Darwin Correspondence Project as letters 9822, 9825, 13695, and 13706, available at http://www.darwinproject.ac.uk/darwin/search/advanced?query=subject:%22%3Csocietal%3E+Cambridge+Scientific+Instrument+Co%22.

19 Bentley notes that *America* copy B was 'stabbed once (perhaps with *Europe* [C]) through three holes, 6.5 and 7.7 cm apart. Stabbed again through three holes 10.7, 12.9 cm apart' (*BB* 100). He also notes that '*America* may have been sewn, either earlier or later [than 1799] with *Europe* (C), which was separate by 1821' (*BB* 100n1). *America*'s second set of stab holes, presumably by Blake, suggests that Blake separated the two books before giving *America* to Tatham.

20 *Works by William Blake* is dated 1876 on its title page but was published after January 1878 (*BBS* 169); it included lithographic facsimiles of *America* and six other works based on tracings.

21 Copy A was printed for George Romney in 1795 on large paper and beautifully coloured; it was one of a series of copies of illuminated books printed on large paper. See Joseph Viscomi, 'The Myth of Commissioned Illuminated Books: George Romney, Isaac D'Israeli, and "One Hundred and Sixty designs of Blake's".' *Blake/An Illustrated Quarterly* 23 (Autumn, 1989): 48–74.

22 Blake had another copy on hand in 1799, since he gave Crabb Robinson copy D, printed in 1793, in 1825 (*BB* 101). Perhaps he viewed this as his own copy and was willing to part gratis with impressions he could gather from an earlier printing, even if the set was incomplete and one leaf was

folded. Or perhaps he simply chose to give Tatham impressions more recently printed.

23 I am grateful to Mark Crosby for confirming my suspicion by checking Dew-Smith's manuscript library catalogue in the Cambridge University Library and coming to the same conclusion. The catalogue has no entries for Blake and appears to have been written after the 1878 sale.

24 Alexander Gilchrist, *Life of Blake, 'Pictor Ignotus'* (London: Macmillan, 1863), I, 109.

25 J.T. Smith, *Nollekens and His Times* (London: Colburn, 1828), II, 477.

26 Geoffrey Keynes, *A Bibliography of William Blake* (New York: Grolier Club, 1921).

27 The possibility that the seven-like mark or symbol might be a backward F was first raised by Lange ('Two Forged Plates,' 213), and Bentley also mentions the possibility (*BBS* 53n2). I thought it might be a 'printer's mark rather than a number' ('Viscomi, 'Facsimile or Forgery?' 222n10), and as such meant to call attention to itself as an insertion. I sought writing examples by Dew-Smith in hopes of identifying this mark as well as the authorship of the description and numbering.

28 Foster became a fellow at Trinity in 1870 and presented lectures on the elements of physiology (for example, physiology of digestion, nervous system, embryology). Gerald L. Geison, *Michael Foster and the Cambridge School of Physiology: The Scientific Enterprise in Late Victorian Society* (Princeton, NJ: Princeton University Press, 1978), 117. But in the spring of 1873 he 'announced the creation of a new "practical course of elementary biology"' which marked the 'beginning of a new epoch in the teaching of biology in the English university' (ibid., 117–18).

29 Ibid., 182.

30 Michael Foster, 'In Memoriam,' *The Cambridge Review*, 30 April 1903, 261 of 261–2. Balfour went on to become a fellow at Trinity for his work done at the station, recommended by T.H. Huxley. When Balfour died climbing Mount Blanc, in fall of 1882, Huxley called his death 'the greatest loss to science – not only in England, but in the world – in our time.' Geison, *Michael Foster*, 126, 128.

31 Geison, *Michael Foster*, 182. Michael Foster and A.G. Dew-Smith, 'On the Behaviour of the Hearts of Mollusks under the Influence of Electric Currents,' *Proceedings of the Royal Society* 23 (1875): 318–43. Michael Foster and A.G. Dew-Smith, 'The Effects of the Constant Current on the Heart,' *Journal of Anatomy and Physiology* 10 (1876): 735–71.

32 Geison, *Michael Foster*, 190, 222. Geison discusses the significant and extensive influence of these papers in detail, in parts 3, 'The Problem of the

Heartbeat and the Rise of the Cambridge School,' and 4, 'Denouement and Conclusion' (222–355).

33 W.J. O'Conner, *Founders of British Physiology: A Biographical Dictionary, 1820–1885* (Manchester, UK; Manchester University Press, 1988), 166.

34 John Pollock, *Time's Chariot* (London: John Murray, 1950), 146.

35 Geison, *Michael Foster*, 182.

36 M.J.G. Cattermole and A.F. Wolfe, *Horace Darwin's Shop: A History of The Cambridge Scientific Instrument Company, 1878 to 1968* (Bristol and Boston: Adam Hilger, 1987), 37.

37 Foster, 'In Memoriam,' 261. During the 1880s he was producing colour photographs for the Cambridge Scientific Instrument Company, which included a set of the sunsets at Krakatoa after the volcanic eruptions of 1883, published by the Royal Society and said by scientist and president of the Royal Society, George Stokes, to be the 'finest colour prints that he had ever seen.' Mary Reed Bobbit, *With Dearest Love to All; The Life and Letters of Lady Jebb* (Chicago: H. Regnery, 1960), 218; George Gabriel Stokes, *Memoir and Scientific Correspondence of the Late G. G. Stokes*, selected and arranged by Joseph Larmor (Cambridge: Cambridge University Press, 1907), 21.

38 Joseph John Thomson, *Recollections and Reflections* (New York: Macmillan, 1937), 285.

39 He exhibited platinum prints, also called platinotypes, of Aldis Wright, Professor Caley, Herr Joachim, and an unidentified subject (http://erps .dmu.ac.uk/exhibits_year.php?sortorder=title&enid=1885&add=999999). Platinum prints are 'photographic prints made by a monochrome process that provides the greatest tonal range of any printing method using chemical development. Unlike the silver print process, platinum lies on the paper surface, while silver lies in a gelatin or albumen emulsion that coats the paper. As a result, since no gelatin emulsion is used, the final platinum image is absolutely matte with a deposit of platinum (and/or palladium, its sister element which is also used in most platinum photographs) absorbed slightly into the paper' (see Wikipedia http://en.wikipedia.org/wiki/Platinum_prints).

40 Foster, 'In Memoriam,' 262.

41 Cattermole and Wolfe, *Horace Darwin's Shop*, 42.

42 A remarkable personality in her own right, she published *Soul Shapes* (1890) anonymously, and the novel *White Umbrellas* (1895) under the pen name 'Sarnia.' As Alice Dew-Smith, her best known work was *Diary of a Dreamer*, published in 1900, in which 'Dew' is 'Max' and a collector of encyclopedias and dictionaries. She was a good friend of the classicist Jane Harrison, recalled by Raverat: 'I can't remember seeing any other

women smoke, except her [aunt's] friends Jane Harrison and Alice Dew
Smith.' Gwen Raverat, *Period Piece; A Cambridge Childhood* (London: Faber
and Faber, 1952, reprint 2003), 193. She was also a friend of Henry James,
who referred to her as 'mystical.' Susan E. Gunter, *Dear Munificent Friends:
Henry James's Letters to Four Women* (Ann Arbor: University of Michigan
Press, 1999), 194. She is sometimes recorded as Alice Murray Dew-Smith
and Alice Lloyd Murray Dew-Smith; somewhere down the line, her mid-
dle name of Mary appears to have been incorrectly transcribed as Murray
and used as her maiden name (suggested to me by Tommy Nixon, research
librarian at my own research library, the University of North Carolina at
Chapel Hill, who helped solve this puzzle).

43 Foster, 'In Memoriam,' 262.

44 *Facsimile of the Manuscript of Milton's Minor Poems*, preserved in the Library
of Trinity College Cambridge, ed. Aldus Wright, Cambridge University
Press, 1898. 'The Council of Trinity College have requested me to superin-
tend the reproduction of this chief treasure of the College Library, and after
the photographic portion of the work had been executed by the skilful
hands of Mr. A.G. Dew-Smith, himself a member of our body, I thought
I should do a greater service to students of Milton if, instead of merely
recording the variation between the MS. and the printed text, I enabled
them to ascertain the variation for themselves' (2–3). See also Edward G.
Brown, *A Traveller's Narrative*, 2 vols. (Cambridge University Press, 1891):
'The Persian titlepage does not belong to the original, but was subsequent-
ly written at Acrre by my request in black, and beautifully reproduced
in colours by Mr. Dew-Smith' (liii); Robert Sinker, *The Library of Trinity
College, Cambridge* (1891): 'As regards the illustrations, for the frontispiece
and the four facsimiles of MSS. I am indebted to the skill of Mr A.G. Dew-
Smith, of Trinity College' (vi).

45 David McKitterick, *New Worlds for Learning, 1873–1972*, vol. 3 of *A History
of Cambridge University Press* (Cambridge: Cambridge University Press,
2004), 130.

46 See Mari E.W. Williams, *The Precision Makers: A History of the Instruments
Industry in Britain and France, 1870–1939* (London: Routledge, 1994);
Geison, *Michael Foster*; Cattermole and Wolfe, *Horace Darwin's Shop*; Louis
J. Acierno, *The History of Cardiology* (London: Parthenon, 1994); Barbara J.
Hawgood, 'Sir Michael Foster MD FRS (1836–1907): The Rise of the British
School of Physiology,' *Journal of Medical Biography* 16, no. 4 (2008): 221–6;
W.J. O'Conner, *Founders of British Physiology*; Edward Sharpey-Schafer,
'History of the Physiological Society during its First Fifty Years, 1876–
1926,' part 1, *Journal of Physiology* 64, no. 3 suppl. (1927): S1–S76; Henry

Dale, 'Sir Michael Foster, K.C.B., F.R.S. A Secretary of the Royal Society,' *Notes and Records of the Royal Society*, London 19, no. 1 (1 June 1964): 10–32.

47 Pollock, *Time's Chariot*, 146–7.

48 Sidney Colvin, *Memories and Notes of Persons and Places, 1852–1912* (New York: C. Scribner's Sons, 1921), 5–8.

49 Colvin, *Memories and Notes*, 61–4; R.L. Stevenson, *The Letters of Robert Louis Stevenson*, 2 vols., ed. Sidney Colvin (New York: Charles Scribner's Sons, 1899), 215–17.

50 Colvin, *Memories and Notes*, 126.

51 Pollock, *Time's Chariot*, 146.

52 Gernsheim, in his *The History of Photography*, gives the Stevenson print as an example of the technique. Helmut Gernsheim and Alison Gernsheim, *The History of Photography from the Earliest Use of the Camera Obscura in the Eleventh Century up to 1914* (Oxford: Oxford University Press, 1955), xxv. Wikipedia does the same: http://en.wikipedia.org/wiki/Platinum_prints.

53 Colvin, *Memories and Notes*, 126.

54 Ragnar Granit, *Charles Scott Sherrington* (London: Nelson, 1966), 50.

55 Colvin, *Memories and Notes*, 126.

56 Pollock, *Time's Chariot*, 146.

57 Walter Langdon-Brown, *Some Chapters in Cambridge Medical History* (Cambridge: Cambridge University Press, 1946), 92. 'In telling anything of special interest that had happened to himself, Dew-Smith had a trick of avoiding the first person singular, and instead of saying "I did" or "I felt" so and so would say abstractly in the third, "one did" or "one felt." This scrupulous manner of non-egotism, I remember, came with specially odd effect when one day he was telling us how an official at a railway station had been offensively rude to him. "What did you do?" he was asked, and replied in a deprecating voice, "Well, you know, one had to put him through the door-panels." It is this aspect of Dew-Smith's character which no doubt suggested, although it did not really much resemble, the ruthless task-master, the man of stern Calvinistic doctrine and iron fatalism, who is the other half of Stevenson's Attwater.' Colvin, *Memories and Notes*, 126–7.

58 Foster, 'In Memoriam,' 262.

59 In the 1880s and 1890s, Fairfax Murray acquired *America* copy P, *Thel* copy G, *Descriptive Catalogue* copy G, *Jerusalem* copy H, *Marriage of Heaven and Hell* copy K, and *Songs of Innocence and of Experience* copy Z (*BB* 105, 127, 138, 261, 300, 425).

60 David Elliot, *Charles Fairfax Murray: The Unknown Pre-Raphaelite* (New Castle, DE: Oak Knoll, 2000), 163, 164.

61 Raverat, *Period Piece; a Cambridge Childhood*, 203. Gwen Raverat was daugh-

ter of George Darwin, married to Jacques Raverat and sister to Margaret, who was married to Geoffrey Keynes. One of the instruments the workshop designed and made was a microtome, which facilitated the cutting of thin sections of tissues for microscopic examination.

62 See Margaret Elizabeth Keynes, *A House by the River* (Cambridge: Privately Printed, 1984), 64. I am grateful to Robert Essick for bringing this reference to my attention. Dew-Smith made a platinotype of Margaret Darwin in 1894. He reproduced (and restored) an old and faded photograph of Charles Darwin by Messrs. Maull and Fox, circa 1854, used in Francis Darwin's *Annals of Botany*, xiii, 1899. The A.E. Shipley, and James Crawford Simpson, *Darwin Centenary, The Portraits, Prints and Writings of Charles Robert Darwin, Exhibited at Christ's College, Cambridge*, 1909, included a 'Portrait of Charles Darwin ... by the late A. Dew-Smith, Esq., of Trinity College' (no. 103).

63 Available at http://www.darwinproject.ac.uk/darwin/search/advanced?query=subject:%22%3Csocietal%3E+Cambridge+Scientific+Instrument+Co%22.

64 Available at http://england.prm.ox.ac.uk/noajax-individuals.foo?i_l=D&i_id=1957.

65 Foster, 'In Memoriam,' 262, 261.

66 Ibid., 262.

67 Sharpey-Schafer, 'History of the Physiological Society.'

68 Foster, 'In Memoriam,' 262.

69 Colvin, *Memories and Notes*, 126.

70 The Sotheby's catalogue states: 'MS note on the fly-leaf in the autograph of Mr. Dante G. Rossetti states that the volume was formerly in the possession of Mr. Tatham, a friend of Blake's. It was exhibited at the recent Blake Exhibition. The notes are of great interest and value' (Sotheby Auction Catalogue, London, 29–30 January 1878). *BB* makes no mention of Rossetti's hand, and with good reason: it is dated 1839, when Rossetti was just 11 years old. The Burlington Fine Arts Exhibition records this volume as belonging to Mr Kirby, who can now be added to its known provenance as recorded in *BB* (696).

71 Sotheby Auction Catalogue, London, 27–30 June 1906.

72 Whitman writes to William Michael Rossetti, 5 May 1876 to tell him that 'the books, according to list sent, will now be prepared, packed, & sent (together with your & Mrs. Gilchrist's copies, which have been waiting) probably to London express'; the books are *Leaves* and *Rivulets*, '(the latter Vol., as you see, includes *Memoranda of the War* as a constituent part) ... I send my love & thanks to W B Scott – I shall try to write a line to him, to C

W Reynell, to J L Warren, to A G Dew-Smith, & one or two others, soon as I can.' He sent Dew-Smith his two volumes on 19 May 1876. Walt Whitman, *The Correspondence: Volume III: 1876–1885*, ed. Edwin Haviland Miller (New York: New York University Press, 1964), 44, 45n6.

73 Geoffrey A. Keynes and Edwin Wolf, *William Blake's Illuminated Books: A Census* (New York, Grolier Club of New York, 1953), 59. It is interesting to note that the impressions of *Songs* copy J also have fake platemarks. They were trimmed to 'within 0.5 cm of the etching, skillfully inlaid into larger sheets (13.1 × 19.7 cm), carefully indented at the join of the inner and outer leaves (perhaps, as Keynes & Wolf [59] suggest, "by putting each print, damped, in press with a blank plate") to look like platemarks' (*BB* 416).

74 *The Academy*, February 9, 1878: 119.

75 Ibid., 131.

76 Shirley, 'Bibliomania in 1879,' *Fraser's Magazine for Town and Country*, July 1879, 71–88. 'Shirley' is a man, referred to in *Fraser's Magazine for Town and Country*, March 1880, page 370, as 'our brother-contributor the accomplished "Shirley."'

77 Shirley, 'Bibliomania in 1879,' 74.

78 Ibid., 73, 74.

79 Ibid., 74.

80 Ibid., 75.

81 Ibid., 76.

82 Ibid.

83 Ibid., 81.

84 Gilchrist, *Life of Blake*, 'Pictor Ignotus' (1863), I, 370.

85 Shirley, 'Bibliomania in 1879,' 82.

86 Jerome McGann, *The Textual Condition* (Princeton: Princeton University Press, 1991).

87 Shirley, 'Bibliomania in 1879,' 84.

88 Ibid., 83.

89 Ibid., 84.

90 'Table Talk,' *The Gentleman's Magazine*, vol. ccxlii, January to June 1878 (London: Chatto & Windus, 1878): 626.

91 The 1878 sale also included works with facsimiles, including W.Y. Ottley's *'Inquiry into the Origin and Early History of Engraving*, 2 vol. numerous facsimiles, half morocco, uncut, top edges gilt, scarce, 1816' (lot 225), and Rembrandt's *'L'Oeuvre* decrit et commente par M. Charles Blane, 2 vol. imperial 4to. With 40 etchings by Flameng, and 35 Heliographs by Amand Durand, half green morocco, uncut, top edges gilt. Paris, 1873' (lot 258).

92 One of the earliest uses of photolithography for book reproduction is

Blake's *The Book of Job* engravings in Gilchrist's *The Life of Blake* (1863). See Joseph Viscomi, 'Blake after Blake: A Nation Discovers Genius,' in *Blake, Nation and Empire*, ed. Steve Clark and David Worrall (London: Palgrave, 2006), 239–62.

93 O'Conner, *Founders of British Physiology*, 182.

94 Foster, 'In Memoriam,' 262.

95 Ibid., 261–2.

3 Blake's Painting Materials, Technical Art History, and the Legacy of G.E. Bentley Jr

JOYCE H. TOWNSEND AND BRONWYN A. ORMSBY

Introduction

Studies of artists' materials and technical art history open a door to the understanding of an artist's creativity and personality when they are linked to the working method and chosen lifestyle of an artist. This open door is a good point of entry to art collections, particularly for those who have no training in art history: it makes a high level of artistic skill comprehensible, and therefore more accessible and admirable. This door can also lead art historians, who are rarely practising artists, into new understanding of artists' intent and the ways in which the aging of art materials can seriously mask intent. The greatest art historians and teachers of art know that appreciation of artistic skills as well as subject matter and/or iconography lead to a better understanding of the artist's message. G.E. Bentley Jr is a scholar in this modern tradition – indeed, he is its earliest exponent in the case of William Blake. Bentley's life's work has constantly demonstrated the value of studying the material content of the work of art in as much detail as one examines the artist's writings and ideas, in order to gain a holistic and deeper understanding and appreciation of his work. Bentley's attention to all other facets of Blake's life makes possible the grand synthesis that takes scholar, specialist, and art lover alike closer to Blake the man.

Blake's uses of engraving and the printing methods he invented which were capable of producing more than one coloured copy were not only innovative, and matched to technological developments in his era, but also obscure. There has been endless speculation about his techniques, including contributions from Bentley.[1] Blake's own writings on art throw some light on these questions but resist definitive interpretation.

William Blake has at least three audiences today, whose members would assert that their own creative output owes much to his inspiration and ideals: writers and poets, individuals with democratic or progressive politics, and artists who seek to portray states of mind as well as outward appearance. In the later twentieth century and indeed into the twenty-first century, Blake's art has been viewed more in terms of message than medium. Yet the medium *is* also part of the message. The choice of painting medium influences the success of execution and partly determines whether an artist's work survives into the future to inspire others. The wrong choice of painting medium can condemn art to send a limited or muted message to later generations. This has been the fate of much of Blake's pictorial output and explains why it is the least considered of his achievements.

This paper discusses the motives that inspired our research into this understudied aspect of Blake's output, the way it developed, and its findings in the context of other technical studies on Blake. It then discusses the transmission of such research to a wider public than Blake scholars. Finally, it presents recent thoughts on Blake's use of metal supports for his temperas, a topic that aligns very closely with Bentley's extensive research into Blake's chalcographic printing.

Filling a Knowledge Gap: *William Blake, The Painter at Work* (Tate 2003)

William Blake, The Painter at Work (2003) was the second in an intermittent series of Tate books on artists' materials and techniques in context, the others having covered J.M.W. Turner and the Pre-Raphaelite Brotherhood.[2] Several research projects[3] were presented together in *Blake the Painter* to gain new knowledge of the way Blake worked with coloured materials and to use this information to understand *why* and *to what extent* his temperas, watercolours, and colour prints have changed with time. Only with such understanding can Blake's message be appreciated today. The temperas, which Blake himself called 'frescoes,' were the most neglected and complex by far of these three groups, and the most research time, and words, were devoted to them. Indeed it was obvious to us – as it is to all conservation professionals, accustomed as they are to thinking about the physicality of a work of art – both that there have been considerable changes in appearance in many of Blake's temperas, and that the temperas have altered more than any other group within Blake's *oeuvre*. The fairly well-known fact that large numbers of

Blake's works in tempera have not survived gives an obvious clue to their propensity for rapid deterioration, and one that was highlighted recently in '*The grand Style of Art' restored: William Blake's 1809 Exhibition*, held at Tate Britain, London, in 2009 (plates 1 and 2, this volume). This brought together almost all[4] the surviving works from Blake's 1809–10 exhibition of sixteen 'frescoes' and watercolours, based on Blake's own *Descriptive Catalogue* (1809) which has been recently discussed elsewhere,[5] and which was reprinted with a contemporary commentary to accompany the 2009 exhibition.[6] There were six vacant spaces on the walls marking the six lost works, captioned with titles, medium, and dimensions where these are known.

In order to understand the materials in Blake's temperas, several lines of enquiry had to be pursued. First, methods of materials analysis that would work on suitably small samples (the size of a pinhead, or less) had to be sought out, compared, and made more suitable for successful analysis of the expected materials. For this reason the project was undertaken as doctoral research by a conservation scientist with experience in the conservation of artists' materials, their application, and their behaviour.[7] Once the components of the paint medium were known – that is, once it had been confirmed that his painting medium was indeed water based, and therefore correctly described as 'tempera' – it became obvious that Blake's decision to apply such a medium to fairly flexible supports like canvas, paper or copper sheets, and his early habit of reworking the painting surface, combined with nineteenth-century restoration techniques far more suited to oil paintings, was the cause of the deterioration that manifests today as severe darkening, cracking, and extensive paint loss. Their appearance today – even their survival – depends critically on their history. A rare surviving example still in excellent condition is *The Body of Christ Borne to the Tomb* (c. 1799–1800), which is also the only one of the temperas studied during this project that may today be housed in a frame of Blake's personal choice (plate 3, this volume). In sad contrast, examples in poor condition are not difficult to find. One which is particularly difficult to appreciate today is *The Bard, from Gray* (1809?) (plate 4, this volume), whose altered appearance can be attributed to early glue lining, a treatment appropriate to an oil painting but not to one on a chalk and glue ground. Another is *Satan calling Up his Legions – An experiment Picture* (c. 1795–1800, Victoria and Albert Museum, London, B661), whose working and reworking Blake wrote was 'a great labour,' of which indeed 'the labour has destroyed the lineaments, it was with difficulty brought back again to a certain

effect, which it had at first, when all the lineaments were perfect.'[8] This would imply it was already significantly altered by the 1809 exhibition, and even earlier.

And what *were* the expected materials in Blake's temperas? The starting point for our research was the historical sources dating from Blake's own day, which provided information that had previously been missed by researchers who did not have artistic production at the forefront of their minds. Accordingly, this material was assembled in the publication *Blake the Painter* for ready assessment by future scholars, as well as by ourselves.[9] It was then necessary to delve deeper into the artists' materials available in Blake's lifetime, through studies of the importation of plant gums and other painting materials into London, and by examining the artists' manuals, watercolour cakes and recipe books of the period.[10] The only one of these manuals easily obtained today is by the watercolour artist David Cox, and it does not discuss the paint medium in any detail.[11] Surviving records from artists' colourmen such as Winsor and Newton, Roberson, and Reeves, who supplied both ready-made paints and raw materials in Blake's era, are far more informative, and they have been used recently to reconstruct watercolour recipes from the time of J.M.W. Turner and Blake.[12] Although Blake lived and bought goods in the capital city of a country undergoing the world's first industrial revolution – in fact, he could have bought almost any painting material he dreamed of, albeit at a high price, and years sooner than artists in other countries – we found that he used only a very narrow, unchanging range of inexpensive pigments (Prussian blue, indigo, vermilion, red ochre, brazilwood, gamboge, yellow ochre, carbon black; plus ultramarine and red lakes for the temperas), and that the paint medium he regularly prepared for the temperas (gum Arabic, gum tragacanth and added sugar) was more complex than his colour mixing. These choices say something intriguing about his character, his priorities, and his practical mind. The particular and quite complex mixture of gums, animal glue, and sugar that he employed for the painting medium of the temperas[13] gave him the immediate 'jewel-like' visual effects he sought, yet were fatal to their preservation, because such a mixture darkens severely through a chemical reaction well known in both food science and biology, the Maillard reaction. This occurs when sugars (which include honey and plant gums) and amines (proteins which include animal glue) are mixed together, and it leads to the development of brown reaction products. In other words, it is responsible for the significant darkening of a paint medium such

as Blake's. He used the same materials, in simpler combinations, for the paint medium of his colour prints, and chose the same range of colours. An even narrower selection sufficed for his watercolours,[14] whose colours were previously investigated by Maheux, who also undertook research on a group of works complementary to the works studied here.[15]

The printing processes Blake used to create limited copies of the large colour prints are disputed to this day, and the most insightful studies (noted earlier) have used practical printing, as well as close studies of Blake's prints, to shed light on their production and to highlight impractical ideas as untenable. Some studies have been undertaken by skilled printers and engravers who work with presses similar to those used in Blake's era, and others have been undertaken by materials historians who understand how the papers used by Blake would respond to printing and painting, and who can clarify why he used particular types of paper in preference to others.[16] That in spite of his small income Blake used high-quality and expensive papers that would withstand high pressure from the printing press, and take ink and colour in a predictable way, again shows where his priorities lay.

Blake the Painter also includes a substantial section which considers the living and workshop spaces occupied by Blake throughout his life; it discusses the practicalities of working in a very confined space, and then taking the finished works downstairs and outdoors for exhibition,[17] while storing day-to-day supplies and his lifetime's output in the same building. This model of scholarship and meticulous attention to detail, combined with insight and common sense, brings to mind Bentley's life-long studies of Blake's chalcographic printing processes, processes which permitted both text and image to be reproduced in multiple copies, with subtle to significant variations in each 'copy.'

The main aim of *Blake the Painter* was to assemble all of the information pertinent to Blake's painting practice, as exemplified by his works now at Tate, or available in other UK collections. The book grew out of a wish to add value to the results of a number of research projects, and to make their findings accessible to a non-professional audience and to artists, as well as to Blake scholars. Studies of Blake's works now in overseas collections have still to be undertaken. In fact the sections on Blake's colour printing methods,[18] the coincidentally simultaneous conservation treatment of a newly acquired Blake print during the writing process,[19] and the presentation of Blake's paintings[20] were commis-

sioned once the book had begun to facilitate a fuller overview of the artistic choices Blake made and the ways in which later decisions about treatment and display, taken by curators and conservators, have either preserved or devalued his choices. The draft of the book was sent out for review by Blake scholars, and it may be permissible to say here that one of them was Bentley.

Building on Blake the Painter and Other Blake Technical Research

New information enables old questions to be answered at last, or at least in more detail than previously possible. One such question concerned the authenticity of a suspected Blake palette for oil paint at the Victoria and Albert Museum, London, which would have to date from circa 1780 – the only period of his life when he painted in oil. It would be the only such Blake relic if it were genuine. Materials analysis, cross-checking with the materials he used in practice, and a careful comparison of the materials historically available to Blake[21] (because they were used by his British contemporaries such as Turner)[22] indicated that the palette cannot have been used by Blake circa 1780, since its most likely date of use was circa 1834–45.[23]

Gallery displays demonstrating how an artist achieved mastery are always popular, and have become more common in recent decades. Their production generally involves conservators and conservation scientists, materials historians, and sometimes practising artists who can demonstrate artistic skills to an audience, as well as art historians and scholars who have spent years studying the artist in question. One such display entitled *Blake at Work* was mounted at Tate Britain in 2004–5. It was based on *William Blake, The Painter at Work*, and was set up in the room long devoted to Blake displays (plates 5 and 6, this volume). Its captions were later reviewed and reproduced for a wider audience in *Blake Quarterly*.[24] A one-day conference was also held at Tate Britain at the same time.[25] It also showcased ongoing UK-based research into Blake's materials, which has since been completed and published. This research included Blake's use of gold and silver in paintings and illuminated books;[26] a study of the reverse sides of Blake's copperplates, which reveals corrections he made during the engraving process;[27] and another on the materials used in his separate colour prints.[28]

Several new reassessments of Blake's working spaces have also recently been carried out, contributing new information to Hamlyn's discussion of Blake's workshop practice;[29] his printmaking workshop

in 13 Hercules Buildings, Lambeth;[30] the cottage at Felpham – including new information on the building's history;[31] and his last home at 3 Fountain Court, Strand.[32]

Blake's Use of Metal Supports for His Temperas

In addition to Blake's choice of medium and his working environment, we need to consider his choice of support. Viscomi has offered the following general description of Blake's use of metal: 'Blake worked *on* rather than *in* the metal surface, as though it were paper, with tools that enabled him to work outside the conventions and codes of printmaking and indulge his love of drawing and writing.'[33] At least six of Blake's seventy or so surviving temperas, somewhat unusually for the time, were painted on metal supports and were often catalogued as 'oil on copper' by early Blake scholars. Blake is known to have reused his copperplates[34] and it is likely that his tempera painting supports were engraving plates no longer considered fit for the purpose. The majority of the information on Blake's use of metal supports originates from scholarship on Blake's design, printing, and engraving techniques. In one important recent study, Bentley stated that copper was 'enormously important to Blake,'[35] that he worked with it on a daily basis, and that many pieces apparently survived his death in 1827, until they were subsequently lost/stolen or possibly sold for scrap.[36]

In Blake's day, copper sheets were smelted, hammered, and rolled to achieve a desired thickness by coppersmiths, where the desired thickness 'depended upon the intended surface dimensions of the finished plate.'[37] From the variety and non-uniformity of the dimensions of the metal supports used by Blake, it is probable that he cut the plates by hand from larger copper sheets. However, it is also possible that Blake or his patrons also bought plates (polished or not) that had been cut down by a vendor. The edges of the copper sheets intended for engraving were frequently bevelled so that 'the sharp metal would not cut the paper when printed under enormous pressure.'[38]

Of the tempera paintings on metal supports, at least six were completed during the years 1799–1800 as part of the commission by Thomas Butts for fifty small paintings,[39] destined to hang in one room of Butts's house in the manner of a 'traditional collector's cabinet.'[40] According to Bentley, this group stayed in London with Butts when the Blakes moved to Felpham.[41] Three of the group have similar dimensions of approximately 270 × 380 millimetres, including *The Agony in*

the Garden (Tate N05894: plate 7, this volume), *Eve Tempted by the Serpent* (Victoria and Albert Museum, P28-1953), and *The Nativity* (Philadelphia Museum of Art, 64-110-1). *The Miracle of the Loaves and Fishes* (private collection) is larger, at 327 × 494 millimetres. As it is difficult to see the surfaces of these plates under several layers of paint and varnish, it is not surprising that there is no visible evidence of engraving.

Most of Blake's surviving temperas on metal are on copperplates; however, one, *The Agony in the Garden*, is painted on tinned steel.[42] It has been suggested that this plate may have been salvaged from abandoned attempts at etching,[43] or might, due to the bevelled edges, have originally functioned as a box lid – perhaps from a paint box.[44] The tempera painting on metal with the latest date is *The Horse*, painted circa 1805, during a period in Blake's life when he was experimenting with miniatures. This copperplate has dimensions of 107 × 67 millimetres and is etched on the reverse with foliage and practice strokes – probably not done by Blake.[45] Butlin suggested this painting might be one of the 'little high finish'd Pictures' recorded as being 'in progress' in 1808.[46]

The money Blake spent on copperplates is known from Bentley's research,[47] and it is clear is that he would have spent far more on his copperplates than on the fairly standard and inexpensive individual pigments, plant gums, and glues he used for his paint layers. Engravers who worked to commission received advance payments for expensive copper and paper supplies, but Blake would have had to bear much of the cost himself in anticipation of later sales.

The condition of the works in tempera on metal vary from relatively sound – for example *The Horse* has fewer and thinner paint layers than other examples and remains in good condition – to extremely unstable, with severe and ongoing paint delamination problems, which are particularly prevalent in *The Agony in the Garden* (plate 8, this volume) and *The Miracle of the Loaves and Fishes*. Indeed, many of Blake's temperas 'began to flake badly from an early date, especially those on copper.'[48] Blake's tempera materials were consistent throughout and included plant gum and animal glue binders with added sugar, chalk-glue grounds and, as mentioned, a restricted palette of pigments which he tended to use pure and unmixed.[49] He also often layered unpigmented animal glue between paint applications and sealed paint layers with a final coating of animal glue, inevitably followed by at least one natural resin varnish layer.

In consequence, these often thick, moisture-sensitive paint films have contracted over time, creating a tendency to delaminate, enhanced by the poor adhesion of the chalk and glue grounds to the metal supports. Pockets of original paint on the most damaged paintings exhibit the circular cracking typical of Blake's temperas on metal, and also the stress fractures seen in most of Blake's medium-rich paint layers. In most cases, delamination has occurred at the metal-ground interface, resulting in significant loss of original paint. An artist of Blake's experience would have been aware of the different ways in which paint adhered to metal and to canvas and that the surfaces of the metal plates required preparation; including roughening and/or coating with a layer of oil and lead. Indeed Blake applied an additional pigmented layer directly to the metal on two of his temperas. *The Nativity* has a preparatory tempera layer containing Mars red and vermilion, and *The Agony in the Garden* has a tempera layer containing red lead pigment. Unfortunately, the adhesion of these layers to the metal is also poor. It is probable that iron corrosion products are also partially responsible for the severe delamination of the paint on the face of *The Agony in the Garden*, though this could not be verified during recent examinations due to the extreme vulnerability of the paint layers. Another recent examination of the reverse of the plate identified a sulphur-based corrosion product, probably resulting from the exposure of the metal to atmospheric pollutants.[50]

Many of the temperas have also suffered periods of neglect; for example, *The Miracle of the Loaves and Fishes* was noted as being 'lost' for a period.[51] In addition, some paintings were stored in unsuitable environments after Blake's death.[52] *The Nativity* is an example of one of the more fortunate temperas on metal, as it was owned first by the Butts family until after Blake's death, then by J.C. Strange in 1863, and then by William Bell Scott in 1865, who wrote the following inscription on the reverse: 'Don't place this picture in the sun or near the fire, or it will crack off the copper! W.B.S 1868.'[53] Towards the end of his life Blake made use of wood panels as supports for tempera painting, possibly after witnessing the deterioration of his works on both metal and canvas.[54]

In addition to the inherent deterioration of his painting materials and the combined effects of neglect and environment, many of Blake's temperas have been restored several times, particularly those on metal supports. Indeed, some of the first restoration treatments occurred within

Blake's lifetime or shortly after his death.[55] As a result, the majority of the surviving temperas are now heavily retouched and impregnated with restoration materials such as wax, oil paint, and varnish. This combined with the often profuse cracking, flaking, and natural discolouration of Blake's materials has made these paintings the least legible of his entire *oeuvre*, and they are therefore, unfortunately, relatively difficult to appreciate.

NOTES

Robert. N. Essick, Los Angeles, California; Joseph Viscomi, Chapel Hill, North Carolina; Robin Hamlyn and Jacob Thomas, both formerly Tate, London; Nicola Costaras, Victoria and Albert Museum, London; Theresa Fairbanks, Yale Center for British Art, New Haven, Connecticut; Mark Tucker, Philadelphia Museum of Art, Philadelphia, Pennsylvania; and David Worrall, Nottingham Trent University have all contributed to the research discussed here. We thank Professor Nigel Llewellyn, Martin Myrone, and Stephen Hackney, all at Tate, for reviewing 'Blake's Painting Materials, Technical Art History, and the Legacy of G.E. Bentley Jr.'

1 Robert N. Essick, *William Blake Printmaker* (Princeton: Princeton University Press, 1980); Joseph Viscomi, *Blake and the Idea of the Book* (Princeton: Princeton University Press, 1992); Michael Phillips, *The Creation of the 'Songs' from Manuscript to Illuminated Printing* (London and Princeton: Princeton University Press, 2000); Robert N. Essick and Joseph Viscomi, *An Inquiry into Blake's Method of Color Printing*, first accessed 15 November 2001, http://www.rochester.edu/college/ENG/blake/inquiry/enhanced/index.html; Robert N. Essick and Joseph Viscomi, 'An Inquiry into William Blake's Method of Colour Printing,' *Blake/An Illustrated Quarterly* 35, no. 3 (2002): 74–103; Michael Phillips, 'The Printing of Blake's *America a Prophecy*,' *Print Quarterly* 21, no. 1 (2004): 18–38.
2 Joyce H. Townsend, *Turner's Painting Techniques*, 5th ed. (Tate Publishing, London: [1st ed. 1993] 2007); Joyce H. Townsend, J. Ridge, and S. Hackney, *Pre-Raphaelite Painting Techniques 1848–1856* (London: Tate Publishing, 2004).
3 N. Cahaner McManus and J.H. Townsend, 'Watercolour Methods and Materials Use in Context,' in *William Blake, The Painter at Work*, ed. J.H. Townsend with consultant ed. R. Hamlyn (London: Tate Publishing, 2003),

61–80B. Ormsby with J.H. Townsend, B. Singer, and J. Dean, 'Blake's Use of Tempera in Context,' in *William Blake, The Painter at Work*, ed. J.H. Townsend, 134–48; S.L. Vallance, B.W. Singer, S.M. Hitchin, and J.H. Townsend, 'The Analysis of Proteinaceous Artists' Media by High Performance Liquid Chromatography,' *LC-GC International* 10, no. 1 (1996): 48–53; Vallance, Singer, Hitchin, and Townsend, 'Development and Preliminary Application of a Gas Chromatographic Method for the Characterisation of Gum Media,' *Journal of the American Institute for Conservation* 37 (1998): 294–311.

4 Ten were shown, and one more was not available for the exhibition. The other five are lost.

5 T.R.C. Patenaude, 'Recovering William Blake's 1809 Exhibition,' *The British Art Journal* 4, no. 1 (2003): 52–63.

6 Martin Myrone, ed., *Seen In My Visions. A Descriptive Catalogue of Pictures. William Blake* (Tate Publishing: London, 2009). The exhibition includes a modern caption and a facsimile 'caption' from the *Descriptive Catalogue*.

7 B.A. Ormsby, 'The Materials and Techniques of William Blake's Tempera Paintings' (doctoral thesis, University of Northumbria at Newcastle, Newcastle-upon-Tyne, UK, 2002); J.H. Townsend, 'Analytical Methods,' in *William Blake, The Painter at Work*, ed. J.H. Townsend, 45–51.

8 B. Ormsby, with B. Singer and J. Dean, 'The Painting of the Temperas,' in *William Blake, The Painter at Work*, ed. J.H. Townsend, 126.

9 B. Ormsby and J.H. Townsend, with B. Singer and J. Dean, 'The State of Knowledge on William Blake, The Painter,' in *William Blake, The Painter at Work*, ed. J.H. Townsend, 40–4.

10 B.A. Ormsby, J.H. Townsend, B.W. Singer, and J.R. Dean, 'British Watercolour Cakes from the Eighteenth to the Early Twentieth Century,' *Studies in Conservation* 50 (2005): 45–66; B.A. Ormsby, J.H. Townsend, B. Singer, and J.R. Dean, 'Blake's Use of Tempera in Context,' in *William Blake, The Painter at Work*, ed. J.H. Townsend, 134–48.

11 David Cox, *Painting in Watercolours* (London, 1820 [reprinted by View Publications, Sydney, Australia, 2000]).

12 C. Caspers, 'Reconstructing British 19th-Century Watercolour Paint' (masters thesis, SRAL conservation programme, Maastricht, the Netherlands, 2008). The Winsor & Newton recipes for the nineteenth century have been catalogued in a page-image database, and can be consulted at Tate Britain and some other UK and Dutch institutions. Roberson records are held by the Hamilton Kerr institute, University of Cambridge, UK, and Reeves records by the Museum of London, UK.

13 B.A. Ormsby with B. Singer and J.R. Dean, 'The Painting of the Temperas,'
 in *William Blake, The Painter at Work*, ed. J.H. Townsend, 110–33.
14 J.H. Townsend, ed., *William Blake, The Painter at Work*, appendices 2, 4, and
 6.
15 A. Maheux, 'An Analysis of the Watercolour Technique and Materials of
 William Blake,' *Blake/An Illustrated Quarterly* 17, no. 4 (1984): 124–9.
16 P. Bower, 'The Vivid Surface: Blake's Use of Paper and Board,' in *William
 Blake, The Painter at Work*, ed. J.H. Townsend, 54–60.
17 R. Hamlyn, 'William Blake at Work: "Every Thing Which is in Harmony",'
 in *William Blake, The Painter at Work*, ed. J.H. Townsend, 12–39.
18 N. Cahaner McManus and J.H. Townsend, 'The Large Colour Prints; Meth-
 ods and Materials,' in *William Blake, The Painter at Work*, ed. J.H. Townsend,
 82–98.
19 P. Townshend and J.H. Townsend, 'The Conservation of a Large Colour
 Print,' in *William Blake, The Painter at Work*, ed. J.H. Townsend, 100–8.
20 J.H. Townsend, R. Hamlyn, and J. Anderson, 'The Presentation of Blake's
 Paintings,' in *William Blake, The Painter at Work*, ed. J.H. Townsend, 162–74.
21 J.H. Townsend, 'The Materials Used by British Oil Painters throughout
 the Nineteenth Century,' *Reviews in Conservation* 3 (2002): 46–55. Reprinted
 and updated as J.H. Townsend, 'The Materials Used by British Oil Painters
 throughout the Nineteenth Century,' *Tate Papers* 2 (Autumn 2004), avail-
 able at tate.org.uk/research.
22 J.H. Townsend, 'The Materials of J.M.W. Turner: Pigments,' *Studies in Con-
 servation* 38 (1993): 231–54.
23 J.H. Townsend, B. Ormsby, J. Jönsson, and M. Evans, 'Blake's Only Surviv-
 ing Palette?' *Blake/An Illustrated Quarterly* 39 (2005): 100–3; J.H. Townsend,
 B. Ormsby, J. Jönsson, and M. Evans, 'William Blake's Only Surviving Pal-
 ette?' *V&A Conservation Journal* 49 (2005): 20–1, available at http://www
 .vam.ac.uk/res_cons/conservation/journal/.
24 A. Capet, '*Blake at Work* exhibition, Tate Britain, London,' *Blake/An Illus-
 trated Quarterly* 38 (2004): 115–19.
25 *William Blake at Work*, organized by Joyce Townsend, David Worrall, and
 Robin Hamlyn, with assistance from Tate Education, on 30 April 2004
 at Tate Britain, London; 'Blake, Mattthias Koops and the Straw Paper
 Manufactory at Millbank,' presented by Keri Davies of Nottingham Trent
 University, UK, is published in this volume.
26 A. Whitehead, '"This Extraordinary Performance": William Blake's Use of
 Gold and Silver in the Creation of His Paintings and Illuminated Books,'
 Blake/An Illustrated Quarterly 42, no. 3 (2008): 84–108.

27 Mei-Ying Sung, *William Blake and the Art of Engraving*, History of the Book series (London: Pickering & Chatto, 2009).

28 R. Donnan, 'An Investigation of William Blake's Separate Colour Print: Examples in the National Gallery of Art, Washington D.C.,' *Conservation Research Studies in the History of Art*, National Gallery of Art, Washington, DC (forthcoming).

29 Hamlyn, *William Blake at Work*.

30 M. Phillips, 'No. 13 Hercules Buildings, Lambeth: William Blake's Print-making Workshop and Etching-Painting Studio Recovered,' *The British Art Journal* 5, no. 1 (2004): 13–21.

31 M. Crosby, '"The Sweetest Spot on Earth": Reconstructing Blake's Cottage at Felpham, Sussex,' *The British Art Journal* 7, no. 3 (2006): 46–53.

32 A Whitehead, 'William Blake's Last Residence: No. 3 Fountain Court, Strand. George Richmond's Plan and an Unrecorded Letter to John Linnell,' *The British Art Journal* 6, no. 1 (2005): 21–30.

33 John Viscomi, 'Blake's "*Annus Mirabilis*": The Productions of 1795,' *Blake/ An Illustrated Quarterly* 41, no. 2 (2007): 59.

34 G.E. Bentley Jr, 'Blake's Heavy Metal. The History, Weight, Uses, Cost and Makers of His Copper Plates,' *University of Toronto Quarterly* 76, no. 2 (2007): 759.

35 Ibid., 715.

36 Ibid., 732.

37 Ibid., 718.

38 Ibid., 719.

39 R. Lister, *The Paintings of William Blake* (Cambridge: Cambridge University Press, 1986), 13–15.

40 D. Bindman, *Blake as an Artist* (Oxford: Phaidon, 1977), 125.

41 Bentley, 'Blake's Heavy Metal,' 739.

42 J. Thomas, Tate analysis confirming through portable X-ray fluorescence that the support is tinned steel (unpublished report, 2007).

43 Hamlyn, *William Blake at Work*, 29–30.

44 A. Southall, Tate conservation record N05894 (1988).

45 Bentley, 'Blake's Heavy Metal,' 744.

46 Blake letter to Hayley 25 April 1808, see Martin Butlin, *The Paintings and Drawings of William Blake* (London and New Haven: Yale University Press, 1981), 312. Hereafter *B*.

47 G.E. Bentley Jr, *Blake Records* (Oxford: Clarendon, 1969).

48 Bindman, *Blake as an Artist*, 118.

49 Ormsby, Singer, and Dean, 'The Painting of the Temperas,' 110–33.

50 Thomas, Tate analysis report.

51 *B*, 330.

52 Mrs Gilchrist to John Linnell 11 December 1862, see G.E. Bentley, ed., *William Blake: The Critical Heritage* (London: Routledge, 1975), 267.

53 *B*, 328.

54 Alexander Gilchrist, *The Life of William Blake*, 2 vols. (London, 1863), 225.

55 B. Ormsby, with B. Singer and J. Dean, 'The Appearance of the Temperas Today,' in *William Blake, The Painter at Work*, ed. J.H. Townsend, 157.

PART TWO

'For Friendship's Sake': Friends And Patrons

4 New Light on the Mathews: Flaxman and Blake's Early Gothicism

DAVID BINDMAN

An account of the Reverend Anthony Stephen Mathew and his wife Harriet and their patronage of William Blake and John Flaxman was published by G.E. Bentley Jr in April 1958 in *Notes and Queries*.[1] The relationship between the two patrons and the two artists was of enormous importance to both Blake's and Flaxman's early careers. The Mathews were almost certainly responsible with Flaxman for the publication of Blake's *Poetical Sketches*, and John Thomas Smith recounts tantalizingly that at one of Mrs Mathew's 'most agreeable conversaziones' he had 'often heard him [Blake] read and sing several of his poems. He was listened to by the company with profound silence, and allowed by most of the visitors to possess original and extraordinary merit.'[2] Further light on this fourfold relationship can be found by looking closely at a group of surviving drawings by Flaxman from this early period. A number of these drawings, I will argue, were actually inscribed by Mathew, who may also have owned them.

Some of these drawings were published by the great English drawings collector Iolo Williams in June 1960 in the *Burlington Magazine*,[3] although Bentley was already aware of their existence. Iolo Williams argued convincingly that a number of the drawings, many of which inexplicably had fake monograms of James Ward, the animal and landscape painter, and which were all characterized by a bold 'F' in pen on or near the top of the drawing, were attributable to Flaxman in his early years. These included studies for the famous finished drawing of *Despair offering a bowl of Poison to Chatterton* (British Museum) (fig. 4.1), portraits of Mr and Mrs Mathew and their children, a Gothic doorway, a classical cottage in woods, and a head of Ossian. Many of them are inscribed in pen – Williams assumed by Flaxman – but Bentley had

already realized that the inscription on one of them was not by Flaxman but was probably by Mathew. This is a drawing of an elegant neoclassical country house (British Museum) (fig. 4.2), inscribed in pen 'Ideal improvement of my Cottage in Cranbourne Wood,' to which another contemporary hand has added in pencil 'Mathew.' In any case, the author of the pen inscription is unlikely to have been Flaxman because it is improbable that a penurious sculptor, who was forced to do menial work for Josiah Wedgwood to enable him to go to Rome, would have owned and thought of making improvements to a country house, nor does it particularly resemble Flaxman's known writing. We know also that the Mathews were quite wealthy because with Flaxman's help they bought paintings from Angelica Kauffmann in Rome for the large sum of £200.[4]

What has not been observed before is that the inscriptions on several other early drawings by Flaxman, some with the inscribed 'F' and some without, also appear to be in the same hand, which we can be reasonably sure is that of Mathew. A sketch for *Despair offering a bowl of Poison to Chatterton* is inscribed 'Chatterton taking a bowl of poison,' and it looks like the same hand that has inscribed the title on the large double sheet of *The Massacre of the Britons at Stonehenge* (Cambridge, Fitzwilliam Museum) in illustration of Chatterton's *Battle of Hastings (II)*, and belonging to an album of Flaxman's early drawings.[5] The inscriptions strongly suggest that Mathew was directly involved in Flaxman's early attempts at illustrating Chatterton, and he may well have commissioned the finished drawing of *Despair offering a bowl of Poison to Chatterton,* as well as the drawings for Chatterton's poems in both the Fitzwilliam and the British Museums.

It is particularly intriguing in this regard to consider an unpublished early Flaxman drawing that lacks the 'F' (British Museum) (fig. 4.3) but which is inscribed in bold pen 'Englysh Metamorphosis bk[?] 1st V:84 / Rowley's Poems.' This illustrates a passage in the poem in which the river Severn and Vincent's Rock are created Ovid-style by a giant, who killed Sabryna and Vyncente by tossing a mountain on them.[6] The same hand has inscribed the attribution 'Blake' next to the inscription. This might seem to be a later misattribution, but it appears to be in the same ink, and, though the writing is larger and more confident than the other inscriptions mentioned, I think there is a good chance that it is also in Mathew's hand, especially as it correctly identified the subject and its source, though perhaps at a later date than the others. If so then he, or whichever contemporary wrote it, must have thought the drawing

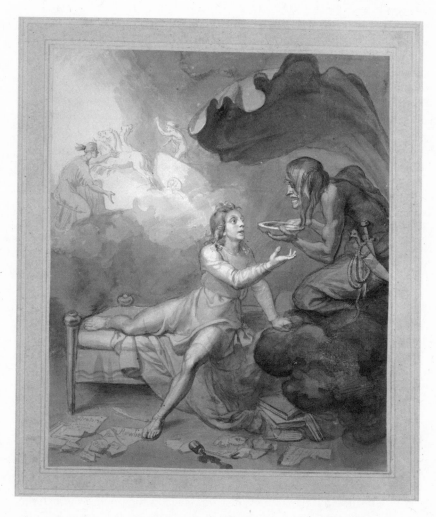

4.1 John Flaxman, *Despair offering a bowl of Poison to Chatterton*, pen and wash. British Museum

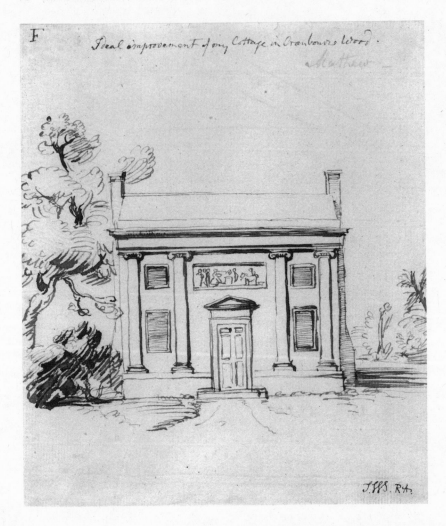

4.2 John Flaxman, 'Ideal improvement of my Cottage in Cranbourne Wood,' pen and pencil. British Museum

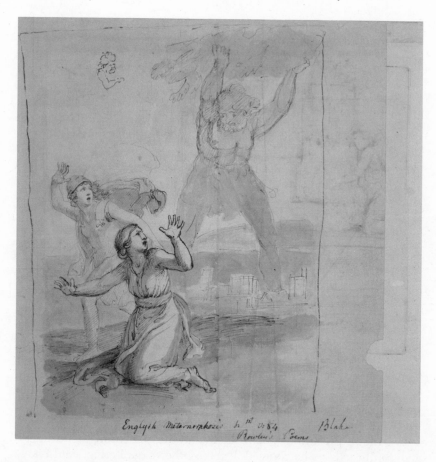

4.3 John Flaxman, *Scene from Englysh Metamorphosis in Chatterton's Rowley's Poems*, pen, pencil, and wash. British Museum

was by Blake, though it is indisputably by Flaxman. Certainly it is in a more fanciful style than most of Flaxman's early drawings, and perhaps gives a clue to Blake's early reputation as an artist.

In any case, these drawings suggest an active engagement on the Mathews' part in Flaxman's and Blake's early career, and it also makes Smith's account of the Mathews' participation in the production of *Poetical Sketches* more plausible: 'This lady [Mrs Mathew] ... was so extremely zealous in promoting the celebrity of Blake, that upon hearing him read some of his early efforts in poetry, she thought so well of them, as to request the Rev. Henry Mathew, her husband, to join Mr Flaxman in his truly kind offer of defraying the expense of printing them; in which he not only acquiesced, but, with his usual urbanity, wrote the ... advertisement, which precedes the poems.'[7]

Whether Mathew wrote the advertisement or not is highly controversial – certainly if he had done so its language suggests that it was under Blake's watchful eye. It emphasizes the poet's 'untutored youth,' and it points out that the poems were 'commenced in his twelfth, and occasionally resumed by the author till his twentieth year.' This is surely intended to evoke a comparison between the young Blake and Chatterton, the brilliant youth who was also supposed to have started writing his first poems at the same age, though of course he was to commit suicide at the age of seventeen in 1770. It will be for literary historians to decide how 'Chattertonian' the *Poetical Sketches* really are, but there are some medieval poems in it that certainly bear Chatterton's influence along with the latter's own mentors, Shakespeare, Thomas Gray, and Horace Walpole. Furthermore it is not hard to see that Blake himself, with his precocious poetic talent and the 'unbending deportment' that Smith tells us he showed at the Mathews' gathering, could have seemed to them to be a new Chatterton who had survived to flourish beyond his early youth, thanks to their efforts, as the earlier poet did not.

As it happens, new light has recently been shed on the relationship between Chatterton, Flaxman, and Blake in a book by William Pressly.[8] He notes that Chatterton's reputation was at its height some years after his death, in the late 1770s, when republication of his poems and critical pieces led to him being compared even with Shakespeare as a genius forced to abase his talent by the ignorance of society.[9] This dates his emergence as 'the archetypal romantic poet, one of whom the world was not worthy'[10] precisely at the point that Blake came to the notice of the Mathews. Pressly dates the young Flaxman's interest in Chatterton

to the year 1780 when he exhibited at the Royal Academy a 'Sketch for a Monument to Chatterton,' although the evidence of a later drawing of it shows no relationship to the artist's drawings of *Despair offering a bowl of Poison to Chatterton*.[11] Pressly argues persuasively that the figure of the poet in the latter drawing has the face of Flaxman himself, suggesting intriguingly an identification with the deceased poet. However, Pressly's most far-reaching claim is of Blake's identification with Chatterton, which he feels achieved its fruition in the famous print *Albion Rose* or *The Dance of Albion*, and which he argues is 'an image of Blake as Chatterton in the same manner as Flaxman's conception of himself as Chatterton.'[12] While I think this is a little far fetched, especially in its comparison of Blake's figure to Flaxman's drawings of Chatterton, it is certainly possible that a reading of the deceased poet might have contributed to the sun-like attributes of Albion.

In *Nollekens and His Times* (1828), John Thomas Smith also mentions that Flaxman was responsible for some Gothic decoration in the Mathews' house: 'Mr. Flaxman in return for the favours he had received from the Mathew family, decorated the back parlour of their house, which was their library, with models, (I think they were in putty and sand,) of figures in niches, in the Gothic manner; and Oram painted the window in imitation of stained-glass; the bookcases, tables, and chairs were also ornamented to accord with the appearance of those of antiquity.'[13] Iolo Williams assumed that another early Flaxman drawing bearing the 'F' was connected with this decorating scheme. This Flaxman drawing (collection of the late Edward Croft-Murray) has been identified for me by Christopher Wilson as the entrance to the Chapter House of Westminster Abbey, the doors of which were blocked at the time, with a group of angels in adoration of the Virgin Mary reconstituted by the artist.

It is difficult to see how this elaborate doorway would have been incorporated into a scheme of domestic decoration, but I can offer as a more plausible candidate, a recently discovered drawing (London, private collection) (fig. 4.4) also bearing the 'F.' This shows samples of medieval decoration and a chair seen from two aspects. The four-sectioned pattern in the middle is of diaper work characteristic of Westminster Abbey dating from the mid-thirteenth century, the window on the left is adapted from standard Perpendicular dating from the fifteenth or early sixteenth century, also of a kind visible in the Abbey, while the chair is in a generic 'Gothick' style, deriving more from Horace Walpole than from any real medieval precedent, and looking forward to the

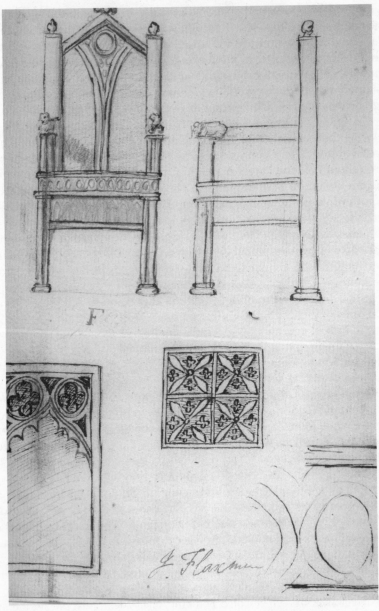

4.4 John Flaxman, *Studies for Gothic decoration here identified as for the Mathews'*
house. Private Collection

Puginesque wooden hall chairs so popular in the nineteenth century. The chair's very simple construction suggests that it is the sort of thing that could have been knocked up easily by a local carpenter, and the other decorative elements could also have been produced easily. Unfortunately, we have no record of the 'models ... in putty or sand' made by Flaxman, but they may well have looked like the famous Gothic chessmen he designed for Wedgwood in 1783 and which were in production by 1785.[14]

What the patronage of the Mathews of both Flaxman and Blake makes abundantly clear, and which Bentley has been fully aware of throughout his long career of elucidating Blake, is that Blake's accomplishments as both visual artist and poet fitted in perfectly with his most important youthful circle. The common factor was a new appreciation of the Gothic not as an antiquarian pursuit but as a living inspiration for both artists and poets, presided over by the shade of the brilliant youth from Bristol who had died tragically from neglect only about ten years before.

NOTES

1 G.E. Bentley Jr, 'A.S. Mathew, Patron of Blake and Flaxman,' *Notes and Queries*, April (1958): 168–78.

2 J.T. Smith, *A Book for a Rainy Day* (London, 1845), 81–3; G.E. Bentley Jr, *Blake Records* (Oxford: Clarendon, 1969), 26. Hereafter *BR*.

3 Iolo A. Williams, 'An Identification of Some Early Drawings by John Flaxman,' *Burlington Magazine* 102, no. 687 (16 January 1960): 246–50.

4 Bentley, 'A.S. Mathew,' 174

5 D. Bindman, ed., *John Flaxman* (London: Thames and Hudson, 1979), cat. no. 9.

6 The queene Gendolyne sente a gyaunte knyghte,
 Whose doughtie heade swepte the emmertleynge skies,
 To slea her wheresoever she shulde be pyghte,
 Eke everychone who shulde her ele emprize.
 Swefte as the roareynge wyndes the gyaunte flies,
 Stayde the loude wyndes, and shaded reaulmes yn nyghte,
 Stepte over cytties, on meint acres lies,
 Meeteynge the herehaughtes of morneynge lighte;
 Tyll mooveynge to the Weste, myschaunce hys gye,
 He thorowe warriours gratch fayre Elstrid did espie. (80)

He tore a ragged mountayne from the grounde,
Harried uppe noddynge forrests to the tide,
Thanne wythe a fuirie, mote the erthe astounde,
To meddle ayre he lette the mountayne flie,
The flying wolfynnes sente a yelleynge crie;
Onne Vyncente and Sabryna felle the mount;
To lyve æternalle dyd theie eftsoones die;
Thorowe the sandie grave boiled up the pourple founte,
On a broade grassie playne was layde the hylle,
Staieynge the rounynge course of meint a limmed rylle. (90)

7 John Thomas Smith, *Nollekens and His Times* (1828) vol. 2, and quoted in *BR*, 456.
8 William L. Pressly, *The Artist as Original Genius: Shakespeare's 'Fine Frenzy' in Late-Eighteenth-Century British Art* (Newark, University of Delaware Press, 2007), 163–83.
9 Ibid., 164.
10 Ibid., 165.
11 Reproduced ibid., 171.
12 Ibid., 179.
13 *BR*, 26–7.
14 Bindman, *John Flaxman*, nos. 45 a–d (reproduced).

5 'a Ladys Book': Blake's Engravings for Hayley's *The Triumphs of Temper*

MARK CROSBY

In a letter to Thomas Butts of 10 January 1803, Blake discusses his deteriorating relationship with William Hayley. Blake's frustration with his Sussex patron was centred on the engraving commissions he was then working on for Hayley: 'my unhappiness has arisen from a source which if explored too narrowly might hurt my pecuniary circumstances.'[1] This comment is prefaced by a more direct reference to the source of his unhappiness: 'As my dependence is on Engraving at present & particularly on the Engravings I have in hand for Mr H. & I find on all hands great objections to my doing any thing but the meer drudgery of business' (E 724). The engraving commission Blake had in hand was plates for a new edition of Hayley's most successful poem, *The Triumphs of Temper*. Blake executed six engravings after designs by John Flaxman's half-sister, Maria Flaxman. These engravings were published in the twelfth edition of the poem in 1803, and replaced the engravings after designs by Thomas Stothard, which had first appeared in the sixth edition in 1788, and which were also reprinted in the subsequent five editions until replaced by Blake's engravings.

In 1807 a rare thirteenth edition of the poem was published, which also reprinted Blake's engravings. The same year another thirteenth edition of the poem appeared. While the typesetting for the two thirteenth editions is identical, except for some minor changes to the title page, including the removal of any reference to Maria Flaxman, this second and more common thirteenth edition replaced Blake's engravings with the engravings after Stothard. After the *second* thirteenth edition, the next British edition containing illustrations was published in 1817 and included a selection of the Stothard engravings and a colour printed stipple frontispiece engraving by T.B. Brown after George

Romney.[2] To establish why Blake's six plates were not reprinted in the *second* thirteenth edition, this essay sets out the accurate historical and bibliographical contexts for *The Triumphs of Temper* before examining Blake's engravings themselves.

I

Hayley's most successful poem was a product of the tension he experienced between rural retirement and metropolitan concerns. According to his *Memoirs*, Hayley entered rural retirement in 1774, relocating from London to the county of his birth and his 'beloved little villa' at Eartham in Sussex.[3] The move was occasioned by a combination of Hayley's growing dislike of metropolitan life and his failure to establish himself as a playwright. In a note written after he had returned to Sussex from a brief visit to London, Hayley reflects on his decision to retire stating: 'I feel more & more attached to my own system of privacy & retirement. – I feel also a sort of indignation against this treacherous city.'[4] Following the tradition of the retirement poets earlier in the century, such as William Shenstone, Hayley justified his removal to Sussex by connecting his rural surroundings to literary production.[5] In a letter to his first wife, Eliza, written during a visit to Anna Seward, Hayley states: 'As to my own serious business, I find that I can do nothing but in the inspiring tranquillity of the dear and delightful Eartham. The prosaic visitants of a county town absolutely rob me of all literary powers and not even the Sublime Muse of Litchfield can counterbalance their lethargic influence.'[6] While Hayley referred to himself as retired, frequently signing his letters with the moniker 'Hermit,' he spent a few months of each year in London during the 1770s. However, after witnessing with disgust 'scenes of riot and destruction' during the Gordon riots in June 1780, including the sacking of Lord Mansfield's house, Hayley returned to 'the inspiring tranquillity' of Eartham, and began composing what would become his most commercially successful and enduring poem, *The Triumphs of Temper*.

The poem is a mock epic invoking, among others, Homer, Dante, Spenser, Shakespeare, and Milton to set out a model for the regulation of female sensibility.[7] Following Samuel Butler, Alexander Pope, and Matthew Green, Hayley employed the mock-epic form, but rather than simply satirizing drawing-room behaviour, *The Triumphs of Temper* emphasized didacticism and aimed to improve polite society by provid-

ing an exemplum of female virtue.[8] In the preface, written in the third person, Hayley locates his vocation and his new poem in the Shaftes-burian tradition of poetry: 'It seems to be a kind of duty incumbent on those, who devote themselves to poetry, to render a powerful, and too often a perverted, art as beneficial to life, and manners, as the limits of composition, and the character of modern times, will allow.'[9] Hayley reiterates this point in his *Memoirs*, where he outlines his civic humanist intentions, hoping that his poetry 'Might render an important service to social life, if his poetry could induce his young and fair readers to culti-vate the gentle qualities of the heart and maintain a certain flow of good humour.'[10] *The Triumphs of Temper* was Hayley's first successful attempt at achieving this aim. In the preface, Hayley orients his readers not only to the poem's moral purpose, but also to its style. Unlike Pope or Green, who were both concerned with highlighting human weakness, Hayley sets out to celebrate certain female traits.[11] His heroine, Serena, does not behave like Pope's Belinda, but instead operates as a paradigm for what Hayley considers 'female excellence.' In addition, Hayley claims that his intention was not to imitate Pope, but to adapt Popean satire so that it would prove beneficial to polite society by providing a new poet-ic medium. Hayley further claims that, like Alessandro Tassoni before him, he had created a new form of poetry and, referring to Augustan satire, which he saw as a composite form that encouraged adaptation, he states:

> I imagined it might be possible to give a new character to this mixed spe-cies of poetry, and to render it by its object, though not in its execution, more noble than the most beautiful and refined satire can be. We have seen it carried to inimitable perfection, in the most delicate raillery on female foibles: – it remained to be tried, if it might not also aspire to delineate the more engaging features of female excellence.[12]

For Hayley, mock-heroic was sufficiently capacious to accommodate satire and epic, serious and the comic, the visionary and the real, in order to achieve the same moral purpose – to instruct young women how to exercise their temper to regulate the effects of spleen.[13] Com-prising six cantos that alternate between drawing-room melodrama and the allegorical realm of spleen, the narrative follows Serena as she negotiates the transition from adolescence to adulthood and attempts to combat the threat of spleen. Perhaps anticipating Blake's own con-

ception of mental fight, Hayley's central conceit is that by experiencing 'Mental strife' Serena is transformed from a naive girl into an 'accomplished wife.'

Hayley depicts spleen as an apolitical, typically aristocratic disease that is extremely contagious, initially manifesting in females when they become adults. The poem juxtaposes Serena's quotidian existence with allegorical encounters, which Hayley refers to as his 'visionary cantos.' Elaborating on Pope's Cave of Spleen, Serena visits the Dome of Spleen, an inferno-like underworld containing the souls of those who had succumbed to the effects of spleen. Her second 'visionary' trip is to a *Purgatorio*-like realm occupied by those who vacillated between following and regulating spleen. Finally, Serena's guide, the nymph Sophrosyne, shows her a *Paradiso* state, reserved for those who had exercised temper to control spleen. During these nocturnal jaunts, Serena encounters the personifications of jealousy, apathy, pride, and discontent that prepare her for real-life confrontations with spleen, which are occasioned by her gout-ridden father, the irascible Sir Gilbert, her envious spinster aunt Penelope, and a potential suitor, the self-important Lord Filligree. Hayley deploys satire in the quotidian cantos to highlight a number of themes including the inconsistency of Whig policies, the superciliousness of the aristocracy, and the regulation of burgeoning sexuality by older women – a theme he would treat more expansively in *Essay on Old Maids* (1785). But mirroring the central theme of the poem, satire is regulated so as not to undermine Hayley's exemplary purpose.

First published in 1781, both poet and poem garnered laudatory reviews. The *Monthly Review* referred to Hayley as a 'gallant Writer' for producing an 'exquisite and enchanting' poem that 'will be of considerable service to Society.'[14] The *Gentleman's Magazine* compared the poem to the *Rape of the Lock*, stating that the 'moral tendency of [*The Triumphs of Temper*] is much superior.'[15] Thomas Tyler also noted the similarities between Pope and Hayley.

> It has been already almost admitted there have been as good versifiers as Mr. Pope. Mr. Hayley must be admitted of that small number. His last poem of the Triumphs of Temper, amongst its many happy incidents, contains an enlargement of Pope's Cave of the Spleen, and is full of energy and excellent poetry. He has augmented the number of rhymes, the paucity of which, in all Mr. Pope's poetry, is astonishing.[16]

Other critics focused on the poem's instructional qualities:

I have been much pleased with the lovely picture of Serena, in Mr. Hayley's instructive poem, the Triumphs of Temper; and I cannot conclude, without earnestly entreating the ladies to view it as a looking-glass, by which they may learn to dress their minds in a manner which can never be out of fashion; but which will enable them to secure, as well as extend, their conquests; and to charm, even when the lilies and roses are all withered. If the poem should effect its very laudable purpose, the Virtues, the Muses, and the Graces should unite to form a wreath for the poet's brow, and hail him as the restorer of a golden age.[17]

As well as being hailed as the vanguard for the dawn of a new age of sensibility, the poem was frequently anthologized and, in 1785, set to music by John Percy.[18] Later critics also recognized Hayley's innovative use of Popean satire. In 1798, Nathan Drake observed that *The Triumphs of Temper*

Seems well entitled to the honour of forming a new species of poetry, for in structure and design it differs materially from what has been denominated the Heroi-comic poem. Its visionary scenes are drawn and tinted with a masterly pencil, and do great credit to the Italian school, in whose spirit and style they have been conceived and executed, and his Heroine, all gentle and interesting, fully develops the magnetic influence of that sweetest of all possessions, an amiable temper.[19]

Some critics, however, found Hayley's juxtaposition of the real and allegorical realms confusing. For example, Jeremiah Newman critiqued this aspect of the poem, complaining: 'My memory was burthened, my attention fatigued, and my ideas confused by Mr. Hayley's alternate cantos.'[20] A more famous detractor was the politician and playwright, Richard Brinsley Sheridan. In an unpublished manuscript fragment composed in Bath *circa* 1781, Sheridan satirized, among other things, the length of Hayley's poem.

Bath

To Mr H__y on his entitled
Incomparably long Poem ~~called~~ the
 Triumphs of Temper .

thro,
Your Nymph her temper keeps six Cantos
By God! its more than half your readers dos

Another
With Patient ado
...... & her Triumphs three!
Why I have read your Poem thro'
What do you say to me?
 A third by way of motto.
..... as & for our Trials three
We beg your reading patiently.
 A fourth
If fair Serena yet retains
Her patient Virtues let her Hew'en
One harder Trial yet remains
-Prevail on her to read your Poem
 A Fifth
Three Trials past Serena says
Tis Hard a fourth succed'em!
Ah! H_l_y spare the fatal praise
-I lose my Triumphs if I read 'em
 ~~To be continued~~
 A sixth
In praise of Patience H_l_y's muse
With alter'd strains her theme pursues
Who'd grudge to lay the generous lay
Where every reader shoves [?] the Praise[21]

Criticisms such as Newman's and Sheridan's were rare however, and the poem was extremely popular, which is evident in the number of editions published during Hayley's lifetime.

In Britain, sixteen editions of the poem were published between 1781 and 1817. James Dodsley published the first edition in quarto, priced six shillings. A second edition was published the same year, also in quarto. The third and fourth editions were also in quarto and appeared in 1782 and 1784. Four years later, Hayley approached Thomas Cadell and William Davis to publish a corrected version of the poem.[22] With Hayley's approval and incorporating his corrections, Cadell and Davies made significant alterations to the sixth edition of the poem, which was published in 1788, including reducing the format from quarto to octavo and commissioning seven illustrations by Thomas Stothard.[23] These engravings appeared in the subsequent five editions, published between 1793 and 1801, until replaced by Blake's engravings in 1803.

The six engravings by Blake were after designs by John Flaxman's half sister, Maria, and, in addition to appearing in the twelfth edition, were also included in a *first* thirteenth edition, published in 1807. The same year another, much more common *second* thirteenth edition was published. However, this edition incorporated the seven engravings after the Stothard illustrations that were first published in the sixth edition. Two more editions, again published by Cadell and Davis, appeared in 1809 and 1812. These editions were not illustrated. Another edition was published in 1817 with four engravings after the Stothard from the sixth edition. This was the final edition published in Britain before Hayley's death.

II

Blake began engraving Maria Flaxman's designs at the beginning of 1803. In his letter to Butts of 10 January 1803, Blake reveals that he was 'engaged in Engraving 6 small plates for a New Edition of Mr Hayleys Triumphs of Temper' (*E* 723). The next day the young Oxford scholar Edward Garrard Marsh wrote to Hayley, closing his letter with the post-script 'Mr Blake is (I hope) proceeding vigorously in the triumphs of temper' (*BR2* 148). In a letter of 30 January, Blake informed his brother that he was being paid '10 Guineas' for the six plates (*E* 726).[24] According-ing to the imprint, the engravings were published on 9 May 1803.

During the engraving process, Blake and Hayley edited Maria Flax-man's drawings. In his letter of 24 August, John Flaxman indicates that there were actually seven original drawings: 'There certainly was a drawing of Serena viewing herself in the Glass when dressed for the Masquerade' (*BR2* 166).[25] Writing to Flaxman at the beginning of August, Hayley revealed that he and Blake had exercised edito-rial judgment over the original designs, particularly 'one Figure (the tall Minerva) that Blake & I thought it would be better to omit' (*BR2* 157). These editorial decisions, coupled with Blake's engravings, did not impress Flaxman or his wife. Referring to the expurgated design of Serena viewing herself in a mirror, Flaxman told Hayley in his letter of 24 August that

it was so great a favourite with us that Nancy & myself prevailed on my Sister to make its fellow for our private collection, you will therefore natu-rally imagine we were surprised when we greedily examined our Friend's present, to find that our favourite had either been overlooked, or discard-ed from the suite of decorations. (*BR2* 167)

Flaxman goes on to critique both his half-sister's drawings and Blake's engravings.

> I hope you will excuse my partiality when I say the sentiment of my Sister's drawings always appeared to me, just & delicate, although I must acknowledge there is room for amendment in the effects & drawing of her figures, these corrections might be done in the engraving but I confess the prints for Serena seem in these respects to be worse than the drawings. I am sorry for it because now there is no remedy. (*BR2* 167)

While recognising the deficiencies in his half-sister's drawings, Flaxman expected Blake to correct these faults during the engraving process. Earlier that month, in a letter of 7 August 1803, Hayley had told Flaxman 'that the Ladies ... find Fault with the Engravings' (*BR2* 157). Hayley may have been referring to William Cowper's cousin, Lady Harriet Hesketh, to whom he had sent a copy of the new edition at some point in June. In a letter to Hayley of 1 July 1803, Hesketh notes that she was 'disappointed in the Prints' (*BR2* 157). Hesketh had also been critical of a number of Blake's other engravings for Hayley, including the portrait of Cowper after Romney in *Life of Cowper* and some designs for the ballad project.[26] Referring to the frontispiece of *The Eagle*, Hesketh claims her criticism of the design is 'a very feminine one,' and goes on to say that Blake's rendering of 'the faces of his babies are not young' and therefore do not contain the 'Infantine Graces' that appeal to women.[27] As Lady Hesketh's criticisms make clear, it was the failure of Blake's engravings to appeal to feminine tastes that proved most troubling.[28] In his letter to Flaxman of 7 August, Hayley explicitly refers to *The Triumphs of Temper* in this context as 'a Ladys Book' (*BR2* 157) and distributed numerous copies of the poem to various female friends and acquaintances, including Blake's wife, with manuscript dedications. In a letter to Cadell of 17 May 1793, Hayley requests copies of the seventh edition for this purpose.

> Whenever you complete our new pocket edition of the Triumphs of Temper, have the goodness to send me half a dozen copies for a few little female friends, who were hardly born when it was first published. The most enchanting compliments I ever receiv'd, as an author, arose from that publication – the first was from the most accomplished Lady highly married, who told me she ow'd all her brilliant prosperity to having studied that poem – the second was a complement by an excellent mother

who thank'd me with affectionate sincerity for having produced a very delightful change in the Temper of her Daughter; for having converted (by the influence of Serena) a very untoward disposition into a character of docility & tenderness.[29]

Hayley's reference to a 'Lady highly married' may have been to Emma Hamilton, who had asked George Romney on 20 December 1791 to

Tell Hayly I am allways reading his 'Triumphs of Temper'; it was that that made me Lady H., for, God knows, I had for 5 years enough to try my temper, and I am affraid if it had not been for the good examples Serena taught me, my girdle would have burst, and if it had I had been undone, for Sir W. minds more temper than beauty. He, therefore, wishes Mr Hayly would come, that he might thank him for his sweet-tempered wife.'[30]

Just before the publication of the sixteenth edition, Hayley again asked his publisher to send him copies for distribution: 'As the new Edition of the Triumphs of Temper will travel to you in a few days, I request you to furnish me with a dozen copies neat in boards & plain green paper for particular friends just before they are circulated.'[31] Hayley sent a copy of the sixteenth edition to Nancy Flaxman with the following manuscript dedication in black ink on the front flyleaf: 'To / Mrs Flaxman / from the Author / June 26 / 1817.' This copy evidently did not stay in Flaxman's library for very long because underneath Hayley's dedication in another hand is the following: 'given to her God-daughter / Emily Kay / by her Sincere friend / Maria Denman / September / 1825.'[32] There are a number of earlier examples of Hayley dispatching copies of *The Triumphs of Temper* to female friends with poetic dedications. For example, Hayley sent a copy of the eleventh edition with the following manuscript dedication in black ink on a separate sheet of paper:

> To
> Sophia
> With the Triumphs of Temper
> Jan: 1800
> Sweet Nymph, accept, with spirit kind
> A mark of just esteem!
> Fancy for the Nymphs like you design'd
> This gay poetic dream.

Sophia hear the poet's prayer!
'your destiny be this!
Surpass my visionary fair
In beauty and in bliss!

May I (if aught to grief belong
That can your love engage)
Hear from your voice a sweeter song
To soothe afflicted age!'[33]

This was the same edition that Hayley had given to Blake in July 1800, with the following dedication:

Accept, my gentle visionary Blake,
Whose thoughts are fanciful and kindly mild;
Accept, and fondly keep for friendship sake
This favor'd vision, my poetic child.

Rich in more grace than ever fancy won,
To thy most tender mind this book will be,
For it belong'd to my departed son;
So from an angel it descends to thee[34]

This dedication reveals that Hayley had given Blake the copy that had previously belonged to Thomas Alphonso. In giving Blake this particular copy, Hayley was not only providing poetic and behavioural paradigms, but perhaps also associating Blake with his recently deceased son. In this context, Hayley might have been seeking to define the imbalance inherent in any patronage relationship in more polite terms by referring to Blake in a paternalistic register. This could have been in response to Blake's more egalitarian conception of the relationship as evinced in his letter to Hayley of 6 May 1800, where he offers his patron 'a brothers Sympathy' (E 705) upon learning of the death of Thomas Alphonso.

Hayley also dedicated various copies of the 1803 edition, including a copy to his friend the travel writer Marianna Starke with the following dedication: 'To / His Daughter Mariana / The Conqueress / of / Blue Devils / This Little Book / is presented / as a leaf of Laurel / for her Victory / by the Hermit / rejoicing in her Triumph / and wishing it / perpetual.'[35] The copy Hayley gave to Blake's wife contains the follow-

ing dedication in black ink on the flyleaf: 'To / Mrs Blake / from the Author / 1803.'[36] This copy also contains numerous pencil annotations, typically underlining and bracketing, in an unknown hand. While it is impossible to identify the author of the pencil annotations from a palaeographical analysis, the particular passages and words they underline might suggest Catherine as potentially responsible.[37] For instance, pencil underlining occurs in the following lines: 'Discontent's eternal house' (canto 3, line 53), and 'Justly feel no joy, who none bestow' (canto 3, line 59).[38] As well as becoming increasingly frustrated with his professional relationship with Hayley from at least late 1801, Blake and his wife also suffered from repeated bouts of ill health in Felpham, which Blake appears to have attributed to the proximity of their cottage, and its concomitant exposure, to the sea.[39] As a consequence, by the end of January, the Blakes had formulated a plan to 'take a House in some village further from the Sea Perhaps Lavant' (*E* 726).[40] It is possible that the pencil annotations in Catherine's copy of *The Triumphs of Temper*, particularly the underlining of 'Discontent's eternal House,' refer to their Felpham cottage. Like Blake's statements in his letters to his brother and to Butts in January 1803, as well as the pejorative epigrams in his manuscript notebook, these pencil annotations offer another barometer of the personal and professional unhappiness the Blakes were experiencing in Felpham in 1803. Could this unhappiness have affected Blake's engravings of Maria Flaxman's designs?

III

Robert Essick has noted the 'cluttered crosshatching' on the impressions in the 1803 edition of *The Triumphs of Temper*, further describing them as 'Blake's poorest signed engravings.'[41] Essick observes that the quality of the impressions could be linked to Blake's deteriorating relationship with Hayley. According to his letters of early 1803, Blake's attitude toward *The Triumphs of Temper* plates appears to reflect his contradictory view of Hayley's patronage. In his letter to Butts of 10 January, Blake discusses *The Triumphs of Temper* engravings, anticipating further commissions from Hayley 'if I but Copy these well' (*E* 723). In the next paragraph, however, Blake complains about the 'meer drudgery of business' in relation to Hayley's engraving commissions. Similarly, in the letter to his brother at the end of January, Blake begins by accusing Hayley of being jealous of his abilities – 'The truth is As a Poet he is frightend at me & as a Painter his views & mine are opposite

he thinks to turn me into a Portrait Painter as he did Poor Romney'
(*E* 725) – before emphasizing the positive side of Hayley's patronage:
'I am fully Employd & Well Paid,' and 'I have made it so much H's
interest to employ me that he can no longer treat me with indifference'
(*E* 726). This last statement may appear odd because it suggests that
Blake is both rejecting and cultivating Hayley's copy-engraving com-
missions. This seemingly contradictory view is, however, consistent
with how Blake configured Hayley's patronage in 1803. Essentially,
Blake saw Hayley's patronage in two opposing registers: as financially
beneficial yet creatively damaging. Blake's letters of January 1803 indi-
cate that he was working through a solution to this situation or what
might more appropriately be termed the patronal dilemma – that is,
a conflict between the financial stability offered by Hayley's patron-
age and its concomitant negation of Blake's creative agency. To resolve
this dilemma, Blake anticipates converting Hayley's economic assist-
ance and knowledge into a project that would afford him creative inde-
pendence. Blake outlines this project in the letter to his brother where
he praises Hayley's knowledge of publishing before proposing his own
plan to re-establish himself as printer-publisher in London:

> It now [would] be folly not to venture publishing. I am now Engraving
> Six little plates for a little work of Mr H's for which I am to have 10 G each
> & the certain profits of that work are a fortune such as would make me
> independent supposing that I could substantiate such a one of my own &
> I mean to try many. (*E* 726)[42]

It appears, then, that for Blake the twelfth edition of *The Triumphs of Tem-
per* operated as a template for his projected publishing venture. While
not specifying the content and theme of his 'many' proposed publi-
cations, Blake implies that they will be similar in format and contain
approximately the same number of illustrations as the twelfth edition
of *The Triumphs of Temper*.[43] Blake anticipates that his proposed publish-
ing venture would secure him the financial independence to work on
other projects, possibly including relief etching the 'long poem ... on
One Grand Theme Similar to Homers Iliad or Miltons Paradise Lost'
about which he informed Butts on 25 April 1803 (*E* 728). *The Triumphs
of Temper* engravings, then, were an important part of Blake's solution
to ending the unhappiness he was experiencing in Felpham. As such,
it does seem surprising that Blake did not execute the plates with the
same diligence and professionalism evident in his other engraving
commissions for Hayley.

A comprehensive survey of the twelfth and rare *first* thirteenth editions of the poem reveals that the impressions in the 1807 edition are of much poorer quality than the 1803 engravings.[44] The impressions in a number of the small-paper copies of the 1803 edition are also of appreciably poorer quality than the engravings in the large-paper copies of the same edition. The poor quality is due to the plates being worn. This wearing is even and is particularly noticeable on a number of small-paper copies of the twelfth edition. For example, in the first plate, which depicts Serena presenting a basket of vegetables to her father, the lines delineating text on the open leaves of Sir Gilbert's book are considerably lighter. The delicate stippling on Serena's face is also less pronounced. In the second plate, which depicts Serena alone in her room in an attitude of supplication, her headband contains very little shading compared with other copies, particularly the large-paper copies. Finally, in certain small- and large-paper copies of the twelfth edition there is an imperfection, possibly a scratch, on the sixth plate evident below Sir Gilbert's knees and extending to the left-hand margin of the engraving. This imperfection is less obvious on the 1807 impression. The appearance of the imperfection in certain copies of the 1803 edition indicates that at some point during the 1803 print run the plate was damaged. Through repeated printing, however, the imperfection was gradually erased. The apparent smoothing out of the imperfection in the *first* thirteenth edition suggests a possible reason why Blake's plates were replaced in the *second* thirteenth edition: they were worn to the extent that they were no longer of publishable quality. As previously stated, the wearing of the copperplates visible in the poorer quality impressions in both 1803 and 1807 editions is even, which discounts inconsistency in the inking process. Rather, it suggests a number of possible problems in the engraving and/or printing processes. The use of soft copperplates and/or shallow etching would account for the even wearing. Too much pressure applied to the plates during the initial print run could also be a factor in their deterioration[45] (figs. 5.1 and 5.2).

As previously noted, Blake saw this particular commission as a model for his proposed publication venture. It is therefore unlikely that he would have deliberately produced substandard plates and, while noting Essick's observation on the 'heavy web of insensitive lines' that constitute the engravings, Blake's plates must have satisfied Hayley in the proof stage before being published.[46] We know that Blake often engraved by Hayley's side, particularly when working on projects for his Sussex patron and, as we have seen, they shared an editorial role in

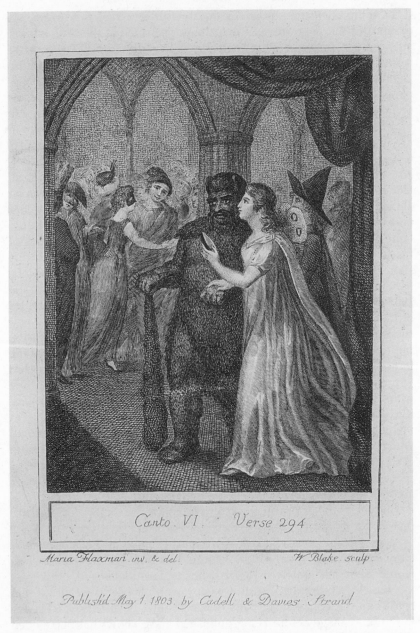

Canto. VI. Verse 294.

Maria Flaxman. inv. & del. W Blake. sculp.

Publish'd May 1. 1803. by Cadell & Davies. Strand

5.1 William Hayley, *The Triumphs of Temper* (12th ed.) (1803), 'Canto VI, Verse 294,' William Blake after Maria Flaxman (Robert N. Essick, Altadena, CA)

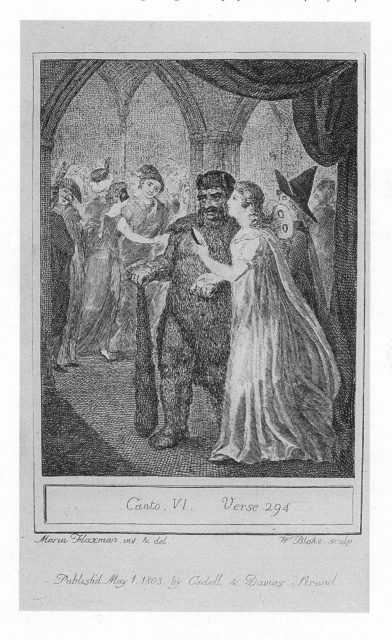

Canto. VI. Verse 294

Maria Flaxman . inv . & del. W Blake . sculp.

Publish'd May 1. 1803. by Cadell & Davies . Strand

5.2 William Hayley, *The Triumphs of Temper* (13th ed.) (1807), 'Canto VI, Verse 294,' William Blake after Maria Flaxman (Robert N. Essick, Altadena, CA)

this project.[47] While Hayley was not an engraver and indeed suffered with poor vision, he had been taught miniature portraiture by Jeremiah Meyer, one of the foremost miniaturists of the late-eighteenth century, and frequently dispensed painting advice to artists such as Joseph Wright and George Romney. Hayley exercised critical judgment over the illustrations to his numerous publications. In a letter of 7 February 1793 he told Cadell to omit one engraving and alter another for the third edition of *Essay on Old Maids*: 'In the infinish'd print of the man at his door his face & his hat should be made a little more manly.' He also frequently dictated the content of the illustrations.[48] In 1795 Hayley wrote to Davies about the forthcoming second, unexpurgated edition of his biography of Milton: 'I have various ideas concerning decorations for the Book.'[49] Hayley had also been critical of Blake's engraving of Thomas Alphonso Hayley published in *Essay on Sculpture* (1800) and he invited Blake to Felpham in July 1800 to work on an improved version for a projected volume of sonnets dedicated to Thomas Alphonso. Blake's engraving was after Henry Howard's drawing of John Flaxman's medallion of the boy. Hayley described the engraving published in *Essay on Sculpture* in a letter to Lady Hesketh of 13 September 1800 as 'the miserably unjust medallion' (*BR2* 98) and composed a sonnet on the subject:

> Sonnet august 1
> forsakes
> Moments there are when skill deserts the skill'd
> When absent Genius from its master strays
> Yet not the less deserve thy love & praise
> Who reputation like my Howard builds
> graceful
> On lifes large field with patient studies fill'd
> once kind Howard
> Thy hand dear artist once has fail'd to raise
> So potent
> Thy dead friends semblance to affections gaze
> In truths pure light, - light that should ever guide
> His form, for he as truth herself was true
> Yet will this talent in a happier hour
> Shine forth
> Kindly vouchsafe to set in stronger view
> His lessen'd pencil
> Scenes that our young departed sculptor drew

how uninspir'd tho such in what power
To deck filial love his father's lonely bower[50]

This sonnet, written in black ink, on the recto of Hayley's sonnet of July 1800 encouraging Blake's reworking of the Thomas Alphonso plate, is concerned with the apparent loss of skill of all three artists in executing a visual representation of his dead son. In a letter to Howard of 1 October [1800], Hayley reiterates this point, describing another sonnet he composed on the Thomas Alphonso medallion as 'commemorating the very strange & striking failure of three highly ingenious & affectionate artists united.'[51] Hayley believed that this failure would be redressed in his poetic memorial to Thomas Alphonso: 'The new publication will consist chiefly of devotional sonnets, composed in the long illness, & since the departure of my filial angel, which I am tempted to print by the opinion of some tender-hearted friends, who persuade me the book may prove, in some degree, soothing & medicinal to parents in general under similar afflictions.'[52] This proposed work was to include 'two engraved portraits' of Thomas Alphonso presumably by Blake (*BR2* 98). Hayley's disappointment with the engraving of his son in *Essay on Sculpture* almost certainly would have prompted him to inspect the proofs of a new set of engravings to illustrate his most popular work, as he did for the engravings for the Cowper biography and the ballad project, before proceeding to publication.

IV

Besides printing proofs it is not known if Blake printed the published engravings for the twelfth edition of *The Triumphs of Temper* on his own copperplate rolling press. According to Blake's letter to his brother at the end of January 1803, Catherine printed the engravings for the biography of Cowper: 'My Wife has undertaken to Print the whole number of the Plates for Cowpers work which she does to admiration & being under my own eye the prints are as fine as the French prints & please every one' (*E* 726–7). Hayley's regular printer, Joseph Seagrave, printed the letterpress for both 1803 and 1807 editions of *The Triumphs of Temper* in Chichester. Based on surviving copies of both editions in research institutes and private collections, the print run for the 1803 edition was probably between fifteen hundred and two thousand.[53] The quantity of materials required to produce approximately 12,000 prints of octavo size for the 1803 print run of *The Triumphs of Temper* was significantly more than the materials Catherine would have required to print the

four plates of quarto size for the first two volumes of Hayley's biography of Cowper, which appears to have had a print run of less than five hundred.[54] We know that Blake did not always print the plates he executed for Hayley. In a letter to Samuel Rose of 1 April 1804, Hayley relates that Blake 'had found an excellent Copperplate printer' to print his two plates for the third volume of the *Life of Cowper* (*BR2* 192). It is possible that after printing the plates for *Designs to a Series of Ballads* (1802) and the first edition of the *Life of Cowper*, Blake and Catherine did not have the time or materials to print the 12,000 impressions required for the twelfth edition of *The Triumphs of Temper*. Seagrave might have taken responsibility for having Blake's plates printed. According to the Quarter Sessions records, compiled in accordance with *The Suppression of Seditious Societies Act* (1799), Seagrave possessed two printing presses.[55] But these presses would not be able to print copperplate engravings and there is no record Seagrave owned a copperplate rolling press.[56] Most probably the impressions were printed in London through Hayley's publishers. Such an arrangement had been in place from as early as 1793. In a letter of 7 February 1793 to his publishers, Hayley critiqued the proof impressions for the third edition of *Essay on Old Maids* that year, telling Cadell:

> I am heartily glad, my good Friend, that you happen'd to send me the proof-designs, as I may save you perhaps, in these <u>inquisitional times</u>, from the vexation of being carried before a magistrate, as a <u>wicked seller of indecent prints</u> – Seriously there is one of the designs that it will be <u>better to suppress</u> – 'To the pure all things are pure' & the belove'd painter who made the original sketch had <u>no idea of such prudish criticism</u>, as you & I (from our experience in regard to this little book) ought to <u>guard against</u> – but his two figures contemplating the apparition of Eve are certainly not very fit to decorate a book for antient Virgins, in their present unnecessary state of absolute Nudity – <u>Luckily</u> we <u>do not want this print</u>, as there is <u>another</u> design from the <u>same story</u>; & our Book is <u>complete without it</u>, having an engraving <u>as a frontispiece</u> to each volume ... I detain the <u>objectionable Eve</u>, & return you the other prints wither the References as you desire.[57]

Hayley was genuinely taken aback by the criticisms he received from friends, such as Anna Seward, after the first edition of *Essay on Old Maids* was published. As his comments to Cadell make clear, despite the numerous revisions he made to the subsequent editions in response to these criticisms, Hayley was still wary of offending the sensibilities of his intended readership.

Unlike the *Little Tom the Sailor* broadside, which Blake designed, relief etched, and printed, and the plates for the first edition of the *Life of Cowper*, there is no indication in Blake's or Hayley's extant correspondence that Blake printed the impressions for *The Triumphs of Temper*.[58] It is possible that once engraved to Hayley's satisfaction, the six plates were dispatched via Seagrave to London to print. This may account for the imperfection evident on plate six in a number of 1803 copies. If Blake or Catherine had been responsible for printing the plates, it is highly likely that they would have spotted the imperfection and corrected it. Furthermore, there is no extant record that Blake had any contact with Hayley, Seagrave, or Hayley's London booksellers, regarding the reprinting and publication of his plates in the *first* thirteenth edition, which indicates that Blake was not in possession of the plates. It is likely that the plates were in the possession of Cadell and Davies, or their copperplate printer, from the initial print run of 1803. Based on surviving copies, the print run for the *first* thirteenth edition was not more than between fifty and one hundred. This exceptionally small print run may be explained by the extremely poor quality of the impressions in this edition. The wearing had rendered Blake's plates unprintable and Hayley was no longer in contact with his former protégée to have the copperplates repaired or to have a new set of plates made.[59]

The criticisms of the engravings by Hayley's contemporaries indicate that Blake's linear engraving style proved unsuitable for a poem aimed at a predominantly female readership. These criticisms, however, did not dissuade either Hayley and/or his publishers from attempting to reuse Blake's plates for a thirteenth edition of the poem in 1807. Yet, by this time, the wearing evident on a number of the impressions in the 1803 small-paper copies had become so extensive that the plates had to be repaired or replaced. Replacements were on hand in the seven plates after Stothard. These plates were reworked, often extensively, in each new edition.[60] That Blake's plates were not reworked and indeed replaced during the initial print run of the thirteenth edition suggests that either they were considered beyond repair, or that the plates were terminally damaged during the initial print run. It would have been less expensive for Cadell to have the plates after Stothard reworked again than it would have been to have new plates made.[61] In addition to replacing Blake's engravings, the title page had to be changed to remove the attribution of the designs to Maria Flaxman. These visual and typographical changes resulted in the publication of two thirteenth editions of Hayley's most celebrated poetic work.

NOTES

I am indebted to Robert N. Essick for his images from two editions of Hayley's *The Triumphs of Temper*, as well as for comparing the typesetting of the two versions of the thirteenth edition of the text.

1 William Blake, *The Complete Poetry and Prose of William Blake*, rev. ed., edited by David Erdman, with commentary by Harold Bloom (New York, NY; London: Doubleday, Anchor Books, 1988), 724. Hereafter cited parenthetically as *E*.

2 For a discussion of Brown's engraving after Romney, see D.W. Dorrbecker, 'The Reader Viewing the Reader Reading: Romney's Serena Liest in Hayley's *The Triumphs of Temper*,' *Entrée aus Schrift und Bild* (Berlin, 2008), 162–250.

3 William Hayley, *Memoirs of the Life and Writings of William Hayley Esquire, the Friend and Biographer of Cowper, written by Himself with extracts from his private correspondence and unpublished poetry and memoirs of his son, Thomas Alphonso Hayley – the Young Sculptor*, ed. John Johnson, 2 vols. (London: Henry Colburn, 1823), 1:129–30.

4 Beinecke Rare Book and Manuscript Library, Yale University, General MSS Vol. 352 I:56. Blake echoes Hayley's negative sentiments of London in a letter to his friend George Cumberland of 1 September 1800. After describing his forthcoming move to Felpham, Blake congratulates Cumberland on *The Captive of the Castle of Sennaar* (1798), before providing a warning concerning the novel's critical reception: 'how canst thou Expect any thing but Envy in Londons accursed walls.' G.E. Bentley Jr, *Blake Records*, 2nd ed. (New Haven and London: Yale, 2004), 96. Hereafter cited parenthetically as *BR2*.

5 Blake makes a similar comment after he arrived in Felpham, describing his new home as 'a sweet place for Study. Because it is more spiritual than London' (*E* 710).

6 Hayley, *Memoirs*, 1:160–1.

7 For a critical analysis of the poem in the context of the tradition of mock-heroic poetry see Ulrich Broich, *The Eighteenth-Century Mock-Heroic Poem*, trans. David Henry Wilson (Cambridge: Cambridge University Press, 1990), 175–8.

8 For an examination of the evolution of the mock-epic poem in the eighteenth century, see Richard Terry, *Mock-Heroic from Butler to Cowper: An English Genre and Discourse* (Aldershot: Ashgate, 2005).

9 William Hayley, *The Triumphs of Temper* 12th ed. (London: Cadell and Davies, 1803).

10 Hayley, *Memoirs*, 1:207–8.

11 Hayley does follow Matthew Green's concept of spleen as a psychological

phenomenon rather than a physiological condition. See Matthew Green, *The Spleen An Epistle to a Friend*, 2nd ed. (London: A. Dodd, 1732).

12 Hayley, *The Triumphs of Temper*, ix.

13 Susan Matthews has observed that Hayley's poem provided women with 'an acceptable form of femininity.' See Matthews, 'Blake, Hayley and the History of Sexuality,' *Blake, Nation and Empire*, ed. Steve Clark and David Worrall (Basingstoke: Palgrave, 2006), 90 of 83–101.

14 *Monthly Review* 65 (1781): 38–9.

15 *Gentleman's Magazine*, May (1781): 228.

16 Thomas Tyler, *An historical rhapsody on Mr. Pope* (London, 1782), 95.

17 Vicesimus Knox, *Essays moral and literary*, 2 vols. (London: Charles Dilly, 1782), 2:161.

18 For example see *The annual register, or a view of the history, politics, and litera-ture, for the year 1781* (London: Printed for J. Dodsley, 1782), 169–73; Anon., *The bouquet, a selection of poems from the most celebrated authors*, 2 vols. (London: J. Deighton, 1792), 2:70–3; and John Perry, *Sophrosyne – the words from Mr. Hayley's Triumphs of Temper set to Music by Mr. Percy* (London: Printed for E. Scott, 1785). In February 1787, Blake's former business partner, James Parker, engraved two companion plates, *The Ticket* and *The Novel*, after James Northcote's illustrations of Hayley's poem.

19 Drake goes on to situate Hayley as the head of a school of poets writing in this mode: 'It would occupy too much room, and would indeed be super-fluous, to dwell at large upon all the excellent productions of this class, popular as most of them are. When to those already mentioned we can add the Sympathy of Pratt, the Louisa of Seward, the Peru of Williams, the Sonnets of Charlotte Smith and Bowles, the County Justice of Langhorne, the Influence of Local Attachment by Polwhele, the Poems of Burns, and a variety of other productions of no less merit.' See Nathan Drake, *Literary hours or sketches critical and narrative* (Sudbury, 1798), 172.

20 Jeremiah Whitaker Newman, *the lounger's common-place book, or, alphabeti-cal arrangement of miscellaneous anecdotes; a biographic, political, literary, and satirical*, 2 vols. (London, 1792–3), I, 82.

21 The verses are undated, written in black ink on paper with TAYLOR water-mark. Beinecke Rare Book and Manuscript Library, Yale. James Marshall and Marie-Louise Osborn Collection MSS File, f. 13565. Lady Elizabeth Holland attributes the couplet: 'Your nymph her temper keeps six canto[s] thro / By G-d that's more than half your readers do' to Richard Fitzpatrick, founder of the Whig Club and intimate of Charles James Fox. See *The Journal of Elizabeth Lady Holland (1791–1811)*, ed. the Earl of Ilchester, 2 vols. (London: Longmans, Green, 1908), I, 268.

22 Hayley made minor revisions to successive editions of the poem. In a letter
 to Cadell of 14 July 1795, Hayley requests a copy for this purpose: 'I rejoice
 with you in the prosperity of our little Serena – I will send you a few cor-
 rections, & insert them in an unbound copy of the last edition.' Princeton
 University Rare Books and Manuscripts Library, Hannay Collection, box 4,
 folder 42.
23 The Stothard illustrations were engraved by Sharp, Heath and Neagle.
 I have been unable to trace a fifth edition. In personal correspondence,
 Nicolas Barker has suggested that it may be a phantom edition designed
 by Cadell and Davies as a marketing ploy to inflate the number of editions
 already published thereby exaggerating its popularity. See table 1 for the
 editions published in Britain during Hayley's lifetime.

Table 1

Date	Edition	Publisher	Illustrations
1781	First	R. Dodsley	None
1781	Second	R. Dodsley	None
1782	Third	R. Dodsley	None
1784	Fourth	R. Dodsley	None
1788	Sixth	T. Cadell and W. Davies	7 engravings after T. Stothard
1793	Seventh	T. Cadell and W. Davies	7 engravings after T. Stothard
1795	Eighth	T. Cadell and W. Davies	7 engravings after T.Stothard
1796	Ninth	T. Cadell and W. Davies	7 engravings after T. Stothard
1799	Tenth	T. Cadell and W. Davies	7 engravings after T. Stothard
1801	Eleventh	T. Cadell and W. Davies	7 engravings after T. Stothard
1803	Twelfth	T. Cadell and W. Davies	6 engravings after M. Flaxman
1807	Thirteenth (A)	T. Cadell and W. Davies	6 engravings after M. Flaxman
1807	Thirteenth (B)	T. Cadell and W. Davies	7 engravings after T. Stothard
1809	New Edition (fourteenth)	T. Cadell and W. Davies	None
1812	New Edition (fifteenth)	T. Cadell and W. Davies	None
1817	New Edition (sixteenth)	T. Cadell and W. Davies	5 engravings: 1 engraving by T.B Brown after Romney, 4 after Stothard.*

* There is a degree of indeterminacy in the number of engravings in this particular edition. Not all of the six copies of the 1817 edition I have examined contained these five listed engravings. For example, one copy contained only the frontispiece by T.B. Brown after Romney (HEH) and another copy contained two portrait engravings of Hayley in addition to the Brown frontispiece and the four engravings after Stothard (Pierpont Morgan Library).

24 Sharp received the same sum per plate in 1787 for his engravings after Stothard; see Robert N. Essick, *William Blake Printmaker* (Princeton: Princeton University Press, 1980), 170 and fn.

25 Two of the seven were, as Essick points out, 'exhibited at the Royal Academy in 1800, no. 665 in the catalogue, and all were sold from John Flaxman's collection at Christie's, 26 February 1883, lot 295 (now untraced).' See Robert N. Essick, *William Blake's Commercial Book Illustrations* (Oxford: Clarendon, 1991), 83–5.

26 For the gestation and execution of Blake's engravings for Hayley's biography of Cowper, see G.E. Bentley, Jr., 'Blake, Hayley and Lady Hesketh,' *Review of English Studies* 7 (1956): 265–86.

27 British Library Add. MS 30803 B, fols. 54/5. Also see *BR2* 138–9.

28 Marsh also implicitly criticized Blake's engraving style for the same reason in a letter of 9 January 1810. After complimenting Hayley on the Romney biography, Marsh refers to Hayley's use of Caroline Watson's engravings: 'Watson's engravings are beautiful in the extreme; and you never made a happier exchange than when you employed her instead of Blake' (*BR2* 295). While Hayley commissioned Watson to produce engravings for his biography of Romney and the subsequent editions of *Life of Cowper*, he did not commission her to produce engravings for later editions of *The Triumphs of Temper*. For a discussion of Watson's softer, more feminine aesthetic as the antithesis of Blake's linear style, see Robert N. Essick, 'William Blake's "Female Will" and Its Biographical Context,' *Studies in English Literature, 1500–1900* 31, no. 4 (Autumn 1991): 615–30.

29 Fales Manuscript and Special Collection Library, New York University, ND 497.R4.H4.

30 Walter Sydney Sichel, *Emma Lady Hamilton from new and original sources and documents* (London, 1905), 147. Also see Morchard Bishop, *Blake's Hayley, The Life, Works, and Friendships of William Hayley* (London: Victor Gollancz, 1951), 99–100.

31 The letter is dated 'Wednesday April 9 1817.' Pierpont Morgan Library English Misc MA 2983 (9).

32 Pierpont Morgan Library 151394 JPW. Maria Denman was Flaxman's sister-in-law.

33 Beinecke Rare Book and Manuscript Library, Yale University. Osborn MSS files, f. 69777.

34 The copy containing this dedication has yet to be traced. The dedication is taken from a manuscript draft: Beinecke Rare Book and Manuscript Library, Yale University. Osborn MSS files, f. 6968. Also see *BR2* 612.

35 Bodleian Library 12 THETA 1438. For more on Hayley's dedication to Starke, see Mark Crosby, 'William Hayley's Benevolent Gift: *The Triumphs of Temper*,' *Bodleian Library Record* 22, no.1 (2009): 101–8.

36 British Library 11656.g.8. This is a large-paper copy.

37 The pencil annotations comprise underlining and bracketing and are clustered on passages of Canto III.

38 The pencil underlining in line 59 could be an indication of metre.

39 On 28 May 1803, Flaxman wrote to Hayley, expressing his concern at 'Mr. & Mrs. Blake's having suffered so much from a damp Situation' (*BR2* 156).

40 This plan evolved rapidly, becoming a return to London where, with Hayley's assistance, Blake would establish himself as a publisher. See Blake's letters to his brother of 30 January 1803 and Butts of 25 April 1803. For a reconstruction of Blake's cottage in Felpham, see Mark Crosby, "The Sweetest Spot on Earth": Reconstructing Blake's Cottage at Felpham, Sussex,' *British Art Journal* 7, no. 3 (Winter 2006/7): 46–53.

41 See Essick, *Printmaker*, 171.

42 Blake's first attempt at establishing a successful printer-publisher business occurred in the early 1780s with James Parker. Blake's second attempt occurred during the early to mid-1790s and is outlined in his prospectus of 10 October 1793 (*E* 692–3). For Blake's first attempt, see G.E Bentley Jr, *The Stranger from Paradise* (New Haven: Yale University Press, 2001), 93–6. For the second attempt, see Michael Phillips, 'Flames in the Night Sky: Blake, Paine and the Meeting of the Society of Loyal Britons, Lambeth, October 10th 1793,' Colloque 'La Violence et ses Representations,' *Bulletin de la Société d'Etudes Anglo-Américaines des XVIIe et XVIIIe siècles* 44, June (1997): 93–110; Joseph Viscomi, *Blake and the Idea of the Book* (Princeton: Princeton University Press, 1993), 262–76; and Essick, *Printmaker*, 136–64.

43 Blake may have been alluding to the Ballad project as one of the 'many' works. On 22 January 1805, Blake wrote to Hayley about an edition of the Ballads published by Richard Phillips: 'he [Phillips] thinks they should be published <u>all together</u> in a volume the size of the small edition of the <u>Triumphs of Temper</u>, with six or seven plates. That one thousand copies should be the first edition, and if we choose, we might add to the number of plates in a second editions' (*E* 763). Two issues of *Ballads by William Hay-*

ley appeared in octavo in 1805, illustrated with five engravings by Blake. See G.E. Bentley, Jr., *Blake Books: Annotated Catalogues of William Blake's Writings in Illuminated Printing* (Oxford: Clarendon, 1977), 571. Hereafter cited as *BB*.

44 For a list of institutions that own copies, see *BB*, 578–9.

45 I would like to thank Robert N. Essick and Joseph Viscomi for their extremely helpful and patient answers to my various obsessive questions on Blake's *Triumphs* plates. Any infelicities or inaccuracies in my discussion are my own.

46 Essick, *Printmaker*, 171.

47 In a letter to John Carr of 5 September 1801, Hayley reports that, 'Blake who is engraving at my side salutes you affectionately' (*BR2* 108–9).

48 Princeton University Rare Books and Manuscripts Library, Hannay Collection, box 4, folder 42. Hayley is referring to the frontispiece to vol. 1, which depicts a 'daring blade ... Angling for Old Maids at Midnight,' Hayley, *Essay on Old Maids*, 3rd ed. 3 vols (London: T. Cadell, 1793), I, 22–4.

49 Hayley to Davies 22 September 1795, Princeton University Rare Books and Manuscripts Library, Hannay Collection, box 5, folder. 6. The second edition did not include illustrations.

50 Beinecke Rare Book and Manuscript Library, Yale University, Osborn MSS Files, 'H,' f. 6968.

51 While not including a year with the date, Hayley includes a day: Wednesday. In 1800, 1 October fell on a Wednesday. Beinecke Rare Book and Manuscript Library, Yale University Osborn MSS files, f. 7027.

52 British Library Add MSS 30803 A; and Beinecke Rare Book and Manuscript Library, Yale University, General MSS Vol. 352, II: 41/2.

53 Philip Gaskell notes that a typical print run for an edition during this period would be not more than two thousand copies. See Philip Gaskell, *A New Introduction to Bibliography* (Winchester: St Paul's Bibliographies, Oak Knoll, 1995), 161.

54 There were two editions of the first two volumes in 1803. From the extant copies in research institutes it appears that the print run for the first edition was significantly smaller than the second edition. See *BB*, 576–7.

55 West Sussex County Records Office MP 1236 and East Sussex County Records Office QDS/1/EW1. Under the provisions of the act, all persons owning a printing press had to submit their names and the number and type of presses they owned to the clerk of the peace. There is no record of Blake having submitted his name to the clerk of the peace for Lambeth in accordance with this act (39 Geo III, c 79, xxiii).

56 There is no mention of a copperplate rolling press in the correspondence between Hayley and Seagrave's assistant and successor, William Mason. On Seagrave's death, Mason purchased all his employer's equipment, including the two presses. There was a certain degree of friction between Mason and the lawyer acting on behalf of the Seagrave estate. Hayley became involved and smoothed relations between the parties. See Morchard Bishop, 'William Hayley and His Last Printer,' *Book Collector* 31, no. 2 (1982): 187–200.

57 Princeton University Rare Books and Manuscripts Library, Hannay Collection, box 4, folder 42. There are five engravings in the third edition of *Essay on Old Maids*. The first volume contains a frontispiece by Skelton after Stothard, the second volume contains two illustrations: a frontispiece by Bromley after Stothard and an engraving by Blake's former business partner, James Parker, after Stothard. The third volume contains two illustrations: a frontispiece by Fittler after Stothard and an anonymous engraving of *Hroswitha or Rosvida the dramatic Nun of Saxony* facing the appendix.

58 From May 1803 (the month that the *Triumphs* plates were published) until he returned to London in September, Blake appears to have dedicated his time to completing the seven paintings after Biblical subjects that he had 'on the stocks' for Thomas Butts.

59 The last extant correspondence between Blake and Hayley is Blake's letter of 11 December 1805.

60 This reworking is evident in the impressions published in the following editions: seventh (1793), eighth (1795), ninth (1796), tenth (1799), eleventh (1801), and *second* thirteenth (1807). The Stothard plates would have been recut and/or re-etched as the practice of steel facing did not come into widespread use until the 1820s. For engravers reworking their plates, see Essick, *William Blake's Commercial Book Illustrations*, 5. For steel facing, see Majorie Plant, *The English Book Trade* (London: Allen and Unwin, 1974), 311–12.

61 The extensive and skilful reworking evident in the impressions in the *second* thirteenth edition suggests that time and money was invested in the plates so that they could be reproduced in future editions. As previously stated, at least four of the engravings after Stothard were reproduced in the 1817 edition. I would like to thank Alexander Gourlay for this suggestion and for his advice concerning the Stothard plates.

6 More on Blake's (and Bentley's) 'White Collar Maecenas': Thomas Butts, His Wife's Family of Artisans, and the Methodist Withams of St Bartholomew the Great

MARY LYNN JOHNSON

> There are critics who can find things in the Public Records Office, and there are critics who, like myself, could not find the Public Records Office.
>
> – Northrop Frye

In 1956, an impossibly young G.E. Bentley Jr, just finishing his DPhil at the University of Oxford, made his first appearance in a major scholarly journal with a landmark article on Blake's most important patron, Thomas Butts.[1] In this witty, fact-packed exposition of Butts's family history, his career as a clerk in the office of the Commissary General of Musters (downgraded from the family legend of Muster Master General), and his dealings with Blake, Bentley set the standard for his life's work on subjects about which 'little is known,' and 'some of what is known is untrue.'[2] Indeed, Bentley's shrewd inferences from facts and figures mined on site in the Public Record Office (PRO) proved of such lasting value that almost forty years passed before another scholar was emboldened to build on his achievement. Then, in the mid-1990s, assisted in part by the digitization of crucial records, and by Bentley himself, Joseph Viscomi published a trio of interrelated essays complementing, supplementing, and (occasionally) correcting his predecessor's findings, along with news of Butts's second marriage and far-flung family connections, the school run by his first wife, his likely residences and spaces for hanging pictures, his way of matting and displaying art, as well as accounts of previously unknown collectors of Blake's work and early provenances of other Blake works.[3] And now, without once setting foot in the PRO, anyone with inordinate curiosity, monomaniacal

patience, temporary memberships in genealogical societies, institution-al access to archival databases, a reasonably capacious Internet connection, and a ready credit card has a fair chance of contributing to 'what is known' about Butts, simply by gazing into the ever-expanding online universe of period newspapers, books, parish registers, wills, law cases, censuses, financial statements, military records, accounts of charitable institutions, house-to-house street maps, and even private papers, such as those of Butts's great-granddaughter, the writer Mary Butts, recently deposited in the Beinecke Library of Yale University.

Among previously unreported materials to be considered at present are the wills of Butts's maternal grandparents, a 1747 poem by Charles Wesley on the death of Butts's maternal grandmother, details of Butts's 1782 marriage to Elizabeth Mary Cooper, the occupation of her family of origin, the baptismal parishes of their four sons, Butts's ties with his architect first cousin Thomas Hardwick, the missions of the five charities named in Butts's 1844 will, and the burial sites of both Thomas and Elizabeth Mary Butts.[4] Awaiting future exploration are records documenting the 1803 marriage of Butts's son Joseph Edward to Sarah Hoskin; the dispersed baptismal parishes of their six (or so) children; the 1825 baptism of Joseph's natural daughter Mary Ann Powell Butts (by his housekeeper Elizabeth Powell), an heiress in J.E. Butts's 1827 West Derby will (executed in London by his father in 1828); the 1827 partnership dissolution and bankruptcy of the Kent 'mill sawyer' Thomas Butts Jr and his 1828 marriage to Mary Ann Barrow; the 1834 rescue by Blake's patron of his grandsons (via Joseph) Edward Herringham Butts and Henry Halse Wellington Butts upon their failure as linen-drapers in Coventry; Butts's taking his granddaughter Eizabeth (via Joseph) into his home before her 1845 marriage to Alfred Eyre (followed by her death in 1850, Eyre's remarriage in 1851, and his bankruptcy in 1854); a precedent-setting lawsuit in 1855 stemming from an 1851 contract between Butts's grandson-in-law Alfred Eyre and his grandson Edward Herringham Butts; Edward's 1847 marriage to his cousin Sophia Hoskin and the baptisms of their two daughters in Channel Islands' parishes; a court decision on the distribution of Edward's property (according to a handwritten will drafted in 1853) after his 1854 death in France; the 1841 and 1845 marriages of Butts's grandsons (via Joseph) Henry and William in Hamilton County, Ohio; Henry's 1855 letter to his mother Sarah Hoskin Butts, dispatched from his brother William's home in Goshen, Ohio (and later census records of Butts's great-grandchildren in Ohio); details of the military careers of Butts's

grandsons (via Thomas Butts Jr) Captain Frederick John Butts and Lieutenant Aubrey Thomas Butts; Captain Butts's 1863 Chancery lawsuit (amended with different sets of plaintiffs and defendants in 1877 and 1905) against his own mother and the clergyman who served as third executor of his father's 1862 will; and an undated privately printed 'Catalogue' leaflet of 'Some of Blake's Pictures' (thirty-three titles only) at Captain Butts's home, 'The Salterns.' A glittering heap of factual nuggets, to be sure – if only they can be made to yield, *à la* Bentley and Viscomi, the refined gold of an enriched contextual understanding of Blake's friend, patron, and principal collector. (See fig. 6.1.)

My current absorption in all this fact finding is the unanticipated consequence of a longstanding fascination with Blake's watercolours on biblical subjects (c. 1800–5, through c. 1809), executed on commission from Butts. According to a rough scholarly consensus to which I have attempted to contribute, this group of designs constitutes a visual commentary on the Bible – even though such extra-biblical subjects as *The Death of the Virgin*[5] and *The Assumption of the Virgin* (B 513) are drawn from pseudepigrapha rarely treated in Protestant art.[6] For a would-be interpreter of these superficially straightforward but deeply puzzling pictures, even the faintest ray of insight into Butts's perspective on the Bible is to be welcomed, for it was the patron's prerogative to choose the subjects, while 'always' leaving the grateful artist to his 'own Judgment' in developing them.[7] The date of Blake's first encounter with Butts is unknown. But as Bentley and Viscomi have noted, their correspondence in the early 1800s (with Butts's side represented only by a single draft) reflects the easy familiarity of a well-established friendship. Despite their glaring difference in social status, the two men and their wives frequently enjoyed each other's company: on 23 September 1800, for example, at the beginning of the Blakes' three-year sojourn in Felpham, Blake wrote 'I shall wish for you on Tuesday Evening as usual' (E 711); and on 10 January 1802, as he made plans to return to London, he noted that he and his wife Catherine 'often wish that we could unite again in Society & hope that the time is not distant when we shall do so' (E 725). While separated, Blake and Butts stayed in touch in letters punctuated by playfully duelling poems, quotations of scripture, semi-serious doctrinal bantering, and warmly complimentary – even delicately risqué – messages to each other's wives, all luckily preserved for posterity by Butts. As Blake's highly pleased 'employer,'[8] Butts expanded his initial order for 'fifty small pictures from the Bible' – the original plan for the 1799 tempera series that trailed off at about

Figure 6.1 Immediate ancestors and descendants of Blake's patrons, Thomas and Elizabeth Butts (and Butts's maternal uncle, aunt, and first cousin)

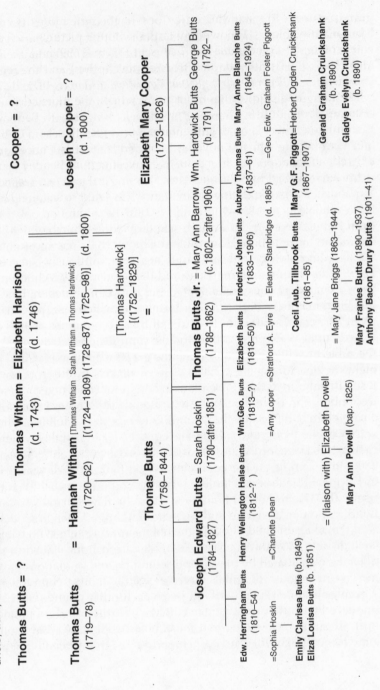

thirty pictures – to a standing order for what became more than eighty biblical watercolours, followed by larger synoptic pictures such as the watercolours *A Vision of the Last Judgment* (1806; B 639) and *The Fall of Man* (1807; B 641; title adapted from an inscription) and the tempera known as *An Allegory of the Spiritual Condition of Man* (c. 1811; B 673).

The more one studies these intriguing works, the more curious one becomes about Butts's own religious beliefs. But, as both Bentley and Viscomi note, there is no documentary support for the claim of Butts's great-granddaughter, the novelist Mary Butts, that her ancestor was a Swedenborgian. After an exhaustive investigation, Bentley sensibly surmised in 1956 that Butts was 'probably an Anglican or a respectable Methodist, but in the absence of evidence it is safest to say that his religious affiliation is unknown.'[9] And Viscomi, having found only Butts's baptism and his second marriage recorded in the Church of the Latter-day Saints' International Genealogical Index (IGI), the most comprehensive database of Anglican parish registers, cautiously conjectured, in 1996, that Butts's first marriage and the baptism of his children may have occurred 'in one of over 40 parishes not yet included in the IGI' or that Butts may have been a nonconformist, 'in which case there may not be any official or surviving records' of these ceremonies at all.[10] Now records unavailable to Bentley and Viscomi bear out their most conservative hunches: Butts and his family – like William and Catherine Blake and their parents – consistently relied on the Church of England for 'hatching, matching, and dispatching,' as the saying goes. On 21 December 1782, by licence, Butts married Elizabeth Mary Cooper in his parish church, St George the Martyr, Queen Square, Holborn, Middlesex (hers was St George's, Hanover Square).[11] The couple had all four of their sons baptized in or near their mother's parish: Joseph Edward (b. 4 Feb. 1784) in St George's, Hanover Square, on 1 March 1784; the others in neighbouring St James's, Westminster – Thomas Butts Jr (b. 27 Sept. 1788) on 28 October 1788, the short-lived William Hardwick (b. 2 July 1791) on 26 July 1791, and George (b. 22 Sept. 1792) on 21 October 1792.[12] And Joseph and Thomas, the only surviving sons with babies of their own, in due course observed this rite in their local Anglican parishes. Finally, as will be seen, Thomas and Elizabeth Mary Butts were buried in the parish of Butts's maternal grandparents in London.

Similarly, Butts's five charitable bequests for fifty pounds each – substantial sums, but not a huge percentage of the thousands of pounds in cash, stocks, annuities, and real estate holdings that he passed to heirs in his fifteen-page will (proved 23 June 1845) – largely benefited institu-

tions with ties to the Church of England, and perhaps reveal an active involvement in local affairs of the large parish of St Pancras to which he belonged after moving to Fitzroy Square in 1809:

> The Westminister Hospital late in James Street ... [,] The Strangers Friend Society[,] The Auxiliary Bible Society in Saint Pancras [,] the Society for Visiting the Sick in their own houses within that part of the district of Saint Pancras in which I reside[,] [and] the Indigent Blind Visiting Society whose Office is no 20 Red Lion Square[,] I having been for many years a Subscriber to those several Charitable Institutions[.]

The two organizations most closely related to Butts's interest in biblical subjects are the Auxiliary Bible Society and the Indigent Blind Visiting Society, both of which sought to expand access to the Bible and encourage Bible reading. The Auxiliary Bible Society, organized in parish- or county-level fundraising units, was an offshoot of the interdenominational and scrupulously non-proselytizing British and Foreign Bible Society, founded in 1804 to produce and disseminate Bibles 'without note or comment,' under the leadership of a committee formed exclusively of laymen: fifteen Anglicans, fifteen Dissenters, and six foreigners.[13] Butts's local branch, the Bloomsbury and South Pancras Auxiliary Bible Society, which provided 'the neighbouring poor' with free or low-cost Bibles, was founded on 15 February 1813 – more than a decade after Butts commissioned his first Bible illustration from Blake. Those attending the meeting in Freemasons' Hall numbered 'between seven and eight hundred ladies, and about four hundred gentleman[,] among whom was a very considerable portion of the distinguished and respectable inhabitants of the district,' a company easily imagined as including Butts himself.[14] The assembly's first round of subscriptions totalled nearly £500, 'including a donation of fifty pounds from His Grace the Duke of Bedford,'[15] the principal landholder in the area. At the meeting, it was pointed out that 'among 2481 families, consisting of 9652 individuals, 5942 of whom could read, there were only 467 perfect Bibles, and 126 imperfect ... In the six poorest of the thirty sub-divisions ... among 858 families, consisting of 3600 individuals, only thirty Bibles or Testaments were found; being a proportion of not more than one book to twenty-eight families, or 120 individuals!'[16] Similarly, the Indigent Blind Visiting Society, founded in 1834 by Lord Shaftesbury, arranged for volunteers to read the Bible aloud to blind people in need, hired guides to conduct them to places of worship, provided a fund to

tide them over in financial emergencies, and later offered employment opportunities and self-help classes (by 1844 'it was allowing James Frere to teach his own alphabet to some of the juveniles on its roll').[17]

The other three organizations named in Butts's will were dedicated to caring for the destitute ill. Westminster Hospital, founded in 1716 to relieve 'the Sick Poor and Needy,' opened in 1724 as the first such institution in London to be supported by voluntary contributions from the public.[18] When Butts signed his will in 1844, the hospital had been settled for a decade in its new building on Broad Sanctuary, along the northern side of Westminster Abbey, but for more than a century (1733–1834) it had been on James Street, near Oxford Street and Portman Square, a bit closer to Butts's homes in Great Marlborough Street and Fitzroy Square. The Strangers' Friend Society (The Benevolent or Strangers' Friend Society For Visiting and Relieving the Sick and Distressed Poor at their own Habitations in London and its Vicinity) was founded in 1785 by John Gardiner (sometimes spelled Gardner), a Methodist layman, immediately attracting as a subscriber John Wesley, who is often named as a cofounder. With Wesley's encouragement, sister societies soon sprang up in Bristol, Manchester, Leeds, Liverpool, Glasgow, and Dublin, eventually spreading across the United Kingdom and Ireland and throughout the British Empire to offer assistance, according to one of its rules, 'without distinction of sect or country' to those ineligible for parochial relief under the Poor Laws.[19] As it grew, it received support from Anglicans, Unitarians, Quakers, and Catholics, and some local branches moved their main offices to secular locations. In London, the Society's base after 1798 was the metropolitan centre of Methodism, the Wesleyan Chapel of Great Queen Street, but by the time of Butts's will its headquarters had moved to Exeter Hall, the city's largest assembly hall, in the Strand.[20] Regrettably, the starting date of Butts's 'many years' of subscribing to this society cannot be determined from published lists of donors – some anonymous – such as those in the London *Times*.[21] It is much more difficult to pin down Butts's similar bequest to 'the Society for Visiting the Sick in their own houses' because the phrase is apparently a generic description rather than the official name of any society on record. Perhaps Butts intended his bequest for the Sick Man's Friend, a 'society for visiting the sick at their own houses' founded by Henry Peckwell, D.D. (1776–1823), an Anglican clergyman and a popular Methodist preacher.[22] More likely, the reference to 'the district of St. Pancras in which I reside' is shorthand for Butts's support of his local unit of the District Visiting Societies established by

the Church of England in the 1820s under control of its clergy, partly to compete with the volunteer-run Strangers' Friend Society operated by Methodist laity.[23]

Another clue to Butts's interest in the Bible, consistent with his apparent philanthropic commitment to the social teachings of the Gospel, may (or may not) be found in his staunchly Methodist heritage. Butts's mother, neé Hannah Witham, came from a family well acquainted with John and Charles Wesley, as may be worked out from key proper names mentioned in the 1807 will of Butts's uncle, the younger Thomas Witham (proved 1809). Witham, presumably a bachelor or a widower without offspring, appointed as co-executors his nephews 'Thomas Hardwick of Berners Street London Architect' and 'Thomas Butts of Great Marlborough Street London Coal Merchant' (a rather odd designation, as Butts by then had worked in the Musters office for fourteen years), charging the two men with selling his assets, jointly investing the proceeds in 'Government Securities,' and using part of the interest to continue a twenty-pound life annuity to Butts's sister, 'my Niece Sarah Harris wife of William Harris,' and to her husband if she should be the first to die – a legacy continued in Butts's 1844 will. Butts's architect cousin Thomas Hardwick (1752–1829), who merits a substantial entry in the *Oxford Dictionary of National Biography* (*ODNB*), was the son of the stonemason and self-trained architect Thomas Hardwick (parish of St Lawrence, New Brentford, Middlesex, about seven miles west of Hyde Park Corner) and his wife Sarah Witham (c. 1728–87), sister of Hannah Witham Butts. Thomas and Sarah were married by Charles Wesley himself on 31 December 1748 in St Anne's, Soho, as recorded in the clergyman's journal: 'I married T. Hardwick and Sally Witham. We were all in tears before the Lord.'[24] According to the Special Collections catalogue of the John Rylands University Library, the elder Thomas Hardwick, Sarah's husband, was 'well-known to the Wesley brothers during the second half of the 1740s and accompanied John Wesley on one of his preaching tours in late 1747'; he attended 'at least part of the Methodist Conference' that year, and on 17 December 1748 – two weeks before his wedding – he assisted a fatigued Charles Wesley by meeting him in a post-chaise.[25] Several other references to Thomas Hardwick, Sarah Witham, and the elder Withams in the journals of both John and Charles Wesley support an editorial observation that 'the Wesley brothers ... enjoyed frequent hospitality and spiritual conversation' with the Withams.[26]

As the Withams' involvement in the Methodist movement is further

considered, it is important to recall that in the 1740s, well before the Methodists broke from the Church of England in 1795, British members of Methodist societies retained membership in the established church. They did not receive the sacraments in their meetings, which were held at times and in places that did not interfere with regular church services. The family's spiritual leader seems to have been Butts's grandmother, whose first name and parish are mentioned at the beginning of her son Thomas Witham's will: 'I desire to be buried as near as possible to the body of my Mother the late Mrs Elizabeth Witham in the Green Church Yard of the Parish of Saint Bartholomew the Great near West Smithfield' – the same London parish, be it noted, in which Butts's parents Thomas and Hannah had baptized their first child on 13 March 1746/7.[27] In 1748, the congregants of this parish complained to the bishop of London that their rector (1738–60), Richard Thomas Bateman, a Methodist convert and an old school friend of John Wesley, 'invites Mr. Wesley very frequently to preach,' only to be chastised: 'What would you have me do? I have no right to hinder him. Mr. Wesley is a clergyman, regularly ordained and under no ecclesiastical censure.'[28] Bateman's first invitation was for a charity sermon on Christmas Eve 1738. Almost a decade later, on 31 May 1747, after Wesley 'had been shut out of the London churches for eight years,' his friend Bateman, as a recent Methodist convert, was the first to welcome him back to a London pulpit.[29] On this occasion, Wesley noted that 'it was with much difficulty I got in; not only the church itself, but all the entrances to it, being so thronged with people ready to tread upon one another.'[30]

At the time of Witham's will, Elizabeth Witham's body had indeed been 'buried in green churchyard, 1 Dec. 1747, Reg. vii, 89,' an area supplementing the overcrowded churchyard proper, but her remains were later interred in the Cloister.[31] The date and circumstances of her death, two days before her burial, are established in John Wesley's journal for 29 November 1747:

About six in the morning, Mrs. Witham slept in the Lord. A mother in Israel hast thou also been, and thy works shall praise thee in the gates. Some years ago, before Mr. Witham died, she seemed to stand on the brink of eternity. But God renewed her strength, till she had finished the work which he had given her to do. She was an eminent pattern of calm boldness for the truth, of simplicity and godly sincerity; of unwearied constancy in attending all the ordinances of God; of zeal for God and for all good works; and of self denial in every kind. Blessed is the dead that hath

thus lived and died in the Lord! for she rests from her labours, and her works follow her.[32]

A few weeks later Charles Wesley noted in his journal: 'Mon. and Tues., December 14th and 15th [1747]. I had great rejoicing over our lately departed sister Witham. Her dying prayers for me I found strengthening my hands, and confirming my hope of shortly following her.'[33] In this vein, the prolific writer of sacred verse composed 'On the Death of Mrs. ELISABETH WITHAM,' a nineteen-stanza celebration of her life and influence on those around her, including the poet.[34] 'By her Example fir'd I rise, / ... / And if I dare believe the Word, / And follow her as she her Lord, / The glorious Prize is sure.' If Wesley's hyperbole has any basis in reality, Elizabeth Witham presumably passed on at least something of her faith to her whole family: 'Resolv'd, her House should serve the Lord, / The Parent unto Him restor'd / The Children He had given, / ... The Wife her Husband sav'd at last, / And follow'd him to Heaven.' To judge from Charles Wesley's tears while officiating at Sarah Witham's wedding soon after her mother's death, Mrs Witham succeeded in bringing that daughter up in the faith, and Butts's mother, at the age of about twenty, may well have been the 'Hannah With[am]' recorded in John Wesley's journal on 14 July, noting a visit, conversation, and prayer, and the 'Miss Witham' recorded on 13 August 1740 among ladies who had travelled from London to hear Wesley preach in Oxford.[35] According to Sondra Matthaei, Mrs Witham was a 'London band-leader,' a member of the 'select society' of 'those who have reached an advanced state of spiritual growth' who 'met on Monday mornings with John Wesley.'[36]

Whether or not Elizabeth Witham was instrumental in converting her husband, as Charles Wesley's elegy would have it, she must have taken comfort four years earlier in the hymnist's attendance at her husband's deathbed, when Mr Witham preceded her in an inspirational departure of his own:

About the middle of November [1743] he [Charles Wesley] ... came to London. where he ... was a joyful witness of the power of religion. [December 8] 'I called upon Mr. Witham,' says he, 'given over by his Physicians; trembling at the approach of the king of terrors; and catching at every word that might flatter his hopes of life.' On the day following he adds, 'I prayed with him again, and found him somewhat more resigned.' Eleven days afterwards [Dec. 20] he says, 'I prayed in great faith for Mr. Witham,

the time of whose departure draws nigher and nigher ... At half-hour past seven in the evening he broke out, 'Now I am delivered! I have found the thing I sought. I know what the blood of sprinkling means!' He called his family and friends to rejoice with him. Some of his last words were, 'Why tarry the wheels of his chariot? I know that my Redeemer liveth. Just at twelve this night my spirit will return to Him.' While the clock was striking twelve he died like a lamb, with that word, 'Come Lord Jesus.'[37]

Perhaps it was their shared witness of Mr Witham's joyous departure from this life that prompted Charles Wesley, on 16 January 1746/7, to send Elizabeth Witham a manuscript of another poem, later published as the first of his 'Hymns for Widows.'[38]

Mundane facts of Thomas and Elizabeth Witham's lives may be derived from their wills, signed only days before their respective deaths (his, on 10 December 1743; hers, on 23 November 1747).[39] Mr Witham identifies himself as a 'Woollen Draper' of 'Cloth Fair,' probably meaning that the family lived in that precinct southwest of Smithfield Market rather than actually within the narrow two-block-long street running parallel to Long Lane on the north and along the churchyard of St Bartholomew the Great and Bartholomew Close on the south. The cloth merchants' annual exposition on and around the saint's feast day, August 24 (changed in 1753 to September 3 under the new calendar), dating from the church's founding in 1123, grew into the saturnalia of Bartholomew Fair, notorious in the Withams' lifetime, though in the Victorian era it gradually dwindled and finally closed in 1855.[40] Mr Witham's remarkably brief and plainspoken will (proved 10 January 1743/4) names his wife and his friend Samuel Fludyer co-executors, provides ten pounds for his married niece Lidia Osborn 'in Consideration of her living in necessitous Circumstances,' and leaves the rest to his immediate family – real estate in Essex to his son Thomas, real estate in Waddesdon, Buckinghamshire, to his wife 'and her heirs,' to be devised 'to and among such of my Children ... that She shall think most deserving of the same.' His 'personal estate' is to be divided 'amongst my Wife and Children according to the Ancient Custom of the City of London' – probably meaning that Mrs Witham was to receive more than the common-law 'widow's third.'[41] In probate, Elizabeth Witham was granted the right to administer all the property on her own, with her co-executor's right reserved until 'he shall apply for the same' (TW will).

In her own will, Mrs Witham leaves the Waddesdon real estate

'which my late Husband devised to me in fee simple' exclusively to her daughters 'Hannah wife of Mr Thomas Butts' and 'Sarah Witham.' This property, which Thomas Witham had purchased during their marriage (TW will), would have allowed Elizabeth Harrison Witham a foothold in what must have been her original home village, where, according to her will, her brother Thomas Harrison, a 'Mal[t]ster,' and her widowed sister Joanna Stratford (each bequeathed five pounds) still lived. Mrs Witham also leaves five pounds each to her married sisters (Sarah, wife of Daniel Symons, a gardener in Norfolk; and Ann, wife of George Oliver, a 'Yeoman' in Devon), twenty pounds to her niece Lydia Osborn (still in 'necessitous circumstances'); and a few pounds to her two servants. She appoints as executrix her twenty-seven-year-old married daughter Hannah Butts (passing over her twenty-three-year-old son Thomas) and charges her 'to bring up and educate (or see that this be done) my niece Rebecca Harrison [presumably the daughter of her brother the maltster] fitting for the Station of a Servant.' She leaves all her 'Household Goods Furniture Plate and Linnen' to be divided equally among her three children, 'Except one large Silver Spoon I do give and devise to my Grandson Thomas Butts' – referring to Thomas and Hannah Butts's short-lived firstborn, baptized 13 March 1746/7 in St Bartholomew the Great.[42] Mrs Witham's signature, dated 23 November 1747, 'in the presence of us ... at her request and in her presence,' was witnessed by 'Francis Butts[,] Henry Jewett[,] Hen: Thornton Gray's Inn Holborn.' The lawyer Thornton, not to be confused with Henry Thornton (1760–1815) of the Clapham Sect, was one of the trustees who contracted (5 March 1745/6) with John Wesley to assume ownership of his property in Newcastle and run it as an orphanage.[43] As the law required witnesses to sign the document in the presence of the dying woman, perhaps all three were associated with Thornton's legal office in nearby Gray's Inn. The witness Francis Butts is presumably Butts's uncle, brother of the elder Thomas Butts; if he worked with Thornton, he would have been in an ideal position to assist Hannah Witham Butts with her duties as executrix. Possibly, too, he is the Francis Butts whose untimely illness (8–12 December 1748) and death the following year led to Wesley's journal entry of 14 December 1748: 'Thus, in the strength of his years, died Francis Butts, one in whose lips was found no guile. He was an honest man, fearing God, and earnestly endeavouring to work righteousness.'[44]

As Viscomi notes,[45] Hannah and her husband Thomas Butts were married on 19 May 1746, in the parish of St Andrew by the Wardrobe

(IGI). But this parish designation is a bit complicated. In his marriage licence allegation of 14 May 1746, to the Faculty Office, Mr Butts 'made Oath and Prayed Licence to solemnize the said Marriage in the Parish Church of St. Ann Blackfryers [*sic*].' In fact, the church building belonging to this old parish, just to the west of St Andrew, was destroyed in the Great Fire. When the rebuilding committee headed by Christopher Wren decided not to replace it, the parish was merged with St Andrew by the Wardrobe in 1670 but retained its own name and identity.[46] In the relevant parish record, newly available on www.ancestry.co.uk, the Buttses' entry appears under the following page-heading: 'A.D. / 1746[,] Married in S^t Andrew Wardrobe & S^t Anne Blackfry^rs London.' In all entries, the third name is that of the clergyman who performed the ceremony, usually William Grainger, the rector (1736–59), often identified only by his initials.[47] Sometimes others officiated under his auspices: on the facing page, on 26 December 'J Challis,' presumably a lower-level cleric, is entered 'for W. Grainger'; on 10 April the surrogate is 'J^no Wills'; and on 7 May, the rector's representative is 'Ben: Pearce' (who is also listed in his own right on 17 June). For the marriage of Thomas Butts and Hannah Witham on 19 May a different name is recorded: 'Thomas Butts of the parish of S^t Luke in the county of Middlesex Batchelor and Hannah Witham of the parish of S Bartholomew the Great London spinster p[er] L[icence] p[er] John Wesley for himself.' In what appears to be Wesley's name, a long 's' may have been written over an underlying 'l,' as if the parish clerk first wrote 'Welley.' (Similar long forms of 's' appear on the facing page, in the same hand, in 'Castle,' 'Wilson,' 'Pilson,' and occasionally in 'parish,' usually written with a short 's'). Did the Methodist leader John Wesley officiate at the wedding of Blake's patron's parents? Did the clergyman who claimed that the world is his parish act 'for himself' to carry out the terms of a marriage licence in a parish in which neither the bride nor the groom resided? Wesley's journal does not provide an answer: 'I preached at Bath [15 May, having left London on 4 May] and, setting out at three the next morning, in the evening came to Blewbury' [16 May]; 'And setting out early in the morning, Saturday 17, in the evening came to London.' There is no entry for 18 May. The only entry for 19 May records yet another deathbed struggle, this one by a young woman 'cursing and blaspheming' in an agony extending over many days, inconclusively – possibly allowing an interval just long enough for Butts's parents to receive Wesley's blessing.[48]

Butts's mother, the former Hannah Witham, died sometime in 1762,

long before she could have significantly influenced the adult religious leanings of her son Thomas, who would not have turned three until December of that year. But the family's Wesleyan connection was so pronounced in the 1740s that its residual effects may have reached Butts through his aunt Sarah Witham Hardwick (1728–87) and his uncle Thomas Witham (1724–1809).[49] One indication of Butts's continuing involvement with the family, even after his aunt Sarah's death, is that her husband, the elder Thomas Hardwick, left Butts and his wife mourning rings (13 June 1796 will, proved 24 September 1798). Butts appears to have been especially close to the Hardwicks' only son, his cousin the architect Thomas Hardwick the younger, who seems to have played a larger role in his life than did his younger half-siblings John and Matilda, children of his father's second marriage. On 20 December 1782, when the barely twenty-three-year-old Butts was married to twenty-nine-year-old Elizabeth Mary Cooper at the church of St George the Martyr, with the curate John Willis officiating, it was Butts's thirty-year-old cousin Thomas Hardwick, only weeks before his own wedding, who acted as witness (parish register).[50] The other witness, on the bride's side, was Joseph Cooper, probably Elizabeth's father or perhaps her younger brother.[51]

Cousin Thomas Hardwick, having exhibited at the Royal Academy in architecture 'almost continuously from 1772 to 1805' (ODNB) – partly coinciding with Blake's watercolour and tempera exhibits there in 1780, 1784, 1785, 1799, 1800, and 1808 – was well positioned to arouse and encourage Butts's interest in collecting or commissioning works of art.[52] Hardwick's specialty was remodelling and restoring churches, including St Bartholomew the Great (1791, with further work in 1809, 'saving it from demolition' [ODNB]). He was well connected in the art world, even counting among his pupils J.M.W. Turner, whom he famously advised to give up architecture for painting. Is it merely a coincidence, then, that on 16 August 1803 Blake thanks Butts for his 'kindness in offering to Exhibit my 2 last Pictures in the Gallery in Berners Street' (E 731)?[53] Or might Butts's access to this unnamed gallery have been facilitated by Hardwick, who lived at number 55 Berners Street, just east and north of Butts's home on Great Marlborough Street? An earlier distinguished resident of Berners Street, long 'celebrated as the 'home and haunt' of artists, painters, and sculptors,' was Hardwick's mentor Sir William Chambers (1722–96), at number 13, a 'commodious house' briefly leased by Fuseli in 1803–4.[54] Even after the Buttses moved to Fitzroy Square in 1809, they were hardly more distant from Berners

Street just to their south and west. The proximity must have been especially a convenience while the cousins were serving as co-executors of their uncle Thomas Witham's 1807 will and co-trustees of funds that Witham set aside to produce income for his niece, Butts's older sister Sarah Butts Harris – a responsibility that Butts took over alone after Hardwick's death in 1829. In Hardwick's own will, which leaves his assets directly or in trust to his four children, Butts is named one of four recipients of a 'mourning ring of the value of two guineas,' along with Hardwick's brother-in-law, his sister-in-law, and one other friend. In the end, Hardwick and his wife, who had died earlier, were buried with his father's relatives in St Lawrence, New Brentford, while Butts, reaffirming his strong bond with the Withams, had already chosen to inter his first wife Elizabeth Mary Cooper Butts in the parish of his maternal grandparents, St Bartholomew the Great, in 1826; and there, in 1844, his own remains followed hers.[55]

Matters of religion aside, the parish affiliations of Thomas and Elizabeth Cooper Butts help establish their whereabouts and likely activities in the years before Butts began commissioning work from Blake, while other records of this period fill in details of Elizabeth's family of origin and document Butts's early investments. Together, these hitherto unreported facts challenge but do not entirely disprove Viscomi's hypothesis that, before the Buttses moved to Fitzroy Square, their primary residence was in Dalston, a district of St John the Evangelist in Hackney.[56] According to Butts's 10 December 1782 marriage licence allegation, the bridegroom 'hath had the usual place of his Abode in the parish of St. George the Martyr ... for the space of four Weeks last past.' This statement, referring merely to the required minimum period of residency, is not a reliable indication of the length of time Butts had lived in Holborn. As Butts did not enter the Musters office until 1783, his employment at the time of his marriage is unknown. Perhaps, as his uncle Francis Butts may have done before him (EW will), he found work in one of the many law offices or related firms in or near his compact parish, which abuts St George Bloomsbury on the west, St Andrew on the east, and St Pancras on the north, near the Inns of Court. Or – assuming that by 1807 Butts was really running a side business as a 'coal merchant' (as specified in the younger Thomas Witham's will) – perhaps he was already involved with some kind of coal enterprise in Holborn. Butts's paying Blake 'By Coals' in 1805 (BR 765) anticipates John Linnell's similar payments by chaldrons of coals in 1823–5 (BR 781, 783, 785, 806–7), presumably supplied by Linnell's coal-merchant

father-in-law, a form of compensation that the busy artist may have found convenient. Butts's ownership of stock in the 'Cwm Ammons Association in South Wales' at the time of his death is probably irrelevant; in context, the Association is more likely to be a railway extension than a mine, and in either case unremarkable among all the other investments in gold and copper mines, canals, waterworks, railways, and bridges (1844 will) in Butts's hefty portfolio.

Thomas and Elizabeth Mary Butts apparently made their first home together in the bride's parish of St George's Hanover Square, where their son Joseph Edward was baptized in 1784. But this was not the neighbourhood of Elizabeth's parents, as recorded in the 1800 will of her widowed father, Joseph Cooper 'of Noble Street Foster Lane ... Carver and Gilder.'[57] Noble Street, in the general area of Cheapside, lies across Aldersgate Street just to the south of Butts's grandparents' home in Cloth Fair, St Bartholomew the Great. Running parallel to Aldersgate Street, Noble Street is a northern continuation of Foster Lane, beginning at the jagged intersection of Foster Lane with St Ann's Lane on the west and Maiden Lane on the east, and extending north for about a block into Falcon Square, near Silver Lane. Mr Cooper's house, number 20, given in some of the trade directories summarized below, lies at the end of the street at Falcon Square (another '20' appears to be located on Foster Lane proper).[58] Baptismal records for Elizabeth Mary Cooper and her siblings are yet to be located. But in Mr Cooper's simple, straightforward will, Elizabeth Mary is listed as the third (though apparently the second-born) of his eight children: she had an older brother, George Yardly, or Yardley (who married Sarah Birch on 10 February 1781 in St Edmund the King and Martyr, Lombard Street, London); a younger brother, Joseph, Jr (who later married first an Elizabeth and then a Sarah and died in Acre Lane, Surrey); and five younger sisters named Ann (married Thomas Watkins), Frances (married Benjamin Mitchell, 2 April 1792, St Matthew, Friday Street), Winifred (married Lawrence Byron, a schoolmaster, 2 July 1797, St Saviour, Southwark), Elyn (married Richard Bowtell, whose 6 July 1808 will places him in St James, Clerkenwell), and Sarah (married Thomas Symmonds). The executors, who were to receive only an additional £10 for their trouble, were Mr Cooper's younger son, Joseph, Jr, and his son-in-law Richard Bowtell. The will specifies that if any of Mr Cooper's adult children should die before their father, the surviving grandchildren were to inherit 'such equal proportion of such share on dividing my property as would fall to the share of his her or their Father or Mother if they had been living.'

The paterfamilias Joseph Cooper passed on his skills in carving, gilding, looking-glass making, cabinet making, upholstering, and related crafts to his sons and to many other apprentices – as summarized, with some confusion between the elder and younger Joseph Cooper, in Beard and Gilbert's standard guide to period furniture.[59] George opened his own business at 8 Lombard street in 1784, moved to number 82 in 1785, and then moved across town to Piccadilly, in various locations through 1839. His trade label (c. 1785) reads in part: 'Looking glasses and all sorts of frames with carving and gilding done by George Cooper, real manufacturer, 82 Lombard Street, London ... Coach and sash glasses on the shortest notice, old looking glasses new silvered.'[60] The younger Joseph, identified in his father's will as 'of Bishopsgate ... Cabinet and Looking Glass Manufacturer,' initially worked with his father, who is listed in such trade directories as *Kent's* (1776–8; 1783) *Lowndes* (1779–91), *Andrews* (1789) and *Wakefield's* (1790) as 'looking glass manufacturer toy making' or variations thereof. By 1790, the younger Joseph had opened his own establishment, 37 Bishopsgate Within: in *Wakefield's* he is 'cabinet maker, wood/furniture/carriage trades, upholsterer, textiles' and in *Bailey's*, 'upholder [upholsterer] household hard ware.'[61] In 1822, by then trading as 'Joseph Cooper and Sons Looking-glass and Furniture Warehouse, No. 93, Bishopsgate-street-within' and claiming pride in a half-century of excellent work, the younger Joseph repeatedly ran a long advertisement in the *Times* announcing a plan to 'vary our arrangements' in view of 'the limits to which the commercial horizon has tended gradually to contract.' The notice deplores 'a class of speculators, who have endeavoured to benefit themselves by offering goods of very inferior manufacture,' challenges the 'exorbitant demands' of other tradesmen, acknowledges that 'we must have a profit, but we shall be satisfied with a moderate one,' pledges to give 'fair wages' and use 'first rate material,' and offers (in addition to the usual goods and services of new and used looking-glasses, carving and gilding, and furniture making) Turkey carpets, paperhanging, 'seasoned floor cloths,' and 'funerals furnished.' Moreover, to 'evince the anxiety they feel for the effective completion of their orders,' the firm has 'engaged artists competent to exhibit drawings suited to every display of taste, economy, and elegance; among these the ornaments attending heraldic emblazonments will form a prominent feature.' Finally, Cooper and Sons will also buy used furniture and provide appraisals at a 'reduction from 25 to 30 percent for the advantage of immediate payment.'[62]

In view of all these activities, it seems impossible that the Coopers engaged in yet another line of work:

> The Scrivener who took in by far the largest number of apprentices during these years [later eighteenth century] was Joseph Cooper (senior). Cooper was a successful carver and gilder in Noble Street where the Company had owned the Hall and still owned ground rents. He was Master of the Company in 1780. His apprentices numbered 26. Cooper's son, George Yardley Cooper, also a carver and gilder of 36 Piccadilly, had five apprentices during the period considered ... Joseph Cooper (Junior) who was apprenticed to his father, became a freeman of the Company in 1779, a member of the Court of Assistants in 1795 and Master in 1801 and 1821.[63]

According to the organization's web site, the Worshipful Company of Scriveners, claiming ordinances dating from 1373, was and is a livery company of 'Writers of the Court Letter' in such papers as 'wills, charters and legal documents,' with most members serving as notaries (www.scriveners.org.uk). Perhaps all this bears on the fact that the name 'Joseph Cooper' on the parish register of Thomas and Hannah Butts's marriage is written in a distinctively large, dark, clear, and bold script – useful in any occupation, including the crafting of decorative objects for the homes of the wealthy. More likely, as the various liveries by the nineteenth century took in all manner of unrelated craftspersons, the Coopers remained carvers and gilders in their rise to the top of the Worshipful Company.

As a twenty-nine-year-old spinster from such an enterprising family, Elizabeth Cooper may have been living independently in 1782, the year of her marriage, already running a school for girls. The 1790 will of Captain James Denty of the East India Trading Company refers to 'my natural Daughter Elizabeth Denty a Girl of about seven years of age now at Mrs. Butts Boarding School in South Molton Street near Hanover Square' (signed c. March 1790; probated 16 July 1792).[64] This street (to which, coincidentally, the Blakes were to move in 1803) is in the parish of St George's Hanover Square, where Thomas and Elizabeth Butts lived at least until their first son's baptism in 1784. By 28 October 1788, when Thomas Butts Jr was baptized in St James's Piccadilly, they had apparently moved to 9 Great Marlborough Street, the address of Elizabeth Butts's school from at least as early as 1790.[65] Captain Denty, preparing his will a month before his death in Cawnpore, India, was probably unaware of the new address. As Elizabeth Denty was only seven years old in 1790, though, she must have very young

when (before 1788) she enrolled at the South Molton Street school. If the Buttses were acquainted with her father or her (unnamed) single mother, or with someone else who had the child's welfare at heart, perhaps they accepted little Elizabeth as a four- or five-year-old boarder because of the special circumstances of her birth and of her father's overseas assignment. Certainly Elizabeth Mary Cooper Butts, as the eldest of six sisters, would have been quite accustomed to dealing with little girls of such a tender age.

Corroborating evidence of the Buttses' movements across parish boundaries in this period may be extracted from records of Butts's financial holdings. In 1786, the 27-year-old Thomas Butts, having worked only three years in the office of the Muster Master General, already owned Bank of England annuities of the sort that he later inherited from his uncle Thomas Witham. In 1791, 'Thomas Butts, of the Pay Office, Whitehall, Gent.' (p. 19) appeared on the bank's list of 'proprietors of unclaimed dividends on Bank stock' because he had left unclaimed '2' dividends of stock that became payable in 'Jan. 1786' as a 'Consolidated 3£ per Cent. Annuity' (p. 7).[66] Thus before 1786, when Butts bought the stock, he apparently preferred to use his business address rather than his home address. This may have been close to the time when the family moved from the parish of St George, Hanover Square (South Molton Street) to St James's, Westminster (Great Marlborough Street). But by 1800, after he had bought two more stocks (these, held jointly with his eldest son), his address on bank records was the same as his wife's school: 'Thomas Butts, Great Marlborough-street, Gent. and Joseph Edward Butts, same place, a Minor' are listed under 'The Names of Proprietors of £ .5 per Cent. Annuities 1797' as having two unclaimed dividends, or interest thereon, payable since 'Oct. 1799' (p. 406, image 416).[67] In this same Bank of England publication, 'Thomas Butts, Pay Office, Whitehall, Gent.' still has not claimed his '2' dividends (p. 30) that have been payable since January 1786. So even if Viscomi is correct in speculating that Thomas and Elizabeth Butts had a home in the Dalston district of Hackney from 1786 until 1808,[68] they apparently did not regard it as their principal residence, for they neither baptized their three younger sons in that parish nor listed that address when Butts purchased stock from the Bank of England. But certainly the Buttses put down roots at number 9, Great Marlborough Street, the address to which Blake directed his correspondence from September 1800 until he and Catherine returned to London in September 1803. Judging from outlines in Richard Horwood's amazingly detailed map of London (which of course cannot indicate the number of storeys), the Great

Marlborough house, which had a back garden twice as large as the house itself, is larger than the Buttses' post-1808 (and post-hypothetical-Dalston) home at number 17, Grafton Street, Fitzroy Square. Certainly it offered ample room for both a comfortable family home (with space for Blake's work) and a boarding school (which may also have displayed Blake's pictures, as both Viscomi and Bentley suggest).[69] And should Mrs Butts have required 'wooden frames without front mats' to accommodate Blake's large-margined, crayon-board-matted biblical watercolours embellished with 'washline mounts,'[70] her carver-gilder father Joseph Cooper, or her brothers, or her nephews, or their apprentices would doubtless have been happy to oblige.

From this point on, overlapping events, tangled intergenerational connections, and complicated parish boundaries make straightforward exposition of the further activities of Butts and his family well-nigh impossible. That is why I hope soon to honour the tradition of Bentley's *Blake Records* by publishing in an appropriate scholarly vehicle a workaday list of 'Butts Records,' 1782–1905, arranged chronologically in tiers or columns according to family groups: one for Butts, the others for the family lines of Joseph Edward and Thomas Butts Jr. Other findings may be more usefully presented in other formats, perhaps as annotations to transcripts of the wills of Butts, his sons, and others whose lives touched theirs in ways that affected the disposition of their assets. What, then, is to be made of the present array of miscellaneous facts? Nothing in this paper, admittedly, shows that Butts was inclined toward Methodism – but now we know that as a motherless boy he remained close to the maternal side of his family, a family that included a well-connected architect. We know, too, that an artistic streak ran through his wife's family of hardworking carvers, gilders, picture frame makers, and scriveners, perhaps bearing on the Buttses' way of matting, inscribing upon, and displaying Blake's watercolours. Finally, wearying though it is to sort through online archives, surely there remains yet one more elusive fact, just one mouse click away, that will enlarge and enrich our understanding of Blake and the marvels he created for his 'white collar Maecenas.'

NOTES

For crucial help at critical times, I wish to thank Jerry Bentley, Joe Viscomi, Judy Lester, Ron Lankshear, Morgan Swan, Tim Marshall, Samuel Rogal, and Karen Mulhallen.

Epigraph: 'Literature as Context: Milton's *Lycidas*,' in *Northrop Frye on Milton and Blake*, ed. Angela Esterhammer, 34, *Collected Works of Northrop Frye*, vol. XVI (Toronto: University of Toronto Press, 2005). As Frye reiterated, 'But of course even the simplest kinds of scholarly apparatus baffle me: as I said once, I don't understand the people who say: "I bet what I want is in the Public Records Office," and go & find it there, when I couldn't even find the Public Records Office,' *The Diaries of Northrop Frye, 1942–1995*, ed. Robert D. Denham (Toronto: University of Toronto Press, 2001), 307. (In the official name of the PRO, 'Record' appears in the singular.)

1 G.E. Bentley Jr, 'Thomas Butts, White Collar Maecenas,' *PMLA* 71, no. 5 (1956): 1052–66.
2 Bentley, 'Maecenas,' 1052.
3 Joseph Viscomi, 'William Blake's "The Phoenix/to Mrs Butts" Redux,' *Blake/An Illustrated Quarterly* 29, no. 2 (1995): 12–15; 'Blake in the Marketplace 1852: Thomas Butts, Jr. and Other Unknown Nineteenth-Century Blake Collectors,' *Blake/An Illustrated Quarterly* 29, no. 3 (1995): 40–68; 'A "Green House" for Butts? New Information on Thomas Butts, His Residences, and Family,' *Blake/An Illustrated Quarterly* 30, no. 1 (1996): 4–21.
4 Also previously unreported are the full maiden names of Butts's first wife, Elizabeth Mary Cooper, and those of his daughters-in-law Sarah Hoskin (not 'Hoskins,' as in some parish records and in the sources available to Viscomi), and Mary Anne (or Ann) Barrow, along with their ages (as will be seen) at the time of their respective marriages.
5 Martin Butlin, *The Paintings and Drawings of William Blake* (London and New Haven: Yale University Press, 1981), 512. Hereafter cited parenthetically as *B*.
6 My article 'The Dormition and Assumption of Blake's Mary: Puzzling Iconography in Two Biblical Watercolors for Butts' is to appear in *Blake at 250: Contentions and Collaborations*, ed. Angus Whitehead, Mark Crosby, and Troy Patenaude, currently in preparation. For earlier essays on this general subject, often heavily indebted to and sometimes in contention with Anthony Blunt (1959), David Bindman (1977), Martin Butlin (1981), and Christopher Heppner (1995), see Mary Lynn Johnson, 'Blake's Judgment on the Book of Judges: The Watercolor Designs as Biblical Commentary,' in *Reconciliations: Studies in Honor of Richard Harter Fogle*, ed. Mary Lynn Johnson and Seraphia D. Leyda (Salzburg: Institut für Anglistik und Amerikanistik, 1983); 'Human Consciousness and the Divine Image in Blake's Watercolor Designs for the Bible: Genesis through Psalms,' in *The Cast of Consciousness: Concepts of the Mind in British and American Romanti-*

cism, ed. Beverly Taylor and Robert Bain (New York: Westport; London: Greenwood, 1987); 'David's Recognition of the Human Face of God in Blake's Designs for the Book of Psalms,' in *Blake and His Bibles*, ed. David V. Erdman, with introduction by Mark Trevor Smith (West Cornwell, CT: Locust Hill, 1990); and 'Mary and Martha on the Mount of Olives,' in *Women Reading William Blake*, ed. Helen Bruder (Houndmills, Basingstoke: Palgrave Macmillan, 2007).

7 Blake to Butts, 6 July 1803; William Blake, *The Complete Poetry and Prose of William Blake*, rev. ed., edited by David Erdman, with commentary by Harold Bloom (New York NY; London: Doubleday: Anchor Books, 1988), 731. Hereafter cited parenthetically as *E*.

8 Blake to Cumberland, 26 August 1799 (*E* 703).

9 Bentley, 'Maecenas,' 1055.

10 Viscomi, 'A "Green House" for Butts?' 10.

11 This information and an image from the Parish Register of St George the Martyr were kindly emailed to me by Judy Lester, London, through the good offices of Ron Lankshear, Sydney, both of whom I encountered through freepages.rootsweb.ancestry.com. I found the date of the Buttses' marriage in *Boyd's Marriage Index, 1538–1840* and in the Marriage Licence Allegations Index of the Vicar-General's Office, both of which are available on the British Origins website (www.origins.net); an image of Butts's marriage licence allegation of 19 December 1782, which granted permission for the couple to be married in either parish, was supplied by the Society of Genealogists, ordered through British Origins. Incidentally, Blake's parents were also married in Elizabeth Cooper's home parish, St George's, Hanover Square, Bentley, *Blake Records*, 2nd. ed. (New Haven and London: Yale University Press, 2004), 7. Hereafter cited as *BR2*. The 'B' in 'Thoˢ Butts' on both the marriage allegation and the parish register does not at all resemble the distinctive 'B' in Butts's hand on his 1805 account with Blake, as discussed in Viscomi, 'A "Green House" for Butts?' 9. For another example of Butts's professional signature – as 'Tho: Butts,' with the distinctive 'B' – see the 29 December 1804 appointment of Thomas Higgins to the rank of ensign in the Fifth (or Northumberland) Regiment of Foot: http://www.napoleon-series.org/images/research/biographies/commission2.jpg.

12 In passing, it may be recalled that St James's also known as St James', Piccadilly, is the site of Blake's own baptism (1757) and those of his siblings (*BR2* 7). Confirming information noted in Burke and reported by Viscomi ('A "Green House" for Butts?' 10), the boys' birthdates (including the exact hours: Joseph Edward at '5 o'Clock,' Thomas at '9 o'Clock P.M.,' William Hardwick at '2 o'Clock A.M.,' and George at '5 m. past 10 o'Clock P.M.')

are recorded on a sheet detached from a Bible that Joseph Edward Butts's son Edward Herringham Halse Butts sent to his mother Sarah Hoskin Butts with an inscription dated 31 January 1830; Edward's records of the hours of his father's and uncles' births were presumably based on original notes by one of his grandparents, Thomas or Elizabeth Butts. These to-the-minute birth times were also recopied, fairly accurately, into a family Bible (bound with the Whole Book of Psalms and the Book of Common Prayer) belonging to Thomas Butts Jr, inherited by his son Frederick John. Butts (Capt. Butts) – whose family added further notes – which eventually became the property of Captain Butts's daughter, Mary Butts. Both the family Bible (BEIN 2004 551) and the loose sheet, now catalogued separately (GEN MSS 487, Series II), are in the Mary Butts Papers in the Beinecke Rare Book and Manuscript Library, Yale University. I am grateful to Dr Morgan Swan, Public Services Assistant, for providing details beyond the cataloguing notes and advising me on my order of images from these materials and from 'Catalogue of Some of Blake's Pictures at "The Salterns"' and the typescript 'Pedigree of the Family of Butts.'

13 Information culled from John Owen, *The History of the Origin and First Ten Years of the British and Foreign Bible Society* (London: Tilling and Hughes, 1817), 1:58 (Google Books, digitized from the University of Michigan; accessed 29 August 2009); George Browne, *The History of the British and Foreign Bible Society: From Its Institution in 1804, to the Close of Its Jubilee in 1854* (London: The Society's House, 1859), I, 12 (Google Books, digitized from the University of Michigan; accessed 29 August 2009); Stephen K. Batalden, Kathleen Cann, and John Dean, eds., 'Introduction,' *Sowing the Word: The Cultural Impact of the British and Foreign Bible Society 1804–2004* (Sheffield: Sheffield Phoenix, 2004), 1–13; and Brian Stanley, review of *Sowing the Word*, *The Historical Journal* 51, no. 4 (2008): 817–19.

14 The reference to 'the neighbouring poor' is from a brief account of the local branch's founding in the March issue of *The Christian Observer, Conducted by Members of the Established Church for the Year 1813, Being the Twelfth Volume from the London Edition* (New York: Whiting and Watson, 1814), 190; other quotations are from the April issue, 853 (Google Books, digitized from the University of Michigan; accessed 29 August 2009).

15 Ibid., March, 190.

16 Ibid., April, 853.

17 Gordon A. Phillips, *The Blind in British Society: Charity, State and Community, c.1780–1930* (Aldershot: Ashgate, 2004), 130. Within the first five years of its operation, the society ceased employing children as readers in favour of pious adult 'members of the Church of England, who are not only

capable of reading but also of conversing with the blind, and impressing
upon them the importance and necessity of attending the public worship
of almighty God'; in this way the society also aided 'aged Christians ... by
employing them at a small weekly salary,' *The Church of England Magazine*
8 (1840): 73 (Google Books, digitized from the University of Michigan;
accessed 29 August 2009).

18 For details, see J.C. Humble, 'Westminster Hospital: First 250 Years,' *British Medical Journal 7*, no. 1 (15 January 1966): 156–62; Adrian Wilson, 'The
Politics of Medical Improvement in early Hanoverian London,' in *The Medical Enlightenment of the Eighteenth Century*, ed. Andrew Cunningham
and Roger Kenneth French, 4–39 (Cambridge: Cambridge University Press,
1990).

19 F[rank]. K. Prochashka, *Women and Philanthropy in Nineteenth-Century
England* (Oxford: Oxford University Press, 1980), 99; and his *Christianity
and Social Service in Modern Britain: The Disinherited Spirit* (Oxford: Oxford
University Press, 2006), 62.

20 Sampson Low Jr, *The Charities of London: Comprehending the Benevolent,
Educational, and Religious Institutions* (London: Sampson Low, 1850), 125–6
(Google Books, digitized from the University of California; accessed 28
Aug. 2009). As the Methodist minister Benjamin Gregory recalls in *Side
Lights on the Conflicts of Methodism in the Second Quarter of the Nineteenth
Century, 1827–1852, Taken Chiefly from the Notes of the late Rev. Joseph Fowler*
(London, 1897), 'The visitors of the Stranger's Friend Society were indefatigably devoted to the work, and never slunk or shrunk from duty, but the
dying would often wish for a minister to pray with them. Thus the Queen
Street ministers became conversant with ... squalid settlements' of 'a large
section of Central London' and 'its immense systemless system of lanes,
and courts "Buildings," and gruesome "Gardens" and "Paradises" which
Eve might have left without a sigh' (26). According to Low, the society
relieves those in need 'without regard of sect or country; but chiefly such
as have no parochial relief, and are "strangers"'; and 'none are established
on better principles, few indeed with less working expenses, or more wide
spread in their scope of usefulness' (125).

21 21 January 1820: Times Digital Archive (TDA), issue 10834, p. 2, col. A; 27
November 1822: TDA, issue 11727, p. 2, col. A; 29 January 1825: TDA, issue
12563, p. 2, col. A.

22 The quotation is from the entry for Peckwell in *The London Encyclopaedia:
or, Universal Dictionary of Science, Literature, and Practical Mechanics*, [ed.
Thomas Curtis] (London: Thomas Tegg, 1829), XVI, 714 (Google Books,
digitized from the University of Michigan; accessed 28 August 2009).

Other information is from Nigel Aston, 'Peckwell, Henry (*bap.* 1746, *d.* 1787),' *Oxford Dictionary of National Biography* (Oxford: Oxford University Press, 2004), accessed 28 August 2009, http://www.oxforddnb.com.proxy .lib.uiowa.edu/view/article/21747.

23 A clergy-led General Society for the Promotion of District Visiting was established jointly by Anglicans and Dissenters in 1828, according to F. David Roberts, *The Social Conscience of the Early Victorians* (Stanford: Stanford University Press, 2002), 197, but local parish organizations operated independently. According to Low, in St Pancras the district immediately surrounding the church in Euston Square, only a tenth of the parish as a whole, took in £137 for its District Visiting Society in 1847 (*Charities of London*, 446). As M.J.D. Roberts, *Making English Morals: Voluntary Association and Moral Reform in England, 1787–1886* (Cambridge: Cambridge University Press, 2004), remarks in passing, 'Evangelical advocates of a reinvigorated parish-based Anglicanism set up a metropolitan District Visiting Society to reclaim "client market share" from the Dissenter-dominated Christian Instruction Society' by 1828 (118n91). In Leeds, according to Robert John Morris, *Class, Sect, and Party: The Making of the British Middle Class: Leeds, 1820–1850* (Manchester: University of Manchester Press, 1990), 'the effect of the Church District Visiting Society was to fragment the class efforts of the Strangers' Friend' as Anglicans withdrew to work through their own organization (268). A fundraising advertisement for another area of Butts's parish uses wording similar to that in his will: 'in behalf of the South-West St. Pancras Visiting Society for Visiting and Relieving the Poor and the Sick at their own Dwellings' (*The Times*, Friday, 16 January 1852; TDA, issue 21013, p. 1, col. A [actually col. C]; accessed 15 September 2009).

24 *The Manuscript Journal of the Reverend Charles Wesley, M.A.*, eds S.T. Kimbrough Jr and Kenneth G.C. Newport (Nashville: Kingswood Books, 2007) II, 564. Sally is, of course, a common nickname for Sarah. The names of the younger Thomas Hardwick's parents appear in his *ODNB* entry; the place as well as the date of their wedding, consistent with C. Wesley's diary entry, are recorded in IGI (M062365 1686-1784 0918609 Film 6901254). In a letter of 15 May 1749 to his wife, Wesley also mentions Sarah's brother, Butts's uncle: 'I called on Mr. Witham, and found his brother and sister Hardwick, just returned from Hereford. Many kind salutations they send my dearest Sally [C. Wesley's wife] … All join in the vain inquiry, when you come to town.' (179–80). Quoted from a copy of Thomas Jackson's 1849 edition at Harvard University (Google Books, digitized under a shortened title: Charles Wesley, *Journal, Etc: To which are Appended Selections from His Correspondence and Poetry*; accessed 21 August 2009).

25 'Hardwick, Thomas' entry in the A–Z index of www.library.manchester.
ac.uk/specialcollections/collections/methodist/. The detail of the post-
chaise is from Charles Wesley's *Journal*, 2:47. According to the Hardwick
entry in the online John Rylands Library catalogue, 'Hardwick disappears
from the Methodist record after the early 1750s.'

26 W. Reginald Ward and Richard P. Heitzenrater, eds., *The Works of John Wesley*,
vol. 20: *Journals and Diaries* III (Nashville: Abington, 1991), 198n, where 'Han-
nah' should read 'Elizabeth.' This apparent error in the standard edition
of Wesley's works has resulted in the materialization of a ghost personage,
'Mrs. Hannah Witham,' in the 'W' volume of Samuel J. Rogal, *A Biographical
Dictionary of 18th Century Methodism* (Lewiston: Mellen Press, 1999) 9:460. So
far as I have been able to determine from published records, Elizabeth was
the only 'Mrs. Witham' in the Wesleys' London circle in the 1740s, and the
only 'Hannah' was her daughter, probably to be identified with the 'Hannah
With[am]' and 'Miss Witham' of Wesley's journals, as suggested below. Wes-
ley's typically busy Saturday of 26 April 1740, which began as usual at 5:30
a.m., encompassed an afternoon dinner and conversation at Mr Witham's
and a 6:30 meeting with more than eight ladies, including Butt's grandmoth-
er, followed the next day by 'At Mrs Witham's, tea. 8.15 Society, Love-feast.
10 At Mrs Witham's, supper, religious talk. 11' (Ward and Heitzenrater, eds.
Works 19 [1990]: 417). Transcription details differ in the eight-volume 'Stand-
ard Edition' (London: Charles Kelley, n.d. [1909–16] by Nehemiah Curnock,
the scholar who cracked Wesley's cipher and shorthand; available on Inter-
net Archive, most conveniently at http://www.archive.org/search.php?
query=creator%3A%22Curnock%2C%20Nehemiah%22.

27 Viscomi, 'A "Green House" for Butts?' 5. A reminder: under the Grego-
rian calendar finally adopted throughout Britain and its colonies in 1752
(Scotland had made the change in 1600), the first day of the new year was
changed from 25 March to 1 January, and 11 days were dropped to adjust
the new calendar to the solar year; thus the equivalent new-calendar date
of this first Thomas's baptism is 24 March 1747. Hereafter, for pre-1753
dates falling in the year-straddling months of January–March, both years
are provided, separated by a forward slash, according to common practice
among historians, and the 11-day differential is ignored.

28 E.A. Webb, *The Records of St. Bartholomew's Priory and of the Church and
Parish of St. Bartholomew the Great, West Smithfield* (London: Humphrey
Milford / Oxford University Press, 1921), 2:341–2; also available in Google
Books and through www.british-history.ac.uk/report.aspx?compid=51794
(accessed 21 September 2009). The incident is also noted in Samuel J.

Rogal, *John Wesley's London: A Guidebook*, Texts and Studies in Religion, no. 34 (Lewiston and Queenston: Edwin Mellen, 1988), 113–14. I am grateful to Professor Rogal, who graciously read a late draft of my essay, for enabling me to update my documentation and correct a serious chronological error.

29 Webb, *Records of St. Bartholomew's Priory*, 2:342; quoting L[uke] Tyerman, *The Life and Times of the Rev. John Wesley, M.A., Founder of the Methodists* (London: Hodder and Stoughton, 1852), 1:548.

30 Curnock, ed., *Journal*, 2:116–17, 3:300; Ward and Heitzenrater, *The Works of John Wesley*, 19:28–9, 20:175–6.

31 Webb, 'Grave stones in the church and churchyard,' in *The Records of St. Bartholomew's Priory* 2: 499n10; www.british-history.ac.uk/report .aspx?compid=51794; accessed 7 August 2009.

32 Curnock, ed., *Journal*, 3:322–3; Ward and Heitzenrater, 20:198. In Butts's time the entry on Mrs Witham appeared in a serial publication of excerpts prepared by Wesley himself, *An Extract of the Rev. Mr. John Wesley's Journal* 7 (1788): 49–50; Google, digitized from a copy in the New York Public Library, www.archive.org/details/anextractrevmrj00weslgoog; accessed 20 August 2009.

33 Kimbrough and Newport, eds., *The Manuscript Journal of the Reverend Charles Wesley*, II, 515. Cf. Wesley Center Online, http://wesley.nnu.edu/ charles_wesley/journal/1747c.htm. .

34 Charles Wesley, *Hymns and Sacred Poems* (Bristol: Felix Farley, 1749), 1:282–6 (sourced from the British Library; ECCO, Gale Document No. CW3320109498l; accessed 20 August 2009 [another copy: Gale Document No. CW3320109502]), immediately following Wesley's four-stanza elegy honouring his mother, Susanna[h]. Earlier editions, dating from 1739, had been attributed to both John and Charles Wesley. The impetus for the 1749 publication by subscription of poems by Charles only, as explained in the introduction to web-based edition available through the Duke Center for Studies in the Wesleyan Tradition, www.divinity.duke.edu/wesleyan/ texts/cw_published_verse.html, accessed 21 August 2009, 'was the need to demonstrate to the parents of Sarah (Sally) Gwynne that he could provide sufficient financial support in their proposed marriage.' G[eorge] Osborn, ed., *The Poetical Works of John and Charles Wesley . . . Together with Poems of Charles Wesley Not Before Published* (London: Wesleyan-Methodist Conference Office, 1869), 5, 87n, helpfully footnotes the link between this poem and John Wesley's diary entry of 29 November 1747 (Google Books, digitized from Harvard University; accessed 20 August 2009). Charles Wesley 'made a regular practice of writing hymns on the death of friends or prominent mem-

bers of the Methodist movement' (Randy L. Maddox, 'Editorial Introduc-
tion,' [online edition of Wesley's] *Funeral Hymns* [London: 1746 – too early
to include the elegy to Elizabeth Witham], Duke Center for Studies in the
Wesleyan Tradition, 31 January 2008; accessed 10 August 2009).

35 Curnock, ed., *Journal*, 2:376; 2:477; cf. Ward and Heitzenrater, 19:427, 459,
469.

36 Sondra Matthaei, 'Transcripts of the Trinity: Communion and Community
in Formation for Holiness of Heart and Life,' *Quarterly Review: A Journal of
Theological Resources for Ministry* 18, no. 2 (1998): 133. Without referring to
Mrs Witham's Christian name, Matthaei cites the Ward and Heitzenrater
edition of the journal, but her point about Elizabeth Witham's position
within the society remains valid.

37 Thomas Jackson, *The Life of the Rev. Charles Wesley, M.A.* (Lon-
don: John Mason, 1841), 1, 358 (digitized from the Princeton Theo-
logical Seminary Library, Steven F. Radzikowski, for the Internet
Archive; accessed 31 August 2009, http://www.archive.org/stream/
lifeoftherevchar001458mbp#page/n289/mode/2up. I cite this source,
rather than the journal itself, because it appeared before Butts's death
in 1844. The bracketed dates in the quotation are from the Google Book
facsimile of Jackson's edition of the journal (*The Journal of the Rev. Charles
Wesley, M.A.*, ed. Jackson, 1, 343).

38 Number CXL, *Hymns and Sacred Poems*, 2, 195–6; on the inclusion of the
manuscript in Charles's letter to Mrs Witham, see n106 on the correspond-
ing page in the Web edition prepared by the Duke Center for Studies in the
Wesleyan Tradition, 46_Hymns_and_Sacred_Poems_(1749)_Vol_2_mod[1].
Accessed 21 August 2009.

39 Both wills are available from Documents Online, Public Record Office,
Crown copyright: Thomas Witham, PROB 11/731, file ref. 231 (hereafter
cited in parentheses as TW will) and Elizabeth Witham PROB 11/758, file
ref. 463 (hereafter cited in parentheses as EW will).

40 The Cloth Fair Precinct is described in E.A. Webb, 'The Parish: Itinerary of
Cloth Fair,' in *The Records of St. Bartholomew's Priory [and] St. Bartholomew
the Great, West Smithfield* (1921), II, 232–47. Also available in Google Books,
British History Online, http://www.british-history.ac.uk/report
.aspx?compid=51782. Accessed 12 September 2009. According to John
Strype, *Survey of London* (London, 1720; ed. J.F. Merritt, 2007; updating
John Stow's 1598 *Survey*), 'To this Priory, King Henry II. granted the Privi-
lege of a Fair to be kept yearly, at Bartholomewtide, for three Days; to wit,
the Eve, the Day, and the next Morrow. To the which the Clothiers of Eng-
land, and Drapers of London repaired; and had their Booths and Stand-

ings within the Churchyard of this Priory, closed in with Walls and Gates, locked every Night, and watched, for Safety of Mens Goods and Wares … But now … in place of Booths within this Churchyard (only letten out in the Fair time, and closed up all the Year after) be many large Houses builded; and the North Wall, towards Long lane, being taken down, a number of Tenements are there erected, for such as will give great Rents' (2:355); available online at http://www.hrionline.ac.uk./strype/parishes .jsp, through The Stuart London Project, Humanities Research Institute, The University of Sheffield; accessed 15 September 2009. For a description and illustration of the street as it appeared in 1904, see Philip Norman, *London, Vanished and Vanishing* (London: Adam and Charles Black, 1905), 149–58 (two copies in Google Books). The street is so closely fitted into the church grounds that, according to Simon Bradley and Nikolaus Pevner, *London: The City Churches* (New Haven: Yale University Press, 1998), 'The rest of the exterior must be seen from Cloth Fair, N, accessible from the raised churchyard' (64). On complaints about the fair in the nine-teenth century, see http://www.victorianlondon.org/entertainment/ bartholomewfair.htm (accessed 12 September 2009).

41 Referring to arrangements predating the Magna Carta that governed property and inheritance rights within the City. Although the 'custom' and the statute amending it strictly applied only to heirs of men dying without wills, under which the surviving spouse received one-third plus a third of another third, the 'dead man's portion,' Witham apparently intended his estate to be divided in this manner, with the rest going to his three children, all unmarried at the time, and another portion to his co-execu-tors. For the complicated formula, see William Blackstone, *Commentaries on the Laws of England*, ed. Edward Christian (1800), II, 517–19; ECCO; sourced from the British Library; accessed 12 September 2009.

42 Hannah (recorded as 'Hanna') Witham was baptised in St Bartholomew the Great on 14 Aug. 1720 (parish record, newly available, as of September 2009, through www.ancestry.co.uk). The ages of her siblings Thomas and Sarah may be derived from their baptismal dates in the parish register of St Bartholomew the Great, his on 2 Oct. 1724, hers on 14 Aug. 1728 (recorded by Tim Marshall, whose generous help and advice on the Witham, Hard-wick, and Cooper families have been invaluable. It was Viscomi's posting of his articles on the Internet that led Marshall to mail Viscomi his unpub-lished genealogical notes in 2008; Viscomi immediately sent the notes to Bentley; and Bentley's summary in private correspondence enabled me to reach Marshall directly in September 2009, weeks after Karen Mulhallen and I had erroneously considered my paper complete).

43 Curnock, ed., *Journal*, 3: 242.

44 Ibid., 3: 388–9; Ward and Heitzenrater, 20:261.

45 'A "Green House" for Butts?' 5.

46 See Henry B. Wheatley, *London Past and Present/Its History, Associations, and Traditions* [incorporating work by Peter Cunningham] (London: John Murray, 1891), I, 47; Google Books, digitized from a copy at Indiana University; accessed 27 September 2009; James Elmes, *A Topographical Dictionary of London and its Environs* (London: Whittaker, Treacher and Arnot, 1831), 15–16; Google Books, digitized from a copy in the New York Public Library; accessed 27 September 2009; Walter Besant, *London City* (London: Adam and Charles Black, 1910), 206–7.

47 Grainger's positions in the Church of England are provided in Robert Forsyth Scott, *Admissions to the College of St John the Evangelist in the University of Cambridge* (Cambridge: Cambridge Univ. Press, 1903), III, 326; Google Books, digitized from the University of California; accessed 27 September 2009.

48 Quotations are identical in Ward and Heitzenrater, *The Works of John Wesley*, 3:121; and Curnock, ed., *Journal*, III, 241–2; both editions note that the last line in the deathbed account, 'But afterwards God turned her heaviness into joy,' was added only when Wesley published his journals in his *Works* (1774). On the same May–July 1746 sojourn in London, Wesley enlisted Henry Thornton of Gray's Inn as a trustee of one of his charities (Curnock, ed., *Journal*, 242n3), as discussed earlier.

49 The year of Hannah Witham Butts's death is recorded in *Burke's Landed Gentry of Great Britain* (12th ed., 1914), cited by Viscomi, 'A "Green House" for Butts?' 6; neither Hannah nor Thomas Butts appears in parish burial records indexed in IGI or available on genealogical websites. Tantalizingly, an earlier 'Mrs. Hannah Butts,' also the mother of many children who died young, is the subject of several elegies and funeral hymns by Charles Wesley in the 1740s (*Journal of the Rev. Charles Wesley*, ed. Jackson, II, 393–8). Hannah Butts's husband should not be confused with the Thomas Butts associated with the Methodist movement in this period as 'book steward' or bookkeeper and as a compiler and publisher of hymnals.

50 Elizabeth Mary Cooper's birth in 1753 may be deduced from the parish record of her burial and the floor slab in the church of St Bartholomew the Great, to be discussed in note 55. The age difference between Blake's patron and his wife is also captured in Blake's miniatures of the two (*B* 176 and 177), as is especially evident now that Butts's portrait has been convincingly redated from 1801 to 1809 – the same year as his wife's – by

Mark Crosby, 'William Blake's Miniature Portraits of the Butts Family,' *Blake/An Illustrated Quarterly* 42, no. 4 (2009): 137–52. (A slightly plump woman of fifty-six can be expected to have a double chin and 'jowls' [ibid., 150]; perhaps the five locks of hair fastened to the back of Butts's portrait are those of his wife and his four sons, including the short-lived William Hardwick.) Butts's cousin Thomas Hardwick married Elizabeth Hardwick (1763–1804) of Credenhill, Herefordshire, on 12 January 1783 (Tim Marshall), probably a cousin from the family visited in Hereford by the newly-weds of the previous generation, Thomas and Sarah Witham Hardwick, as reported in Charles Wesley's diary (passage cited in note 24).

51 As I will discuss, Elizabeth Mary Cooper's father was apparently a widower when he died in late 1800 or early 1801 (will signed 3 December 1800, proved 20 April 1801), leaving everything to his children; his second son Joseph, Jr, is named as a co-executor.

52 On the Academy's talented entering class at its opening in 1768 and Hardwick's silver medal, see Sidney C. Hutchinson, *The History of the Royal Academy 1768–1968* (London: Taylor and Francis, 1968), 52.

53 Butts's original offer is acknowledged in a postscript to Blake's letter of 10 January 180[3], *E* 723.

54 The characterization of Berners Street appears in Edward Walford, *Old and New London: A Narrative of Its History, Its People, and Its Places* [incorporating earlier eds. by Walter Thornbury] (London: Cassell, 1878), 4:491, available online (without page numbers) through the Centre for Metropolitan History, www.british-history.ac.uk/report.aspx?compid=45207, and through the Internet Archive at www.archive.org/details/oldnewlondon-narr04thoruoft. Hardwick recalls Chambers's home and his visitors in a memoir introducing Sir William Chambers, *A Treatise on the Decorative Part of Civil Architecture*, ed. Joseph Gwilt (London: Priestley and Weale, 1825), xliv. Fuseli's residence is recalled in John Knowles, *The Life and Writings of Henry Fuseli* (London: Colburn and Bentley, 1831), 2:284.

55 Elizabeth's burial on 4 April 1825, at the age of 72, is recorded in the parish register of St Bartholomew the Great (information supplied by Tim Marshall) and confirmed in Evans, *The Records of St. Bartholomew's*, 489, in which her age is recorded as 71, with a footnote stating that the date of her death is illegible (n6, Reg. xvii, 80). The floor slab for 'Elizabeth Mary Butts' is at 2, S[outh] T[ransept], beside that of 'Thomas Butts,' whose burial date is recorded as 23 March 1815, at age 85 (n7, Reg. xxii, 7), but the actual burial of Blake's patron (1759–1845) is correctly recorded in the register as having occurred on 1 May 1845, when Butts's age was 86 (Tim Marshall). As Butts's father died on 19 April 1778 and is not known

to have been buried in this parish, I cannot explain the discrepancy other than to suspect that the information is mis-transcribed in *The Records of St. Bartholomew's*, or that the floor slab is so badly worn that '1 May 1845' has come to resemble '23 Mar. 1815.' I hope that the Blake Society – or individual readers of Blake – will soon visit the church and report that Thomas (d. 1845) and Elizabeth Butts (d. 1825) indeed rest side by side beneath the floor of Butts's grandparents' church.

56 If at the age of nineteen Butts was still living in Hackney with his father and stepmother and their two very young children (just over and just under two years old) at the time of Mr Butts's death on 19 April 1778, perhaps he struck out on his own about that time. Butts's 1844 will refers to an indefinite number of children of 'my late half sister Mrs. Matilda Floyd,' who received nineteen pounds nineteen shillings and sixpence, just short of the twenty pounds that would have triggered legacy duty, and to the schoolmaster 'Mr. Thomas Butts grandson of my deceased father,' who received 'three hundred pounds free of legacy duty.' As Viscomi notes, these legatees are probably descendants of a Thomas and an Ann Butts whose daughter Matilda was baptized on 3 January 1776 in St John the Evangelist in Hackney, within five miles of central London, and whose son John was baptized in the same church on 9 December 1776. The death date of this Thomas Butts of Hackney, presumably the patron's father, as registered in the same parish, differs by less than two weeks from the death date of 7 April 1778 given in Burke (Viscomi, 'A "Green House" for Butts?' 6). For the sake of geographical clarity, I am ignoring (without dismissing or disproving) Viscomi's inference that Butts's father married a woman named Ann Cook in St Leonard, Shoreditch, just south of Hackney, in 1767, and with her traced an expansive arc across the Greater London area, siring numerous children baptized in the Middlesex parishes of St Marylebone (about four miles and three parishes west of St Leonard) and St Andrew, Enfield (some nine miles and four good-sized parishes north). These distances are derived from the mileage scales alongside parish maps in Cecil R. Humphery-Smith, ed., *The Phillimore Atlas and Index of Parish Registers*, 3rd ed. (London, Phillimore, 2003), s.v. 'London' and 'Middlesex.' Other parishes significant to Butts's family of origin, all noted by Viscomi, are located within a two- to three-mile radius of Butts's 1782 parish of St George the Martyr in Holborn: his father and mother were married by licence in St Andrew by the Wardrobe (1746), a Thames-side parish southwest of St Paul's, in the City of London; they had their first child baptized (1746) in St Bartholomew the Great in London, the ancestral home parish of the Methodist Withams, and many

of their other children, including Butts, were baptized (1750–9) in St Luke, Old Street, Finsbury, a close-in Middlesex parish less than a mile north-west of St Bartholomew. As Viscomi reports, another sibling may have been the John Butts, son of a Thomas and Hannah Butts of Queen Street Hoglane, who was born 7 June and baptized 17 June 1748 in St Leonard Shoreditch and presumably died before the second John was born across the parish border in Hackney.

57 All quotations from Joseph Cooper's will (signed 2 December 1800, proved 20 April 1801) refer to PROB 11/1356, Prerogative Court of Canterbury, Albequerque Quire Numbers 220-274, image ref. 39/45; available through Documents Online of the National Archives, http://www.nationalar-chives.gov.uk/documentsonline/wills.asp?WT.hp=Wills.

58 The footprint of the house may be viewed in Richard Horwood, *Plan of London and Westminster, the Borough of Southwark and Parts adjoining Shewing every House* (London: 1792–9), available online from MOTCO, starting from the home page, http://www.motco.com/Map/81005/, and at Old London Maps, spanning two panes of detail, moving south to north: http://www.oldlondonmaps.com/horwoodpages/horwood13201.html; http://www.oldlondonmaps.com/horwoodpages/horwood13101.html. For the 3rd ed. of Horwood, see *The A to Z of Regency London*, introduction Paul Laxton (Lympne Castle, Kent: H. Margary/Guildhall Library, 1985).

59 Geoffrey W. Beard and Christopher Gilbert, eds. *Dictionary of English Furniture Makers 1660–1840* (Leeds: Furniture History Society, 1986), 197; also 195–6; kindly brought to my attention (with convenient photocopies) by Tim Marshall.

60 For this quotation and more on his company, carried into the next generation with his own sons and apprentices, who expanded into japanning and varnishing, see Beard and Gilbert, eds., *Dictionary of English Furniture Makers*, 195. The first sentence of the trade label is also quoted in Luke Vincent Lockwood, *Colonial Furniture in America* (New York: Scribner, 1901; 3rd ed. 1926), 1:308, with an image of one of the mirrors. See also Jacob Simon's online Directory of British Picture Framemakers, 1740–1950 at the National Portrait Gallery, www.npg.org.uk/research/conservation/directory-of-british-framemakers/c.php (accessed 12 September 2009).

61 *U.K. and U.S. Directories, 1680–1830* [database online] (Provo, UT, USA: The Generations Network, 2003). Original data: Avero. *Biography Database, 1680–1830* (Newcastle-upon-Tyne, England: Avero, 1998); available through ancestry.co.uk; accessed 21 September 2009.

62 *The Times*, Monday, 4 November 1822: TDA, issue 11707, p. 4, col. A [B]; Gale article CS67259236; accessed 27 September 2009.

63 Brian Brooks and Cecil Humphrey-Smith, *A History of the Worshipful Company of Scriveners of London* (London: Phillimore, 2001), 31.

64 On 2 May 2008, Viscomi kindly forwarded to Bentley and me his email correspondence of 2 March 2008 with Alison Cater, a New Zealander, who discovered the reference to Mrs Butts's school in the will of her ancestor.

65 *Universal British Directory*, cited by Viscomi, 'A "Green House" for Butts?' 13.

66 Bank of England: *The names and descriptions of the proprietors of unclaimed dividends on Bank stock, and on the public funds, transferable at the Bank of England, which became due between 31st December 1780, and the 31st of December, 1788, and remained unpaid on the 21st October 1791, with the Dates when the first dividends respectively became payable and the number of dividends due* ... (London [1791]), 196 pp. *Eighteenth* Century Collections Online, Gale Group: http://galenet.galegroup.com.proxy.lib.uiowa.edu/servlet/ECCO; Gale Document Number: CW3304595125.

67 Bank of England: *The names and descriptions of the proprietors of unclaimed dividends on bank stock, and on the public funds, transferable at the Bank of England, which became due on and before the 5th July 1797, and remained unpaid on the 1st October 1800,* ... (London, 1800), 444 pp. Eighteenth Century Collections Online. Gale Group: http://galenet.galegroup.com.proxy.lib.uiowa.edu/servlet/ECCO; Gale Document Number: CW3304640182.

68 Viscomi, 'A "Green House" for Butts?' 10.

69 Ibid., 15, carrying forward a suggestion by Bentley, 'The Daughters of Albion and the Butts Household,' *Blake/An Illustrated Quarterly* 18 (1984): 116. Viscomi helpfully gauges the size of the Great Marlborough Street property by noting that it held a carpet and rug manufacturing business in 1828, and that the space was divided with a firm of coal merchants in 1833 ('A "Green House" for Butts?' 15; n22).

70 Viscomi, 'A "Green House" for Butts?' 15.

7 'Went to see Blake – also to Surgeons college': Blake and George Cumberland's Pocketbooks

ANGUS WHITEHEAD

Introduction

G.E. Bentley Jr is best known for his pioneering biographical and bibliographical research concerning the life and work of William Blake. However, over the past fifty years Bentley's research has regularly travelled beyond Blake, and has resulted in a series of publications concerned with members of Blake's circle, throwing much needed light on the figures themselves as well as their relations with the poet-painter. These figures include Blake's fellow apprentice and business partner James Parker, his patron Thomas Butts, and the engraver and entrepreneur Robert Hartley Cromek.[1] As Keri Davies has observed, members of Blake's circle while 'not in the limelight nor in the literary canon still have the capacity to contribute to a recoverable culture by virtue of the lives they led. Their sometimes poignant microhistories evoke issues relevant to the interpretation of Blake's work and re-situate William Blake in the intellectual life of his time.'[2] Through assiduously focused archival research, Bentley has significantly enhanced our knowledge and understanding of another key member of Blake's circle: the author, artist, art connoisseur, and geologist George Cumberland (fig. 7.1). Bentley's examination of hitherto neglected MSS materials in the British Library manuscripts collection relating to Cumberland has unearthed much valuable information concerning Cumberland's meetings with Blake, now published in *Blake Records* (1969/2004). Bentley has also published a *Bibliography of George Cumberland (1754–1848)* (1975), and an edition of Cumberland's controversial novel of the 1790s, *The Captive of the Castle of Sennaar* (1991). Bentley's research on Cumberland thus

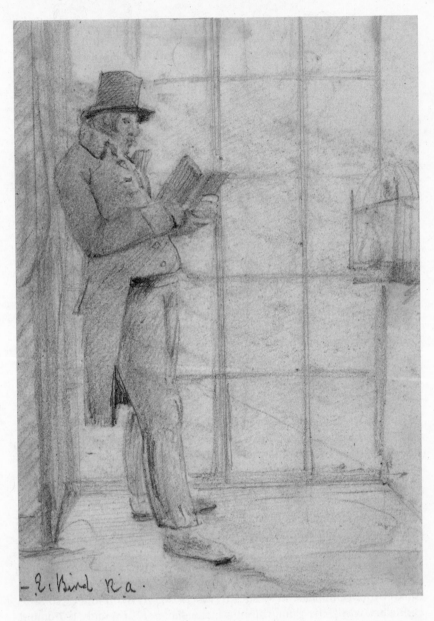

7.1 Edward Bird, full length sketch of George Cumberland, after 1807. Picture
Library, Royal Academy

far has revealed just how important Cumberland was – not only in the context of Blake's circle, but also as a major figure in both Bristol and London's visual art, literature, and geological circles during the late eighteenth and early nineteenth century.

In this essay I begin by discussing new information pertaining to Blake in Cumberland's pocketbooks, including a previously unrecorded reference to Blake recently discovered in Cumberland's pocketbook for 1820 in which Cumberland briefly describes a call on Blake on his way to the Royal College of Surgeons. I go on to reconstruct the immediate context of Cumberland's visit in order to enhance our currently sparse knowledge of Blake, Cumberland, and their respective London and Bristol milieux during the summer of 1820. In the process, I also hope to bring Cumberland's active interests in art and geology into sharper focus. It has hitherto been assumed that, about 1815, Cumberland's growing interest in geology began to eclipse his earlier involvement in the arts. This shift is thought to have had detrimental consequences for his relationship with Blake.[3] I will argue that, at least in June 1820, those two interests appear rather to complement one another. Indeed, Cumberland's geological interests may have afforded a potential opportunity for Blake and Cumberland to discuss both art and geology, and perhaps stimulated Cumberland to attempt to seek out further engraving commissions for his old friend.

Blake and Cumberland

Blake's friendship with George Cumberland was one of the most consistent and enduring of the poet-artist's life, beginning during their days as fellow students at the Royal Academy in the early 1780s and continuing until Blake's death almost half a century later.[4] As friends and fellow artists, the young Blake and Cumberland shared similar views concerning politics, book production, and visual art. Blake's republican sympathies of the late 1780s and 1790s were also shared by Cumberland. Cumberland's self-suppressed novel of the period, *The Captive of the Castle of Sennaar* (1798), articulates similar views to Blake's regarding religion and sexuality. In his introduction to Cumberland's novel, Bentley describes Cumberland as 'passionately concerned with the reform of politics and society, a radical deeply sympathetic to society's castaways, the poor, the blind, the slaves ... a widely cultivated and deeply humane person.'[5] Cumberland's own recollection, in a letter of 5 March 1820, of the time (presumably in the late 1780s–early

1790s) 'when I wore the white hat' of liberty reminds us of Gilchrist's account of Blake's wearing of the bonnet rouge in the streets of London during the same period.[6] Both Blake and Cumberland had known the miniaturist Richard Cosway since the 1780s.[7] During this period the friends also collaborated on a number of projects and corresponded, as evidenced in the seven surviving letters from Blake to Cumberland.[8] Cumberland's own attempts at etching played a key role in Blake's experiments with and development of relief etching.[9] In 1791 Cumberland secured Blake's employment engraving plates for James Stuart and Nicholas Revett's *Antiquities of Athens*.[10] Cumberland's assistance may explain Blake's compliment to him in a recently discovered letter, postmarked '1 SE[ptember 1]800,' 'To have obtained your friendship is better than to have sold ten thousand books.'[11] Cumberland recommended Blake for other engraving and painting commissions.[12] On receiving a bequest of £300 a year, Cumberland gave up his job as a clerk in the Royal Exchange Insurance Office,[13] and resided in Italy for the majority of the period October 1785 to circa 1790.[14] While in Florence he read the fifteenth-century manuscript of Cennino Cennini's *Trattato Della Pittura*.[15] As Michael Phillips observes, 'Cennino Cennini's handbook was the classic manual recording the techniques and recipes used by the artists Blake revered ... Through Cumberland, Cennino may have supplied Blake with formulas he used for mixing his pigments.'[16] About 1796 the friends collaborated on a publication: Cumberland's *Thoughts on Outline* (1796) for which Blake produced eight plates and, as Bentley suggests, Blake also appears to have provided the inscriptions for all twenty-four designs.[17] On receiving a copy of the volume Blake wrote to Cumberland in December 1796:

> Go on Go on. such works as yours Nature & Providence the Eternal Parents demand from their children how few produce them in such perfection how Nature smiles on them how Providence rewards them. How all your Brethren say, The sound of his harp & his flute heard from his secret forest chears us to the labours of life. & we plow & reap forgetting our labour.[18]

About 1803 Cumberland left the metropolis for Weston-super-Mare, Somerset, and finally settled at 'Mount Pleasant,' 10 Culver Street, Clifton, Bristol, in or shortly before 1806, where he remained until his death in 1848.[19] However, Cumberland continued to promote and support Blake,[20] and kept in touch with him either through his London-based

sons George Cumberland Jr and Sydney or through correspondence with Blake himself.[21] Between 1806 and 1825, Cumberland also regularly made extended visits to London. These trips, which usually occurred between May and September, allowed Cumberland to pursue his multifarious interests as well as to renew contacts with friends and acquaintances. The minute particulars of Cumberland's miscellaneous interests are recorded in pencil throughout his journals, in a series of pocketbooks (manufactured by the firm of John Letts) which Cumberland kept during this period.[22]

Cumberland used these visits to maintain contact with Blake. As Bentley notes, Cumberland recorded the address of William and Catherine Blake's 17 South Molton Street studio-residence, which the couple had occupied since the end of 1803, in his pocketbooks for 1809 and 1810.[23] A prior entry suggests that Cumberland called on Blake in the early summer of 1807.[24] Cumberland also records two calls he made to Blake's South Molton Street studio-residence during his visit to London in 1812.[25] Cumberland also visited Blake there on 6 June 1820. This visit, described in Cumberland's pocketbook in uncharacteristically sustained detail, will be discussed shortly.[26] Over five years later, on 25 October 1825, Cumberland made a note 'to see Blake.'[27]

As Bentley observes, the pocketbooks also refer to Cumberland calling on 'Townly' at 61 South Molton Street in 1812, 'Blake opposite.'[28] A year later, on 3 June 1813, Cumberland pencilled in his pocketbook, 'Calld Cosway by [?] Dayley N 51 South Molton St facing Poor Blake – where he [Daley] has been 3 years – (Eagles cousin) Calld Blake - still poor still Dirty.'[29] A reading of Bentley's transcription of this just decipherable note of Cumberland's appears to be the source for Richard Cosway's recent biographer, Gerald Barnett's otherwise uncorroborated assertions that Cosway kept a house at 51 South Molton Street for the study of magic.[30] However, other entries in the pocketbooks, discussed below, indicate that Cumberland visited Cosway at his residence and studio, directly opposite the northern end of South Molton Street, across Oxford Street, at Stratford Place. As we shall see, although Cumberland's reference to 51 South Molton Street appears to refer to more pedestrian matters than Barnett suggests, Cumberland's pocketbook references to Daley and Townly throw significant light on both Cumberland and Blake.[31]

The copious entries in Cumberland's pocketbooks testify not only to the multiplicity of his artistic, geological, and other interests, but also to just how much he was trying to cram into his annual summer

visit to London before returning to Bristol. Blake was clearly only one name, albeit a noteworthy one, amid Cumberland's wide and various London milieux. Other entries in the pocketbooks, not cited by Bentley, indicate that in 1813 Cumberland regularly called on both 'Daly N 50' and 'Townly N61' South Molton Street.[32] *Blake Records* informs us that Cumberland '[s]aw Blake' on 12 April 1813.[33] But Cumberland's 1813 pocketbook also reveals that on the same day ('Easter Monday'), Cumberland 'Call[ed on] Daly & Cosway & Stodhart [*sic*] cosway showed me some very fine drawings.'[34] Bentley suggests that Daly and Townly were 'George Cumberland's friends' and neighbours of Blake's.'[35] Bentley also reveals that the Eagles of whom Daly was a cousin, mentioned in the 3 June 1813 entry, can be identified as 'a Bristol artist and friend of Cumberland's.'[36] The Reverend John Eagles was a Bristol-born author and artist, who during this period was curate at St Nicholas' church, Bristol, not so far from Cumberland's Culver Street residence.[37] Although I have been unable to discover further information concerning the identity of 'Dal[e]y,' 'Townly' can be identified. He is undoubtedly the 'George Townley' Cumberland met and dined with at 32 Spring Gardens on Thursday 8 July 1813.[38] Indeed Cumberland makes more references to 'Towny' than any other individual recorded in his pocketbooks.[39]

Significantly, on Monday 6 June 1814 Cumberland records that he 'came to sleep at No 61 South Molton Street at Townl[e]y's house.'[40] Cumberland's staying at a friend's house or apartment opposite the Blakes' studio-apartment at the end of the London season may confirm his claims of limited financial means at this time. On 18 August 1814 Cumberland 'Introduced Mr Townl[e]y to Mr Cosway.'[41] A month earlier, on 11 July 1814 Cumberland had 'spent the evening with Cosway Stratford Place.'[42] Cumberland's MS correspondence reveals that George Townley (1777–1859) was the son of Cumberland's old friends James Townley, proctor of Doctors Commons, and his wife, Mary Townley (née Gander), with whom Cumberland had corresponded since 1783.[43] James Townley's son George, a solicitor at Doctors Commons, and later Fellow of the Royal Society of London, was also an art collector and correspondent of Cumberland's from 1811 until 1830.[44] It seems likely that Cumberland's friend George Townley, art collector and amateur artist, would have encountered his neighbours William and Catherine Blake during his period of residence in South Molton Street, circa 1812–14, and may even have examined if not purchased some of Blake's paintings, drawings, and illuminated books.[45] Cumberland's pocketbooks indicate that by 1815 Townley had moved from

South Molton Street to '59 Weller [?] Street.'[46] By 1821, Cumberland noted George Townley's address as 'Albany,' Piccadilly.[47] Townley was residing in one of the chambers at the same address over thirty years later when he died in 1854. In his will the unmarried George Townley, while leaving several properties and a considerable amount of money to his surviving brothers and sisters, left his nephew 'James Townley, solicitor,' 'picture books prints drawings marbles [illeg.] & copper plate engravings.'[48] Further research should reveal more information about the contents of Townley's collection.[49]

An Unrecorded Reference to Blake in Cumberland's Pocketbooks

In his entry on George Cumberland in the *Oxford Dictionary of National Biography*, Francis Greenacre observes that Cumberland's 'letters have already been a vital source of information for students of William Blake.'[50] However, Greenacre makes no mention of the series of pocketbooks Cumberland utilized in the period 1810–21, especially during his annual summer visits to the metropolis.[51] The pocketbooks for each year contain diagrams such as a design for a prototype bicycle (the 'pedestrian curricle'),[52] appointments, recorded meetings and other events, as well as examples of satirical doggerel.[53]

Almost forty years ago G.E. Bentley Jr (1969) and Sir Geoffrey Keynes (1970) separately published hitherto unknown information concerning George Cumberland, derived from the Cumberland Papers, including eight manuscript allusions to Blake made by Cumberland between 1803 and 1825. In the first edition of *Blake Records*, G.E. Bentley Jr stated that 'When George Cumberland came to London for his spring visit of 1820, he called on Blake on Tuesday, 6 June and, not surprisingly, met [John] Linnell there too.'[54] Bentley goes on to cite Cumberland's pocket book or 'journal'[55] entry for this date:

> went to Blakes and read the Courier to him about Queens arrival [.] Mr Linel came in – & I recommended to him the Subject of Spring on a large scale – viz the whole of That Season from the first budding to the full leaf – with many anachronisms To introduce fly Fishing, Rooking [?] Trees Lambing in watered Vallies – later – Leaping on exposed Hills – Horses fighting for mares – &c with showers. He likes the idea as does Blake – [56]

According to *Blake Records*, this is the first reference to Cumberland visiting Blake since an entry dated 3 June in Cumberland's pocketbook for 1813, seven years earlier.[57]

However, Cumberland's 1820 pocketbook also includes a hitherto unrecorded reference to a visit made by Cumberland to 'Blake' three days before the 6 June visit. In this entry, dated [Saturday] 3 June 1820, Cumberland writes:

> arranged my Italian [illeg.] George came to say he could not get the views by Reinbad [?Abraham Raimbach?] the german of Italy etching 72 he bid as far as 65 shilling Sydney came 12 oclock [illeg.] Went to see Blake – also to Surgeons college to introduce [him?] to Mr Clift – [58]

This entry appears to commence with a reference to George Cumberland's eldest son, George Cumberland Jr, unsuccessfully bidding at a London art sale earlier that day, perhaps for his father. The reference suggests that, alongside his growing interest in geology, Cumberland was still collecting, or at least was interested in collecting, art works.[59] Such information casts an interesting light on Cumberland's claim that about this time he ceased to buy Blake's work and other art works due to poverty.[60] However, George Cumberland Jr's final bid of '65 shilling' at the sale might indeed suggest a somewhat modest offer.

Most significantly, although Cumberland's pocketbook entry for 3 June 1820 contains no reference to 17 South Molton Street or to the purpose of their visit, the fact that George and Sydney Cumberland visited 'Blake' in London three days before a hitherto established call by George Cumberland on Blake suggests that the pocketbook reference is to William Blake, poet and artist.[61] The rest of Cumberland's pocketbook entry for 3 June 1820 establishes that Sydney Cumberland, Cumberland's younger son and a clerk at the army pay office in Whitehall accompanied his father 'to see Blake.' A newly discovered contemporary reference by George Cumberland to a visit he and Sydney made to William Blake presumably at his flat in South Molton Street, recorded three days before a similar visit, is significant. Cumberland's calling on Blake twice in the space of four days in early June 1820 throws some doubt on Aileen Ward's recent assertion that George Cumberland 'grew increasingly distant' in his dealings with Blake after leaving London for Bristol.[62]

Sydney Cumberland

The new reference also reveals only the second recorded visit to Blake made by Cumberland's second son, Sydney.[63] Little is known of Sydney. Both Cumberland's sons, Sydney and George Cumberland Jr,

gained employment through their father's friend Charles Long, Baron Farnborough (1760–1838), politician and connoisseur of the arts, who was paymaster-general of the armed forces on the death of William Pitt in 1806 until Long's retirement in 1826.[64] Bentley suggests that: 'Both boys had artistic inclinations, and their father was anxious that they should meet men who could advise them well.'[65] Keynes claims that '[Cumberland's] later dealings with Blake were conducted through his sons, George and Sydney.'[66] George indeed played a role in communications between his father and Blake and pursued his own artistic interests. In a letter dated 20 January 1819, presumably referring to his brother's experiments in lithography, Sydney told his father, 'I can say nothing for certain about the progress of his [George Cumberland Jr's] stone engraving – but suppose he is making such advances as he cannot find time to see us.'[67] However, there is no evidence to suggest either that Sydney had any direct involvement in Cumberland's dealings with Blake or that he was an aspiring artist. In a letter to economist David Ricardo on 28 January 1816, George Cumberland describes Sydney as 'not yet 20 years of age.'[68] Sydney must therefore have been born at Cumberland's home at Bishopsgate about 1796. Some previously unpublished references to Sydney reveal a little more of his early life. In his pocketbook for 1810 Cumberland noted that Sydney, presumably beginning work in the army pay office aged about 14, resided at 'Mrs Parkers No 3 North st, Fitzroy Square.'[69] However, a letter from George Cumberland's second cousin Henry Man to Cumberland in Bristol, dated 26 July 1810, reveals that Sydney was about to move into lodgings with a 'widow lady' in Kennington Lane, near Lambeth. Sydney had

a good bedroom to himself ready furnished but his own furniture is to be taken in and left in the room till otherwise disposed of. To breakfast at eight, dine at five, drink tea and sup with the family consisting of a widow and her daughter, in a good plain but comfortable family way, to pay for washing of towels and bed linen extra but for the board and lodging twenty five shillings per week without any other charge tea and sugar to be provided for him.[70]

On 8 August 1810, Man wrote: 'I make little doubt [Sydney] has gone on an excursion with his friend Stothard.'[71] Sydney Cumberland's friendship with Thomas Stothard's son Robert (who was later employed to engrave plates for George Cumberland) might suggest Sydney did indeed move in artistic circles.[72]

By late 1811 Sydney had moved to 'Mr Bulls, Salisbury St, Strand.'[73] On 21 July 1812, Man reported that in 'an act of abominable careless-ness,' Sydney had mislaid a £20 note.[74] On 24 August 1812, Cumberland accompanied by his youngest son travelled home to Bristol.[75] By the spring of 1813 Sydney must have travelled abroad. As Keynes observes, during the Peninsular War George Cumberland Jr was sent to Lisbon in his capacity as clerk in the paymaster-general's office.[76] About 1812 Sydney's dissolute behaviour resulted in his employer, Charles Long, sending Sydney to join his brother at Lisbon.[77] On 1 March 1813 Man reported: 'It is long since we heard anything from our young friends George and Sydney. They must already have seen a great variety of service and I hope will continue to do so well I suppose Sydney saw Madrid ... I wish the British were all safe home again.'[78] Shortly after the end of the Peninsular War on 12 April 1814, George and Sydney returned to England.[79] Their recent experience of the war provides a context for their visit to William and Catherine Blake at 17 South Mol-ton Street on 21 April 1815, in which Catherine responded violently to renewed if short-lived fears of an invasion by Napoleon during the Hundred Days.[80] The brothers may have been able to inform Blake that thirty-six-year-old Captain, formerly lieutenant, George Hulton, First Dragoons, who had brought the bill of indictment against Blake for sedition in August 1803, and had put up a fifty pound bond for the trial, had died of 'natural causes' on 26 February 1814 at Tauste, Spain, in the closing stages of the Peninsular War.[81] The poet-artist's probable knowledge of Hulton's early death may provide some background to Blake's six references to him in *Jerusalem*.[82]

No other record survives of Sydney Cumberland visiting Blake. However, about November 1827, a few months after Blake's death, Sydney wrote to his father of his brother George's visit to Catherine Blake.[83] On 15 January 1828, Sydney belatedly provided George Cum-berland Jr with the money to purchase from Mrs Blake an unfinished late work by Blake, an engraved calling card commissioned by his father George Cumberland.[84] At the time of the June 1820 visit to Blake, Sydney was a married man and soon to be a father. Emily Elizabeth Cumberland, daughter of Sydney and Frances Cumberland, was bap-tized at St Mary's, Battersea, on 27 September 1820.[85] We gain a later glimpse of Sydney at a criminal trial, of John Boileau, for a misdemean-our, on 14 February 1839. The minutes of evidence reveal that he was still employed as a clerk at the army pay office.[86] Our final sight of Sydney Cumberland appears in an 1844 report in the *Age and Argus*

newspaper which reveals that on 20 April 1844, Cumberland's daughter Emily Elizabeth married Thomas Greenaway, Esq., of the Madras Native Infantry at Trinity Church, Brompton.[87]

'Surgeons college' and 'Mr Clift'

In the latter part of the recently recovered 3 June entry in his pocketbook for 1820, Cumberland writes: 'also to Surgeons college to introduce [him?] to Mr Clift.' Whether this entry indicates that George and Sydney Cumberland left 17 South Molton Street to introduce Sydney to Mr Clift, or that Blake also accompanied the Cumberlands to 'Surgeons college' and was himself introduced to Clift is unclear.[88] In 1820 Sydney was still working as a clerk at the war office. In addition Sydney, Cumberland's youngest and, as we have seen, not the most practical or reliable of sons, was in the process of starting a family. It therefore seems unclear why Cumberland would introduce Sydney to Clift. Saturday 3 June was towards the beginning of George Cumberland's summer visit to London in 1820. This may have marked Sydney's first free afternoon since his father's arrival in London and therefore his first chance to spend a day with his father. However, due to his father's numerous interests and busy calendar the day must have involved Sydney accompanying George Cumberland on a succession of social calls and errands. But Cumberland may have wanted to introduce Blake to Clift. Two days earlier, on 1 June 1820, Blake's recently completed commission, a commercial engraving of 'Mrs Q' was published by the artist John Barrow, who was a friend of Henry Banes, Blake's brother-in-law and landlord at 3 Fountain Court, Strand.[89] On visiting Blake two days later, and finding his friend's previous engraving project completed, Cumberland may have asked Blake to accompany him and Sydney to Mr Clift's, perhaps, in order to introduce him in the hopes of possible future engraving commissions.[90] In that case the new Blake reference might indicate that Cumberland was not merely making the first of the two visits he made to his old friend in three days, but also doing what was in his power obtain Blake further employment.

Whether or not Blake did in fact accompany the Cumberlands to Mr Clift's, Blake would have taken some interest in the location of their next port of call. In his 3 June entry, Cumberland alludes to 'Surgeons college.' Cumberland is referring to the Royal College of Surgeons which since 1801 had been based at Lincoln's Inn Fields. Blake could number two members of the Royal College of Surgeons among

his acquaintance. First, he appears to have been a 'Personal friend' of Thomas Chevalier, writer and surgeon-extraordinary to the Prince of Wales, who lived in South Audley Street, not far from South Molton Street.[91] Chevalier was also Deacon of Keppell Street Baptist church where other friends of Blake, such as the architect Charles Heathcote Tatham, his son, the sculptor, portrait painter, and 'Ancient' Frederick Tatham, as well as John Linnell worshipped during this period.[92] Second, Blake also may have known John Abernethy, the prominent surgeon and assistant governor at the Royal College of Surgeons, who is referred to in a letter of Blake's to John Linnell, dated 16 July 1826. Blake tells Linnell that his doctor James Fincham was 'a Pupil of Abernethy's this is what gives me great pleasure I did not know it before yesterday from Mr Fincham.'[93] The newly discovered entry in Cumberland's pocketbook may suggest a context in which to explore Blake's evident and hitherto unexplained acquaintance (personal or otherwise) with Abernethy.

However, in his pocketbook allusion to the Royal College of Surgeons, Cumberland does not mention Abernethy, but only refers to a 'Mr Clift.' He is referring to William Clift, curator of the Hunterian Museum at the Royal College of Surgeons, Lincoln's Inn Fields.[94] Between February 1792 and October 1793 Clift had been the last apprentice of the celebrated surgeon and 'founder of modern surgery'[95] John Hunter.[96] In the 1780s, both Blake and Cumberland had encountered Hunter when members of the literary circle of Rev. Anthony Stephen Mathew and his wife Harriet. Hunter is referred to in 'An Island in the Moon.'[97] Clift's brief apprenticeship under Hunter was spent 'preparing anatomical, biological specimens for Hunter's Museum, drawing and, above all, taking down voluminous notes from Hunter's dictation, a task which seldom ended before 11 p.m.'[98] After Hunter's death on 16 October 1793, Clift was temporarily and informally employed as curator of the Hunterian collection at Hunter's establishment in Castle Street.[99] The post was made official and permanent in 1799 after the Royal College of Surgeons (formerly the Corporation of Surgeons) was made custodian of the collection. Clift held this post until his death in 1849.[100] In the late 1790s, the government, on behalf of the nation, had bought Hunter's collection for £15,000. However, over two decades later, the Hunterian Museum, now part of the Royal College of Surgeons in Lincoln's Inn Fields, had still not yet opened to the public due to the difficulties involved in authoritatively cataloguing Hunter's vast collection.[101] Clift

and his son, the unofficial assistant curator and conservator William Home Clift, were making slow, careful progress with this task at the time of George and Sydney Cumberland's visit.[102]

In his official museum diary, Clift makes no mention of the visit of George and Sydney Cumberland to the museum, perhaps accompanied by Blake. However, other entries in his diary do refer to several communications and meetings with Cumberland. From these entries it is possible to provide a context for the Cumberlands' 3 June visit. Frances Austen observes that '[t]here, at the Royal College of Surgeons, Clift became one of the leading *cognoscenti* of the first half of the nineteenth century, and scientists from all over the world consulted him and inspected the Museum.'[103] As well as having a vast knowledge of medical matters, Clift also took a great interest in specimens of extinct life forms contained in fossils.

It is evident that by the summer of 1820 Cumberland had become a keen collector and authority on fossils. Keynes relates that 'Cumberland naturally became an assiduous collector of Italian prints, coins and other antiquities, with cabinets of minerals and fossils.'[104] Although he is often characterized as an amateur and dilettante,[105] Cumberland was also a knowledgeable and gifted early nineteenth century geologist. Bentley noted Cumberland's varied interests:

> Perhaps most impressive of all, [Cumberland] plunged energetically into theoretical and practical geology, possibly stimulated by the remarkable fossil formations near Clifton, and his contemporaries came to think of him as one of the more distinguished geologists of the age.[106]

Hugh Torrens has described Cumberland as 'a major collector of fossils.'[107] From around 1815, Cumberland made copious references to fossils in his pocketbooks, and wrote several articles as well as a book on fossils.[108] Eminent and pioneering figures in the recovery of information concerning the prehistoric world, such as William Conybeare and Henry de la Beche, acknowledged Cumberland's assistance in their paper 'Notice of the discovery of a new Fossil Animal, forming a link between the Ichthyosaurus and Crocodile, together with general remarks on the Osteology of the Ichthyosaurus,' read before the Royal Society on 6 April 1821.[109]

In a letter to Blake's widow, Catherine, dated 27 November 1827, Cumberland concludes:

PS.
The reason I did not continue to purchase everything Mr Blake engraved, was that latterly I have not only been unable to continue Collecting but have even sold all I had Collected – yet still preserving all I possessed of his graver.[110]

Lack of money does appear to have been a concern in Cumberland's later years. However, as Bentley observes:

About eighteen months before [writing this letter to Catherine], Cumberland wrote in his *Reliquiae Conservatae* (1826), i: 'any one possessed of perfect [fossil]Specimens which they are desirous of disposing of, will find in him [George Cumberland] a ready purchaser.' Of course what he meant in his letter to Catherine was that his collecting interests had changed.[111]

The new reference to Blake and its context shows Cumberland's reunion with his old friend and fellow artist in the early summer of 1820 while in the midst of Cumberland's current and predominant pursuit.[112] Clift's diaries reveal that Cumberland had visited him at the Hunterian Museum five days earlier. In his entry for Monday 29 May 1820, Clift recorded that 'Mr Cumberland called concerning mr morgan's Proteosaurus Price £25.'[113] As a rule, the museum opened for visitors (though not the general public) on Tuesdays and Thursdays.[114] Evidently Cumberland was making a business call concerning a fossil offered, on behalf of another collector, to Clift for purchase.[115] But, Cumberland was clearly not merely running an errand for his Clifton friend Mr Morgan, but also had his own interest in the recently discovered specimen. On Thursday, 1 June Clift recorded that he 'Wrote to Mr Cumberland concerning Mr Morgan's fossil skeleton of Proteosaurus, no 8 Buckingham Street Strand.'[116] It is highly probable that Cumberland's visit to Clift two days later after calling on Blake was principally in response to Clift's letter.

'Proteosaurus' was one of two names ascribed to a fossil specimen first made known to the British scientific establishment in 1812 through the Anning family's discovery of the first British specimen at Lyme Regis.[117] The term was coined circa 1814 by Clift's associate and the son-in-law and successor of John Hunter as head surgeon at the Royal College of Surgeons, Sir Everard Home, who wrote several papers on the Anning specimen.[118] However, Karl Koenig, German palaeontologist and keeper of the department of natural history at the British Museum,

had initially coined the term 'Ichthyosaurus in communis' for the specimen in 1817.[119] Home responded in 1819 with a paper arguing that the name proteosaurus was anatomically more accurate.[120] However, by 1821 Conybeare and de la Beche had conclusively demonstrated that Home had made fundamental errors in ascribing the name 'proteosaurus,' and that therefore 'ichthyosaurus' was a more accurate name.[121] In 1820 the two terms still appear to have been used synonymously. For instance, Clift refers to an 'ichthyosaurus' in papers dated 1819. However, in his diary for 1820 he still consistently uses 'proteosaurus.'[122]

In approaching and offering to sell a fossil skeleton of a proteosaurus (or ichthyosaurus)[123] to Clift, George Cumberland was acting on behalf of a friend or acquaintance, a Mr William Morgan of Bower Ashton Cottage in Clifton, near Bristol.[124] Morgan must have been a fellow member of the established circle of fossil collectors in Bristol, in which Cumberland was prominent. Cumberland's journals and published work reveal that Morgan was a fellow collector whom Cumberland had known for some years. Cumberland's most explicit reference to his friend is to be found in Cumberland's 1826 study of encrinite (crinoid) fossils: *Reliquiae Conservatae – from the primitive materials of our present globe, with popular descriptions of the prominent characters of some remarkable fossil encrinites, and their connecting links* (figs. 7.2 and 7.3). In this work, Cumberland makes clear that 'that dilligent [sic] labourer … Mr. WILLIAM MORGAN'[125] discovered as well as collected fossils:

> To the persevering activity of this gentleman, we are indebted for the early discovery of several rare Encrinites, at *Clevedon* [just west of Bristol], in sandy limestone; and also for a nearly entire Ichthyosaurus, at Watchet [Somerset], now in the College of Surgeons, London.[126]

Cumberland is clearly referring to the ichthyosaurus specimen he had successfully offered to William Clift for William Morgan six years earlier.[127]

Clift purchased other fossils for the Hunterian Museum during this period. However, specimens and species of ichthyosaurus must have been of special interest in 1820 at the height of the controversy principally between Home on one side and Koenig, de la Beche, and Conybeare on the other over the nature of and most appropriate appellation for this newly discovered specimen. Numerous ichthyosaurus fossils were discovered between 1812 and 1820, not merely in the Lyme Regis area, but throughout England.[128] Almost a week after Cumberland's

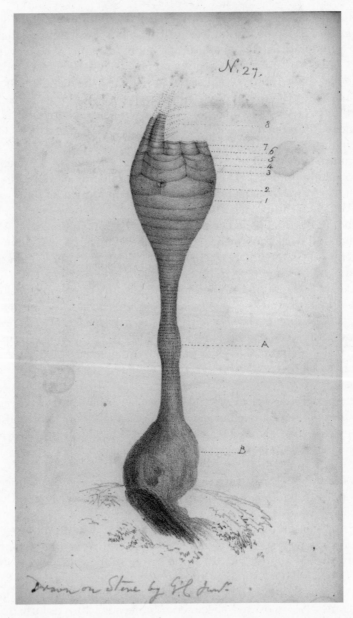

7.2 Encrinite, lithographic print by George Cumberland Jr., frontispiece to George Cumberland, *Reliquiae Conservatae* (1826), no. 27. Victoria University Library, University of Toronto, Toronto

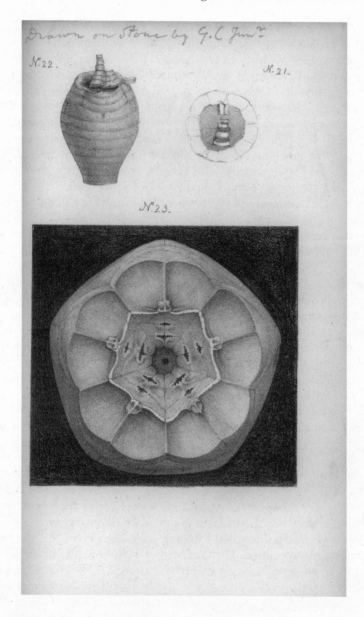

7.3 Magnified sections of the Bradford or pear encrinus, lithographic prints by George Cumberland Jr., from George Cumberland, *Reliquiae Conservatae* (1826), nos. 21–3. Victoria University Library, University of Toronto, Toronto

visit, Clift recorded that he had 'Received from Mr Bullock Col Birch's fossil of Proteo-saurus (lot 102.) £100. 0. 0.'[129] William Bullock was the proprietor of the recently closed London Museum of Natural History located at the Egyptian Hall, Piccadilly.[130] He had purchased and displayed the first ichthyosaurus discovered in England by the Annings at Lyme Regis.[131] Its public display in London initiated a wider interest in and consequent 'collectability' of the fossilized remains of prehistoric animals. Blake is likely to have heard or read in the press about the public display of this new discovery around 1814. Unfortunately Blake's views on the 'proteosaurus,' and other fossils, which Cumberland, a 'diluvialist,' believed were remnants of 'a former' creation, were not recorded. Cumberland's pocketbook for the same year contains a drawing of an ichthyosaurus with 'Bullock' written faintly above which indicates that he had seen and taken an early interest in this specimen (fig. 7.4).[132] In 1814 Home delivered a paper to the Royal Society concerning the fossil.[133]

By 1817 Colonel Birch had become a friend and benefactor to the poverty stricken Anning family of Lyme Regis. Through their discovery of numerous fossils in the blue lias formation the Annings had contributed greatly to British scholarship on prehistoric animals, a study then in its infancy. Birch decided to sell his personal collection of fossils for the Anning family's benefit. The sale of Birch's fossil collection was held at William Bullock's Egyptian room, Piccadilly, on 15 May 1820.[134] Bullock had sold the entire contents of his former museum piecemeal from 29 April to 11 June 1819.[135] He had evidently acquired a taste for the position of auctioneer, turning part of his former museum, the Egyptian Hall, into an auction room.[136] Bullock's well publicized ichthyosaurus specimen was sold to the British Museum. Clift successfully bid for another ichthyosaurus specimen, lot 120 in the May 1820 sale. Clift's clear interest in the 'proteosaurus' must have been the reason why Cumberland approached Clift with the offer of another ichthyosaurus specimen less than a fortnight after the Birch auction.[137]

Clift was clearly interested in Cumberland's offer of Mr Morgan's ichthyosaurus specimen. On Wednesday 14 June Clift 'wrote to Mr Morgan … to send skeleton of proteosaurus. £25.'[138] That Clift paid Morgan only a quarter of the price he had paid for Birch's ichthyosaurus specimen suggests Morgan's proteosaurus fossil was of inferior quality to that of Colonel Birch's. Almost a fortnight later, William Morgan's specimen arrived at Lincoln's Inn Fields. On Tuesday 27 June Clift recorded 'Received a box containing the skeleton of a proteosaurus from Mr Morgan … waggon Carriage 108 lbs. 0.10.2.'[139]

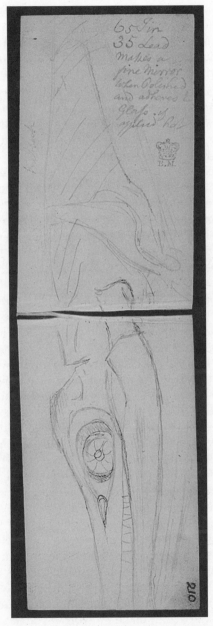

7.4 Page from George Cumberland's pocketbook (1814), sketch of proteosaurus fossil, BL Add MSS 36520 D 209 v – 210 f. British Library

Even if George and Sydney Cumberland merely called on Blake on their way to the Royal College of Surgeons, rather than the equally likely scenario of their taking the poet-artist to meet Clift, it seems likely that father and son would have discussed the nature and subject of their next port of call and the reason for it. As Cumberland appears to have been collecting fossils for over a decade, the subject may have been one the friends had previously discussed face to face or in correspondence. It is intriguing to think of George and Sydney Cumberland and William and, perhaps, Catherine Blake discussing and reflecting upon the significance of this specimen of the fossilized remains of a prehistoric sea creature 'such as existed in the most remote periods of antiquity.'[140] Although unrecorded in Cumberland's pocketbook, Blake and Cumberland may also have discussed the outcome of the meeting with Clift three days later when Cumberland again visited Blake. By 1820 Cumberland had written a number of articles attempting to reconcile geology and 'the traditions of Moses.'[141] Six years later, in *Reliquiae Conservatae* Cumberland wrote:

> Geology … is in our times, permitted to disclose other truths calculated to confirm in us the belief of the goodness and power of the Creator; and to shew us that Matter fluctuates under his direction in form and quality; and that *nothing is unchangeable but Spirit*. That the Earth which sustains the life of human beings, is as liable to mutation of form as our own structure and as capable of complete renovation, or restitution, after being reduced to an inert state, by the decree of the supreme incomprehensible intellect … in the great event of the creation or *re*formation of the globe, they consisted of the decomposed chaotic materials of a formal world, disorganized by the fiat of that Omniscient Spirit who governs all plastic matter, and can, by his *word*, reorganize it for his own wise but inscrutable purposes … For these are the *Hieroglyphics of Nature*, which, well understood, point to the initiated, the concealed wealth which she has deposited in the bowels of the earth for the use of men in every age of their existence.[142]

The new reference to Blake in Cumberland's pocketbook poses two further questions: first, could Cumberland's interest in fossils, particularly those of encrinites, have influenced his friend's art and poetry? Cumberland's interest, particularly in basic crinoid life forms, appears to have begun around 1815. As Noah Heringman has recently suggested, this period overlaps with Blake's reworking of *The Book of Urizen* in copy G (c. 1818) and his completion of *Jerusalem*, the illuminated books

in which Blake's references to geology are most prevalent, the latter work especially 'teeming with verbal and visual images of rocks.'[143] According to Heringman, 'images of rocks, cliffs, and caves in Blake's later poetry ... constitute a symbolic intervention in the debate about primitive matter.'[144] It is therefore possible that untraced communications between Cumberland and Blake concerning geology and fossils could have influenced, or have produced, one of the multiple contexts for Blake's use of geological imagery.[145]

Ruthven Todd, writing in 1946, observed that 'Blake makes no direct reference to fossils ... However, it would be absurd to suggest that he did not know of the speculation current at his time for, according to Gideon Mantell, his friend George Cumberland was "a celebrated geologist," and the subject must have been discussed by them.'[146] Heringman is sceptical of Todd's unsubstantiated assertion.[147] However, the new pocketbook entry which brings Cumberland, Blake, Clift, and a major fossil specimen in such proximity might provide a likely occasion for just such a conversation.[148] Cumberland and Blake appear to have had very different views on geology. Cumberland, like other geologists of the period, viewed rocks and other geological phenomena with wonder. However, Blake's writings suggest that rocks appear to be a testimony to man's fallen condition. Nevertheless, as Heringman argues, Blake's response can be viewed as more complex. Blake may have been familiar with Cumberland's belief in a previous creation (surviving rocks of which, especially 'fossil saurians' were 'undoubted marks of the Noatic flood')[149] from articles and letters Blake would have encountered in *The Monthly Magazine*, a magazine we know the poet-artist not only read, but contributed to. According to Heringman, such ideas would not necessarily have alienated Blake.[150] Geology was still a new area – not yet mapped by the professionals – though under imminent threat of being so. In an article published during this period, Cumberland condemns the growing monopoly of geology by academic experts:

We ought ever to remember, that the world would to this day have remained ignorant of the treasure England possessed, but for the patient labours of three female pioneers in this service, viz. *Mary Anning*, a dealer, *Miss Congrieve*, and *Miss Philpots*, residents, who for years had been collecting and preserving these bodies from the wreck of the coast ... They, and a few others, gathered the materials of this fabric raised to fame, and are entitled to a full share of the honours reaped by those who, without

their aid, could never have brought them before the world, yet some of whom, with a vanity that *greatly impedes scientific pursuits*, affix their own insignificant names to every little shell they find or purchase of some poor quarrier by the road side ... this tickle-toby approach has now been carried too far ... this greediness of fame infects even public societies, and they would cancel, if possible, the discoveries of private individuals unconnected with them, or veil them by neglecting them in their general reports, until such time as the leading members of their own institution are prepared to amalgamate them into their own papers as previously known to them; and this system of exclusiveness is not only unhandsome and unjust, but prejudicial to the discovery of truth in science, as it checks the ardour of many solitary labourers in every branch of study, and so far impedes the march of science.[151]

'Went to see Blake'

The unusual route of George and Sydney Cumberland's journey from George Cumberland's London lodgings at 8 Buckingham Street, Strand,[152] to Blake's flat and then to the Hunterian Museum at the Royal College of Surgeons, Lincoln's Inn Fields, off the Strand, may cause Blake scholars to reconsider afresh two aspects of Blake's biography: first, the precise location of William and Catherine Blake's studio-residence in early June 1820 and second, the likelihood of Blake's accompanying George and Sydney Cumberland on their visit to Clift. It has traditionally been accepted, albeit with scant evidence, that the Blakes moved from 17 South Molton Street to 3 Fountain Court, Strand during 1821.[153] Thus according to this 'tradition' in Blake biography, the Blakes were still living in South Molton Street when George and Sydney Cumberland visited them on the afternoon of 3 June 1820. However, if that is the case, then George and Sydney Cumberland must have taken themselves considerably out of their way to walk (if they did walk) from 8 Buckingham Street, Strand, some distance northwest to 17 South Molton Street, Mayfair, before retracing their steps to the southern side of Lincoln's Inn Fields, a short distance east from Cumberland's lodgings in the Strand. Conversely, 3 Fountain Court, Strand, four blocks east along the Strand from Buckingham Street, would have been en route if one were travelling directly from Buckingham Street to Lincoln's Inn Fields.

John Linnell, writing less than ten years after the event, gives the removal of the Blakes' landlord Mark Martin from 17 South Molton

Street to France as the reason for William and Catherine Blake's move to Fountain Court.[154] The rate books for the parish of St George, Hanover Square, reveal that by March 1821 'Mark Martin' was no longer ratepayer for 17 South Molton Street.[155] Martin must therefore have vacated the residence sometime between March 1820 and March 1821. This information coupled with the topographical context just discussed of George and Sydney Cumberland's potentially circuitous journey across Westminster on 3 June 1820 throws some doubt on the traditionally accepted if not materially substantiated date of the Blakes' move from South Molton Street to Fountain Court (1821) and might suggest a slightly earlier date for the removal to Fountain Court. However, the Cumberlands' indirect route on their journey from Buckingham Street to the Royal College of Surgeons might equally suggest that the Cumberlands needed to visit South Molton Street before Lincoln's Inn Fields, and therefore that Blake was indeed called for by the Cumberlands because they intended to introduce him to William Clift.

The new information discussed in this paper, derived from revisiting afresh previously explored archival material, the pocketbooks or 'journals' of George Cumberland, sheds further light on Blake's milieu at South Molton Street, and a period of Blake's life of which we still know very little. The hitherto unrecorded reference to Blake by Cumberland indicates the friends' enduring friendship, Cumberland's continued active interest in art, side by side with his growing interest in geology, and a potential context for Blake's involvement in geological debate in the 1820s. It is clear that focused archival research of the kind Bentley has been carrying out for the past sixty years still has the capacity to open up exciting possibilities in biographical studies of Blake.

However, we still do not know whether Blake met Daley and George Townley, his South Molton Street neighbours, friends of Cumberland and members of contemporary art circles. It is as yet unclear whether or not George and Sydney Cumberland either discussed proteosaurus fossils with Blake or introduced him to William Clift. The location of the Blakes' studio-residence by June 1820 still requires further investigation. Cumberland's notebooks, correspondence, and other published and MS writings have yet to be fully explored. Further, long overdue, biographical and bibliographical research on Cumberland, building upon Bentley's groundbreaking scholarship (and, with hope, resulting ultimately in an edited edition of Cumberland's published works, MSS, and correspondence and an accompanying biography), would contrib-

ute valuably to a much-needed, considerably fuller, and clearer picture not only of a lifelong friend and collaborator of Blake's, and a key figure of the period, but also a richer, deeper, more focused picture of this as yet little-known and inadequately researched period of Blake's life.

NOTES

I wish to thank Tina Craig, chief curator of the archives at the Royal College of Surgeons, for her assistance during my initial research for this paper.

1 See G.E. Bentley Jr, 'Blake and Cromek: The Wheat and the Tares,' *Modern Philology* 71 (1974): 366–79; 'Cromek's Lost Letter about Blake's *Grave* Designs,' *Blake/An Illustrated Quarterly* 26, no. 4 (1993): 160; 'The Unrecognized First Printing of Flaxman's *Iliad* (1793),' *Analytical and Enumerative Bibliography* ns 9 (1995): 102–20; 'The Death of Blake's Partner James Parker,' *Blake/An Illustrated Quarterly* 30, no. 2 (1996): 49–51; 'The Journeyman and the Genius: James Parker and His Partner William Blake with a List of Parker's Engravings,' *Studies in Bibliography* 49 (1996): 208–31; 'Thomas Butts, White Collar Maecenas,' *PMLA* 71 (1956): 1052–66.

2 Alan Philip Keri Davies, 'William Blake in Contexts: Family, Friendships, and Some Intellectual Microcultures of Eighteenth- and Nineteenth-Century England' (doctoral thesis, St Mary's College, University of Surrey, 2003), 13. Concluding his thesis, Davies reminds us that despite the efforts of Erdman, Bentley, and other 'fact scholars' since the 1950s, much initial archival groundwork in Blake scholarship still needs to be carried out. 'It still remains for us to locate yet undiscovered data in archival sources that will give William Blake as full and detailed a biography as that of other major English poets.' Ibid., 322.

3 See, for example, G.E. Bentley Jr, *Blake Records, 2nd ed.* (New Haven and London: Yale University Press, 2004), 477. Hereafter *BR2*.

4 See *BR2*, 56. On 27 May 1780, writing under the pseudonym 'Candid,' Cumberland praised Blake's 'Death of Earl Godwin,' in *The Morning Chronicle and London Advertiser*. See *BR2*, 21; see also *BR2*, 479. Both artists appear to have been members of the Mathew circle. See Geoffrey Keynes, 'Some Uncollected Authors XLIV: George Cumberland 1754–1848,' *The Book Collector* 19 (1970): 34. Blake's last engraving was a calling card for Cumberland. See *BR2*, 475–8. Cumberland also assisted Catherine Blake in widowhood. See *BR2*, n754.

5 G.E. Bentley Jr, ed., 'George Cumberland, *The Captive of the Castle of Sen-naar: An African Tale'* (Montreal and Kingston: McGill-Queen's University Press, 1991), xiv; see also xxii and xxxvi–xli. Cumberland appears like Blake to have pugnaciously practised what he preached, often to the annoyance of fellow members of the gentry. 'my sentiments are as near as any man's, those of that exalted Statesman, Mr. FOX: I love, revere, and will ever to the utmost of my poor powers support the Constitution, but I must forever deplore the cause and conduct of this, in my opinion (and I have had some opportunities of forming it) unnecessary War.' George Cumberland, *A Letter to Henry Griffiths, Esq., of Beaumont Lodge* (Windsor: C. Knight, 1797), 15.

6 British Library (BL) Add MSS 36507 f. 276, cited *BR2*, n56. E.P. Thompson is surely wrong to date Cumberland's recollection to 1819. See E.P. Thompson, *Witness against the Beast: William Blake and the Moral Law* (Cambridge: Cambridge University Press, 1994), 126. See also Alexander Gilchrist, *Life of William Blake* (London: J.M. Dent & Sons, 1945), 80–1.

7 See Michael Phillips, ed. William Blake, *An Island in the Moon* (Cambridge: Cambridge University Press; Institute of Traditional Science, 1986), 84; *BR2*, 68. As late as 1799, a writer in the *Critical Review* described Cumberland as 'an enthusiast as well as an artist.' See *Critical Review*, 1799, 453.

8 See William Blake, *The Complete Poetry and Prose of William Blake*, ed. David V. Erdman (Berkeley and Los Angeles: University of California Press, 1982) (hereafter *E*), 699–700, 703–4, 706–7, 769–70, and 783–4; *BR2*, 95–7. Keynes notes Cumberland's 'taste in book production' (Keynes, 'Some Uncollected Authors XLIV,' 36).

9 See *BR2* 44. In December 1795 Blake sent Cumberland instructions concerning the preparation and etching of a copper plate (see *BR2* 67).

10 See *BR2*, n61.

11 *BR2*, 95; see also Robert N. Essick and Morton D. Paley, '"Dear Generous Cumberland": A Newly Discovered Letter and Poem by William Blake,' *Blake/An Illustrated Quarterly* 32, no. 1 (1998): 4–13. Blake's letter contains a poem which begins: 'Dear Generous Cumberland nobly solicitous for a Friends welfare. Behold me / Whom your Friendship had magnified.' The letter also reveals evidence that Blake endeavoured to promote Cumberland's proposed publications. See *BR2*, 96.

12 See *BR2*, 80 and 82. In 1796 Blake etched the inscriptions on the plates of Cumberland's *Thoughts on Outline* (1796) (see G.E. Bentley Jr, *The Stranger from Paradise: A Biography of William Blake* [New Haven and London: Yale University Press for the Paul Mellon Centre for Studies in British Art, 2001], 37n). Cumberland owned watercoloured copies of *Thel* (A), *Visions*

(B); colour printed copies of *Europe* (C), *Song of Los* (D), *Songs* (F); and uncoloured copies of *America* (F), *For Children: The Gates of Paradise* (C) (see *BR2*, n278).

13 At this time Cumberland's address was Bishopsgate, Windsor Great Park, Egham.

14 See Francis Greenacre, 'George Cumberland,' *Oxford Dictionary of National Biography*, Oxford University Press, 2004. Hereafter *ODNB*.

15 See Joan K. Stemmler, 'Cennino, Cumberland, Blake and Early Painting Techniques,' *Blake/An Illustrated Quarterly* 17, no. 4 (Spring 1984): 145–9.

16 Michael Phillips, *William Blake: The Creation of the 'Songs'; From Manuscript to Illuminated Printing* (London: The British Library, 2000), 100.

17 See Bentley, *The Stranger from Paradise*, 120–1.

18 *E*, 700.

19 The address is written in pencil in Cumberland's hand on the inside of the front board of Cumberland's 1806 pocketbook. See BL Add MSS 36519 F. The address also appears in a letter from Cumberland to G. Manley of Abergeveney. See BL Add MSS 36507 f. 20.

20 See *BR2*, 150, 155, 246, 306, 454, and 457.

21 See *BR2*, 246–7, 252, 278–9.

22 The rectangular notebooks are literally (coat) pocket size, measuring approximately 12 × 9.5 cm. The 1820 pocket book has a green marbled cover and is inscribed 'journal 1820.'

23 See *BR2*, n223.

24 See BL Add MSS 36519 G ff. 307–8, cited *BR2*, 246. An entry for May 1808 reads 'Got Blake to Engrave for Athens.' BL Add MSS 36519 H f. 355, cited *BR2*, 251. However, as Bentley suggests this probably refers 'to past, not future, engravings' (ibid.).

25 These were made on Monday 12 April 1813, and Friday 3 June 1813. See BL Add MSS 36520 C, f. 153, cited *BR2*, 316; BL Add MSS 36520 C, f. 155, cited *BR2*, 316; BL Add MSS 36520 D f. 182, cited *BR2*, 316.

26 See BL Add MSS 36520 H ff. 384–5, cited *BR2*, 370.

27 See BL Add MSS 36520 K ff. 472, cited *BR2*, 414.

28 See BL Add MSS 36520 C f. 153, cited *BR2*, n316.

29 BL Add MSS 36520 D f. 182, cited *BR2*, 316.

30 See Gerald Barnett, *Richard and Maria Cosway: A Biography* (Tiverton: West Country Books, 1995), 171. The interpretation is accepted by Marsha Keith Schuchard; see Marsha Keith Schuchard, *Why Mrs Blake Cried: William Blake and the Sexual Basis of Spiritual Vision* (London: Century, 2006), 318.

31 According to the relevant rate books of St George's ward, Hanover Square, and directories of the period, between 1803 and 1812, 51 South Molton

Street was occupied by Charles King, who ran a turnery workshop and warehouse from this address. See Richard Angus Whitehead, 'New Discoveries Concerning William and Catherine Blake in Nineteenth Century London: Residences, Fellow Inhabitants, Neighbours' (PhD thesis, University of York, 2006), vol. 2, 325. By 1817–21 John Thorogood ran a plasterer's shop here (ibid.). It is unclear whether Daly was sole occupant of 51 South Molton Street between 1812 and 1817. Alternatively, he may have been a lodger with King or Thorogood.

32 See BL Add MSS 36520 C f. 153. The slightly different address for Daley may be significant. Directories for 1805 and 1808 record Rev. Thomas Nicholas as resident at no. 50. In 1821, the ratepayer was Edward Jackson, Royal Artillery. See Whitehead, 'New Discoveries,' vol. 2, 325.

33 *BR2*, 316.

34 BL Add MSS 36520 C f. 154.

35 *BR2*, 748.

36 *BR2*, n316.

37 See 'Death of the Rev. John Eagles,' *Blackwood's Edinburgh Magazine* (December 1855): 757; Geoffrey Grigson, *The Harp of Aeolus* (London: Routledge, 1947), 68; Gordon Goodwin and Anne Pimlott Baker, 'John Eagles,' *ODNB*.

38 BL Add 36520 C ff. 137 and 139.

39 On Thursday 15 June 1820, Cumberland recorded in his pocketbook, 'met Townly three times in one day' (BL Add MSS 36520 H f. 391).

40 BL Add MSS 36520 D f. 185. In the 1793 edition of rake and poet Samuel Derrick's directory of high-class prostitutes, *Harris's list of Covent-Garden ladies*, three prostitutes are listed as resident in three houses near the southeastern corner of South Molton Street at nos. 59, 60, and 61, including 'Miss Br—ley, No. 61, South Moulton-street' 'about twenty years of age and ever satisfied with a single guinea.' Jack Harris [Samuel Derrick], *Harris's list of Covent-Garden ladies. Or man of pleasure's kalender for the year 1793* (London: Printed for H. Ranger [1793]), 30–1.

41 BL Add MSS 36520 D f. 205.

42 BL Add MSS 36520 D f. 186. In a later entry (27 May 1820) Cumberland recorded a visit 'to Cosway's who is quite imbecile' (BL Add. MSS. 36519 H f 389).

43 See BL Add MSS 36494–501, 36503. James Townley, originally a portrait painter and probably a fellow traveller with Cumberland on the continent in the 1780s, was a recipient of one of George Cumberland's bound copies of *Thoughts on Outline* in 1796 (see G.E. Bentley Jr, *Blake Books: Annotated Catalogues of William Blake's Writings in Illuminated Printing* [Oxford:

Clarendon Press, 1977], 685; *BR2*, 794). On Friday 3 June 1814 Cumberland appears to refer to James Townley in his pocketbook, 'Got to Evans' in Pall Mall where … Mr Townly's books were on sale – an immense collection' (BL Add MSS 36520 D f. 182).

44 See BL Add MSS 36503–7, 36511–12. See also *Philosophical Transactions of the Royal Society of London for the Year 1833* (London: Richard Taylor, 1833), 21.

45 In December 1817 *Blackwood's Edinburgh Magazine* reported that Townley's forty views of Pompeii were in the process of being 'engraved in mezzo-tinto' and published. See *Blackwood's Edinburgh Magazine* (December 1817), 338.

46 BL Add MSS 36520 E f. 232.

47 BL Add MSS 36520 K f. 459.

48 See Will of George Townley, Public Record Office PROB 11/2201.

49 Townley was also a collector of paintings. Between 1824 and 1829 he purchased Dutch master Nicholas Berghem's 'Women with Milk Cans' (originally in the collection of Citizen Robit) from George Hibbert, Esq., for 300 guineas. See John Smith, *A Catalogue Raisonné of the Works of the Most Eminent Dutch, Flemish and French Painters* (London: Smith and Son, 1835), part 5, 43; William Buchanan, *Memoirs of Painting* (London: R. Ackermann, 1824), 38–9.

50 Greenacre, 'George Cumberland,' *ODNB*.

51 Cumberland's pocketbooks, which cover the years c. 1800–20, are part of the Cumberland papers stored in the manuscripts collection of the British Library, BL Add MSS 36520, lettered A–K (J is missing).

52 BL Add MSS 36507 f. 32.

53 Such doggerel included a skit on Whig minister and former fellow supporter of liberty Charles Grey, Second Earl Grey, in the pocketbook for 1820:

> Some say Grey has wit
> Others they have felt it
> But he walks as if he was beshit
> And looks as if he smelt it

(BL Add MSS 36520 F f. 362). Cumberland's rhyme alludes to a remark about Grey's near namesake Thomas Gray and is attributed to Christopher Smart. Smart is supposed to have said Gray 'walks as if he had fouled his small-clothes, and looks as if he smelt it.' See [Richard Gooch ed.] *Facetiae Cantabrigienses* (London, 1825), 45. Cumberland's pocketbook for 1801 features a sketch of William Pitt as a devil. See BL Add MSS 36519 B.

54 *BR2*, 370. See also Geoffrey Keynes, 'George Cumberland and William Blake,' in *Blake Studies: Essays on his life and work*, 2nd ed. (Oxford: Clarendon Press, 1971), 246.

55 Cumberland's term; see front cover of Cumberland's pocketbook for 1820 (BL Add MSS 36520 H).

56 BL Add MSS 36520 H f. 384; cited *BR2*, 370.

57 Friday 3 June 1813 (see BL Add MSS 36520D f. 182, cited *BR2*, 316).

58 BL Add MSS 36520 H f. 380.

59 See George Cumberland, *An Essay on the Utility of Collecting the Best Works of the Italian School* (London: Payne and Foss, 1827). See also Morton D. Paley, *The Traveller in the Evening* (Oxford: Oxford University Press, 2003), 74.

60 See *BR2*, 477. My thanks to G.E. Bentley Jr for this observation (letter to author, 10 November 2006).

61 As Geoffrey Keynes observed, the Cumberland papers include references to two other Blakes, c. 1825, one to whom Cumberland paid £500 concerning a lease, the other Blake a house decorator. See Keynes, 'George Cumberland and William Blake,' 50. There is also another reference to a 'wrong' Blake in the notebook for c. 1825: 'Paid Blake for building Ho. £ 461 . ___' (BL Add MSS 36520 K f. 463). See also G.E. Bentley Jr, 'A Collection of Prosaic William Blakes,' *Notes and Queries* (May 1965): 172–8.

62 See Aileen Ward, 'William Blake and His Circle,' in *The Cambridge Companion to William Blake*, ed. Morris Eaves (Cambridge: Cambridge University Press, 2009), 22. In the same passage Ward describes Cumberland as 'merely a knowledgeable amateur of engraving' (ibid.). However, Susan Matthews's recent essay reminds us that Cumberland's active involvement in the development of early nineteenth-century printmaking cannot be dismissed as mere dilettantism (see Matthews, 'Fit Audience tho Many: Pullman, Blake and the Anxiety of Popularity,' in *Blake, Modernity and Popular Culture*, ed. Steve Clark and Jason Whittaker [London: Palgrave, 2007], 205–20).

63 See *BR2*, 320.

64 See Howard Colvin, 'Charles Long, Baron Farnborough,' *ODNB*.

65 *BR2*, 275.

66 Keynes, 'Some Uncollected Authors XLIV,' 33.

67 BL Add MSS 36507 f. 11. As the illustrations to George Cumberland's *Reliquiae* attest, by 1826 George Cumberland Jr was still creating lithographic prints (see figs 7.2 and 7.3).

68 See Piero Sraffa, ed., *The Works and Correspondence of David Ricardo* (Cambridge: Cambridge University Press, 1955), vol. 10, 144–59.

69 BL Add MSS 36520 A f. 1.

70 BL Add MSS 36502 f. 246.

71 BL Add MSS 36502 f. 262.

72 See *BR2*, 396–7. However, the boys' friendship might have had as much to do with their respective fathers' own longstanding friendship.

73 BL Add MSS 36520 B 59 f. 1.

74 BL Add MSS 36502 f. 281. In January 1816 Sydney, in another ill-judged episode, accompanied a dismissed servant girl to London, resulting in a heated correspondence with her former employer, political economist David Ricardo. The misunderstanding was investigated and smoothed over by Sydney's father. See Sraffa, ed., *The Works and Correspondence of David Ricardo*, vol. 10, 144–59.

75 BL Add MSS 36504 f. 50.

76 See Keynes, 'Some Uncollected Authors XLIV,' 45.

77 See ibid.

78 BL Add MSS 3650 f. 24.

79 See Keynes, 'Some Uncollected Authors XLIV,' 47.

80 See *BR2*, 320.

81 See *BR2*, 164–6; Mary Preston, MS letter to Rev. William Gunn, 30 Apr 1814, The Archive of Rev. William Gunn [friend of John Flaxman] Norfolk Record Office WGN 1/6/10; *Gentleman's Magazine* (August 1814), 137; Christopher Thomas Atkinson, *History of the Royal Dragoons 1661–1934* (Glasgow: R. Maclehose, 1934), 279.

82 See *Jerusalem* 5.25; 7.24; 19.18; 32.11; 36.17; 71.36 (*E* 147, 149, 164, 178, 195, 225). Bentley speaks of Blake's indignation directed against Hulton (see *BR2*, 166n). After 1814–15 Blake's indignation may have been aimed at Hulton's shade.

83 See *BR2*, 475.

84 See *BR2*, 482.

85 Church of the Latter-day Saints' International Genealogical Index (IGI). A Sydney George Cumberland was born to Sydney and Frances Cumberland on 15 September 1822 and baptized at St Luke's Church, Chelsea, 16 March 1825 (ibid.). A third child, George Cumberland, was baptized 5 January 1827 at St Luke's, Chelsea (ibid.). He died, aged 21, at Guildford on 18 July 1847 (see *The Court Magazine and Monthly Critic* for 1 October 1847, p. 82).

86 See Central Criminal Court; Minutes of Evidence [4th Session, 1839] (London: George Herbert, 1839), 711–12.

87 *Age and Argus*, 27 April 1844, 14.

88 Sydney's elder brother George Cumberland Jr appears to have met Clift before 3 June 1820. In loose papers kept with Clift's 1819 diary is an undated note in Clift's hand: 'Mr Cumberland, army pay office, whitehall: – will

take care of a copy of the paper & print of Ichthyosaurus. for his father.' William Clift, 'Diary,' 1819 (Clift Papers, Archive of the Royal College of Surgeons).

89 See Angus Whitehead, '"I also beg Mr Blakes acceptance of my wearing apparel," The Will of Henry Banes, Landlord of 3 Fountain Court, Strand, the Last Residence of William and Catherine Blake,' *Blake/An Illustrated Quarterly* 39, no. 2 (Fall 2005): 78–99.

90 Clift, in his capacity as curator and cataloguer of the Hunterian Museum, was involved in a number of engraving projects during this period. See for example, *A Series of Engravings, Accompanied with Explanations, which are Intended to Illustrate the Morbid Anatomy of Some of the Most Important Parts of the Human Body.* London: W. Bulmer for J. Johnson, and G. and W. Nicol, 1803. 2° (318 × 244mm). The work included seventy-three engraved plates by William Skelton, James Basire, and James Heath, after watercolour drawings by William Clift.

91 See *BR2*, n398; G.T. Bettany and Michael Bevan, 'Thomas Chevalier,' *ODNB*. South Audley Street is southwest of South Molton Street, across Grosvenor Square.

92 Cumberland records that after the visit to Clift on 3 June 1820 there was a visit to 'Mr Woods [?]. To show Syd his great picture.' This may be a reference to the Bristol landscape artist W. Woods, an admirer of Blake and his work (see *BR2*, 722). The entry for 3 June concludes 'got dinner at the Coalhole + took Syd home for coffee – Lent him my telescope till I want it … that I bought from Rome' (BL Add MSS 36520 H f. 381). On the previous evening, Friday, 2 June, Cumberland records visiting the Coalhole, 'where I got my dinner … spring soup' (MSS 36520 H f. 379). In both entries Cumberland must be referring to the celebrated Coalhole tavern in Fountain Court, Strand, directly opposite William Blake's final residence at no. 3 Fountain Court.

93 *E* 780. See also Lane Robson and Joseph Viscomi, 'Blake's death,' *Blake/ An Illustrated Quarterly* 30, no. 2 (Fall 1996): 36–49. John Linnell recorded in his Ms. Autobiography, 'I was very intimate with … Mr Chevalier the surgeon.' Linnell, Ms. 'Autobiography' f. 43, Library of the Fitzwilliam Museum, Cambridge. William Clift refers to Thomas Chevalier's death in the Hunterian Museum diary for Wednesday 9 June 1824: 'Mr Professor Chevalier died at his house in South Audley Street, at four o'clock this morning after a few hours illness' (Clift, 'Diary').

94 Abernethy was also a member of the Court of Examiners at the Royal College of Surgeons. See L.S. Jacyna, 'John Abernethy,' *ODNB*. Clift's diary for Friday 14 July 1826 records, 'Midsummer Court New President Mr Abernethy.' Abernethy and Clift were both students of the surgeon John

Hunter, who appears to have been a neighbour of Rev. A.S. Mathew and his family. See Michael Phillips, ed., William Blake, *An Island in the Moon*, 9, 77. It is therefore possible that Blake and Cumberland's acquaintance with Abernethy (and possibly Clift) began during the 1780s.

95 Frances Austen, ed., 'William Home Clift,' *The Letters of William Home Clift, 1803–1832* (Sturminster Newton: Meldon House, 1983), 1.

96 See Phillip R. Sloan, 'William Clift,' *ODNB*.

97 See *E*, 454. Hunter had taught the Mathews' son, the surgeon William Henry Mathew (see *BR2*, n30).

98 Austen, ed., 'William Home Clift,' 1.

99 The museum moved to its new premises at Lincoln's Inn Fields around 1801. Clift and his family moved into the building specifically designed by George Dance to house the collection in 1811. See Jessie Dobson, *William Clift* (London: William Heinemann Medical Books, 1954), 48.

100 See Phillip R. Sloan, 'William Clift,' *ODNB*.

101 William Home Clift was officially appointed as assistant to his father in 1823.

102 Clift was made a fellow of the Royal Society in 1823. He was an intimate friend of Abernethy and was well acquainted with Blake's former master James Basire and his family. See Jessie Dobson, *William Clift*, 52, 55. On a visit to Paris in October–November 1819, Clift had met the geologist Georges Cuvier, a world authority on fossils, and founder of palaeontology. The meeting initiated a sustained correspondence concerning new fossil discoveries. See Dobson, *William Clift*, 54. On the same trip, on a visit to Père La Chaise cemetery, Clift had discovered and laid a wreath at the tomb of Blake's former neighbour at Hercules Buildings, Lambeth, the equestrian performer and impresario Philip Astley (see Dobson, *William Clift*, 55).

103 Austen, ed., 'William Home Clift,' 2.

104 Keynes, 'George Cumberland and William Blake,' 233.

105 See for example Francis Greenacre, 'Cumberland, George (1754–1848),' *ODNB*.

106 G.E. Bentley Jr, *A Bibliography of George Cumberland (1754–1848)* (New York and London: Garland, 1975), xxiii.

107 Hugh Torrens, 'Presidential Address: Mary Anning (1799–1847) of Lyme; "the greatest fossilist the world ever knew",' *British Journal of the History of Science* 28 (1995): 261.

108 See George Cumberland, *Reliquiae Conservatae from the Primitive Materials of our Present Globe, with popular descriptions of the prominent characters of some remarkable fossil encrinites* (Bristol: J.M. Gutch, 1826). George Cumberland Jr probably called on Clift over a year earlier, as in a letter dated

15 March 1819, his father informed him: 'Mr <u>Clift</u> is the name of the
gentm. At the College – you may go there any thursday at 2 o'clock hav-
ing my name – look over all the encrinites there. they don't value them or
understand them –' (BL Add MSS 36507 f. 67).

109 See William Conybeare and Henry de la Beche, 'Notice of the Discovery
of a new Fossil Animal, Forming a Link between the Ichthyosaurus and
Crocodile, Together with General Remarks on the Osteology of the Ich-
thyosaurus,' *Transactions of the Geological Society* 5 (1821): n560. Conybeare
and de la Beche had recently set up a museum in Bristol and had con-
nections with Cumberland and the circle of local collectors to which he
belonged.

110 Ivimy MSS. Cited *BR2*, 477.

111 *BR2*, n477. Blake may have viewed with bemusement an interest of Cum-
berland's that had in effect deprived him of a buyer of his works. Blake's
last commission appears to have been the card plate for Cumberland
(see *E* 784). Blake's excuse for not finishing the card is that he has 'been
reduced to a skeleton' (ibid).

112 However, as we have seen, evidence suggests that Cumberland was still
taking an active interest in the arts.

113 Clift, 'Diary,' 1820, 25. In fact Cumberland made contact with Clift three
days earlier. Cumberland's pocketbook entry for Friday 26 May 1820
includes 'called Clift at Surgeons Hall' (BL Add MSS 36520 H v. 373).

114 On Tuesday 9 May 1820 Clift recorded, 'The Museum opened for the
season on Tuesdays and Thursdays' (Clift, 'Diary,' 1820, 22).

115 On one of the first pages of Cumberland's 1820 pocketbook is a list,
presumably of tasks Cumberland wished to attend to on his visit to the
metropolis. Clift features in this list: 'Mr Clift' is written faintly in pencil
and scored through in brown ink. See BL Add MSS 36520 H f. 370.

116 Clift, 'Diary,' 1820, 25.

117 See Torrens, 'Presidential Address: Mary Anning,' 259–60.

118 See for example Sir Everard Home, 'Some Account of the Fossil Remains
of an Animal More Nearly Allied to Fishes Than Any of the Other Classes
of Animals' (read 23 June 1814), *Philosophical Transactions of the Royal Soci-
ety, London* 104 (1814): 571–7.

119 See C. Koenig, *Synopsis of the Contents of the Contents of the British Museum*,
11th ed. (London: [no publisher] 1817), 54.

120 See Everard Home, 'An Account of the Fossil Skeleton of the Proteo-
Saurus,' *Philosophical Transactions of the Royal Society of London* 109 (1819):
209–11; 'Reasons for Giving the Name Proteo-Saurus to the Fossil Skel-
eton Which Has Been Described,' *Philosophical Transactions of the Royal
Society of London* 109 (1819): 212–16.

121 See William Conybeare and Henry de la Beche, 'Notice of the Discovery of a New Fossil Animal, Forming a Link between the Ichthyosaurus and Crocodile, Together with General Remarks on the Osteology of the Ichthyosaurus,' *Transactions of the Geological Society* 5 (1821): 563–4. Ichthyosaurus is the name still used today. One of Mary Anning's ichthyosaurus specimens is on display at the Natural History Museum (my thanks to Noah Heringman for this information).

122 See entries in Clift's diaries for 29 May, 1 June, 9 June, 14 June, 27 June, and 6 July 1820.

123 Clift called on Cumberland, presumably in Buckingham Street, on Monday, 5 June 1820 as the latter recorded in his pocketbook, 'Mr Clift of the Surgeons College having called and requested [illeg.]' (BL Add MSS 36520 H f. 382).

124 Cumberland first refers to Mr Morgan of Clifton in his pocketbook in 1807 (see BL Add MSS 36519 G 323 v).

125 Cumberland, *Reliquiae Conservatae*, 55.

126 Ibid., n43. Note Cumberland's use of 'ichthyosaurus' six years after selling the 'proteosaurus' to Clift.

127 Morgan is almost certainly the author of the topographical poem *Long Ashton, a poem in two parts; descriptive of the local scenery of that village and its environs including St Vincent's rocks, Bristol & C...* (Bristol: R. Rosser, 1814).

128 See Conybeare and de la Beche, 'Notice of the Discovery of a New Fossil,' 580.

129 Clift, 'Diary,' Friday, 9 June 1820, 26; 'lot 102' refers to the auction of Colonel Birch's large fossil collection by William Bullock at Bullock's Egyptian Hall on 15 May 1820. See *A Collection of Small But very fine Collection of Organised fossils from the Blue Lias formation at Lyme and Charmouth ... the property of Colonel Birch, which will be sold by auction etc.* (London: W Smith, 1820). For information on Colonel Birch, see H.S. Torrens, 'Collections and Collectors of Note: 28 Colonel Birch (c. 1768–1829),' *Newsletter of the Geological Curators Group* 2 (1979): 405–12.

130 See E.D. Alexander, 'William Bullock: Little Remembered Museologist and Showman,' *Curator* 28: 117–47.

131 Ibid.

132 BL Add MSS 36520 D 209 v – 210 f. On the following page Cumberland drew the eye of the ichthyosaurus specimen in detail.

133 E. Home, 'Some Account of the Fossil Remains of an Animal More Nearly Allied to Fishes Than Any of the Other Classes of Animals' *Philosophical Transactions of the Royal Society London* 104 (1 January 1814): 571–7. Home published further papers on the same specimen in 1816, 1819, and 1820.

134 Bullock had auctioned the contents of his own museum here the previous year. See Torrens, 'Presidential Address: Mary Anning,' 266.

135 [William Bullock] *Catalogue … of the Roman Gallery, of Antiquities and Works of Art, and the London Museum of Natural History … at the Egyptian Hall in Piccadilly* (London, 1819), 63 (ninth day [7 May 1819], lot 100).

136 See Alexander, 'William Bullock: Little Remembered Museologist and Showman,' 128.

137 In his pocketbook Cumberland recorded that he had met Mary Anning in Lyme on 4 October 1819 evidently to view and purchase specimens from Mary Anning's stock: 'Mary Hanning is to send me the 2d head she found of the sea [illeg.] Pantocrenete – or palm [illeg.]' (see BL Add MSS 36520 G f. 350).

138 Clift, 'Diary,' 14 June 1820, 27.

139 Clift, 'Diary,' 27 June 1820, 29.

140 Home, 'Some Account of the Fossil Remains,' 571.

141 See for example 'To the Editor of the Monthly Magazine,' *Monthly Magazine* 40 (1 April 1815): 18–20; and 52 (1 November 1821): 301–5. For a full list of Cumberland's publications on geology and fossils, see Bentley, *A Bibliography of George Cumberland*, 63–72.

142 Cumberland, *Reliquiae Conservatae*, iv–v.

143 Noah Heringman, *Romantic Rocks; Aesthetic Geology* (Ithaca, New York: Cornell University Press, 2004), 100.

144 Ibid., 94.

145 Although Blake never explicitly refers to fossils, he does draw upon the image of the polypus in his later writings. Blake's polypus is not a crinoid, basically a sea urchin, stalked and rooted with a calyx like body. However, Blake may intend a 'cephalopod having eight or ten tentacles, as an octopus, squid, or cuttlefish' (*OED*). See Andrew Lincoln, *Spiritual History: A Reading of William Blake's 'Vala' or 'The Four Zoas'* (Oxford: Clarendon Press, 1995), 246–7.

146 Ruthven Todd, *Tracks in the Snow: Studies in English, Science and Art* (London: The Grey Walls, 1946), 16.

147 Heringman, *Romantic Rocks*, 96.

148 See ibid., 97; Robert N. Essick, *William Blake's Commercial Book Illustrations* (Oxford: Clarendon, 1991), 45–9. Blake would have already encountered contemporary geological theory in Erasmus Darwin's *Botanic Garden*, for which he engraved eleven plates for successive editions between 1791–1806. As Heringman demonstrates, Blake's response to geology was clearly different than Cumberland's (see Heringman, *Romantic Rocks*, 95–111, 130–47). Heringman's reading, coupled with a newly discovered

potential occasion for Blake and Cumberland to have discussed fossils, provides some potential context for Blake's references to rocks in his works. However, Heringman's discussion of Blake's responses to Cumberland's work on geology is not concerned with fossils.

149 George Cumberland, letter to the *Monthly Magazine* 52 (November 1821): 301.

150 Heringman, *Romantic Rocks*, 104.

151 George Cumberland, 'Some Account of the Order in which the Fossil Saurians were Discovered,' *Quarterly Journal of Literature, Science and the Arts* 27 (June 1829): 349.

152 Mentioned by Clift in his diary, Thursday 1 June 1820, 25.

153 See Alexander Gilchrist, *Life of William Blake* (London: Dent, 1945), 282.

154 However, see Angus Whitehead, 'Mark and Eleanor Martin, the Blakes' French Fellow Inhabitants at 7 South Molton Street, 1805–21,' *Blake/An Illustrated Quarterly* 43, no. 3 (Winter 2009/10): 84–95.

155 Ibid.

8 George Richmond, Blake's True Heir?

MARTIN BUTLIN

I sat down with Mr. Blake's Thornton's *Virgil* woodcuts before me, think-
ing to give to their merits my feeble testimony. I happened first to think
of their sentiment. They are visions of little dells, and nooks, and corners
of Paradise; models of the exquisitest pitch of intense poetry. I thought of
their light and shade, and looking upon them I found no word to describe
it. Intense depth, solemnity, and vivid brilliancy only coldly and partially
describe them. There is in all such a mystic and dreamy glimmer as pen-
etrates and kindles the inmost soul, and gives complete and unreserved
delight, unlike the gaudy daylight of this world. They are like all that
wonderful artist's works the drawing aside of the fleshly curtain, and the
glimpse which all the most holy, studious saints and sages have enjoyed,
of that rest which remaineth to the people of God. The figures of Mr. Blake
have that intense, soul-evidencing attitude and action, and that elastic,
nervous spring which belongs to uncaged immortal spirits ... Excess is the
essential vivifying spirit, vital spark, embalming spice ... of the finest art.
Be ever saying to yourself 'Labour after the excess of excellence.'

This famous account by Samuel Palmer of Blake's illustrations to Dr
R.J. Thornton's edition of 1818 of *The Pastorals of Virgil ... Adapted for
Scholars*[1] reflects the inspiration behind Blake's influence on the visual
arts well into the twentieth century, if not beyond.[2] This began with
the 'Ancients,' the group of young artists who gathered around Samuel
Palmer (1805–81) in Shoreham, Kent.[3] The main figures besides Palmer
were Edward Calvert (1799–1883) and George Richmond (1809–96).[4]
John Linnell (1792–1882) presided over the group in an avuncular role
and was to become Palmer's father-in-law. Their engravings, ink draw-
ings, and early paintings were widely admired, particularly from the

end of the nineteenth century, by such artists as F.L. Griggs (1876–1928), Paul Drury (1903–87), and Robin Tanner (1904–88). They were also influential on the early works of Paul Nash (1885–1946) and Graham Sutherland (1907–80). A further wave of influence is found in the works of a group of young artists associated with the patriotic revival of the visionary landscape during the Second World War, particularly John Minton (1907–57), Keith Vaughan (1912–77), Michael Ayrton (1921–75), and John Craxton (b. 1922). This influence has been traced still further in the work of the ruralists, including Peter Blake (b. 1932), Graham Inshaw (b. 1942), and Graham Ovenden (b. 1943), though here the stylistic, if not the inspirational, links are tenuous.

In fact the 'little dells and nooks, and corners of Paradise' of the Virgil illustrations are only a tiny part of Blake's achievement, though the visionary element is there throughout. Blake grew up with, and fully accepted, the neoclassical hierarchy of genres that placed the subject of a picture, biblical or historical, at the peak of artistic ambition: figurative subjects came at the top above landscapes, however redolent of classical times and however many figures might appear in them. (Blake also, of course, accepted the neoclassical insistence on clarity of form as opposed to the 'blurring demons' of the richer, more painterly technique of such artists as Rubens.) In contrast, although Palmer drew a number of figure subjects in his 1824 sketchbook, these did not form a central part of his finished work.[5] Figures take a more prominent position in Calvert's early prints, but again these works hardly qualify as subject paintings; in later life, in the words of his Ancient fellows, he reverted to 'paganism.'[6]

It was George Richmond, the youngest of the group, who approached closest to Blake's central figurative style and subject matter. Indeed, it may well be that, being the youngest and most receptive, he came closer to the essentials of Blake's art. Alone of the group he was prepared to argue with Blake. As Palmer's son A.H. Palmer records, 'no one could imagine Palmer arguing with Blake as Richmond did.'[7] Alexander Gilchrist describes how 'Just as Mr. Palmer speaks of Blake's tolerant kindness towards young men, Mr. Richmond relates that, in their intercourse, he would himself, as young men are prone to do, boldly argue and disagree, as though they were equals in years and wisdom, and Blake would take it all good-humouredly.'[8] Later, arriving just after he died on 12 April 1827, it was Richmond who closed Blake's eyes, 'to keep the vision in,' as Richmond's grandson Sir Arthur Richmond, told Ruthven Todd,[9] and it was Richmond who wrote to Palmer, away

at the time, informing him of Blake's death: 'He died on Sunday Night at 6 Oclock in a most glorious manner. He said He was going to the Country he all His life wished to see & expressed Himself Happy hoping for Salvation through Jesus Christ – Just before he died His Countenance became fair – His eyes brighten'd and He burst out in Singing of the things he saw in Heaven.'[10] In addition Richmond, alone of the Ancients, was one of the six mourners at Mrs Blake's funeral on 23 October 1831.[11] Years later he was still able to draw a plan of Blake's last home at 3 Fountain Court,[12] and it is to George Richmond's memory that we owe Mrs Blake's saying, 'You see, Mr. Blake's skin don't dirt.'[13]

Richmond first met Blake in 1825 at the age of 16, when he was taken by John Linnell to see the architect Charles Heathcote Tatham, the father of Richmond's later brother-in-law Frederick Tatham, who himself was to look after Mrs Blake and act as her de facto executor and heir. Blake had already met father and son through John Linnell, who had become the chief patron of his late years.[14] After his first meeting Richmond walked home with Blake: it was 'as if he were walking with the Prophet Isaiah.'[15] Exactly when and how Richmond had become one of the Ancients is not clear, but it was probably as a student of the Royal Academy Schools which he entered in December 1824; his first exhibit there, *Abel the Shepherd* (plate 9, this volume), occurred the next summer.

Soon after their first meeting Blake helped Richmond with this painting. A page removed from a sketchbook and now in the Fitzwilliam Museum, Cambridge, with drawings by Richmond on the back, shows the torso of the figure of Abel and is inscribed by Richmond 'drawn by Wm Blake – to help me in my picture of "Abel" 1825' and by Samuel Palmer, 'Drawn by Mr Blake, August 4th 1825' (fig. 8.1).[16] What may be the same drawing, or a further lost drawing, was mentioned by Anne Gilchrist who described *Abel the Shepherd* as a 'gesso watercolour, worked in Blake's favourite "fresco" medium'; she goes on, 'It was Richmond's first picture; one that was submitted to Blake, who made a careful correction-drawing on the shepherd's arm in his pupils sketch-book.'[17]

The page in the Fitzwilliam Museum is bound together with two other pages. One bears sketches of 'A Portrait from memory of Fuseli by Mr B' and another 'Drawn by Mr Blake to shew me how … what Fuselli's [sic] mouth was when a young man.' The verso bears another drawing by Blake together with a drapery study by Samuel Palmer. A further drawing by Richmond is stuck onto the recto. The third page

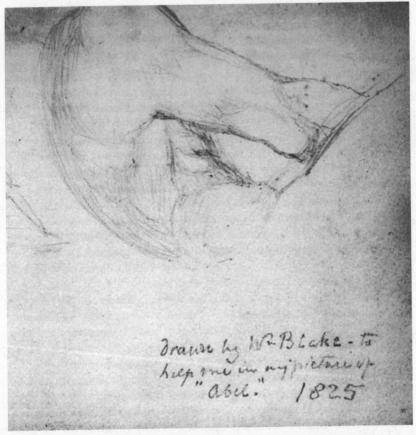

8.1 William Blake, study for George Richmond's, *Abel the Shepherd*, 1825,
4³/₁₆ × 7³/₈ in (10.7 × 18.7 cm), detail. Cambridge, Fitzwilliam Museum.

bears drawings by Samuel Palmer. Onto this have been stuck two piec-
es of paper bearing portraits by Richmond inscribed 'GR W. Blake from
recollection after his death 1827' and 'GR Henry Fuselli, from recol-
lection after death' (Fuseli had died in 1825). The initials are in Rich-
mond's hand but the rest of the inscription is by Samuel Palmer, the
head of Fuseli having itself been drawn over figure studies by Palmer.
Such was the close interaction between these artists.[18]

Another drawing, in Tate Britain, shows a rather awkward variant of
the figure of Abel, here fettered to the ground. It is inscribed by Rich-

mond, 'Drawn by W. Blake. GR' but is clearly by Richmond, not Blake.[19] The inscription was probably added by Richmond later in his life (similar inscriptions are found on a number of his drawings, sometimes with alternative dates, as if annotated from memory when Richmond was going through his portfolios in old age).[20] This drawing may also reflect Blake's advice to Richmond.

It is important to remember that Richmond's contacts with Blake occurred late in the latter's life and career, when Blake's style had become, on the whole, sweeter and more graceful than that of his earlier work. Blake's earlier works for such patrons as Thomas Butts and the Reverend Joseph Thomas do not seem to have been known to the Ancients. Palmer wrote that 'Dear Mr. Blake promised to take me himself to see Mr. Butts' collection - but alas! It never came off.'[21] Richmond's early tempera paintings are therefore, as Anne Gilchrist suggests, close to the late tempera paintings by Blake, both in composition and technique, although the rounded hill crowned by a crescent moon in the background of *Abel the Shepherd* is indebted still more to the early works of Samuel Palmer.

Blake's tempera technique had taken a great change for the better in the early 1820s, preceded by the Arlington Court picture ('The Sea of Time and Space') of 1821 (Butlin Plate 969, Cat 803) which employs the same technique except that the ground is laid over paper rather than over the mahogany panels of *Count Ugolino and his Sons in Prison, The Body of Abel found by Adam and Eve*, and *Satan smiting Job with Sore Boils* (Butlin Plate 972, Cat 807).[22] These three last works have always been dated to about 1826 but, in view of the dependence of Richmond's technique on that of Blake in these works, are perhaps slightly earlier. They were mentioned in a letter by Blake to John Linnell of 25 April 1827 as follows: 'As to Ugolino, &c, I never supposed that I should sell them; ... I am too much attach'd to Dante to think much of anything else'; the reference to Dante is to the series of watercolour illustrations begun in 1824 but left incomplete at Blake's death. The white gesso ground common to these works contributes to the stability of their technique and to their light tonality, as compared to Blake's earlier temperas. Richmond's *Abel the Shepherd, The Creation of Light*, 1826 (plate 10, this volume) and *Christ and the Woman of Samaria*, 1830, and also Samuel Palmer's *Coming from Evening Church*, 1830 (all in Tate Britain) follow Blake's technique in their use of wooden supports, thinner primings and paint layers, chalk-based grounds, use of animal glue beneath the resin varnishes and to seal the grounds (and in Richmond's case in the actual paint as

well), and the occasional use of shell-gold for special effects.[23] Blake's intervention was not, however, by example only: in March 1825, as mentioned, he copied out chapter 6 from the 1821 edition of Cennini's *Il Libro dell'Arte* (entitled here 'Trattato dello Pittura' and given to Blake that year by John Linnell) into Richmond's sketchbook. In 1828 Palmer passed on to Richmond the recipe for 'Blake's White.'[24]

Significantly, Richmond actually owned Blake's tempera painting of *Satan smiting Job with Sore Boils*, though it is not known when he acquired it; the inscription on the back by Frederick Locker, who lent the picture to the great Blake exhibition at the Burlington Fine Arts Club in 1876, recalls that 'this drawing by Blake belonged to George Richmond R.A. Frederick Locker.' Richmond also owned a set of the Job engravings, odd pages from the illuminated books, and a number of drawings, many of which bear inscriptions by his brother-in-law Frederick Tatham. (Later, in the 1870s, Palmer gave Richmond the earlier tempera of *The Bard* and Richmond restored Blake's *Spiritual Form of Pitt Guiding Behemoth* in Palmer's studio. Palmer also owned *Satan calling up his Legions* [second version] and the mysterious *Spiritual Form of Napoleon* [now lost, Butlin Cat 652]. All but the last of these works had been exhibited by Blake in his exhibition in 1809.)

Richmond's early temperas resemble Blake's later works, not only in technique but also in style. After the Palmeresque landscape of *Abel the Shepherd*, that of *Christ and the Woman of Samaria* reverts to Blake's example, with buildings almost engulfed among rolling hills as in, for instance, *Satan smiting Job with Sore Boils*, while the engraving of *The Shepherd*, 1827 (fig. 8.2), places the sheep from Blake's Job series against the same rolling hills and a Palmeresque cottage, tucked away among the hills on the left.

The elegant figures in *The Shepherd* and the even more exquisite drawing of *The Sower*, 1830,[25] like that in *The Creation of Light*, recall those in many of Blake's later works, such as *Mirth* (Butlin Plate 1040, Cat 705), and the Dante series, such as *Dante and Virgil penetrating the Forest*, 1824–7 (Butlin Cat 812/2) and *Beatrice addressing Dante from the Car* (Tate Britain).

Another probable source in Blake's work is the unfinished series of watercolour illustrations to Bunyan's *Pilgrim's Progress*, the one such series of illustrations to a poet of the past that remained in the possession of Blake at the time of his death, passing to Mrs Blake and from her to Frederick Tatham and therefore available for Richmond to examine.[26] The figure in *Christian passes the Lions* is particularly close to that

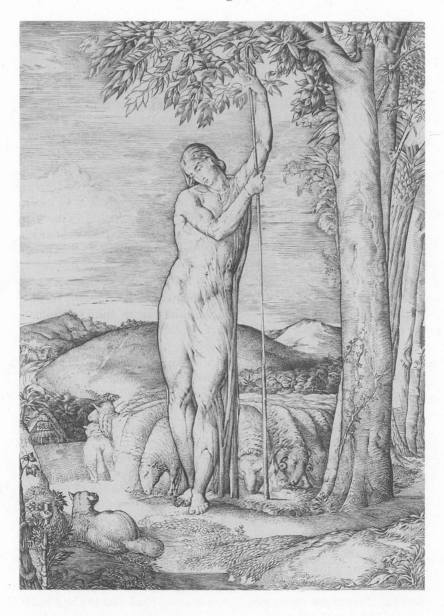

8.2 George Richmond, *The Shepherd*, 1827, 6 × 4¾ in (15.3 × 11.2 cm). London, Tate Britain

in Richmond's *Creation of Light*. Some of Richmond's chunkier figures such as that of *Samson carrying the Gates of Gaza*, 1827,[27] are also close to figures in the *Pilgrim's Progress* series, for instance, the two figures of Giant Despair.[28]

It is also tempting to see, in some of the exquisite elongated figures drawn by the young George Richmond, the influence of Michelangelo's late highly finished drawings. In the 1820s several of these were already in the Royal Collection and in that of Sir Thomas Lawrence. This is not withstanding the fact that, when he was in Rome in the late 1830s, Richmond was to write 'The more I see of those who copy M A the more steadily convinced I feel that he of all men in art will least adorn an imitation … M.A. thoughts can only be well read in his own language and it is the perfect harmony between the thoughts and the expression of it that enables to first bear and then to admire the labours of the mighty man'; this was written after Richmond had spent many hours studying the ceiling of the Sistine Chapel including a closer view from the cornice.[29]

Although Richmond had probably not seen the works by William Blake in the Butts collection it is noticeable how, with only one possible exception, he seems to have avoided the Biblical subjects painted by Blake, particularly those for his two great series in tempera and water-colour. Blake painted finished versions of *The Body of Abel found by Adam and Eve*, one for his 1809 exhibition, one in the group of late temperas; Richmond chose to depict the more pastoral *Abel the Shepherd*. Blake painted many subjects from the life and the mission of Christ, but not *Christ and the Woman of Samaria*. Richmond also painted *Isaac going forth to meditate at the Eventide*, circa 1828, and did drawings of *Hagar in the Wilderness* and *Hagar lamenting* in 1829, subjects untreated by Blake.[30] In the case of *The Creation of Light*, there is however a lost work by Blake.[31] Perhaps Richmond saw himself in some way as following on and adding to Blake's series.

The *Creation of Light* is Richmond's masterpiece in its summation of his approach to Blake's visionary inspiration. The wonderful air-bound, soaring figure of God the Father, a distillation of late Blake and, perhaps, Michelangelo, is set against a magnificent depiction of the division of the darkness of the originally unilluminated universe and the light of the rising sun; the gesture of God's right hand as He creates this vision dominates the composition. In technique and finish, the work is perfection. Some of this inspiration remains in the less

ambitious, more graceful works of the following years like *The Shepherd*, 1827, the *Eve of Separation*, 1830, and *The Shepherd* of 1830. Richmond's later work was never less than highly accomplished as in his well-characterized portraits, both in oils and in his characteristic chalk medium, in the Mulready-like sensitivity of his *Woman and two Children* of 1834, his Old Masterly subject pictures, and his sensitive landscapes.[32] But, as Laurence Binyon summed it up, 'Of all the works produced by the youthful "Ancients", none partakes so immediately of Blake's peculiar inspiration, none is so near to him in technical character, in design and in colour, as the tempera picture *The Creation of Light*, painted by George Richmond in 1826, when he was 17 years old.'[33]

NOTES

It is perhaps appropriate that, in a work dedicated to G.E. Bentley Jr, the factual side of this essay is taken almost exclusively from his various publications; in most cases references are to these rather than to his own original sources.

1 A.H. Palmer, *The Life and Letters of Samuel Palmer, Painter and Etcher* (London: Seeley, 1892), 15–16; reprinted in part in Bentley, *The Stranger from Paradise* (New Haven: Yale University Press, 2001), 392.
2 The most recent accounts of this are to be found in Simon Martin, Martin Butlin, and Robert Meyrick, *Poets in the Landscape: The Romantic Spirit in British Art*, exhibition catalogue, Chichester, Pallant House, March–June 2007; and Jerrold Northrop Moore, *The Green Fuse: Pastoral Vision in English Art 1820–2000* (Woodbridge, Suffolk: Antique Collectors' Club, 2007).
3 For Palmer see note 1. Also, in particular, Geoffrey Grigson, *Samuel Palmer, the Visionary Years* (London: K. Paul, 1947; and William Vaughan, Elizabeth E. Barker, and Colin Harrison, *Samuel Palmer 1805–1881: Vision and Landscape*, exhibition catalogue, London, British Museum, and New York, Metropolitan Museum, October 2005–May 2006.
4 For Calvert see *A Memoir of Samuel Calvert by his Third Son* [Samuel Calvert] (London: Sampson Low , 1893); and Raymond Lister, *Edward Calvert* (London: G. Bell, 1962); and for Richmond, Raymond Lister, *George Richmond, a Critical Biography* (London: Robin Garton, 1981). Unfortunately what should be the equivalent of the nineteenth-century filial publications on Palmer and Calvert, A.M.V. Stirling's *The Richmond Papers* (London and

New York: William Heinemann, 1926), lacks discipline and concentrates more on Richmond's son, Sir William Blake Richmond; see Bentley, *Blake Records* (Oxford: Clarendon, 1969), n403. Hereafter *BR*.

5 Martin Butlin, *Samuel Palmer: The Sketchbook of 1824*, 2nd ed. (London: Thames and Hudson, 2003, 2005).

6 Lister, *Edward Calvert*, 4, 33—5, and 43.

7 A.H. Palmer, *Exhibition of Drawings, Etchings and Woodcuts by Samuel Palmer and Other Disciples of William Blake*, exhibition catalogue (London: Victoria and Albert Museum, 1926), 4; *BR*, 403; Bentley, *The Stranger*, 408.

8 Alexander Gilchrist, *Life of William Blake, 'Pictor Ignotus'* (London: Macmillan, 1863), vol. 1, 297–8; *BR*, 403–4; Bentley, *The Stranger*, 402–8.

9 *BR*, n459; Bentley, *The Stranger*, n437.

10 *BR*, 459, 464, and 547; Bentley, *The Stranger*, 437–8, and 445.

11 *BR*, 547; Bentley, *The Stranger*, 445.

12 *BR*, 753.

13 Ibid., 404.

14 *BR*, 378; Bentley, *The Stranger*, 402.

15 *BR*, 403; Bentley, *The Stranger*, 402.

16 Butlin, *Samuel Palmer*, 547, no. 802 1, plate 1044.

17 Ibid.

18 Butlin, *Samuel Palmer*, 547–8, no. 802 2, plates 1045–6; Geoffrey Keynes, *The Complete Portraiture of William and Catherine Blake* (London: Courier Dover, 1979), 142–3, plate 37; *BR*, 410–11. The drawing of *A Vision of Hercules* recorded by Butlin as no. 802A is in a sketchbook that now belongs to the Rosenbach Museum and Library, Philadelphia, page 26 verso. The sketchbook, which contains dates ranging from 14 January 1824 up to 31 January 1826, also contains the transcription of chapter six of Cennini's *Trattato della Pitture* made by Blake for Richmond and three sketches of *The Creation of Light*, one being the first idea for the figure in the finished painting of 1826. In view of the closeness and size of the pages (4³⁄₁₆ × 7⅜ in / 10.7 × 18.8 cm for the Cambridge drawings and 4⅜ × 7¼ in (11.25 × 18.5 cm) for those in Philadelphia) it is tempting to see the three pages in Cambridge as having been detached from the sketchbook now in Philadelphia. I am indebted to my friend and former colleague Robin Hamlyn for information derived from his inspection of the Rosenbach sketchbook.

19 Martin Butlin, *Tate Gallery Catalogues: William Blake 1757–1827* (London: Tate, 1990), 247, no. 170, illus.; *BR*, 410.

20 *The Tate Gallery 1976–8: Illustrated Catalogue of Acquisitions* (London: Tate, 1976–9), 13–14; this, like the entry for the study for *Christ and the Woman of*

Samaria, is probably the fullest account of any individual work by George Richmond.

21 *BR*, 410.

22 Butlin, *Samuel Palmer*, 549–52, plates 969–72; Joyce Townsend, ed., Robin Hamlyn, consultant ed., *William Blake, The Painter at Work* (London: Tate, 2003), 129–33. The fireplace decorations for the Reverend John Johnson, Butlin, *Samuel Palmer*, 552–3, nos. 808–10, here dated to the early 1820s, are almost certainly from much earlier, circa 1803 (see Angus Whitehead, '"this extraordinary performance": William Blake's Use of Gold and Silver in the Creation of His Paintings and Illuminated Books,' *Blake/An Illustrated Quarterly* 42, no. 3 (2008/9): 85–7.

23 J.H. Townsend, *William Blake, The Painter at Work*, 144–8, the four paintings, figs. 121–3, together with an infra-red photograph of *Christ and the Woman of Samaria*, fig. 124.

24 Ibid., 37 and 118.

25 Lister, *Edward Calvert*, plate 5, fig. 13.

26 Butlin, *Samuel Palmer*, 599–605, no. 829, plates 1093–120; Gerda S. Norvig, *Dark Figures in the Desired Country; Blake's Illustrations to the Pilgrim's Progress* (Berkeley: University of California Press, 1993). This, however, fails to allow fully for the fact that the series was left unfinished by Blake and that most of the watercolours were completed by his widow.

27 Lister, *Edward Calvert*, plate 7, fig. 18.

28 For those examples recorded as having been in the Collection of George III, see A.E. Popham and Johannes Wilde, *The Italian Drawings of the XV and XVI Centuries in the Collection of His Majesty the King at Windsor Castle* (London: Phaidon Press, 1949), 11–14, 251–3, nos. 427–9, plates 21–2, 25; and for examples from the collection of Sir Thomas Lawrence, now in the British Museum, see Johannes Wilde, *Italian Drawings in the Department of Prints and Drawings in the British Museum; Michaelangelo and His Studio* (London: Trustees of the British Museum, 1953), 25–7, 87–91, nos. 13, 52, 54, plates 24, 80, and frontispiece, 83; these last are also included and illus. in Hugo Chapman, *Michaelangelo Drawings: Closer to the Master*, exhibition catalogue, Haarlem, Teyler Museum, and London, British Museum, October 2005–June 2006, pages 139–221, 218, nos. 29, 78, and 76 respectively.

29 Lister, *Edward Calvert*, 37–8.

30 Ibid., 131–2, 134–5, figs. 25, 11, and 12 respectively.

31 For Blake's lost *Creation of Light*, see Butlin, *Samuel Palmer*, 326, no. 433. Although sold as just 'The Creation' in 1853 it had already appeared at Sotheby's the year before, on 26 June 1852, as 'Creation of Light'; see Joseph Viscomi, 'Blake in the Marketplace 1852: Thomas Butts, Jr. and

Other Unknown Nineteenth-Century Blake Collectors,' *Blake/An Illustrated Quarterly* 29, no. 2 (1995): 65, relevant page of catalogue: illus. 54.

32 For an overview of Richmond's career see illustrations in Lister, *Edward Calvert*.

33 Laurence Binyon, *The Followers of William Blake* (London and New York: Halton & Truscott Smith, 1925), 19.

PART THREE

'What I Both See And Hear': Architecture and Industry

9 William Blake and Chichester

MORTON D. PALEY

Scholars agree that the city of Chichester, which John Keats first visited
for about four days in January 1818, deeply affected Keats's imagina-
tion. In *The Eve of St. Mark*, Walter Jackson Bate declares, 'He is obvious-
ly thinking of Chichester' and Aileen Ward remarks on the effect on *The
Eve of St. Agnes* of 'A prosperous city of graceful Georgian houses ... full
of reminders of its medieval past – the old walls which still enclosed the
town, the eight-sided Gothic cross which marked the central square,
the ancient buildings which lined the cobblestoned streets around the
twelfth-century cathedral.'[1] Curiously, no such claim is made for Chich-
ester's effect on William Blake, although Blake spent three years of his
life (September 1800–September 1803) in West Sussex, in the village of
Felpham, about six miles away from the cathedral city. Studies of this
period of Blake's life have instead tended to focus on Blake's troubles
with his patron, William Hayley, and on his trial for sedition. Indeed,
despite an important suggestion by Thomas Wright in 1929, contem-
porary Blake scholarship makes it seem as if Chichester made no sig-
nificant impression on Blake at all.[2] It is time to reconsider the role of
Chichester in Blake's life, both material and imaginative.

A little over a month after the Blakes moved to their new home in
Felpham, Blake wrote to his friend Thomas Butts: 'Chichester is a very
handsom City Seven miles from us we can get most Conveniences
there.'[3] Chichester in 1800 was recorded as having 4,684 inhabitants, of
whom some 450 were eligible to vote for the two representatives it sent
to Parliament.[4] It had a theatre, built for the purpose in 1791, a Library
Society, founded in 1792,[5] and an orchestra directed by Hayley's friend
the composer and musician John Marsh. A coach left for London eve-
ry Monday, Wednesday, and Friday and arrived from London every

Tuesday, Thursday, and Saturday.[6] Markets were held every Wednesday and Saturday and were 'plentifully supplied from the country for many miles round, with all kinds of provision, especially fish of various kinds.'[7] There were also fairs five times a year. Blake at times had the use of a pony named Bruno that had belonged to Hayley's late son Thomas Alphonso and had then been passed on to Hayley's friend Harriet Poole, and in a later satirical poem Blake wrote 'Felpham Billy [Hayley] rode out every morn / Horseback with Death [Blake] over the fields of corn.'[8] So although the Blakes did not own a horse, Blake had ample opportunity to borrow a mount for trips to the neighbouring city's markets. Starting in August 1801 he had an additional reason to go to Chichester for professional reasons.[9]

The printer and publisher Joseph Seagrave, who produced the letterpress of William Hayley's Designs [by Blake] to a Series of Ballads (1802) as well as Hayley's Life and Posthumous Writings of William Cowper, Esqr. (1803–4), illustrated with six of Blake's engravings, lived and worked in Chichester. Seagrave had been apprenticed as a young man to William Andrews, the first important Chichester printer, and after Andrews's death in 1788 Seagrave had succeeded him.[10] In connection with both projects, Blake would have made periodic visits to Seagrave, whose house at 21 East Street had additional significance as the birthplace of William Collins.[11] Seagrave had a speech impediment and evidently was not a tough supervisor, for Hayley wrote to John Johnson on 6 August 1801: 'My good Seagrave is very alert himself; but his pressmen sometimes get drunk, and vex him sadly; not to the improvement, I imagine, of his elocution.'[12] He also suffered what Hayley called 'excesses of morbid sensibility, which disquieted his life and yet endeared him to his intimate friends.'[13]

There was much beyond business to link Blake and Seagrave. Blake knew all too well what depression was. Seagrave was unconventional enough to live with a woman, Mary Shepherd, to whom he was not married, and of whom he said in a document left to be read after his death, 'nothing but a rooted aversion to matrimony prevented me from making her my wife.'[14] His warm-heartedness and generosity were to be demonstrated when he put up £50 toward Blake's bail after Blake was charged with sedition in August 1803. Seagrave also subscribed to Blair's Grave in December 1805,[15] perhaps thinking that Blake could benefit from the project. He also allowed Blake to run up a bill, probably for the 1802 Ballads, that he must have known would not soon be paid. On 11 December 1805 Blake wrote to Hayley: 'Present also my

Thanks to the Generous Seagrave. In whose Debt I have been too long but percieve that I shall be able to settle with him soon' (*E* 767). Blake vigorously defended Seagrave as a printer when Richard Phillips, co-publisher of the 1805 Hayley *Ballads* illustrated by Blake, 'Proceeded to find fault with the Printing of our friend the Chichester Printer.' Phillips wished a London printer to do the job. 'Here I considerd it my duty to interfere,' wrote Blake to Hayley. 'I expressd my own respect for our Good Seagrave & said I knew your chief intentions in Employing him were 1st to Encourage a Worthy Man & 2d For the Honour of Chichester' (19 January 1805, *E* 761). Blake was closer to being right than was Phillips, whose view was, characteristically, self-interested.

Three acquaintances Blake made through Hayley were John Marsh, Richard Dally, and 'Mr. Weller.' Marsh, composer and musician, was father of the Oxford student Edward Garrard Marsh (the 'Bard of Oxford' in Blake's *Jerusalem*). Marsh noted in his diary entry of 5 April 1802 that he intended to give Blake a kitten from the new litter of his white cat.[16] Dally was the Chichester lawyer who assisted in Blake's case in 1803–4, and about whose dilatoriness in acknowledging a payment well after the trial Blake expressed anxiety to Hayley in a letter of 2 April 1804 (*E* 746). Blake evidently kept abreast of Dally about non-legal matters for at least a short time after that, for on 28 May 1804, in urging Seagrave's superiority to Johnson as a printer, he wrote: 'I need only refer to the little job which Mr. Johnson was to get done for our friend Dally. He promised it in a fortnight, and it is now three months and is not yet completed' (*E* 751). John Marsh had met Dally in 1787 and characterized him as 'Mr Dally a young quaker, clerk to Mr Fowler the attorney'; either Marsh was mistaken as to Dally's religious affiliation or it changed later in his life, for in 1833 he was, according to his letter in *The Friend: A Religious and Literary Journal*, 'a Unitarian Christian.'[17] Dally also wrote a book entitled *The Chichester Guide, Containing the History and Antiquities of the City*.[18]

Blake's relationship with Weller was evidently more personal, for in 1805 Blake gave Weller a copy of the newly printed *Ballads*, inscribed 'Mr. Weller, / With grateful remembranc[e] / from William Blake' (*BR* 204).[19] Up to now, 'Mr. Weller' has not been identified. He was John Weller, a cabinetmaker and auctioneer, chiefly of property.[20] A neighbour of Seagrave, he lived at 92 East Street, a considerable Tudor house originally purchased by his father, a joiner, in 1750. Weller was also an accomplished wood carver, and Hayley obtained 'a nice large lump of the Yardley Oak' which he enlisted Weller to make 'into nice little boxes,

for the toilette of the fair.'[21] The two may have known each other for a long time, if Weller was the 'very clever artist of Chichester' who, Hayley wrote, had once made an exercise device called 'a chamber horse' for his late wife Eliza, from whom he separated in 1789.[22] It would be interesting to know why Blake was grateful to him.

Three Chichester residents whom Blake never met in the social sense of the word were nevertheless to affect his life. When Blake travelled from Felpham to Chichester, his way to the east gate lay through a suburb called for unknown reasons the Hornet (or the Harnet). Although Blake did not know it then, he was passing land owned by a man named John Peachey.[23] Peachey, who was to sit as a magistrate at Blake's trials at Petworth in 1803 and at Chichester in 1804, was also the proprietor of large estates outside the city, some very long established, going back to a time when the family name was Peché. He was a trustee of the free school for boys founded by Oliver Whitby in 1702. Another school trustee was William Brereton, who would sit as a justice of the peace at Blake's 1803 trial. Brereton, who lived in The Pallant, owned extensive land in southeast Chichester and in the nearby parishes of Hunston, Pagham, and Mundham as well. With John Quantock, who had taken down the evidence of Blake's accuser and had afterwards sat at both trials, Peachey and Brereton appear in *Jerusalem* among the Giant Sons of Albion, 'seeking for rest and finding none: / Raging against their Human natures' (19: 22–3, E 164). Although each of the twelve Sons is assigned parts of Britain, it seems appropriate that two of them were in fact large property holders, albeit not quite on the scale Blake assigns: 'Peachey had North Wales Shropshire Cheshire & the Isle of Man / … Brertun had Yorkshire Durham Westmoreland' (71: 30, E 225).

In the course of his trips to Chichester, Blake would have had ample time to visit its great cathedral, to walk its streets, and to observe its historical features, including its unusual city plan (plate 11, this volume). From the map of Chichester and from the verbal overview of Hayley's friend Alexander Hay, we can immediately see why its configuration would have appealed to Blake's imagination:

> The scite [sic] of Chichester is a gentle elevation, of which the cross is
> nearly in the center. The Lavant forming here a semi-circle, encompasses
> it on the east side, the whole of the south, and the greatest part of the
> west. From the cross proceed four streets at right angles, whose direction
> is towards the four cardinal points of the compass from which each of
> them is named.[24]

In his *Life of William Blake* of 1929, Thomas Wright apprehended this as the original model for Blake's city of the imagination, Golgonooza, an insight of great importance.[25] Unfortunately, Wright then proceeded unconvincingly to identify various places and persons in and near the city with specific symbolic locations and entities in Blake's long poems. Perhaps this is what caused scholars to ignore Wright's initial perception that, although Blake elaborated the description of Golgonooza after he moved back to London, the foundations of his four-gated city lay in Chichester.[26]

Chichester as a whole follows the layout of the Roman city. Its medieval walls incorporate materials from the Roman walls and from those of the succeeding Saxons. This physical merging and continuity parallels the human blending that Los sees toward the end of *Jerusalem*, when he cries: 'What do I see? The Briton Saxon Roman Norman amalgamating / In my Furnaces into One Nation the English' (92: 1–2, *E* 252). Another distinctive feature is the Pallant. Occupying the southeast quarter of the city, it is a neighbourhood of mostly Georgian houses, the best known being Pallant House (now an art museum), which because of the ostriches on its gate posts became known as Dodo House. The most remarkable aspect of the Pallant is that its plan is the city's in miniature: four main streets, named for the cardinal points, meeting at the centre, where a cross once stood. This kind of microcosm/macrocosm relationship fascinated Blake, as in 'The Crystal Cabinet,' where:

Another England there I saw
Another London with its Tower
Another Thames & other Hills
And another pleasant Surrey Bower (*E* 488)

In *Jerusalem* 13: 20, 'every part of the City is fourfold'; the Pallant, one-quarter of Chichester, topographically mirrors the whole.

The three most important structures in Chichester as far as this discussion is concerned are the market cross, the cathedral, and (unfortunately for Blake) the guildhall. The market cross, pictured on page two of Hay's *Chichester Guide*, is at the centre of the city, and this is where the Blakes would have obtained 'Conveniences,' as markets were held there until 1807. Blake would surely have enjoyed experiencing the integration of old architecture with ordinary life. Erected circa 1500, this octagonal building has eight flying buttresses supporting a cupola with ribbed vaulting. Each side is made up of four arches under an

ogee-arched hood. 'Formerly,' wrote Hay, 'a person might have stood at the cross, and had a perfect view of the four gates,'[27] but the gates had been taken down in the previous century, and the view to the north blocked by buildings.

A few steps from the market cross is the cathedral, the only one in Britain whose tower is visible from the sea. Blake pictured it three times. First was probably the pencil drawing known as *Landscape with a Spire*, in which the cathedral is seen dimly among trees.[28] Next, in the first instalment of the 1802 *Ballads*, below Hayley's dedication of the poems 'to the INHABITANTS OF CHICHESTER' is a tailpiece (fig. 9.1) showing the cathedral still in shadow as the first rays of dawn appear over the sea in a beautiful effect of radiating light similar to that in Blake's 1810 engraving *Chaucers Canterbury Pilgrims*. Much later, Blake returned to the cathedral in one of his Thornton's *Virgil* wood engravings, where, against a dark background in which the town and cathedral spire glow white (fig. 9.2), a traveller passes a marker inscribed 'LXII miles London' (Chichester was sixty-two miles from London, and Blake was sixty-two years of age at that time).[29] Chichester was indeed a bright spot in Blake's memory of the three years he spent in Sussex.

Some of the art in the cathedral could hardly have failed to impress Blake.[30] The thirty-eight carved wood misericords (c. 1330) are executed with astonishing freedom and vitality. Two that stand out for their sheer imaginativeness are no. 7, which represents a female dancer bending back to be kissed by a musician, and no. 28, showing a monster holding a serpentine form in its claws.[31] The entire group is populated with grotesque heads, animals (fox, ape, serpent), legendary creatures (centaur, winged serpent, amphisbaenic snake, wyvern, satyr), and some monsters so wildly conceived that no names can be given them. Anne K. Mellor has suggested that in *The Four Zoas* manuscript some of the grotesque drawings, which Blake may well have made in Felpham, are similar to other Chichester misericord carvings.[32]

We know of Blake's love of the Westminster Abbey tombs that he drew and engraved as an apprentice some thirty years before. There were similar tombs in Chichester Cathedral, and these would have been fresh in Blake's mind when he illustrated Robert Blair's *The Grave* in 1805. It has, for example, been suggested that Blake's fourth *Grave* design, *The Counseller, King, Warrior, Mother and Child, in the Tomb*, may reflect Blake's observation of tombs such as that of Richard Fitzalan, Earl of Arundel.[33] Architecturally, the prominence of ogee arches is remarkable. 'In Chichester cathedral,' writes Francis Bond, 'the ogee

Published June 1802 by W Blake Felpham

9.1 William Blake: View of Chichester with the cathedral. Engraving. Tailpiece to William Hayley's preface to *Designs to a Series of Ballads* (Chichester, 1802). Henry E. Huntington Library

Figure 9.2 William Blake: Illustrations to Thornton's *Virgil*. W4d. 'Colinet.'
Wood engraving. c. 1820. © Trustees of the British Museum; Department of
Prints and Drawings

motive is supreme. There are no more pointed arches; every arch is an
ogee; and the tracing consists of wavy tracery surmounted by a bat-
tlement. The cusping of the upper ogee arches is compound; the foli-
age of pronounced bulbous character.'[34] Another striking feature is the
Arundel Screen, with its three ogee arches and its wealth of boss carv-
ings showing faces of human beings and animals. Blake's use of the
ogee arch as a design form in his own art becomes more pronounced
after 1800, as in the angelic wings in *Christ in the Sepulchre, Guarded by
Angels* (c. 1805)[35] and in the two versions of the *Paradise Lost* subject
The Archangel Raphael with Adam and Eve (1807 and 1808).[36] This great
building, which *The Buildings of England* calls 'the most typical English
cathedral,'[37] must have deepened Blake's valuation of medieval art and
architecture. It is surely significant that, with only one possible excep-
tion, all Blake's positive references to the Gothic[38] occur after 1800.[39]

Not all the statues in the cathedral that would have interested Blake
are medieval. Two of the monuments by Blake's friend John Flaxman
show how close the pictorial vocabularies of the two artists are: the
striking monument to William Collins (1795), and the beautifully con-
ceived *Agnes Cromwell Monument* (1800). Collins's work, along with that
of other poets of the Age of Sensibility, had been important to Blake's
early poetry. As Harold Bloom remarks of *Poetical Sketches*, 'Had we
only these youthful poems of Blake ... it is likely we would place him

as a second and greater Collins.'[40] As Blake well knew, Collins returned to Chichester, his birthplace, to die of what Samuel Johnson called a 'deficiency rather of his vital than his intellectual powers.'[41] Flaxman's striking relief of a man pensively reading the Bible resembles the figure in Blake's second illustration to Gray's 'Progress of Poesy,'[42] one of the group of designs that Flaxman commissioned Blake to do for his wife, Nancy, circa 1797–8.[43] Flaxman's recently installed[44] *Agnes Cromwell Monument* (1800), with its swirl of angelic and human garments, displays, as Nairn and Pevsner remark 'a design as flowing and melting as those of his friend Blake.'[45]

Nor were all the works of art in the cathedral sculptures. On the south wall of the south transept is a great wooden wall panel in which were set portrait heads of the kings of England and (in Blake's time) of the bishops of Chichester, and two large (each approximately 8 × 12 ft/ 244 × 366 cm), ambitious paintings, well known in Blake's day. As these are discussed by Hay circa 1800 and again by him in 1804, they must have been there for Blake to see during his Sussex years. Executed in the early sixteenth century on commission from Bishop Robert Sherburne (d. 1536), the pictures later suffered considerable damage by Commonwealth soldiers and were crudely repaired in the eighteenth century, so that 'all the original merit [was] destroyed, excepting of mere outline and design.'[46] Outline and design, however, were what interested Blake most; his imagination could supply the colours. He would have been especially interested in the fact that these pictures were, in the terminology of his own time, 'history paintings,' showing two decisive moments, one real and one imaginary. Once attributed to 'Bernardi,'[47] they are now known to be by Lambert Barnard, an early sixteenth-century artist, possibly Netherlandish, patronized by Bishop Sherborne. Barnard also painted the heraldic panelled ceiling of the hall in the bishop's palace, a fantasy of vines, grapes, and flowers on the ceiling of nearby Boxgrove Priory, and nine panels on the rare subject 'Heroines of Antiquity' at Amberley Castle (eight remaining, now in Pallant House, Chichester).[48] Barnard employed, in the words of Croft-Murray, 'uncompromisingly English' techniques, using only distemper for painting on plaster or wood.[49] This would have been of no small interest to Blake, who would declare in his *Descriptive Catalogue* of 1809 'The art of fresco painting being lost, oil became a fetter to genius, and a dungeon to art' (*E* 531).

Over the two Chichester paintings is a Latin inscription meaning 'Let all the kings of the earth confess to thee, for thou, O Lord, art a great

king above all kings. – Straight is the way which leads to life.'[50] The painting to the viewer's left shows King Caedwalla of the West Saxons granting St Wilfred of Northumbria land for a monastery in Selsey, an event that occurred circa 685–6 CE. The tonsured Wilfred wears scarlet and white ecclesiastical garments. Among the attendants behind him, one, kneeling, holds his bishop's golden mitre, another, upright, a golden cross on a pole. A texted scroll issues from Saint Wilfred's mouth, saying to the king: 'Grant God's servants a dwelling place according to His will.' Caedwalla stands atop a two-stepped porch, his costume gold-coloured with ermine trim, black-dotted on white. Arms outstretched in either direction, he holds in his right hand a golden sceptre and an arched golden crown. With left hand he points to a book held open by an attendant, in which we read 'Let the petition be granted.' Behind him and his richly clothed retinue, some of whom wear plumed hats, is a massive, towered building, presumably imagined as his palace. The second painting (plate 12, this volume), which illustrates an event that never occurred,[51] reverses the arrangement of the first, placing the magnificently attired Henry VIII (with, impossibly, Henry VII beside him) to our left and Bishop Sherborne to our right. Paralleling the first painting, one of the monks behind the bishop kneels with his mitre and another stands holding a vertical object, this time the bishop's crosier. Henry VIII's arms are outstretched, with his right hand over an open book held by a courtier. The bishop says, by means of an inscribed scroll, 'Most sacred King, on God's account confirm your Church at Chichester, now the Cathedral, as did Caedwalla, king of the South Saxons, with the church at Selsey, once the Cathedral.' The king's reply, by means of the book, is 'For the love of Jesus Christ, I grant your petition.' Below the centre of this painting we read: 'Believe the works.'

As Edward Croft-Murray remarks, 'These pictures remain as an important testimony to Barnard's competence and intrepidity in tackling ambitious subjects on a life-size scale,'[52] something Blake wished he himself could have an opportunity to do. Barnard was no Raphael, but because of the depredations of seventeenth-century iconoclasts, it was unusual to encounter early Renaissance paintings in English churches, and this must have been one of the few occasions where Blake could have seen them. Two aspects of these pictures that would especially have interested him involve gesture and subject. Both kings are presented arms out, a bodily position that Blake used to suggest giving of the self, as in the figure of the Host in *Sir Jeffery Chaucer and the Nine and Twenty Pilgrims on Their Journey to Canterbury*.[53] Also, the first picture

commemorates the establishment of a see at Selsey, the second the continuation of that see in Chichester. The see was moved from Selsey to Chichester in 1075, perhaps because of coastal erosion. Blake took the tradition that the ancient cathedral of Selsey was covered by the sea as a symbol of self-sacrifice in *Jerusalem*:

> Selsey, true friend! who afterwards submitted to be devourd
> By the waves of Despair, whose Emanation rose above
> The flood, and was nam'd Chichester, lovely mild & gentle! (36: 49, *E* 182)

The combination of painting, sculpture, and architectural features in Chichester cathedral would have confirmed Blake in his belief that England could become 'What Italy is an Envied Storehouse of Intellectual Riches' ('Public Address,' *E* 581).

A building that necessarily acquired a personal interest for Blake was the chancel of the Grey Friars, dating from 1270–80, converted to a guildhall a few years after the dissolution of 1538. It is here that Blake was tried for sedition on 11 January 1804.[54] Blake could hardly have been in an architectural tourist's frame of mind then, but, as John Ruskin is supposed to have said, architecture is an art in which we all participate whether we know it or not. During his trial in 1804, Blake had more time than he might have wished to absorb the details of this building (fig. 9.3), with its five bays and its east wall with 'a very fine late-13th-century window of five lancets divided by delicate detached shafts.'[55] An accused person would have felt dwarfed by the building's height, especially if he had to look upward to see the seated justices. The guildhall's historical connection with the Grey Friars is likely to have inspired Blake to write 'The Grey Monk,' in a draft of which the Monk is accused by 'Charlemaine' of being 'Seditious,' an accusation made against Blake by the Crown.[56] The Grey Monk, like Blake, writes under divine command, and in the *Jerusalem* version of this poem Charlemaine characterizes him as 'In vain condemning glorious War' (52: 10, *E* 202), which is of course just what John Scholfield accused Blake of doing in saying 'All you Soldiers are all sold for Slaves.' (This is perhaps the only thing Scholfield alleged Blake to have said that he might actually have said.) The Monk, like Blake, is a writer, and, as Blake no doubt feared, what he writes will result in the destruction of those he loves.

Much depends on how we conceive of William Blake. Was he a man who would have made numerous trips to Chichester to buy Conven-

9.3 Chichester Guildhall interior, engraving. 1789. Engraving. Alan H.J. Green Collection

iences and to collect and deliver proofs, while studiously ignoring the layout of the city, its history, its great cathedral and the works of art it contained? This hardly coincides with everything else we know about him. It is much more likely that what Blake saw in Chichester became part of the major transition in Blake's aesthetics that occurred at the beginning of the nineteenth century, of which the ogee arch and the idea of the Gothic constituted important parts, along with the architectonics of Golgonooza. It's true that painful memories of his trial are marked by Blake's inclusion of names from it among Albion's Giant Sons in *Jerusalem*, and by the portrayal of 'Skofeld' as a lunatic in flames in *Jerusalem* 51. Nevertheless, Blake had warm memories of the city and its inhabitants, with good reason. Hayley later wrote to Lady Hesketh: 'In truth, this diligent & quiet artist was cordially regarded by his rustic neighbors; & the citizens of Chichester (as I probably told you at the time) were loud in their honest exultation of their joy in his acquittal.'[57] Blake in turn paid tribute to the personified city

Chichester, lovely mild & gentle! Lo!
Her lambs bleat to the sea-fowls cry, lamenting still for Albion.[58]

NOTES

1 Walter Jackson Bate, *John Keats* (New York: Oxford University Press, 1963), 454; Aileen Ward, *John Keats: The Making of a Poet*, rev. ed. (New York: Farrar, Strauss and Giroux, 1986), 242.

2 Chichester is not mentioned in an otherwise well-informed study: Jennifer Davis Michael, *Blake and the City* (Lewisburg: Bucknell University Press, 2006).

3 William Blake, *The Complete Poetry and Prose of William Blake*, rev. ed., edited by David Erdman, with commentary by Harold Bloom (New York NY; London: Doubleday: Anchor Books, 1988), 2 October 1800, 714. Hereafter cited as *E*.

4 Alexander Hay, *The History of Chichester* (Chichester: Seagrave, 1804), 4.

5 In 1802, Joseph Johnson published *Three Discourses*, lectures delivered by its president, the physician Thomas Sanden, at its anniversary meetings in 1800, 1801, and 1802. There was some connection between Sanden and the Hayley family, as Sanden owned a pencil-and-wash sketch in a miniature oval frame of Hayley's wife Eliza Hayley (1750–97), West Sussex County Record Office, PD 2355.

6 See *The Chichester Guide, and Directory* (Chichester: Seagrave, 1804), 35.

7 See Alexander Hay, *The Chichester Guide: Containing an Account of the Antient and Present State of the City* (Chichester: Joseph Seagrave, 1800?), 35. This guide was first published in 1783 and was reprinted circa 1795: Alexander Hay, *The Chichester Guide: Containing an Account of the Antient and Present State of the City* (Chichester: J. Seagrave, c. 1795). In 1804, Hay published *The History of Chichester; Interpersed with Various Notes and Observations*, dedicated to Hayley and co-published by Seagrave. On 18 December 1804, Blake wrote from London that he was expecting the arrival of this book from Hayley (*E* 759).

8 Notebook, 'And his legs carried it,' *E* 504.

9 Morchard Bishop, *Blake's Hayley: The Life, Works, and Friendships of William Hayley* (London: Victor Gollancz, 1952), 271.

10 See T.J. McCann, 'Eighteenth Century Printing in Chichester,' *Factotum*: Newsletter of the Eighteenth Century Short Title Catalogue 13 (1981): 13–16.

11 A. Hay, *History of Chichester*, 526. For the address I thank Richard Childs, County Archivist, West Sussex Record Office.

12 William Hayley, *Memoirs of the Life and Writings of William Hayley, Esq.: The Friend and Biographer of Cowper*, ed. John Johnson, 2 vols. (London: H. Colburn, 1823), 2: 122. However, at least one of his apprentices did make good: William Clowes, apprenticed to Seagrave in 1789, became a journeyman in London in 1802, and there pioneered in steam-powered printing, becoming one of the most successful printers of his day. *Dictionary of National Biography*, *s.v.* Clowes, William.

13 T.J. McCann, 'The Tribulations of a Chichester Printer [J. Seagrave],' *Factotum* 27 (1988): 22–3, citing Hayley's epitaph book, West Sussex Record Office, Add MS 2758, f. 37 v. Elsewhere Hayley praised Seagrave for his 'very clear and cultivated understanding,' and for his 'most upright and benevolent heart' (Bishop, *Blake's Hayley*, 270, citing BM Add 3083 A).

14 McCann, 'The Tribulations of a Chichester Printer,' citing WSRO STDII, 1809. Seagrave's will was proved on 8 October 1809. He left Mary Shepherd £100 and some personal effects. She gave birth to a daughter, baptized Marian Seagrave on 25 June 1809.

15 G.E. Bentley Jr, *Blake Records*, 2nd ed. (New Haven and London: Yale University Press, 2004), 220. Hereafter cited as *BR2*.

16 See Robert N. Essick, 'Blake, Hayley, and Edward Garrard Marsh: "An Insect of Parnassus,"' in *Explorations: The Age of Enlightenment*, special series (1987), I, 58–84.

17 *The Friend: A Religious and Literary Journal* 7 (23 December 1833): 205.

18 Dally, *The Chichester Guide, Containing the History and Antiquities of the City* (Chichester: P. Binstead, 1831, 1836).

19 This copy is now in the Pierpont Morgan Library.

20 *The Chichester Guide and Directory*, 1804, 71. The profession of his father is given as a joiner in a document dated 1757 (West Sussex Records Office, Add MSS 40, 354.175).

21 Hayley to John Johnson, 18 January 1804 and 25 November 1804: Hayley, *Memoirs* 2: 148 and 150. Having been the first to publish Cowper's great poem 'Yardley Oak,' Hayley appears to have felt a proprietary interest in the tree. In his *Arboretum et Fruticetum Britannicum; or, The Trees and Shrubs of Britain* (London: the Author, 1838), III, 1766, J.C. Loudon comments on the damage done to the tree, 'Visitors having been in the habit of cutting out and carrying away small blocks or slices of the sounder part of the wood as relics, or to manufacture into snuffboxes.'

22 Thomas Wright, *Life of William Blake*, 2 vols. (Olney: Bucks, 1929), II, 13. Robert Essick has kindly informed me that a chamber horse was a chair with a high seat on a spring, and that in Jane Austen's *Sanditon*, chapters 6 and 11, Mr Hollis has one and Mrs Griffiths inquires about one.

23 This with the immediately following information is summarized from James Dallaway, *A History of the Western Division of the County of Sussex. Including the Rapes of Chichester, Arundel, and Bramber, with the City and Diocese of Chichester*, 2 vols. (London: T. Bensley, 1815–32), vol. 1, pt. 2: 39–44, 58–9, 101–2.

24 A. Hay, *History of Chichester*, 20.

25 Wright, *Life of William Blake*, I, 107.

26 Blake's first mention of Golgonooza is in Night Five of *The Four Zoas*, where Los begins building it (60: 3–5) after the birth of Orc. Golgonooza is named sixteen times in that poem. It has domes, pillars, columns, walls, but no shape or structure. Furnaces, Spires, and a Fount are added in *Milton*, where there are twenty-three mentions. It is 'Golgonooza the spiritual Four-fold London eternal' (6: 1, *E* 99) and 'is namd Art & Manufacture by mortal men' (24[26]: 50, *E* 120). However, it is in *Jerusalem* that Golgonooza attains shape and form. *Jerusalem* must have been at least begun in 1804, the date on its title page, and it is very likely that sixty plates had been completed by June 1807, when Chichester was still fresh in his memory: see Morton D. Paley, *The Continuing City: William Blake's* Jerusalem (Oxford: Clarendon, 1983), 1–7.

27 John Hay, *The Chichester Guide*, 20.

28 Martin Butlin, *The Paintings and Drawings of William Blake* (London and New Haven: Yale University Press, 1981), 371. Hereafter cited as *B*. This

230 Morton D. Paley

is the pencil drawing reproduced by Geoffrey Keynes as 'Landscape with Trees' in his *Drawings of William Blake: 92 Pencil Studies* (New York: Dover, 1970), no. 36. I am grateful to Martin Butlin for valuable advice about this picture.

29 This means that the inscription is facing the 'wrong' way, as Blake the traveller is walking away from Chichester and toward London, but of course Blake needed the visual cue to face the reader. See Morton D. Paley, *The Traveller in the Evening*, 2nd ed. (Oxford: Clarendon, 2008), 40–2. Interestingly, Blake's preparatory drawing (British Museum) has no tower in the background.

30 The two great Romanesque panels of Christ raising Lazarus and of Christ coming to the house of Mary of Bethany were not displayed during Blake's time in Sussex.

31 Reproduced in Francis Bond, *Wood Carvings in English Churches* (London: H. Frowde [Oxford University Press], 1910), I, 43 and 109: see also 'Misericords of the World: "Miserichords of Chichester Cathedral,"' available at http://www.misericords.co.uk/chichester.html.

32 Anne Kostelanetz Mellor, *Blake's Human Form Divine* (Berkeley: University of California Press, 1974), 167–9, 171, 173–6, and plates 46, 47, and 48.

33 Robert N. Essick and Morton D. Paley, *Robert Blair's The Grave Illustrated by William Blake: A Study with Facsimile* (London: Scolar, 1982), 59. The Earl of Arundel's tomb effigy was at this time widely separated from his wife's, and the extended hand linked with hers (which has made the Arundel Tomb famous, as in Philip Larkin's poem of that name) is a Victorian revision.

34 Francis Bond, *Wood Carvings in English Churches*, 2 vols. (London: Henry Frowde/Oxford University Press, 1910), II, 36. Ian Nairn and Niklaus Pevsner point out that a striking canopy of three ogee arches in the south transept '[is] given especial bite by the double curve put in them close to the piers,' *Sussex*, in series *The Buildings of England* (Harmondsworth, Middlesex: Penguin, 1965), 160.

35 Victoria and Albert Museum: *B*, 500.

36 Huntington Art Gallery and Boston Museum of Fine Arts: *B*, 529.6 and 536.6.

37 Nairn and Pevsner, *Sussex*, 129.

38 It is true that much of Chichester cathedral is Romanesque, but the opposition of Gothic to Romanesque is a later idea – *romanesque* as an architectural term does not occur until 1819 (*OED*, *s.v.*) – as we see in the exhibition catalogue *Le Gothique retrouvé avant Viollet-le-Duc* (Paris: Caisse National des Monuments Historiques et des Sites, 1979), in which, for example,

a striking illustration of the Gothic is Ely cathedral as painted from the southeast by Thomas Girtin (nos. 22 and p. 23), showing most of the arches of the façade as round.

39 The one possible exception is in Blake's annotations to Reynolds's *Discourses on Art*, which are dated by Erdman circa 1798–1809 but by Bentley 1801–2, 1808–9. David Bindman. 'The Dating of Blake's Marginalia to Reynolds,' *The Burlington Magazine* 108, no. 763 (October 1966): 522.

40 Harold Bloom, *The Visionary Company: A Reading of English Romantic Poetry* rev. ed. (Ithaca, NY: Cornell University Press, 1971), 15. Margaret Ruth Lowery writes: 'The revival of interest in Collins's poetry after his death, when Fawkes and Woty and Dodsley included his poems in their collections, and when in 1765 Langhorne edited the collected edition that was reprinted in 1771 and 1781, was surely strong enough to have affected Blake.' *Windows of the Morning: A Critical Study of William Blake's* Poetical Sketches (New Haven: Yale University Press), 157.

41 Samuel Johnson, *The Lives of the Most Eminent English Poets: With Critical Observations on Their Works*, ed. Roger Lonsdale (Oxford: Clarendon, 2006), IV, 122.

42 Yale Center for British Art: *B*, 335.52.

43 It has been suggested that Blake, who several times said that Flaxman copied from him, had in mind the figures in the pediment of the Collins Monument, which are 'very close in attitude to those on the frontispiece to *The Marriage of Heaven and Hell*.' See Anthony Blunt, 'Blake's Pictorial Imagination,' *Journal of the Warburg and Courtauld Institutes* 6 (1943): 190–212. Blunt, however, goes on to give other sources for these figures.

44 In August 1800: see Edward Croft-Murray, 'An Account Book of John Flaxman, R.A.,' *Walpole Society* 28 (1939–40): 61.

45 Nairn and Pevsner, *Sussex*, 154.

46 James Dallaway, *A History of the Western Division of the County of Sussex. Including the Rapes of Chichester, Arundel, and Bramber, with the City and Diocese of Chichester*. 2 vols. (London: T. Bensley, 1815–32), vol. 1, pt. 1: 123–4. A restoration was done in the mid-twentieth century.

47 A. Hay, *History of Chichester*, 463. This mistake has been attributed to a misreading by Horace Walpole of George Vertue's notes. See Edward Croft-Murray, *Decorative Painting in England, 1537–1837* (London: Country Life, 1962), I, 23. Croft-Murray writes that 'Vertue, who visited Chichester on more than one occasion to study Barnard's work there, noted, with considerable acumen for his time, that the paintings he saw were in Dutch or German taste, recalling Dürer or Lucas van Leyden.'

48 See Edward Croft-Murray, 'Lambert Barnard, an early English Renaissance

Painter,' *Archaeological Journal* 113 (1957): 108–25; and Jonathan Woolfson and Deborah Lush, 'Lambert Barnard in Chichester Cathedral: Ecclesiastical Politics and the Tudor Royal Image,' *The Antiquaries Journal* 87 (2007): 259–80.

49 Croft-Murray, 'Lambert Barnard,' 111.

50 I use the translations of Woolfson and Lush, 'Lambert Barnard in Chichester Cathedral.'

51 Croft-Murray suggests the purpose of this commission was to show Bishop Sherborne's loyalty to the Anglican church and to invite the king to protect Sherborne's title to his bishopric.

52 Croft-Murray, 'Lambert Barnard,' 115.

53 Pollok House, Glasgow: *B*, 653.

54 On what is probably the most thoroughly documented episode in Blake's life, see especially *BR2* 176–89; John Mee and Mark Crosby, '"This Soldierlike Danger": The Trial of William Blake for Sedition," in *Resisting Napoleon: The British Response to the Threat of Invasion, 1797–1815*, ed. Mark Philp (Aldershot: Ashgate, 2006), 111–24; and Mark Crosby, '"A Fabricated Perjury": The [Mis]trial of William Blake,' *Huntington Library Quarterly* 72 (2009): 29–47; G.E. Bentley, '"Rex v. Blake": Sussex Attitudes toward the Military and Blake's Trial for Sedition in 1804,' *Huntington Library Quarterly* 56 (Winter 1993): 83–9.

55 'A History of the County of Sussex,' vol. 3, ed. L.F. Salzman, http://www.british-history.ac.uk/report.aspx?compid=41659; accessed 21 November 2008. For his generosity in supplying the image reproduced here, I am grateful to the Chichester historian Alan H.J. Green.

56 See David V. Erdman, *Blake: Prophet Against Empire: A Poet's Interpretation of the History of His Own Times*, 2nd ed. (Garden City, NY: Doubleday, 1969), 414. The quotation is from Blake's Notebook draft MS (*E* 811). On the dating of Blake's versions of this poem, see Bentley, 'The Date of Blake's Pickering Manuscript,' *Studies in Bibliography* 19 (1966): 232–43.

57 *BR2* 205, from Hayley's letter of 3 August 1805.

58 *Jerusalem*: 36[40]: 50–51, *E*, 182. The region is home to a famous breed, the Southdown sheep. See S. Foster Damon, *A Blake Dictionary: The Ideas and Symbols of William Blake* (London: Thames & Hudson, 1973), 81.

10 William Blake and the Straw Paper Manufactory at Millbank

KERI DAVIES

And was Jerusalem builded here,
Among these dark Satanic Mills?

<div align="right">Blake, Preface to Milton</div>

It is sometimes alleged that, as a Londoner, Blake could not have witnessed at first hand the heavy manufacturing plants of the Industrial Revolution, and that his 'Satanic mills' refer merely to the over-rational, self-constricting cast of mind of Blake's detested authoritarian figure Urizen. For Damon, Blake's 'dark Satanic Mills' signify 'the philosophy under which all England was suffering,' and the Mill 'symbolizes Aristotelian logic, the basis of dogmatism.'[1] Similarly, Ferber suggests that 'Blake was probably not referring to factories when he wrote' of dark Satanic Mills, while Stevenson insists that 'the phrase refers not so much to the mills built for the new industries, as to Satan's enslavement of the mind, the beginning of human error.'[2]

James Watt's reciprocating steam engine and his development of its use in imparting rotary motion opened up new possibilities of power in milling of many sorts from the 1780s onwards. It came into use in flour-mills, malt mills, iron mills, and, with great rapidity, in the new cotton-spinning mills. 'The people in London, Manchester and Birmingham,' wrote Matthew Boulton to Watt in 1781, 'are steam-mill mad.'[3] Those critics, comments Nuttall, are mistaken who 'insist, antiseptically, on a wholly metaphorical meaning' for the dark Satanic Mills.[4] The steam-powered Albion Flour Mill, the first great factory in London, stood on the Blackfriars Road north of Lambeth. Here, a Boulton and Watt engine was applied to the large-scale grinding of corn for the first time.

When the mill burnt down in 1791, the millers of Surrey rejoiced: 'Success to the Mills of Albion, but no Albion Mills.'[5] It remained a burned-out shell until 1809; Ackroyd points out that Blake must regularly have walked past the blackened ruin when he lived in Hercules Buildings.[6] All of which make it much harder to exclude the simple interpretation that 'Satanic Mills' equates to 'factories.' As well as the steam-driven Albion Mill, London had wind and watermills, donkey mills and treadmills, even a paper mill. What London lacked were the large textile mills of the northern counties; the Streatham silk mill, built to house Jacquard looms, dates only from 1820.[7]

Blake's poetry is concrete and specific:

> I write in South Molton Street what I both see and hear
> (*Jerusalem* 34: 42, E 180)

Blake mixed archetypal and mythic references in his work with more personal preoccupations. Despite its multivalent metaphorical nature, Blake's imagery is always grounded in the local and the contemporary.[8] In his 'Public Address,' Blake wrote: 'Commerce is so far from being beneficial to Arts or to Empire that it is destructive of both' (E 574). As the son of shopkeepers, he perhaps knew more about the operation of the commercial world than many of those who now write about him. In the following pages, I hope to show that Blake's allegories of manufacturing industry in *The Four Zoas* and elsewhere derive from his specific experience, and incorporate elements derived from papermaking. In addition, I shall demonstrate how these themes of commerce, of manufacturing, and of industry in the form of papermaking, seem to constellate around the dubious business practices of one Matthias Koops.

Papermaking is a topic of considerable relevance to any discussion of Blake's work.[9] Blake was insistent on the quality of paper he used for his works in illuminated printing. In his 1792 *Prospectus*, he noted, 'The Illuminated Books are Printed in Colours, and on the most beautiful wove paper that could be procured' (6, E 693). The wove mould, made from a mesh of finely woven brass wires enclosed in a wooden frame, produced a much smoother printing surface than did the earlier 'laid' moulds. Fine-quality English hand-made wove paper was first made by James Whatman, of Turkey Mill near Maidstone, before 1770.[10] It was widely used by artists as well as by publishers of fine editions (for example, it was used by John Boydell) and from the middle of the 1790s, we begin to find the text of ordinary books being printed on

wove paper. Whatman's paper was considered equal in quality to the French and 'manufactured more neatly.'[11] Although Blake shows some knowledge of papermaking, there is no evidence that he ever visited Whatman's Maidstone mill.[12]

However, there was a paper mill closer to hand, on the Neckinger, at Bermondsey. (The Neckinger, a small tributary of the Thames, entered the Thames at St Saviour's Dock to the east of the present Tower Bridge.)[13] Neckinger Mill opened as a paper mill around 1795, for on 19 November that year, Elias Carpenter, 'gentleman, of the Neckinger,' obtained a patent for 'a method of bleaching paper in the water leaf or sheet, and sizing it without drying.'[14] The historical record is incomplete, but the patent tells us that Carpenter was a papermaker in 1795 and that he was located at the Neckinger Mill. Production of paper continued there until the Neckinger Mill was sold to the leather firm Bevingtons in 1805.[15]

Boulton and Watt had erected only one of their engines in a paper mill before the end of the century; they installed a ten-horsepower engine at Messrs. Howard and Houghton's Wilmington Mill near Hull in 1786. Then, at the turn of the century another famous engineer, John Rennie, built and installed a steam engine in London, for the very big but ultimately unsuccessful experimental paper mill set up by Matthias Koops.[16] William Blake could have witnessed papermaking at Carpenter's Neckinger Mill, less than a mile from his home in Lambeth, and later have seen, after his return from Felpham, the remains at Millbank of what Koops, Carpenter's associate, planned as one of the largest industrial enterprises in London.

Papermaking is both a process, and an industry. The essential chemical constituent of paper is cellulose, the main component of plant fibres. The manufacture of paper requires that the cellulose fibres be macerated until each individual filament is a separate unit held in suspension in water. In Blake's day, most paper was made from linen or cotton rags, which had to be prepared by sorting, cleaning, boiling, and bleaching, whence they passed to the 'Hollander' or beating engine. With many improvements and variations in detail, the preparation processes of washing and pulping remain in principle the same today.[17] The resulting 'stuff' – consisting of finely macerated fibres mixed with water – found its way to the 'vat' where the papermaker operated. The papermaker or 'vatman' then formed the sheets by dipping into the liquid a 'mould' consisting of a shallow rectangular box, the bottom of which was made of wire gauze. From the mould

the sheets were turned out by the 'coucher' on to a felt, until a pile or 'post' of alternate felts and sheets of paper was made. After this the paper passed to the pressing, finishing, and drying stages. Although the tasks of the vatman and coucher do not sound complex, their labour was highly skilled and upon this skilled work the industry was entirely dependent.[18]

The journeymen papermakers were brought into the limelight of official disapproval in 1795, when their attempts to secure an increase of wages provoked the masters to petition the House of Commons, which, as might be expected, then passed an Act 'to prevent unlawful combinations of workmen employed in the Paper Manufactory.'[19] It conferred on the justices the power to commit to the House of Correction journeymen papermakers entering into such 'combinations.'[20] Blake was to write, in the *Song of Los* of 1795:

Shall not the Councellor throw his curb
Of Poverty on the laborious?
To fix the price of labour;
To invent allegoric riches (6:16–19, E 68)

We shall see that the riches that the papermaker Matthias Koops promised his investors would prove illusory, if not allegoric.

Papermaking was not the most desirable of employments. Paper had been made from linen and cotton rags long before the invention of the printing press, and rags continued to be used in considerable quantities until the closing years of the nineteenth century. Rags were unpleasant to handle and could transmit diseases and parasites.[21] There was an ever-increasing demand for linen rags for papermaking, and a consequent interest in the possibility of making paper from materials other than linen and cotton.

The French scientist René Antoine Réaumur, in his 1719 treatise on the habits of the American wasp, recounts how the wasp fabricates its nest by using the fibres of wood.[22] Observing how the sheets that form the structure were a type of paper, Réaumur reasoned that the ingenuity of man could surely produce usable paper from these same wood fibres. Twenty years later, Réaumur bemoaned the fact that nothing had been done with respect to his discovery and reproached the papermakers for their apathy and their failure to appreciate and attach some value to his observation:

Je devrois avoir honte de n'avoir pas tenté encore des experiences de cette espece, depuis plus de vingt ans que j'en connois toute l'importance, & que je les ai annoncées; mais j'avois espéré que quelqu'un voudroit bien s'en faire une occupation & un amusement.

[I am ashamed that I have not yet tried this experiment, it is more than twenty years since I first realised its importance and made an announcement of it. But I had hoped that someone would have been interested in making it his occupation.][23]

Indeed, there was no attempt to produce paper on a commercial scale from any rag substitute until 1800, by which time Matthias Koops was working at Elias Carpenter's Neckinger Mill in Bermondsey, attempting to establish the manufacture of paper from materials such as waste paper, straw, and wood. The experimental work of Réaumur, and others, always of a limited nature, is important, and to these scientists should go the credit of the discovery in Europe of many papermaking fibres other than linen and cotton. It was Koops, however, who first made use of various vegetable fibres on a large commercial scale.[24]

Matthias Koops was born in Pomerania, the son of Matthias and Katharina Dorothea Koops.[25] We do not know exactly when Koops came to England, but he leased a house in Edmonton in 1789. He had probably been settled in England for some time, since he was well-enough established to act as godparent, soon after, to the son of John and Frances Knight of Enfield. A baby named Matthias Koops Knight was christened at St Andrew's Church, Enfield, in May 1789.[26] That same year Koops's marriage to a young widow, Elizabeth Jane Austin, took place at St Marylebone Parish Church.[27] Following his marriage, Koops, born a subject of the German Emperor, applied for naturalization. The private bill for his naturalization received royal assent on 1 April 1790.[28] From then on, in all his publications, Matthias Koops is very much the patriotic Englishman.

The impression we gain of Koops from his varied publications is that of someone with particular skills in surveying, mapmaking, and statistics.[29] There is nothing that links him to the trade of papermaking. He capitalized on his knowledge of Europe by publishing in 1796 a set of maps of the Rhine, Meuse, and Scheldt, and a survey entitled *A Developement* [sic] *of the Views and Designs of the French Nation*.[30] The 'elegantly coloured' maps would cost ten guineas and be available by June; subscriptions were to be sent to Messrs. Hammersley and Co. of

Pall Mall. Prospective purchasers were assured of the competence of the cartographer: 'The whole taken and surveyed by Matthias Koops, Esq. who for several years served in different distinguished military characters, under the late Emperor of Germany, and King of Prussia.'[31]

Trade directories list 'Matthias Koops, merchant, Old City Chambers, Bishopsgate within,' a business address easily accessible by the regular coach along the turnpike from Edmonton.[32] However, *The Times* of 1790 carries an account of a curious law case, an 'action of trover' between Koops as plaintiff and a Mr Chapman, allegedly already owed £1,200 by Koops, as defendant with others.[33] The defendants' attorney opened with the claim that Koops

> had never been under the least difficulty since the age of 25, though not worth a shilling, to raise ten thousand pounds on the credulity of the public, by going about to cheat tradesmen of little sums of only 20 or 30 l. or of notes. He has done this in Hamburgh, in Holland, in Germany, as well as in this place. He figured away as a considerable merchant, negotiating bills of exchange, discounting and buying them, and making as good a figure as any merchant in England, till he was found out.[34]

The plaintiff's attorney endeavoured to ascribe all Koops's trading activities to 'another person of the name of Knight.' John Knight of Enfield did not appear in court and the case ended inconclusively; but by 30 June of 1791, Matthias Koops 'otherwise Koops von Ernst, merchant of Edmonton,' was made bankrupt. Three dividends were paid to his creditors between November 1791 and February 1793; these were the only dividends he was to pay his creditors for some time.[35]

It was perhaps as an Edmonton resident, and a fellow commuter on the Hertford turnpike, that Matthias Koops became acquainted with Richard Twiss, antiquary and traveller. The encounter would have disastrous financial consequences for Twiss.

Richard Twiss, born at Rotterdam on 26 April 1747,[36] the son of an English merchant, had rented a house at Bush Hill, Edmonton, in 1779, from where he began a long correspondence with Francis Douce, antiquary and book collector.[37] His letters cover such varied topics as the history of chess (the subject of one of Twiss's publications), botany and entomology, the tuning of harpsichords, children's toys, mathematical recreations, and always books, bought, read, borrowed, and lost. The correspondence demonstrates the social face of book collecting in Douce's circle. Specifically, it provides a context in which knowledge of William Blake's work in illuminated printing was disseminated.

In a letter to Francis Douce, dated 13 September 1794, Twiss wrote

A Lady here has just shown me ... two curious works of Blake N° 13 Hercules Build⁸ Lambeth. One 'the gates of Paradise,' 16 etchings. 24ᵐᵒ the other 'Songs of Innocence' printed in colours. I Suppose the man to be mad; but he draws very well. have you anything by him?[38]

In the next letter of the sequence, dated 25 September 1794, Twiss implies that he has acquired his own copy of Blake's *For Children: Gates of Paradise*:

On Saturday next, 27ᵗʰ any time after 12 o'clock, if you will be so good as to send to the Black Bull Holborn, you will find there ready, your Barbut, Mouffet, 3 imposteurs, Donovans insects &c. Jerᵉ Taylor Mandeville on Stews, & my Curtis insects & Blakes Paradise. and also a very curious Caterpillar, which will produce next May Linnaeus's Phalena Pudibunda.[39]

My '... Blakes Paradise' must be a copy Twiss has purchased, presumably from Johnson's, during that week or after he saw a copy with 'a Lady here.' The letter suggests that he's parcelling up the books for return as he writes, or checking the parcel before sending it off. The sequence in which the books are cited makes it plain that Twiss was lending his own copy of the *Gates* to Douce.

By 1797, in another venture, Koops had set up the Minerva Universal Insurance Office for fire, lives, and annuities, situated at no. 49, Pall Mall, Westminster. The Minerva Office had a very short life, being closed down in less than a year. We know this from a manuscript note: on a leaflet (*To the Public*) advertising the Minerva Office: 'The project of one Koops an uncertificated bankrupt. It did not exist a 12 month.'[40] A certificated bankrupt would be one who had complied with all the requirements of the laws governing bankruptcy, assignation of estates, and dividends. The certificate of conformity was granted only if a good proportion of the creditors agreed to it, and was a mark of trustworthiness. Uncertificated bankrupts had to be eyed cautiously. The manuscript note on Koops the uncertificated bankrupt brings to attention the fact that a bankrupt has tried to set up a financial service, a life insurance business, and had actually issued notices on it.[41]

A copy of another pamphlet (*The Universal Insurance ... containing Fifty Classes*) issued by the Minerva Universal Insurance bears a manuscript note implicating Twiss in the venture: 'The seventeen classes have been extended to Fifty the manuscript from which the Within was

taken was written by Mr Twiss the subject having undergone his revision.'[42] Earlier prospectuses of the Minerva Universal Insurance list only seventeen classes; the fifty classes devised by Twiss include a pioneering offer of insurance against loss of business profits.[43]

What Paracelsus and Boehme did with the symbols of the alchemical process, Blake does with the processes of modern industrial production.[44] In London, Jerusalem labours, while 'The Wheel of Hand. incessant' turns day and night without rest (*Jerusalem* 60: 43, *E* 210); yet even here she sees her Saviour and knows that she is deluded by 'the turning mills' (60: 63, *E* 211). The women workers in the brick and pottery kilns of Lambeth join Vala in

> mourning among the Brick kilns compelld
> To labour night & day among the fires ...
> They labour among flames and smoke:
> ... We are made to turn the wheel for water
> To carry the heavy basket on our scorched shoulders, to sift
> The sand & ashes, & to mix the clay with tears & repentance
> (*Four Zoas*, Night 2–31: 1–2, 7–8, *E* 320)

They lament

> The times are now returnd upon us, we have given ourselves
> To scorn and now are scorned by the slaves of our enemies
> Our beauty is coverd over with clay & ashes, & our backs
> Furrowd with whips, & our flesh bruised with the heavy basket
> Forgive us O thou piteous one whom we have offended, forgive
> The weak remaining shadow of Vala that returns in sorrow to thee
> (*Four Zoas*, Night 2–31: 11–16, *E* 321)

Just as alchemists have a twofold vision of alchemy as chemical process and spiritual transformation, similarly, Blake, previously allegorizing the physical processes of his craft in *The Marriage of Heaven and Hell* (an allegory or allegorical journey derived from its own etching), sets a poetic precedent that he will follow later in reference to papermaking, meditating on the materials of his art.[45]

The description in *Four Zoas* of 'mills / where winter beats incessant' (Night 2–24: 14, *E* 314) is literally, as well as emotionally, accurate. Paper mills operated in relation to water levels, and might shut down if the

water supply fell. Winter 'beats incessant' because the dreary weather would ensure levels sufficient to keep the mill in operation. Turning the linen rags into a pulp with water-powered Hollander beaters is an essential part of the papermaking process. The Hollander replaced the enormous stamping machines whose heavy, pounding hammers had previously been used. Again, the later passage relating the weaving of the atmospheres:

> they the strong scales erect
> That Luvah rent from the faint Heart of the Fallen Man
> And weigh the massy Cubes, then fix them in their awful stations
> And all the time in Caverns shut, the golden Looms erected
> First spun, then wove the Atmospheres, there the Spider & Worm
> Plied the wingd shuttle piping shrill thro' all the list'ning threads
> Beneath the Caverns roll the weights of lead & spindles of iron
> The enormous warp & woof rage direful in the affrighted deep.
> While far into the vast unknown, the strong wing'd Eagles bend
> Their venturous flight, in Human forms distinct; thro darkness deep
> They bear the woven draperies; on golden hooks they hang abroad
> The universal curtains & spread out from Sun to Sun
> The vehicles of light, they separate the furious particles
> Into mild currents as the water mingles with the wine
> (Night 2–28: 32; 29: 1–13, E318–19)

seems also to include references to the manufacture of paper. Some of the expressions Blake uses ('shuttle,' 'threads,' 'warp & woof') are, of course, related to the textile industry, but the observed detail suggests that a paper mill (and the 'wove' paper mould whose brass wires are set in warp and weft) has been part of his experience.

The 'enormous warp & woof' of the atmospheres (suggesting the 'atmospheric engine' invented by Thomas Newcomen in 1712) is distributed by 'strong wing'd Eagles.' During the papermaking process, when the vatman had stirred the rag pulp to the proper consistency, he plunged the mould with its 'warp & woof' of woven brass wires vertically into the vat. He then lifted the mould horizontally and shook it in four directions to remove excess water and mat the fibres of the newly formed sheet. The vatman's shake 'weaves' the fibres into paper: a fourfold act of creation. Great skill and physical strength were required to yield sheets of uniform smoothness and thickness. The vatmen are the 'strong wing'd Eagles ... in Human forms distinct' whose actions

reflect the central importance of geographic space (north, south, east, west) in Blake's thought – the geographical alignment of the Zoas in *Milton* and in *Jerusalem*:

> Four Universes round the Mundane Egg remain Chaotic
> One to the North, named Urthona: One to the South, named Urizen:
> One to the East, named Luvah: one to the West, named Tharmas
> They are the Four Zoa's that stood around the Throne Divine!
>
> (*Milton* 19: 15–18, *E* 112; repeated almost verbatim in
> *Jerusalem* 59: 10–13, *E* 208)

'Eagle' was the largest customary size of handmade paper; only Whatman's 'Antiquary,' specially made for the publications of the Society of Antiquaries, was larger: a sheet bigger than 'the largest mould normally in use, the grand eagle or double elephant.'[46] Sheets of white paper with their intended role in the diffusion of knowledge and as the means to convey ideas are surely 'vehicles of light.'[47]

Only after 1800, according to the paper-historian Dard Hunter, do depictions of papermaking appliances show a mechanical agitator in the vat. The earliest mention of this device appears in an article relating to a visit of a French papermaker to the Matthias Koops paper mill. The description reads:

> Les cuves, dans presque toutes les papeteries anglaises, sont munies d'une petite vannette placée prés du fond et a laquelle ou donne un mouvement lent, au moyen d'une petite roue à aube de deux pieds de diamètre, placée en dehors ... Cette vannette à laquelle les Anglais ont donné le nom de *hog* (cochon), en remuant continuellement le mélange, empêche la fécule qui forme le papier de se précipiter. C'est en grande partie à cette invention qu'on doit l'égalité qu'on observe dans *l'azurage* des papiers anglais; le bleu de *smalt* qu'on emploie toujours de préférence, ayant une grande tendance à se précipiter, le mouvement de la vannette le tient toujours suspendu dans le fluide dans un grand état de division, et sert à azurer également la pâte du papier.

> [The vats in nearly all the English paper mills are fitted with an agitator placed near the bottom, which is given a slow motion by a small paddle wheel, two feet in diameter, fixed outside ... This agitator, to which the English have given the name 'hog,' keeps the macerated stuff in the vat in constant movement and prevents it from settling to the bottom of the vat. It is

due to a great extent to this invention that the English paper possesses a uniform blueness from the smalt colouring as without the agitator the colour would have a tendency to settle. The 'hog' holds the colouring in suspension in the liquid fibre and assures the high quality of the English blue paper.][48]

The process of papermaking separates the 'furious particles' of pulped rags from the churning water in the vat. The blue dye mingles with the water in the vat 'as the water mingles with the wine.' Papermaking contributes to the allegory of industry in the *Four Zoas*, being the only large-scale industrial process Blake could have witnessed at this date.

European papermakers depended on cotton or linen rags as raw materials for their industry. The gap between the demand for paper and the supply of home-produced rags continually widened, such that Matthias Koops complained in 1800 that England did not 'furnish such considerable numbers of rags as might have been expected from the number of its inhabitants, and their superior cleanliness in linen.'[49] There was, therefore, a considerable import trade in materials. In a time of war, 'the battlefields of Europe were picked over before the blood was dry for every scrap of cloth that could be sold in the rag fairs and on the international market.'[50] Blake wrote in the *Four Zoas*:

And all the arts of life they changd into the arts of death
(Night 7b–92: 21, *E* 364; repeated in *Jerusalem* 65: 16, *E* 216)

The war effort has even encompassed the paper industry. Paper was now required for cartridge cases to perpetuate the slaughter.

The price of rags had indeed been rising alarmingly. In the 1780s the average price of fine rags varied from 35 to 37 shillings per hundredweight. By 1792 fine rags were not to be obtained under 42 shillings. In 1799 the price was 45 shillings.[51] In 1800 it was estimated that Great Britain's expenditure on foreign rags was nearly £200,000 per annum.[52] In January 1799, after a meeting with the rag merchants, the Master Papermakers resolved that none of them should pay more than 48 shillings per cwt. for a certain grade of rags. It was hoped to force the price down to 42 shillings. The employers then went on to declare significantly that they were 'fully sensible that the present high Price has not in the least operated to Increase the Collection of Rags of this Country; and that the Advance alone has arisen from a Competition amongst ourselves.'[53]

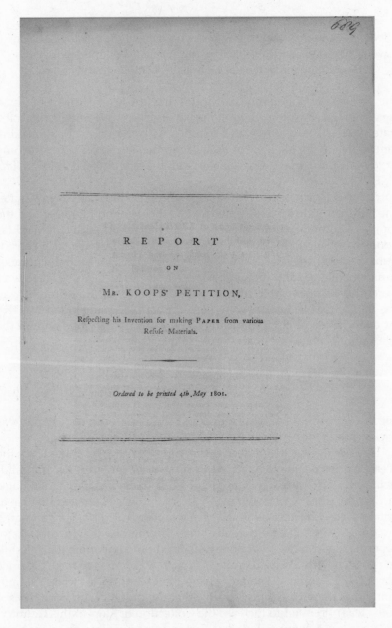

10.1 'Report on Mr Koops' Petition, respecting his Invention for making paper from various refuse materials' (4 May 1801). Victoria University Library (Toronto)

ported with a vigour equal to their importance.

Nothing new is to be found relative to the Invasion of *Tuscany*, excepting that after having plundered *Leghorn*, the French have thought proper to set down the pretended Insurrection and the crimes of the Inhabitants of the Grand Duchy to the charge of the English. Thus, in public as well as in private, we see that those who have despoiled their neighbours of their property attempt also to deprive them of their lives.

As a prelude to the Grand Treaty, or by way of consolation to the French, if they should fail to obtain it, the CHIEF CONSUL has published that which he has concluded with the DEY of ALGIERS. It is conducted upon a System of perfect Equality, and the latter Sovereign has generously promised to *forget the past.*

His MAJESTY gave over the chace.

Yesterday was presented to His MAJESTY at the Levee, by the Marquis of SALISBURY, a Book printed on the first Paper which has ever been made from Straw alone, containing a succinct but general historical account of the Substances which have been used to describe events, and to convey ideas from the earliest date to the Invention of Paper; together with some loose Sheets of Straw Paper, of an elegant transparent texture, which possess all the qualities of the finest Writing Paper fabricated from rags.

The loose Sheets indubitably demonstrate that Paper may be made from Straw alone in the highest state of perfection.—We regard it as a valuable discovery, and of great national importance, and the ingenious Inventor highly deserves the public esteem and support.

Tuesday about one o'clock, the remains of the late Countess of TYRCONNEL were interred in Westminster Abbey.

John Hamblin, the Mail Rider between Penryn and Helstone, who had neglected his duty, and loitered upon the road, to the detriment of the Public Correspondence. The Magistrate immediately committed the man to fourteen days hard labour in the House of Correction at Bodmin, and in hopes that so proper an example will be a warning to all persons of this description, not to neglect their trust, in the exact performance of which the Public are so much interested.

Some days ago, a French Priest was attacked by a footpad in the Edgeware Road, who not content with the few shillings he had about him, insisted on his coat, alledging it as a value superior to his own; the exchange was no sooner completed than the Priest ran, so did the thief, vociferating him to stop, but in vain, fearing he meant to ill use him. On reaching a public street, the thief gave up the pursuit, and the Priest putting his hand in his pocket, found at once the cause of this renewed attack, discovering he had got 50l.

10.2 Article on Straw Paper, *The Sun*, no. 2536, Thursday (6 November 1800). Victoria University Library (Toronto)

Koops must now have felt he had an opportunity to show that paper made from straw, wood, and recycled waste paper could be produced commercially (see fig. 10.1). Between 1800 and 1801 he was granted three patents for papermaking.[54] Just as a charter grants a trading monopoly, a patent establishes a manufacturing monopoly. In his lost Prospectus 'TO THE PUBLIC October 10, 1793,' Blake declares that he

> has invented a method of Printing both Letter-press and Engraving in a style more ornamental, uniform, and grand, than any before discovered, while it produces works at less than one fourth of the expense. (Prospectus, E 692)

Blake, it seems, never sought a patent for that invention, perhaps deliberately eschewing any commercial exploitation.[55]

Koops's first patent (no. 2392) was granted on 28 April 1800 for 'extracting inks from printed and written paper, and converting the paper into pulp.' On 2 August 1800, Koops was granted his second patent (no. 2433), this time for 'manufacturing paper fit for printing and other purposes, from straw, hay, thistles, waste and refuse of hemp and flax, and different kinds of wood and bark.' And on 17 February 1801, Koops was awarded a third patent (no. 2481), again for 'manufacturing paper from straw, hay, thistles, waste and refuse of hemp and flax, and different kinds of wood and bark' in which his processes were described in some detail.[56]

Koops extolled his process in his *Historical Account of the Substances which have been Used to Describe Events, and to Convey Ideas*, printed on paper made from the substitute fibres he himself had advocated (see fig. 10.2). The first edition of this work states on its title page that it was 'printed on the first useful paper manufactured soley [*sic*] from straw.' It has an Appendix of seven pages 'printed on paper made from wood alone, the product of this country, without any admixture of rags, waste paper stock, bark, straw, or any other vegetable substance, from which paper might be, or has hitherto been manufactured.'

In the greatly expanded second edition, Koops wrote,

> I have had the satisfaction to witness the establishment of an extensive Paper-manufactory, since the first of May 1800, at the Neckinger Mill, Bermondsey, where my invention of re-manufacturing Paper is carried on with great success, and where there are already more than 700 reams weekly manufactured, of perfectly clean and white Paper, made without

any addition of rags, from old waste, written and printed Paper; by which the publick has already been benefitted so far, that the price of paper has not risen otherwise than by the additional duty there upon, and the encreased price of labour. And it will not be many weeks before double that quantity will be manufactured at the said mill.[57]

He makes no proprietorial claim to the Neckinger mill itself and the nature of his arrangement with Elias Carpenter is unknown, although there had been a hint of more than routine assistance in a footnote to the first edition that says that the paper was made 'under the inspection of the truly ingenious Mr Carpenter.'[58] Such acknowledgment is omitted from the second edition. (Carpenter, it seems, had providentially split with Koops.) A further issue of this work is printed on paper made exclusively from straw. Presumably the successful use by Koops of such materials (and the paper in these books is still in remarkably fine condition even today) convinced people that his processes were valuable.[59]

Armed with the patents, Koops set about forming a joint-stock company to erect a mill at Millbank, specifically for the manufacture of paper from straw 'and other vegetable substances without the admixture of rags.' The deed of corporation of The Patent Straw Paper Company was made on 26 February 1801. One thousand shares were issued and twenty-five investors allocated shares, Matthias Koops being the principal shareholder with 346½.[60] It was to be Europe's first paper mill in which materials other than linen and cotton rags were extensively used. The greater part of today's paper industry is founded upon the pioneer work of Koops.[61] The stockholders, aside from Koops, advanced £45,000 for the 'buildings, machinery, and utensils.'[62] It began with high hopes and Richard Twiss invested heavily in the venture.

The Grosvenor Estate archives contain papers on the negotiations between Lord Grosvenor and an otherwise unknown Benjamin Cooper (a name that isn't quite Koops) in October 1800 for the lease of land at Millbank 'for the erection of Buildings in which is to be carried out the newly discovered Manufactory of paper from straw and other vegetables.'[63] The site of the Manufactory was to be on the bank of the Thames just a couple of hundred yards upstream from the present Vauxhall Bridge. On 7 August 1801 the company gained occupation and began to build what was at that time the country's largest paper mill.[64]

Over-confident and over-ambitious, the company spent its resources of more than £70,000 with a prodigality that invited disaster. The mill

itself was to be far larger than the ordinary paper mill of the time, for its equipment was to include twenty vats and two steam engines, one of eighty horsepower. Nothing was stinted. Apart from agreeing to what seems an exorbitant rent, for that time, of £1,000 a year for sixteen acres of land, the company employed 'the ingenious engineer, Mr. Rennie' as its designer. John Rennie was one of that distinguished group of Scottish engineers whose work contributed so much to the industrial and commercial development of the United Kingdom in the early nine-teenth century. There was very little in the field of engineering that lay outside the range of his activity; Rennie's suggestions would scarcely have been modest nor his services cheap.[65]

Throughout his career, particularly during the 1790s, Rennie filled many notebooks with information about the works he himself was involved with, and about others that he visited out of professional curiosity. The notebooks also contain addresses, booklists, and notes of expenses for his travels, which often make it clear where he went and when. John Rennie was a keen collector of books and prints, and thus may have found work on the Straw Paper Manufactory particularly enjoyable if it enabled him to relax with fellow antiquarians, such as Richard Twiss.[66] In one of his surviving notebooks is a page of notes on London engravers:

Mr Laurie Engraver
Upper Tichfield Street
–

Mr Basire Engraver
Quality Court Chancery Lane
–

Geo. Richardson
Engraver No 105 Tichfield
Street – Engraver in Aquatinta
– which will take off about
250 impressions.[67]

This is followed by rough estimates for the paper mill.

At Millbank, the Hollander beaters for preparing the pulp were to be driven by a single cylinder, double-acting condensing low-pressure beam engine of eighty horsepower. This was to be built by Boulton & Watt. The engine was to be powered by three steam boilers.[68] When the size of a steam engine for driving the average textile mill at that time

was only about fifteen to twenty horsepower, one of eighty horsepower would have been immense.[69]

In 1795, Joseph Bramah had patented a hydraulic press in which he claimed

> Certain New Methods of Producing and Applying a More Considerable Degree of Power in all kinds of Mechanical Apparatus and other Machinery requiring Motion and Force, than by any Means at Present practised for that purpose.[70]

He recommended its use in paper mills for pressing out the water from the post of wet sheets of paper and felts because the pressure could be considerably greater than that of the earlier screw presses. From the French account of the Straw Paper Manufactory, we learn that at least one hydraulic press was in use there:

> C'est là que nous vîmes pour la première fois l'application de la presse hydraulique, qui fesait le travail de cinq cuves à la fois. Ou sait que cette nouvelle machine a l'avantage de ne pas secouer bâtimens où elle est placée, que la pression est beaucoup plus considérable que celle qu'on obtient par la vis, qu'on peut limiter cette pression à tel degré qu'on désire, et qu'enfin en tournant un simple robinet, les porses sont dégagées a l'instant: au reste nous avons déjà décrit ces presses hydrauliques dont les effets nous ont tant étonné par les différentes applications que nous en avons vues en Angleterre ... en général, nous avons remarqué qu'en Angleterre le bas prix des objets de fonte permet d'établir toute espèce de mécanisme à très-bon compte.

> [It is there that we saw for the first time the use of the hydraulic press, which pressed the water from the paper and felts from five vats. This new press has the advantage of not shaking the buildings when it is used; also, the pressure is considerably greater than that of the old screw press and one can limit the pressure as desired by simply turning a tap; the press is disengaged in an instant. We have been astonished by the different applications of the hydraulic press we have seen in England ... We have remarked that the low cost of machinery in England makes it possible for the establishment of all kinds of mechanism at a reasonable figure.][71]

We see here the change of papermaking from a craft process controlled by the vatman and the coucher, to something approaching the

modern production line. The craftsmen are now constrained in their operations by the speed of the engines (the steam-driven Hollander beaters) which supply the 'stuff,' and by the hydraulic press that squeezes the water from the paper. Industry has become a structure of machinery which human beings are compelled to serve.

Koops seems to have encouraged visitors to the Manufactory site. I have already cited the published account of the French papermaker, and in April 1802, Isaac d'Israeli wrote to Francis Douce about an old acquaintance:

> There is a mild ingenious good man & an old friend of mine, Dr Sherwen of Enfield now in Town. He is the person you walked with from Twiss's Manufactory. He is fond of Literature, & very fond of Chatterton.[72]

Thus d'Israeli, Douce, and John Sherwen all visited the Straw Paper Manufactory, though note that the letter refers to 'Twiss's Manufactory.'

Koops had been declared bankrupt on 30 June 1790. His hopes in taking out the patents and the establishment of the Straw Paper Manufactory led to an advertisement being placed in the London Gazette calling for a meeting of Koops's creditors at the Globe in Moorgate on 12 June 1801.[73] There the ebullient Koops offered to repay his creditors: he would offer four dividends, each of 5 shillings in the pound payable each quarter of the year. Matthias Koops paid the first dividend without trouble. However, when the second dividend was due on 8 December 1801, Koops begged for more time; this dividend was still unpaid by 14 October 1802.[74]

Koops's creditors then issued a writ for seizure of his household goods and furniture as well as the Straw Paper Manufactory itself to the value of £8,804 9s.4d., the remaining debt. On 3 November 1802, Samuel Lister the solicitor to the company declared that the Manufactory was not the property of Matthias Koops as he had no interest in it. However, the proprietors of the Manufactory agreed to pay Koops's debt. At the same time, possibly through an assessment of the assets of the company, the decision must have been taken to wind up its affairs because on 11 November 1802 the assets were revealed to be £3,500 but its debts were £10,500.[75] The import of rags was taxed in 1803, but this came too late to save the enterprise.[76]

On Christmas Day, 1803, the partners were served with notice to quit for failure to keep up with the rent. Twiss, a major investor in the Straw Paper Manufactory, lost most of his fortune. He wrote to Francis Douce:

I am now very little richer than Job, after he had lost everything but his patience, (as Hor. Walpole said).[77]

It must have been at this juncture that Twiss's library was dispersed, including, as I believe, his copy of Blake's *For Children: The Gates of Paradise*.[78] Twiss had learned the price of trusting the man of straw:[79]

What is the price of Experience do men buy it for a song
Or wisdom for a dance in the street? No it is bought with the price
Of all that a man hath his house his wife his children
Wisdom is sold in the desolate market where none come to buy
And in the witherd field where the farmer plows for bread in vain
(*Four Zoas*, Night 2–35: 11–15, *E* 325)

In October 1804, the premises were offered for sale by auction. With every allowance for auctioneers' exaggeration, the particulars of the sale were impressive. The drying house, 459 feet long (139.9 m), was 'the largest and most convenient in the Kingdom'; the eighty horsepower steam engine was 'universally acknowledged to be the most complete and substantial ever made'; there was a 'most excellent Turret clock' by Thwaites of Clerkenwell and stabling for twelve horses, although no more than two seem to have been bought. In addition, there was 'an elegant small bow-fronted dwelling-house three stories high, with an observatory, a patent water-closet, strong room, statuary marble chimney pieces and a wine cellar.'[80] This was evidently the superintendent's house, incorporating an 'observatory' to keep the workers under constant supervision.[81] The Manufactory would have exemplified for Blake how industrial workers are kept under the control of Urizenic forces.

A succession of Blakean themes thus clusters around the figure of Matthias Koops. Koops's major investor, the book collector Richard Twiss, is among the earliest purchasers of Blake's work. Visitors to the Straw Paper Manufactory include Francis Douce and Isaac D'Israeli, future Blake collectors.[82] Koops's business associate Elias Carpenter was an ardent follower of Joanna Southcott, as was William Owen Pughe, close friend and patron of Blake, and, like Carpenter, one of the twenty-three judges appointed by Southcott.[83] The paper mills at the Neckinger (active during Blake's years at Lambeth) and at Millbank would have provided Blake with significant insight into the operation of manufacturing industry. It may be that Blake used Neckinger Mill paper if the fragmentary '... R' watermark on pages 141–2 of *The Four*

Zoas indeed represents NECKINGER.[84] Above all, the various financial disasters associated with Koops bear out Blake's views on Commerce

> In a Commercial Nation Impostors are abroad in all Professions these are the greatest Enemies of Genius
>
> *(Public Address, 25, E 582)*

The proprietors of the Straw Paper Manufactory paid on 28 December 1805 £1,000 to the assignees of Koops's estate. The assignees had already sold Koops's household furniture and goods. The commission of bankruptcy on Matthias Koops, merchant of Edmonton, was renewed on 25 June 1812.[85] This is the last we hear of Matthias Koops.

It seems that Matthias Koops died soon after. His widow died in 1815.[86] Elizabeth Jane Koops's will was made on 6 May and proved in June 1815.[87] The very existence of her will confirms that Matthias died between 1812 and 1815; a woman then could not leave a will unless she was either a spinster or a widow, men being entitled to their wives' property on marriage. She leaves 'to my dear brother Thomas Stephens of Cowley Street Westmr 100£ East India Bond[s] with the Interest of 300£ in the four Pr Cents'; in addition, she leaves the income from a total of £2,212 in annuities to James Moreing and Ann, widow of Charles Moreing; and instructs 'my diamonds Pearls and Trinkets to be laid by for Elizth Moreing.'

Richard Twiss died, in reduced circumstances, in Somers Town in 1821. The *Gentleman's Magazine* records his death:

> [March 5] In Somers Town, at an advanced age, Richard Twiss, esq. – This gentleman has long been known in the literary circles. His first work was – 'Travels through Portugal and Spain,' written at an early period of life, and which excited much notice at the time of its publication ... He successively published 'Anecdotes of Chess,' 'A Trip to Paris,' during the revolution, and several other works. He unfortunately entered into a speculation of making paper from straw, by which he ruined an ample hereditary fortune.[88]

Matthias Koops died bankrupt twice over, but his widow still had her diamonds and pearls. Poor Twiss was left penniless. For as the old papermakers put it:

RAGS MAKE PAPER,
PAPER MAKES MONEY,

MONEY MAKES BANKS,
BANKS MAKE LOANS,
LOANS MAKE BEGGARS,
BEGGARS MAKE
RAGS.[89]

NOTES

A version of 'William Blake and the Straw Paper Manufactory at Millbank' was presented at the conference 'William Blake at Work' held at Tate Britain, Millbank, 30 April 2004. Peter Bower made available a number of papers that I should otherwise have missed. Most of the details of Matthias Koops's life derive from Richard Goulden's article in *Factotum* in 1988. I owe the suggestion that Blake allegorizes papermaking in the *Four Zoas* to C. Suzanne Matheson's Oxford DPhil thesis of 1990.

Citations from William Blake's writings follow the text established by David V. Erdman: *The Complete Poetry and Prose of William Blake*. Newly revised ed.; edited by David Erdman; commentary by Harold Bloom. Anchor books (New York NY; London: Doubleday, 1988). References to the Erdman edition are indicated with the letter *E* followed by page number.

1 S. Foster Damon, *A Blake Dictionary: The Ideas and Symbols of William Blake* (London: Thames & Hudson, 1973), 273.
2 Michael Ferber, *The Poetry of William Blake*. Penguin critical studies (London: Penguin, 1991), 117; William Blake, *The Poems of William Blake*; edited by W.H. Stevenson; text by David V. Erdman. Annotated English poets (London: Longman, 1971), 489n1.28.
3 Quoted in Paul Mantoux, *The Industrial Revolution in the Eighteenth Century*, rev. ed., translated by Marjorie Vernon, Bedford series of economic handbooks, vol. 1 (London: Jonathan Cape, 1928), 340.
4 A.D. Nuttall, *The Alternative Trinity: Gnostic Heresy in Marlowe, Milton, and Blake* (Oxford: Clarendon, 1995), 226.
5 For the burning of Albion Mill on 2 March 1781, and its grip on the popular imagination see chapter 2, 'Conflagration! The Burning of Albion Mill, Southwark in 1791,' of B.E. Maidment, *Reading Popular Prints, 1790–1970* (Manchester: Manchester University Press, 1996), 27–52.
6 Peter Ackroyd, *Blake* (London: Sinclair-Stevenson, 1995), 130. See also Jennifer Davis Michael, *Blake and the City* (Lewisburg: Bucknell University

Press, 2006), 34; and David V. Erdman, *Blake: Prophet against Empire: A Poet's Interpretation of the History of His Own Times*, 3rd ed. (Princeton NJ: Princeton University Press, 1977), 396.

7 Brian Bloice, *From Silk Mill to Superstore: The Story of Streatham Silk Mill 1820–1989* (London: Streatham Society, 2002).

8 One example of many. The horses that Blake saw with the militia forces billeted at Felpham (or paraded along Oxford Street) would have been harnessed with a bearing rein or checkrein that prevented them from lowering their heads, thus putting strain on their backs. Their tails were docked, the tailbone amputated. There was a military fashion whereby the stump of tail remaining was 'nicked,' the muscle and tendon cut so that the horse's tail became a kind of upright brush. Arab horses have small ears, and in emulation army horses had their ears cropped, the flesh of the ear cut away to make the ear 'prettier.' If the harness included a noseband, this could interfere with a horse's breathing so it would have had its nostrils slit.

> He who shall train the Horse to War
> Shall never pass the Polar Bar. ('Auguries of Innocence,' *E* 491)

England was proverbially a 'hell for horses':

> A Horse misusd upon the Road
> Calls to Heaven for Human blood. ('Auguries of Innocence,' *E* 490)

9 G.E. Bentley Jr, *Blake Books: Annotated Catalogues of William Blake's Writings in Illuminated Printing* (Oxford: Clarendon, 1977), 71 [*BB*]; and *Blake Books Supplement: A Bibliography of Publications and Discoveries about William Blake, 1971–1992, Being a Continuation of Blake Books (1977)* (New York: Oxford University Press, 1995), 40 [*BBS*], include tables of watermarks for Blake's books and manuscripts. Blake's paper has now been given detailed study by Peter Bower, 'The Vivid Surface: Blake's Use of Paper and Board,' in Joyce Townsend, ed., *William Blake, The Painter at Work* (London, Tate Publishing, 2003), 54–60.

10 Geoffrey Ashall Glaister, *Encyclopedia of the Book*, 2nd ed. (New Castle DE: Oak Knoll; London: British Library, 1996), 511. The fullest study of the topic is John Balston, *The Whatmans and Wove Paper: Its Invention and Development in the West: Research into the Origins of Wove Paper and of Genuine Loom-Woven Wire-Cloth* (West Farleigh, Kent: John Balston, 1998).

11 Alfred Henry Shorter, *Paper Making in the British Isles: An Historical and Geographical Study* (Newton Abbot: David & Charles, 1971), 60.

12 G.E. Bentley Jr has long recognized the significance of paper and paper-making to Blake studies and has made at least one abortive effort to link Blake to a papermaker: 'The Way of a Papermaker with a Poet: Joshua Gilpin, William Blake, and the Arts in 1796,' *Notes and Queries* 33 (March 1986): 80–4; and 525 (Bentley's 'Postscript': it turned out to be William Staden Blake after all).

13 Ben Weinreb and Christopher Hibbert, eds., *The London Encyclopaedia* (London: Macmillan, 1983), 537.

14 Patent no. 2075. See Bennet Woodcroft, *Alphabetical Index of Patentees of Inventions; With an Introduction and Appendix of Additions and Corrections Compiled in the Patent Office Library* (London: Evelyn, Adams & Mackay, 1969, first published in 1854), 92.

15 On Carpenter, see Alan Crocker and Stephen Humphrey, 'The Papermaker and the Prophetess: Elias Carpenter of Neckinger Mill, Bermondsey, Supporter of Joanna Southcott,' *Surrey Archaeological Collections* 89 (2002): 119–35.

16 Donald C. Coleman, *The British Paper Industry 1495–1860: A Study in Industrial Growth* (Oxford: Clarendon, 1958), 112.

17 Donald C. Coleman, 'Industrial Growth and Industrial Revolutions,' *Economica*, new series 28, no. 89 (February 1956): 4.

18 Donald C. Coleman, 'Combinations of Capital and of Labour in the English Paper Industry 1789–1825,' *Economica*, new series 21, no. 81 (February 1954): 33–4.

19 36 Geo 3. c. 111.

20 Coleman, 'Combinations of Capital and of Labour,' 41. Coleman misdates both petition and Act as 1796.

21 Arthur Chick, 'Paper from Straw: Matthias Koops in London,' *Antiquarian Book Monthly Review* (April 1985): 141.

22 René Antoine Ferchault de Réaumur, 'Histoire des guespes,' *Histoire de l'Académie Royale des Sciences. Avec les mémoires de mathématiques et de physique* (1719), 230–77.

23 René Antoine Ferchault de Réaumur, *Mémoires pour servir à l'histoire des insectes. Par M. de Réaumur*, 6 vols. (Paris: L'Imprimérie royale, 1734–1742), vi, 234. Dard Hunter's translation.

24 Dard Hunter, *Papermaking: The History and Technique of an Ancient Craft.* 2nd ed., revised and enlarged (London: Pleiades, 1947), 332.

25 R.J. Goulden, 'Koops, Matthias (fl. 1789–1805),' rev., *Oxford Dictionary of*

National Biography, Oxford University Press, 2004, accessed 10 March 2009 http://www.oxforddnb.com/view/article/37644.

26 London Metropolitan Archives. Registers of St Andrew's Parish Church, Enfield (31 May 1789).

27 City of Westminster Archives Centre. Registers of St Marylebone Parish Church (12 September 1789).

28 30 Geo. 3 c. xvi.

29 R.J. Goulden, 'The Shadow Limn'd: Matthias Koops,' *Factotum,* no. 27 (November 1988), 18.

30 Matthias Koops, *A Developement* [sic] *of the Views and Designs of the French Nation, and the Advantages which will Derive to Them, if They should be Able, by a Peace, or Otherwise, to Secure to Themselves the Free Navigation of the Rivers Rhine, Maese, and Scheldt, to Which it is Their Long Avowed Intention and Design, to Join Many of Their Numerous Navigable Rivers and Canals ... And Thereby to Monopolize the Whole Trade of Almost All the Northren* [sic] *Part of Europe; and Particularly to the Exclusion of the Trade and Manufacturers of Great Britain* (London: printed by J. Barfield and sold by Mr Stockdale, Mr Richardson; and by Mr Byrne, Dublin, 1796).

31 Matthias Koops, *Proposals for Printing and Publishing by Subscription, Correct Maps of the Rivers Rhine, Maese, and Scheldt, dedicated by permission, to His Royal Highness the Duke of York* [London, 1796].

32 *Kent's Directory for the year 1791,* the fifty-ninth edition (London: printed and sold by Richard and Henry Causton, 1791).

33 Trover (literally 'finding') is a tort, also known as Conversion, which is committed by a person who deals with chattels not belonging to him or her in a manner which is inconsistent with the activities of the person entitled to them. See Earl Jowitt and Clifford Walsh, *Jowitt's Dictionary of English Law,* 2nd ed. by John Burke, 2 vols. (London: Sweet & Maxwell, 1977). Koops here is bringing a case against a man to whom he already owes money.

34 'Law intelligence, Westminster-Hall, December 9: Koops against Mr. Deputy Chapman, and others. Before Lord Kenyon and a Special Jury,' *The Times,* issue 1753 (15 December 1790), 4.

35 *A List of Bankrupts with their Dividends, Certificates, &c. &c. for the Last Twenty Years and Six Months, viz. from Jan. 1. 1786 to June 24, 1806 Inclusiv : Distinguishing at One View the Date of Each Commission, the Number of Dividends to the Joint or Separate Estate, and When Final, the Certificate, if Obtained, and the Name and Residence of the Town and Country Solicitors to Each Estat ; the Whole Faithfully and Accurately Transcribed from the London Gazettes, and Arranged Alphabetically: Forming an Index of Commercial Information, of the*

Greatest Importance and Utility to the Banker, Merchant, Manufacturer, Trades-man, and Lawyer (London: William Smith and Co., 1806): 'Matthias Koopes [*sic*], merchant of Edmonton.'

36 *Oxford DNB.* Also G.E. Bentley Jr, *Blake Records.* 2nd ed. (New Haven and London: Yale University Press, 2004), 64–6 [*BR2*]; and *BBS* 77, 123.

37 Bodleian Library, MS. Douce d.39. The Twiss-Douce correspondence was first drawn to the attention of scholars by Joan K. Stemmler, 'Undisturbed Above Once in a Lustre: Francis Douce, George Cumberland and William Blake at the Bodleian Library and Ashmolean Museum,' *Blake/An Illustrated Quarterly* 26 (Summer 1992): 9–19.

38 Bodleian Library, MS. Douce d.39 fol. 70 (letter of Richard Twiss to Francis Douce).

39 Ibid., fol. 72. I give a fuller account of these letters and their implications for Blake studies in an essay: Keri Davies, 'Mrs Bliss: A Blake Collector of 1794,' in *Blake in the Nineties*, ed. Steve Clark and David Worrall, 212–30 (Basingstoke: Macmillan; New York: St Martin's, 1999).

40 Minerva Office, *To the Public, by the Proprietors of the Minerva Office, Pall-Mall. For Insurances on Lives, and against Fire; for Annuities, &c. Inrolled in His Majesty's Court of King's Bench at Westminster* (London, 1797). Annotated copy formerly at the Department of Health and Social Security, London.

41 Goulden, 'The Shadow Limn'd,' 19.

42 Minerva Office, *The Universal Insurance, for Lives, for Annuities, and Against Fire. Containing Fifty Classes* [London, 1800?]. The copy in Cambridge University Library bears the note referring to Twiss.

43 Chester A. Zagaski, *Environmental Risk and Insurance* (Chelsea, Mich.: Lewis Publishers, 1992), 194. Alas, Koops and Twiss were unable to insure the profits of their own ventures.

44 A point made by Erdman in *Blake: Prophet against Empire*, 334n.

45 The papermaking allegory seems to have been first noted by C. Suzanne Matheson, 'The Respective Functions of Text and Design in the Art of William Blake' (DPhil thesis, University of Oxford, 1990), 250–1.

46 Coleman, *The British Paper Industry*, 119. The eagle as both the largest size of paper and as the immensely strong men who created eagle-paper resonates with the following passage from 'The Marriage of Heaven and Hell*:

 In the third chamber was an Eagle with wings and feathers of air, he caused the inside of the cave to be infinite, around were numbers of Eagle like men, who built palaces in the immense cliffs. (*Marriage* 15, E 40)

The *Marriage*, after all, contains an allegory of its own etching and printing.

47 I follow Matheson closely here.

48 'Sur les Papeteries et Fabrication de Papier-Paille en Angleterre,' *Annales des arts et manufactures, ou mémoires technologiques*. Tome XI (Paris: Imprimerie des Annales, October–November 1803), 201–2 of 199–207. Translation modified from Hunter, *Papermaking*, 176n.

49 Matthias Koops, *Historical Account of the Substances which have been Used to Describe Events and to Convey Ideas, from the Earliest Date to the Invention of Paper. Printed on the first useful paper manufactured soley [sic] from straw.* (Printed by T. Burton, No 31 Little Queen Street, London, 1800), 10.

50 William St Clair, *The Reading Nation in the Romantic Period* (Cambridge: Cambridge University Press, 2004), 178.

51 Coleman, *The British Paper Industry*, 172.

52 Shorter, *Paper Making in the British Isles* (Newton Abbot, 1971), 41–2.

53 Coleman, 'Combinations of Capital and of Labour,' 39–40.

54 Woodcroft, *Alphabetical Index of Patentees of Inventions*, 324: Patents 2392, 2433, 2481.

55 Later, perhaps spurred by Stanhope's development of stereotyping, he makes a claim for priority of invention:

> 1822 W Blakes Original Stereotype was 1788 (Ghost of Abel, colophon, E 272).

56 See the account given in Richard L. Hills, *Papermaking in Britain 1488–1988: A Short History* (London: Athlone, 1988), 133–4. However, Crocker and Humphrey, 'The Papermaker and the Prophetess,' point out that considering Koops's background, 'it is difficult to accept that Koops was responsible for the papermaking innovations revealed in his patents which clearly involved a thorough understanding of applied chemistry' (121).

57 Matthias Koops, *Historical Account of the Substances which have been Used to Describe Events, and to Convey Ideas, from the Earliest Date, to the Invention of Paper* [2nd ed.] (London: printed by Jaques & Co., 1801), 250–1. Dennet Jaques had been a printer in Chichester for a few years before moving to London, and printed William Hayley's *Ode to Mr Wright of Derby* (Chichester: printed by Dennett Jaques, 1783). A jobbing printer, his connection with both Koops and Hayley is probably coincidental.

58 Matthias Koops, *Historical Account of the Substances which have been Used to Describe Events, and to Convey Ideas, from the Earliest Date, to the Invention of Paper* (London, 1800), 78n.

59 Richard L. Hills, 'Some Notes on the Matthias Koops Papers,' *The Quar-*

terly: The Review of the British Association of Paper Historians, no. 2 (August 1990): 3.

60 Ibid.

61 Hunter, *Papermaking*, 332.

62 Ibid., 338.

63 Goulden, 'The Shadow Limn'd,' 18. The Grosvenor Estate archives are held by the City of Westminster Archives Centre. In the history of Matthias Koops, men named Cope and Cooper appear transiently and are never heard from again.

64 Chick, 'Paper from Straw,' 143. Drawings of the layout of this paper mill and its steam engine exist in the Boulton & Watt archives in Birmingham (portfolios 289 and 294), but there seems to be no surviving correspondence.

65 Chick, 'Paper from Straw,' 143.

66 Coincidentally, Rennie's civil engineer son George was friendly with John Linnell. See *BR2*, 410. The Linnell Archive, now in the Fitzwilliam Museum, Cambridge, contains five letters from George Rennie to Linnell.

67 National Library of Scotland, MS 19874 (Rennie Papers), fol. 1v. Search has so far failed to locate any reference to the engraver William Blake.

68 Hills, 'Some Notes on the Matthias Koops Papers,' 3.

69 Hills, *Papermaking in Britain*, 135.

70 Cited in ibid., 59.

71 'Sur les papeteries et fabrication de papier-paille en Angleterre,' *Annales des arts et manufactures, ou Mémoires technologiques*, Tome XI (October–November 1803), 200–1. Translated in Hunter, *Papermaking*, 201–2n.

72 Bodleian Library, MS Douce d 33 (Letters of Isaac d'Israeli to Francis Douce), fol. 24. John Sherwen, surgeon and apothecary, published in 1809 his *Introduction to an Examination of Some Part of the Internal Evidence respecting the Antiquity and Authenticity of Certain Publications, Said to Have Been Found in Manuscripts, at Bristol, Written by a Learned Priest and Others, in the Fifteenth Century; But Generally Considered as the Suppositious Productions of an Ingenious Youth of the Present Age* (Bath: Printed by Meyler and Son, adjoining the great pump-room; for Longman, Hurst, Rees, and Orme, London., 1809). From 1808 to 1813 he was a frequent contributor to the *Gentleman's Magazine*, mainly on the authenticity of the 'Rowley' poems, Thomas Chatterton's literary forgery, of the genuineness of which he was a keen advocate. Henry Julian Hunter, *Old Age in Bath: Recollections of Two Remarkable Men: Dr John Sherwen and Dr Francis Cogan* (Bath, 1873), casts a jaundiced eye on Sherwen's medical career:

In 1805, Dr Sherwen now M.R.C.S. and M.R.C.P. (in which he was

not quite correct) and a corresponding member of the Medical Society of London, came to live at Bath. He came to us as a graduated physician, though at Enfield I believe I must own, he sold 'narcoticum, emeticum et omne quod exit in hum.' (6)

Though Sherwen retained his house at Bath he made frequent trips to Enfield, and died there on 2 September 1826.

73 *London Gazette*, no. 15372 (2–6 June 1801): 'The Creditors who have proved their Debts under a Commission of Bankrupt awarded and issued forth against Matthias Koops, otherwise Koops Von Ernst, of Edmonton, in the County of Middlesex, Merchant, are desired to meet the Assignees of the said Bankrupt's Estate and Effects, on Friday the 12th of June instant, at One o'Clock in the Afternoon, at the Globe Tavern, Moorgate, to assent to or dissent from a Proposal intended to be made by the said Bankrupt for liquidating so much of the Debts due from the said Bankrupt, and proved under the said Commission, as still remain unsatisfied, and to authorise the said Assignees to accept Security for the Payment thereof; and on other special Affairs' (626).

74 Goulden, 'The Shadow Limn'd,' 20.

75 Hills, 'Some Notes on the Matthias Koops Papers,' 5.

76 Hills, *Papermaking in Britain*, 134.

77 Bodleian Library, MS Douce d.39, fol. 104. ('Thurd 1 Decr, [180]3').

78 Bentley (*BBS* 77) suggests this was copy B, acquired by Samuel Lysons before 1820.

79 Arthur Chick's phrase. For the plight of the journeymen employed at Millbank, see Richard Hills, 'Christmas at Matthias Koops Mill, 1802,' *The Quarterly: The Review of the British Association of Paper Historians*, no. 9 (January 1994): 13.

80 *Extensive Premises … Which Will Be Sold by Auction, by Messrs. Robins, at Garraways's Coffee-House, Exchange-Alley, Cornhill. On Saturday, October 27, 1804 at Twelve o'Clock in One Lot.* Cited in Chick, 'Paper from Straw,' 141.

81 Observatory: 'a place of observation' (*Oxford English Dictionary*).

82 For Douce's Blake books, see *BB*, 118, 122, 128, 134, 138, 289, 298; for the D'Israeli collection, see *BB*, 77, 91, 100, 103, 118, 127, 146, 156–57, 170, 180, 289, 384, 412, 465.

83 Frances Brown, *Joanna Southcott's Box of Sealed Prophecies* (Cambridge: Lutterworth, 2003), 288. Carpenter was to sponsor Joanna Southcott's third 'trial' at Neckinger House in 1804.

84 However, Bentley (*BB* 453) suggests that '…R' may be part of the watermark of I TAYLOR.

85 National Archives, Bankruptcy commissions: files, B3/2804.
86 *Oxford DNB.*
87 National Archives, Records of the Prerogative Court of Canterbury, PROB 11/1569/320.
88 Obituary: with Anecdotes of Remarkable Persons,' *Gentleman's Magazine* 91, part 1 (1821): 284.
89 Author unknown, circa eighteenth century, cited in Hunter, *Papermaking*, iii.

Epilogue: A Memorable Fancy

JEROME MCGANN

One of my favourite passages in Blake is this parable of the two classes of men, the Prolific and the Devouring, in the printing house in hell, in *The Marriage of Heaven and Hell* (plates 16–17):

> The Giants who formed this world into its
> sensual existence and now seem to live in it
> in chains, are in truth the causes of its life
> & the sources of all activity, but the chains
> are the cunning of weak and tame minds which
> have power to resist energy, according to the pro-
> verb, the weak in courage is strong in cunning.
> Thus one portion of being is the Prolific, the
> other the Devouring: to the devourer it seems as
> if the producer was in his chains, but it is not so,
> he only takes portions of existence and fancies
> that the whole.
> But the Prolific would cease to be Prolific
> unless the Devourer, as a sea, received the excess
> of his delights.
> Some will say: 'Is not God alone the Prolific?'
> I answer: 'God only Acts & Is, in existing beings
> or Men.'
> These two classes of men are always upon
> earth, & they should be enemies; whoever tries
> to reconcile them seeks to destroy existence.

Now that text has been much discussed, often interpreted, as we know. But I only am escaped alone to tell you what it means.

Simply, it depicts a vision, which is the giant form of G.E. Bentley Jr.

And because G.E. Bentley Jr is what the poet called 'the Ancient Man' (not to worry, GEB: The Man's actually ageless), it is also the visionary form of everybody in this book, the children of the Ancient Man. (But not me. I am the only kangaroo among these beauties.)

Isn't it all obvious? Do I have to explain?

Ok. I'll explain. I hear the Bard's terrific song. Even kangaroos will be gathered into this great harvest.

As we know from Blake, everything external is actually internal. So these two classes of men are 'in truth' the spiritual identity of that one and only Man, the Supreme Fiction, the Essential Man, G.E. 'Jerry' Bentley Jr.

So far so good?

Now, what is GEB's Giant Form, his Prolific Being? Easy. All those books and essays turned out from his Printing House in Hell: clearing away rubbish, building and decorating immense bibliographical palaces, setting us all on fire, melting us away in admiration, etc etc. Scholarship rules! Minute particulars! Portions of Eternity too great for the eye of man.

But not too great for the eye of the Giant Man. No particular is too great.

But there is a war within his members. These are the torments of love and jealousy. (Don't we all love G.E. Bentley Jr? Don't we all wish we were him? We do, we definitely do. Even he wishes sometimes he were him.)

And what *is* this war within his members? Weak and tame minds, those denizens of Ulro, imagine the Giant Man toiling in pedantic chains. 'But it is not so.' The raging Genius of the Giant Man sometimes needs to cool off from his immense labours. Hence that delightful sea. (Ah those Sunday baths, those tootings of the soul – sorry, that's another poet talking. One gets carried away.)

Like Homer, sometimes G.E. Bentley Jr has been known to nod

devouringly. In Eternity that's called Interpretation – Swedenborg (he has many names) trying to fashion meaning from the clothes the Giant Man has already left behind. Look, up in the sky.

When thou seest an Eagle, thou seest a portion of Genius. Lift up thy head!

He's already flying off to another library, a little bookstore, perhaps even a sale room ... leaving me here to hold a candle in his sunshine.

Somebody has to do it.

Appendix
William Blake in Toronto: The Bentley
Collection at Victoria University Library

ROBERT BRANDEIS

In *The Great Code*, Northrop Frye invokes the prologue to Blake's *Marriage of Heaven and Hell* in the context of the fertility imagery in *Isaiah* 35: 18ff and of Blake's expansion of the passage into an image of growth, from an empty wilderness 'into a broad and crowded trade route.'[1] It is tempting to apply Frye's commentary to the growth and development of the Bentley Collection from its early beginnings in 1952 when G.E. Bentley Jr (hereafter GEB) was an undergraduate at Princeton and beginning serious book collecting, to the acquisition of its 'high spot' copy M of *The Marriage of Heaven and Hell* in 1997, and beyond. It is also tempting to see a delightful symmetry in 'The Bentley Collection of William Blake and his Contemporaries' finding its place with the Northrop Frye archives, which include Frye's annotated books, in Victoria University Library.[*]

The story of the Bentleys, and their more than fifty years of collecting adventures, is recounted in his own catalogue listing of the collection[2] and in a more accessible form in his article in *Papers of the Bibliographical Society of Canada* in 2007.[3] The inspired title of the article, 'Bibliomania: The Felicitous Infection and the Comforting Cure' focuses on the 'bibliomania' of GEB and his wife Elizabeth as a 'felicitous infection,' and I would like here to outline the extent of the infection and its ultimate successful 'comforting cure.'

GEB's achievement in the world of Blake bibliography, biography, and scholarship is well known and his collecting efforts have been necessarily directed at supporting that achievement. Books, manuscripts, and prints were acquired with an eye to their utility: fine bindings or

[*] Victoria University, founded in 1836, is federated with the University of Toronto.

nuances of condition were usually secondary considerations. As GEB himself admits 'the condition of the books is, more often than I can contemplate with equanimity, frequently less than perfect, in tattered covers, with boards loose or missing ... These ... were often the best copies I felt we could afford, and sometimes I thought that if I did not buy this copy I would never see another. I do not regret buying them, but wish they were better.'[4] However, many of the volumes in the Bentley collection are nevertheless better than GEB implies, and, in fact, due to the support of the Friends of Victoria University Library for restoration work, many of these volumes have become considerably better.

The Bentley Collection, as described in his 2005 catalogue, consists of more than 2,400 items. Especially well represented are editions and issues of Blake's writings (1788–1988), Blake's art (1790–1980), and Blake's commercial book engravings (1781–1997), totalling more than 475 items. Catalogues (1790–2004) with Blake and items of contemporary relevance relating to auctions, exhibitions, and booksellers number in excess of 350 items. The general literature section is well populated with Blake's contemporaries: more than 700 items including work by Flaxman, Fuseli, Hayley, Stothard, and especially the extensive George Cumberland manuscripts (c. 1788–1831) greatly increase the utility and research potential of the collection.

Given the size and content of the collection it is difficult to limit discussion to only a few items, for along with such things as an original drawing of a 'Visionary Head' (no. 635), the 'The Riddle Manuscript' (no. 417), and copy M of *The Marriage of Heaven and Hell* (no. 394), the central core of the Bentley Collection focuses on books containing Blake's engravings and related individual prints, such as a proof copy of the *Illustrations of the Book of Job* (no. 667) and Blake's *Illustrations to Dante* (no. 707) (see plate 13, this volume).

Before its transfer to Victoria University Library the Bentley Collection was known to scholars as one of the largest gatherings of Blake's commercial book illustrations in a private collection. This section of the collection not only reveals the extent of Blake's commercial work, for after 1782 he had to support both himself and his wife Catherine, but also the way in which he had to contend with the contrary impulses of his own imaginative art as a creative artist and the necessarily restrained use of his skill as a copy engraver. The two do, of course, merge from time to time, as in Blake's woodcuts from his own designs for the 1821 third edition of Thornton's *The Pastorals of Virgil* (no. 787)

and perhaps equally, or at least more famously, in his collaboration with William Hayley.

Blake designed, engraved, and printed the plates to illustrate Hayley's *Ballads* (1802) which were to be published for his benefit. As GEB points out the project was a failure and 'probably only a few dozen sets were sold,'[5] and very few can be traced in public collections today. The Bentley collection contains an important group of Hayley's publications and of Blake's work for them. In addition to the 1802 *Designs to a Series of Ballads* (no. 729), there are the 1805 *Ballads*, bound separate additional prints from that edition, including earlier states of three plates, *The Dog, The Eagle*, and *The Lion* (no. 728).

The other Hayley titles with Blake plates include various editions of *The Life and Posthumous Writings of William Cowper*, including an extra illustrated one (no. 731), and editions of *The Triumphs of Temper* including a large paper copy from 1803 with an inserted draft of a Hayley letter, which GEB suggests is addressed to Erasmus Darwin on the occasion of the death of Josiah Wedgwood (no. 735).

Elizabeth Bentley's purchase of the five Blake prints from Hayley's 1805 *Ballads* at a Christie sale includes a bibliographically interesting copy of Robert Blair's *The Grave* (1808). This was a copy subscribed to by Robert Scott of Edinburgh and contains a description by his son, subsequently quoted in Gilchrist's *Life of William Blake*, as well as a sonnet by W.B. Scott, 'On seeing again after many years William Blake's designs for *The Grave*' (no. 681). The fact that there are multiple copies and editions of this title (nos. 681–91) allows for close examination and comparison of the plates and for the discovery of other bibliographic variants as well.

Several items in the 'Blake Writings' section of the collection (nos. 343–603) merit special attention. The previously mentioned *Marriage of Heaven and Hell* (copy M) is undoubtedly one of the important high spots of the collection and, as GEB has stated is the 'most important and the most exciting "book" we attempted to buy.'[6] Copy M of *The Marriage*, like copy L, consists of three plates, plates 25–27, printed on one folded sheet forming four pages with the first page left blank, suggesting perhaps that Blake printed it this way to create a separate pamphlet. The three plates contain all of *A Song of Liberty*. Copy M, however, is unique in that part of the design, while etched, has not been inked, and a close examination of the plate reveals important details of Blake's working methods (see plate 14, this volume).

GEB has suggested that 'Blake was still adjusting the text and designs when he made copy M' and in examining those adjustments, he concludes that acquiring *The Marriage of Heaven and Hell* copy M 'revealed details of Blake's work as author, artist, and printer which are not revealed in any other known copy.'[7]

The story of the acquisition of copy M and of Elizabeth Bentley's adventures with London booksellers and her ultimate success at obtaining this unique example of Blake's work[8] is a prelude to its subsequent scholarly examination[9] and to its presence at various international exhibitions. It was part of the major Blake exhibition at Tate Britain, London in 2000–1, at Victoria University, Toronto, in 2006 and, along with the *London* plate from *Songs of Innocence and of Experience* (no. 434 plate 46), at the Petit Palais in Paris in 2009 at the first Blake retrospective exhibition in France since 1947.

'The Riddle Manuscript' (no. 417) is another interesting and unique item. Not only is it the only Blake manuscript in Canada, but it is also something 'which has not been seen before in its connection with Blake – for that matter, nothing like it has been seen since.'[10] The verso of the manuscript, argues Bentley, 'is a proof before letters of Blake's fourteenth engraving (dated 9 September 1802 in the published state) for Hayley's *Designs to a Series of Ballads* (1802). The leaf was trimmed to conform to the proof.' Since it is obvious that the trimming removed the beginnings of lines and probably some lines at the top of the leaf, it is safe to assume that the manuscript was present before the proof was pulled. GEB suggests that the manuscript may be 'a list of riddles playing with words – "love lie Girl = Lovely Girl".' Other suggestions include such correspondences as 'an ELL ['L'] taken from London is Undone [ondon]' and 'Love Errs' is equivalent to 'Lovers.'[11] The manuscript was described and reproduced in Bentley's 1969 article in *Library* and subsequently in the Victoria University 2006 exhibition catalogue.[12] (See plate 15, this volume.)

Another serendipitous find was nine prints for *Songs of Innocence and of Experience* (no. 434). GEB 'was astonished' to find them in Blackwell's who had obtained them late the previous year at Sotheby's. Without hesitation GEB purchased them.[13] The plates were printed posthumously by Frederick Tatham in 1831 and only a limited number of these loose prints from *Songs* are known. The Bentley collection already had an important posthumous print, plate 39 *The Sick Rose* from copy O, originally in the collection of Charles Eliot Norton (no. 433), and the new additions created a significant group.

Complementing the prints from *Songs of Innocence and of Experience* are sixteen electrotypes (no. 435). Alexander Gilchrist had electrotypes made from Blake's original copperplates which Frederick Tatham had taken after Catherine Blake's death. The copperplates were subsequently lost. These electrotypes were used in Gilchrist's 1863 *Life of William Blake, 'Pictor Ignotus,'* but were destroyed by Macmillan in the early 1960s. Before that, however, electrotypes of them were made for Geoffrey Keynes which he subsequently gave to the Victoria and Albert Museum in 1955. Electrotype reproductions were made for the Fitzwilliam Museum from the Victoria and Albert set and eventually for GEB in 1964 from the Fitzwilliam set.[14] Only three sets of the electrotypes are known, the Bentley set being the only one in North America. The electrotypes are important since they are exact copies of most of the surface of Blake's copperplates and thus useful for knowing about the state of the plates when Blake etched them and for studying and understanding his methods.

The focus of the Bentley collection as signalled on the title page of Bentley's own catalogue is 'Illustrated Books c. 1770–1830 chiefly those written or illustrated by William Blake, George Cumberland and John Flaxman.' In fulfilling the objective of that focus, the Bentleys 'looked especially for works connected with Blake's intimate friends "Dear Cumberland" and John Flaxman, his "Dear Sculptor of Eternity."'[15] Fortunately for the collection and for future researchers the Bentleys were able to acquire the George Cumberland Archive, 'the only significant collection of Cumberland's manuscript writings aside from his very voluminous letters in the British Library Department of Manuscripts.'[16]

The Cumberland manuscripts and related material (nos. 986A–1004) reveal various aspects of this painter, geologist, printmaker, agricultural experimentalist, critic, draftsman, biographer, novelist, and Blake's long time friend. In addition to extensive correspondence and miscellaneous manuscript material, several items in particular need special mention: the Commonplace Book of 1789–1800 with notes about Coleridge, Wordsworth, and Blake on printing from copper plates; the large Sketchbook with 129 leaves containing mounted sketches, usually more than four or five to a page and dating from 1788–1823; letters from and anecdotes of John Horne Tooke; a fair copy of *The Emigrants or a Trip to the Ohio*, a dramatic farce written circa 1800–5; and a manuscript of the suppressed second part of *The Captive of the Castle of Sennaar: An African Tale*, 1798. Both parts were later edited and published by Bentley.[17] The Cumberland Archive contains such a wealth of original

material that any serious study of the man and his work cannot afford to ignore this resource.

GEB has suggested that the cure for his collecting 'addiction was to get someone else to take the books and prints and manuscripts and busts and drawings and paintings and periodicals off our hands' and to 'shift the responsibility for preserving them for posterity to someone else.'[18] Since the collection was formed largely to support his scholarly work (rather than his addiction), the shifting of responsibility to Victoria University Library has brought with it the obligation to grow the collection upon the principles already established. And indeed, the Bentley collection has grown with some significant major additions.

Three additional plates from copy 'O' of *Songs of Innocence and Experience*, 'Nurses Song' from *Innocence*, 'Nurses Song' from *Experience*, and 'The School Boy' join 'The Sick Rose' (no. 433). To these have been added the Blake printed and coloured 'Spring' plate 23 from *Songs of Innocence*, which is one of only three known examples of designs from *Innocence* printed in colour (see plate 16, this volume).

There have also been significant additions to Blake's commercial engravings, including his stipple and line engraving of Stothard's *The Fall of Rosamond* (1783) and two oval stipple engravings, *Morning Amusement* and *Evening Amusement*, after Watteau's *le rendez-vous de chasse*, 1720. The engravings, dated 1782, were the first prints done by Blake after completing his apprenticeship (see plates 17, 18, and 19, this volume).

Other examples of Blake's commercial work are contained in the recently acquired *1825 Remember Me! A New Years Gift Or Christmas Present*, which includes his last plate, *The Hiding of Moses*. Copy 2 of *Remember Me* is in an original binding and with the original decorated protective sleeve or slip case (see plate 20, this volume). Many other Blake plates are contained in an extra illustrated copy of Bray's *Life of Thomas Stothard* (1851), its original two volumes now extended to ten. To date more than one hundred additional items have been added to the Bentley collection.

The former keeper of rare books at the New York Public Library Bernard McTigue has been quoted as stating that 'private collectors have always been the people who put the pieces together ... it is their passion that builds these collections, along with their energy, their resources, and their expertise ... and if we're lucky they turn it over to us intact.'[19] GEB recognized that Victoria University Library 'was a wonderfully appropriate place for the Blakes,' for not only does it have

the Northrop Frye Archives but it also 'has one of the world's great collections of the works in manuscript and print of Blake's contemporary Samuel Taylor Coleridge.'[20] The Bentley Collection was formed to support scholarship, to be used for research, teaching, and learning. It is the use of rare books and manuscripts which justify the collection and the preservation of them and their presence at Victoria University Library will maintain that objective.

NOTES

1 Northrop Frye, *The Great Code* (New York and London: Harcourt Brace Javanovich, 1981), 161.

2 G.E. Bentley Jr, 'GEB Books: Illustrated Books c.1770–1830, chiefly those written or illustrated by William Blake, George Cumberland, John Flaxman or published by F.J. Du Roveray, John, Richard, and Thomas Edwards, Thomas Macklin plus English Bibles before 1830 and related Scholarship in the Collection of G.E. Bentley Jr.' Given by Beth and Jerry Bentley in 2005 to Victoria University Library (Toronto). (Unpublished: a paper based on the narrative material in the catalogue was given as the Seventh Annual F. David Hoeniger Lecture to Friends of Victoria University Library in Toronto in 2007.) An edited version of the catalogue with items numbered for identification is available at http://library.vicu.utoronto.ca/special/ bentley/blake_collection.htm.

3 G.E. Bentley Jr, 'Bibliomania: The Felicitous Infection and the Comforting Cure,' *Papers of the Bibliographical Society of Canada* 45, no. 1 (Spring 2007): 7–41.

4 Ibid., 38.

5 Ibid., 12–14.

6 Ibid., 31.

7 Ibid., 38.

8 Ibid., 31–8.

9 *Blake/An Illustrated Quarterly* (1998).

10 Bentley, 'Bibliomania,' 27.

11 Ibid.

12 Bentley, 'A New Blake Document: The "Riddle Manuscript",' *Library* 24 (1969): 339; Robert C. Brandeis, *William Blake and His Contemporaries: An Exhibition Selected from the Bentley Collection at Victoria University* (Victoria University Library, Toronto, 30 October–15 December 2006), 11.

13 Bentley, 'Bibliomania,' 17.

14 Ibid., 26–7.
15 Ibid., 30.
16 Ibid., 31.
17 Bentley, ed., *The Captive of the Castle of Sennaar: An African tale in Two Parts: Part 1 The Sophians (Printed in 1798 and 1810), Part 2 The Reformed (Manuscript of c. 1800)* (Montreal, Kingston, London, Buffalo: McGill-Queen's University Press, 1991).
18 Bentley, 'Bibliomania,' 40.
19 Nicholas A. Basbanes, *A Gentle Madness: Bibliophiles, Bibliomanes, and the Eternal Passion for Books* (New York: Henry Holt, 1995), 357.
20 Bentley, 'Bibliomania,' 40.

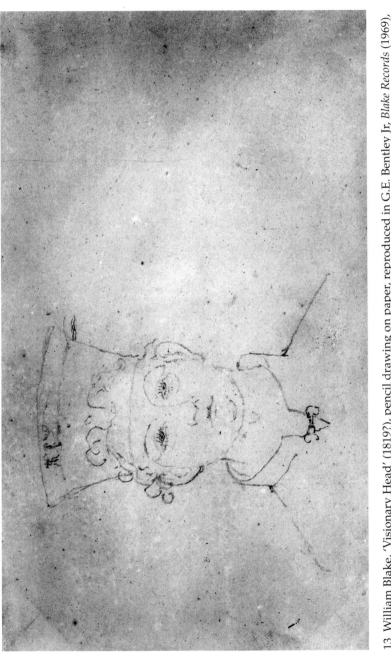

13 William Blake, 'Visionary Head' (1819?), pencil drawing on paper, reproduced in G.E. Bentley Jr, *Blake Records* (1969), at page 259. First owned by John Varley. All images courtesy of Victoria University Library in the University of Toronto

14 William Blake, *The Marriage of Heaven and Hell* (copy M) (1793?), 'A Song of Liberty,' plates 25, 26, and 27

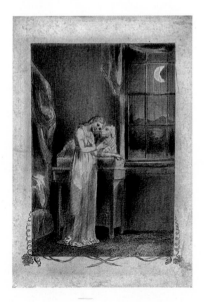

15 William Blake, 'The Riddle Manuscript' (1802?). On the verso is a proof before letters of Blake's 12th engraving (dated 9 September 1802 in the published state) for Hayley's *Designs to A Series of Ballads* (1802)

16 William Blake, *Songs of Innocence and of Experience*, 'Spring,' plate 23 (1789–94)

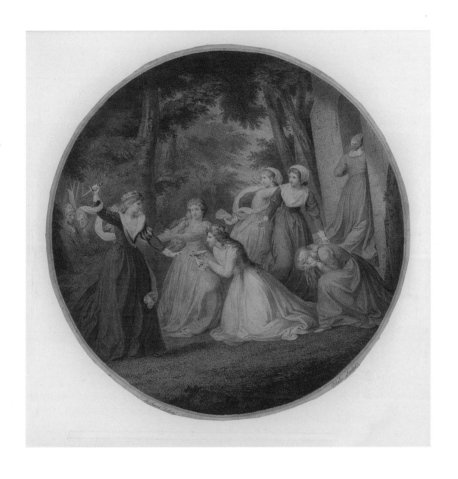

17 William Blake, *The Fall of Rosamond* (1783), Stothard Delin; Blake Sculpt

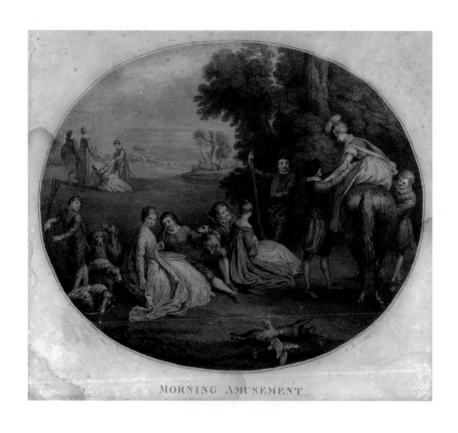

MORNING AMUSEMENT

18 *Morning Amusement*, Watteau Pinxt; W. Blake sculpt (1782)

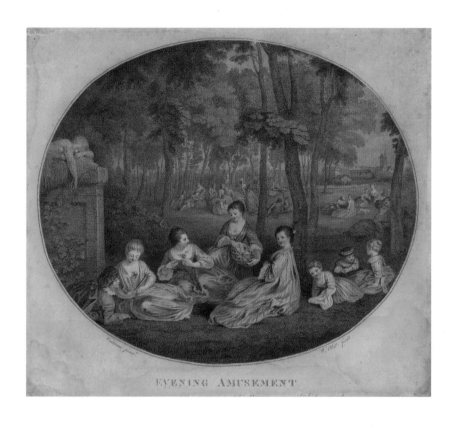

19 *Evening Amusement*, Watteau pinxt; W. Blake fecit (1782)

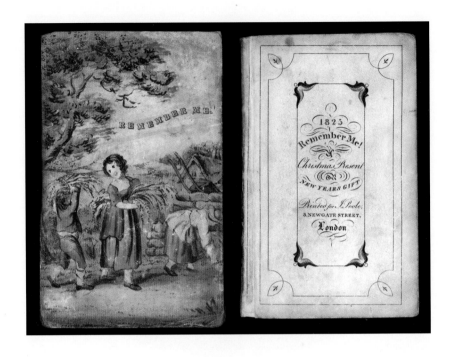

20 *1825 Remember Me! Christmas Present Or New Years Gift*

Selected Bibliography

Ackroyd, Peter. *Blake.* London: Sinclair-Stevenson, 1995.

Balston, John. *The Whatmans and Wove Paper: Its Invention and Development in the West: Research into the Origins of Wove Paper and of Genuine Loom-Woven Wire-Cloth.* West Farleigh: John Balston, 1998.

Barker, Elizabeth, and Colin Harrison and William Vaughan. *Samuel Palmer 1805–1881: Vision and Landscape.* London: British Museum, 2005.

Benjamin, Walter. 'The Work of Art in the Age of Mechanical Reproduction.' http://www.marxists.org/reference/subject/philosophy/works/ge/benjamin.htm.

Bentley, G.E., Jr. *A Bibliography of George Cumberland (1754–1848).* New York and London: Garland, 1975.

– 'Blake and Cromek: The Wheat and the Tares.' *Modern Philology* 71 (1974): 366–79.

– *Blake Books: Annotated Catalogues of William Blake's Writings in Illuminated Printing.* Oxford: Clarendon, 1977.

– *Blake Books Supplement: A Bibliography of Publications and Discoveries about William Blake, 1971–1992, Being a Continuation of Blake Books (1977).* New York: Oxford University Press, 1995.

– *The Blake Collection of Mrs. Landon K. Thorne.* New York: Pierpont Morgan Library, 1971.

– 'Blake, Hayley and Lady Hesketh.' *The Review of English Studies* 7 (1956): 265–86.

– 'Blake's Heavy Metal. The History, Weight, Uses, Cost and Makers of His Copper Plates.' *University of Toronto Quarterly* 76, no. 2 (2007): 759.

– *Blake Records.* Oxford: Clarendon, 1969.

– *Blake Records.* Second Edition. New Haven and London: Yale University Press, 2004.

– 'Cromek's Lost Letter about Blake's *Grave* Designs.' *Blake/An Illustrated Quarterly* 26, no. 4 (1993): 160.
– 'The Date of Blake's Pickering Manuscript.' *Studies in Bibliography* 19 (1966).
– 'The Death of Blake's Partner James Parker.' *Blake/An Illustrated Quarterly* 30, no. 2 (1996): 49–51.
– 'The Journeyman and the Genius: James Parker and His Partner William Blake with a List of Parker's Engravings.' *Studies in Bibliography* 49 (1996): 208–31.
– '"Rex v. Blake": Sussex Attitudes toward the Military and Blake's Trial for Sedition in 1804.' *Huntington Library Quarterly* 56 (Winter, 1993): 83–9.
– 'Ruthven Todd's Blake Papers at Leeds.' *Blake/An Illustrated Quarterly* 16 (1982): 72–81.
– *The Stranger from Paradise*. New Haven: Yale University Press, 2001.
– 'Thomas Butts, White Collar Maecenas.' *PMLA* 71 (1956): 1052–66.
– 'The Unrecognized First Printing of Flaxman's *Iliad* (1793)' *A & B: Analytical & Enumerative Bibliography* ns 9 (1995): 102–20.
– 'The Way of a Papermaker with a Poet: Joshua Gilpin, William Blake, and the Arts in 1796.' *Notes and Queries* 33 (March 1986): 80–4 and 525 ('A Postscript').
– ed. *William Blake: The Critical Heritage*. London: Routledge, 1975.
Besant, Walter. *London City*. London: Adam and Charles Black, 1910.
Bindman, David. *Blake as an Artist*. Oxford: Phaidon, 1977.
Binyon, Laurence. *The Followers of William Blake*. London: Halton & Truscott Smith, 1925.
Bishop, Morchard, *Blake's Hayley The Life, Works, and Friendships of William Hayley*. London, 1951.
Blake, William. *The Complete Poetry and Prose of William Blake*. Newly revised ed., edited by David Erdman, with commentary by Harold Bloom. Anchor Books. New York, NY; London: Doubleday, 1988.
– *Drawings of William Blake: 92 Pencil Studies*. Edited by Sir Geoffrey Keynes. New York: Dover, 1970.
– *The Poems of William Blake*. Edited by W.H. Stevenson, with text by David V. Erdman. Annotated English Poets. London: Longman, 1971.
– *Vala or The Four Zoas*. Facsimile edition, edited by G.E. Bentley Jr. Oxford: Clarendon, 1963.
Bloice, Brian. *From Silk Mill to Superstore: The Story of Streatham Silk Mill 1820–1989* London: Streatham Society, 2002.
Blunt, Anthony. *The Art of William Blake*. New York: Harper & Row, 1974.
Bond, Francis. *Wood Carvings in English Churches*. London: H. Frowde [Oxford University Press], 1910.

Bower, Peter. 'The Vivid Surface: Blake's Use of Paper and Board.' In *William Blake, The Painter at Work*, edited by Joyce Townsend, 54–60. London, Tate Publishing, 2003.

Bradley, Simon, and Nikolaus Pevsner, *London: The City Churches*. New Haven: Yale University Press, 1998.

Brandeis, Robert C. *William Blake and His Contemporaries: An Exhibition Selected from the Bentley Collection at Victoria University*, 30 October–15 December 2006. Catalogue of the exhibition.

Broich, Ulrich, *The Eighteenth-Century Mock-Heroic Poem*. Translated by David Henry Wilson. Cambridge: Cambridge University Press, 1990.

Brooks, Brian, and Cecil Humphrey-Smith. *A History of the Worshipful Company of Scriveners of London*. London: Phillimore, 2001.

Brown, Frances. *Joanna Southcott's Box of Sealed Prophecies*. Cambridge: Lutterworth, 2003.

Butlin, Martin. *The Paintings and Drawings of William Blake*. 2 vols. London and New Haven: Yale University Press, 1981.

– *Samuel Palmer: The Sketchbook of 1824*. Thames and Hudson, 2005.

– *William Blake 1757–1827: Tate Gallery Catalogues*. London: 1990.

Butlin, Martin, Simon Martin, and Robert Merick. *Poets in the Landscape: The Romantic Spirit in British Art*. Chichester: Pallant House Gallery, 2007.

Butts, Mary. *The Crystal Cabinet*. London: Methuen, 1937.

Cattermole, M.J.G., and A.F. Wolfe. *Horace Darwin's Shop: A History of The Cambridge Scientific Instrument Company, 1878 to 1968*. Bristol and Boston: Adam Hilger, 1987.

Chapman, Hugo. *Michelangelo Drawings: Closer to the Master*. London: British Museum, 2005.

Chichester Guide, and Directory. Chichester: Seagrave, 1804.

Chick, Arthur. 'Paper from Straw: Matthias Koops in London.' *Antiquarian Book Monthly Review* (April 1985): 140–4.

Coleman, Donald C. *The British Paper Industry 1495–1860: A Study in Industrial Growth*. Oxford: Clarendon, 1958.

– 'Combinations of Capital and of Labour in the English Paper Industry 1789 1825.' *Economica*, new series 21, no. 81 (February 1954): 32–53.

– 'Industrial Growth and Industrial Revolutions.' *Economica*, new series 28, no. 89 (February 1956): 1–22.

Colvin, Sidney. *Memories and Notes of Persons and Places, 1852–1912*. New York: C. Scribner's Sons, 1921.

Cox, Philip. 'Blake, Hayley, and Milton: A Reassessment.' *English Studies* 75 (1994): 430–41.

Crocker, Alan, and Stephen Humphrey. 'The Papermaker and the Prophetess:

Elias Carpenter of Neckinger Mill, Bermondsey, Supporter of Joanna South-cott.' *Surrey Archaeological Collections* 89 (2002), 119–35.

Croft-Murray, Edward. 'Lambert Barnard, an early English Renaissance Painter.' *Archaeological Journal* 113 (1957): 108–25.

Crosby, Mark. '"The Sweetest Spot on Earth": Reconstructing Blake's Cottage at Felpham, Sussex.' *British Art Journal* 7, no. 3 (Winter 2006/7): 46–53.

– 'William Blake's Miniature Portraits of the Butts Family.' *Blake/An Illustrated Quarterly* 42, no. 4 (2009): 137–52.

– 'William Hayley's Benevolent Gift: *The Triumphs of Temper.*' *Bodleian Library Record* 22, no. 1 (2009): 101–8.

Curry, Kenneth. 'Southey's Portraits.' *Wordsworth Circle* 5, no. 2 (Spring 1974): 67–71.

Dallaway, James. *A History of the Western Division of the County of Sussex. Including the Rapes of Chichester, Arundel, and Bramber, with the City and Diocese of Chichester.* 2 vols. London: T. Bensley, 1815–32.

Damon, S. Foster. *A Blake Dictionary: The Ideas and Symbols of William Blake.* London: Thames & Hudson, 1973.

Davies, Keri. 'Mrs Bliss: a Blake Collector of 1794.' In *Blake in the Nineties*, edited by Steve Clark and David Worrall. Basingstoke: Macmillan; New York: St Martin's, 1999.

– 'William Blake in Contexts: Family, Friendships, and Some Intellectual Microcultures of Eighteenth- and Nineteenth-Century England.' PhD diss., University of Surrey, 2003.

De Luca, Vincent Arthur. *Words of Eternity: Blake and the Poetics of the Sublime.* Princeton: Princeton University Press, 1991.

Dörrbecker, D.W. 'The Reader Viewing the Reader Reading: Romney's Serena Liest in Hayley's *The Triumphs of Temper.*' *Entrée aus Schrift und Bild*, 162–250. Berlin, 2008.

Elliot, David. *Charles Fairfax Murray: The Unknown Pre-Raphaelite.* New Castle, DE: Oak Knoll, 2000.

Erdman, David V. *Blake: Prophet against Empire: A Poet's Interpretation of the History of His Own Times.* 3rd ed. Princeton NJ: Princeton University Press, 1977.

Essick, Robert N. 'Blake, Hayley, and Edward Garrard Marsh: "An Insect of Parnassus".' *Explorations: The Age of Enlightenment*, 58–84. Vol. 1. Special Series, 1987.

– 'Representation, Anxiety, and the Bibliographic Sublime.' *Huntington Library Quarterly* 59 no. 4 (n.d. [1998]): 503–28.

– 'William Blake and John Marsh.' *Blake/An Illustrated Quarterly* 25 (1991): 70–4.

– *William Blake Printmaker*. Princeton: Princeton University Press, 1980.
– *William Blake's Commercial Book Illustrations*. Oxford: Clarendon, 1991.
– 'William Blake's "Female Will" and Its Biographical Context.' *Studies in English Literature, 1500–1900* 31, no. 4 (Autumn 1991): 615–30.
– *The Works of William Blake in the Huntington Collections*. San Marino, California: Huntington Library, 1985.
Essick, Robert N., and Morton D. Paley, '"Dear Generous Cumberland": A Newly Discovered Letter and Poem by William Blake.' *Blake/An Illustrated Quarterly* 32, no. 1 (1998): 4–13.
– *Robert Blair's The Grave Illustrated by William Blake: A Study with Facsimile*. London: Scolar, 1982.
Ferber, Michael. *The Poetry of William Blake*. Penguin Critical Studies. London: Penguin, 1991.
Fine, Ruth E. *Lessing J. Rosenwald: Tribute to a Collector*. Washington, DC: National Gallery of Art, 1982.
Frye, Northrop. *The Diaries of Northrop Frye, 1942–1995*. Edited by Robert D. Denham. Toronto: University of Toronto Press, 2001.
– 'Literature as Context: Milton's *Lycidas*.' In *Northrop Frye on Milton and Blake*, edited by Angela Esterhammer, *Collected Works of Northrop Frye*. Vol. 16. Toronto: University of Toronto Press, 2005.
Gaskell, Philip. *A New Introduction to Bibliography*. Oxford: Oxford University Press, 1972.
Geison, Gerald L. *Michael Foster and the Cambridge School of Physiology: The Scientific Enterprise in Late Victorian Society*. Princeton: Princeton University Press, 1978.
Gernsheim, Helmut, and Alison Gernsheim. *The History of Photography from the Earliest Use of the Camera Obscura in the Eleventh Century up to 1914*. Oxford: Oxford University Press, 1955.
Gilchrist, Alexander. *The Life of William Blake*. Edited with an introduction by W. Graham Robertson. London and New York: John Lane, The Bodley Head, 1907.
– *Life of William Blake*. 2 Vols. New and enlarged edition. London: Macmillan, 1880.
– *Life of William Blake, 'Pictor Ignotus.'* 2 vols. London and Cambridge: Macmillan, 1863.
Glaister, Geoffrey Ashall. *Encyclopedia of the Book*. 2nd ed. New Castle DE: Oak Knoll; London: British Library, 1996.
Goulden, R.J. 'Koops, Matthias (fl. 1789–1805).' Revised, *Oxford Dictionary of National Biography*, Oxford University Press, 2004. Accessed 10 March 2009, http://www.oxforddnb.com/view/article/37644.

- 'The Shadow Limn'd: Matthias Koops.' *Factotum*, no. 27 (November 1988): 16–21.

Grigson, Geoffrey. *The Harp of Aeolus*. London: Routledge, 1947.

- *Samuel Palmer, the Visionary Years*. London: K. Paul, 1947.

Hagstrum, Jean H. 'Romney and Blake: Gifts of Grace and Terror.' In *Blake in His Time*, edited by Robert N. Essick and Donald Pearce, 201–12. Bloomington: Indiana University Press, 1978.

Hay, Alexander. *The Chichester Guide: Containing an Account of the Antient and Present State of the City*. Chichester: Joseph Seagrave, [1800?].

- *The History of Chichester*. Chichester: Seagrave, 1804.

Hay, John. *The Chichester Guide: Containing an Account of the Antient and Present State of the City*. Chichester: J. Seagrave, c. 1795.

Hayley, William. *The Life and Posthumous Writings of William Cowper, Esqr.* 3 vols. Chichester: Printed by J. Seagrave for J. Johnson. London, 1803–4.

- *Memoirs of the Life and Writings of William Hayley, Esq.: The Friend and Biographer of Cowper*. Edited by John Johnson. 2 Vols. London: H. Colburn, 1823.

Heringman, Noah. *Romantic Rocks; Aesthetic Geology*. Ithaca, NY: Cornell University Press, 2004.

Hills, Richard L. 'Christmas at Matthias Koops Mill, 1802.' *The Quarterly: The Review of the British Association of Paper Historians*, no. 9 (January 1994): 13.

- *Papermaking in Britain 1488–1988: A Short History*. London: Athlone, 1988.

- 'Some Notes on the Matthias Koops Papers.' *The Quarterly: The Review of the British Association of Paper Historians*, no. 2 (August 1990): 3–5.

Humble, J.C. 'Westminster Hospital: First 250 Years.' *British Medical Journal* 7.1 (15 Jan 1966): 156–62.

Hunter, Dard. *Papermaking: The History and Technique of an Ancient Craft*. 2nd ed., revised and enlarged. London: Pleiades, 1947.

Hutchinson, Sidney C. *The History of the Royal Academy 1768–1968*. London: Taylor and Francis, 1968.

Jackson, Thomas. *The Life of the Rev. Charles Wesley, M.A.* London: John Mason, 1841.

Jowitt, Earl, and Clifford Walsh. *Jowitt's Dictionary of English Law*. 2nd ed. by John Burke. 2 vols. London: Sweet & Maxwell, 1977.

Kant, Emmanuel. *Kant's Critique of Aesthetic Judgement*. Translated by James Creed Meredith. Oxford: Clarendon, 1911.

Keynes, Geoffrey. *A Bibliography of William Blake*. New York: Grolier Club, 1921.

- *Bibliotheca Bibliographici*. London: Trianon, 1964.

- *The Complete Portraiture of William and Catherine Blake*. London: Courier Dover, 1979.

– *The Gates of Memory*. Oxford: Clarendon, 1981.
– 'George Cumberland and William Blake.' In *Blake Studies: Essays on His Life and Work*, 2nd ed., 230–52. Oxford: Clarendon, 1971.
– 'Some Uncollected Authors 44: George Cumberland 1754–1848' *The Book Collector* 19 (1970): 31–65.
Keynes, Geoffrey, and Edwin Wolf. *William Blake's Illuminated Books: A Census*. New York: Grolier Club of New York, 1953.
Keynes, Margaret Elizabeth. *A House by the River*. Cambridge: Privately Printed, 1984.
Lange, Thomas. 'Two Forged Plates in *America*, copy B.' *Blake/An Illustrated Quarterly* 16 (Spring, 1983): 212–16.
Lincoln, Andrew, *Spiritual History: A Reading of William Blake's 'Vala' or 'The Four Zoas.'* Oxford: Clarendon, 1995.
Lister, Raymond. *Edward Calvert*. London: G. Bell, 1962.
– *George Richmond, a Critical Biography*. London, 1981.
– *The Paintings of William Blake*. Cambridge: Cambridge University Press, 1986.
Lockwood, Luke Vincent. *Colonial Furniture in America*. New York: Scribner, 1901. 3rd ed., 1926.
Loudon, J.C. *Arboretum et Fruticetum Britannicum; or, The Trees and Shrubs of Britain*. 8 vols. London: the Author, 1838.
Maidment, B.E. *Reading Popular Prints, 1790–1970*. Manchester: Manchester University Press, 1996.
Mantoux, Paul. *The Industrial Revolution in the Eighteenth Century*. Rev. ed., translated by Marjorie Vernon. Bedford Series of Economic Handbooks. Vol. 1. London: Jonathan Cape, 1928.
Martineau, James. 'Hours of Thought,' quoted in *The Academy* (9 February 1878): 77.
Matheson, C. Suzanne. 'The Respective Functions of Text and Design in the Art of William Blake.' DPhil thesis, University of Oxford, 1990.
Matthews, Susan. 'Blake, Hayley and the History of Sexuality.' In *Blake, Nation and Empire*, edited by Steve Clark and David Worrall, 83–101. Basingstoke: Palgrave, 2006.
– 'Fit Audience tho Many: Pullman, Blake and the Anxiety of Popularity.' In *Blake, Modernity and Popular Culture*, edited by Steve Clark and Jason Whittaker, 205–20. Palgrave, 2007.
McCann, T.J. 'Eighteenth Century Printing in Chichester.' *Factotum* 13 (1981): 13–16.
– 'The Tribulations of a Chichester Printer.' 'The Tribulations of a Chichester Printer [J. Seagrave],' *Factotum* 27 (1988): 22–3.

McGann, Jerome. *The Romantic Ideology: A Critical Investigation*. Chicago: University of Chicago Press, 1983.

– *The Textual Condition*. Princeton: Princeton University Press, 1991.

McKitterick, David. *New Worlds for Learning, 1873–1972*. Vol. 3 of *A History of Cambridge University Press*. Cambridge: Cambridge University Press, 2004.

Mee, John, and Mark Crosby. '"This Soldierlike Danger": The Trial of William Blake for Sedition.' In *Resisting Napoleon: The British Response to the Threat of Invasion, 1797–1815*, edited by Mark Philp, 111–24. Aldershot, Hants, England, 2006.

Mellor, Anne Kostelanetz. *Blake's Human Form Divine*. Berkeley: University of California Press, 1974.

Michael, Jennifer Davis. *Blake and the City*. Lewisburg: Bucknell University Press, 2006.

'Misericords of the World: "Miserichords of Chichester Cathedral,"' available at http://www.misericords.co.uk/chichester.html.

Moore, Jerrold. *The Green Fuse: Pastoral Vision in English Art 1820–2000*. Woodbridge, 2007.

Morgan, Roy. R. *Chichester – A Documentary History*. Chichester: Phillimore, 1992.

Morris, Robert John. *Class, Sect, and Party: The Making of the British Middle Class: Leeds, 1820–1850*. Manchester: University of Manchester Press, 1990.

Moss, W.E. 'The Coloured Copies of Blake's "Night Thoughts."' *Blake Newsletter* 2 (15 September 1968): 19–23.

Mulhallen, Karen. '"For Friendship's Sake": Some Additions to Blake's Sheets for Designs to a Series of Ballads (1802).' *Studies in Bibliography* 29 (1976): 331–41.

Munby, A.N.L., ed. *Sale Catalogues of Libraries of Eminent Persons*, 83–172. Vol. 2. London: Mansell with Sotheby Parke-Bernet, 1971.

Myrone, Martin. *Seen in My Visions. A Descriptive Catalogue of Pictures. William Blake*. London: Tate Publishing, 2009.

Nairn, Ian, and Nikolaus Pevsner. *Sussex*. The Buildings of England. Vol. 28. Harmondsworth, Middlesex: Penguin Books. 1965.

Norman, Philip. *London, Vanished and Vanishing*. London: Adam and Charles Black, 1905.

Norvig, Gerda. *Dark Figures in the Desired Country; Blake's Illustrations to the Pilgrim's Progress*. Berkeley: University of California Press.

Nuttall, A.D. *The Alternative Trinity: Gnostic Heresy in Marlowe, Milton, and Blake*. Oxford: Clarendon, 1998.

Palmer, A.H. *Exhibition Drawings, Etchings and Woodcuts by Samuel Palmer and*

Other Disciplines of William Blake. London: Victoria and Albert Museum, 1926.

- *The Life and Letters of Samuel Palmer, Painter and Etcher*. London: Seeley, 1892.

Paley, Morton D. *The Apocalyptic Sublime*. New Haven and London: Yale University Press, 1986.

- *The Continuing City: William Blake's Jerusalem*. Oxford: Clarendon, 1983.

- *The Traveller in the Evening*. Oxford: Oxford University Press, 2003.

Phillips, Gordon A. *The Blind in British Society: Charity, State and Community, c. 1780–1930*. Aldershot: Ashgate, 2004.

Phillips, Michael, 'Flames in the Night Sky: Blake, Paine and the Meeting of the Society of Loyal Britons, Lambeth, October 10th 1793,' Colloque 'La Violence et ses Representations.' Bulletin de la Societe D'Etudes Anglo-Americaines des XVIIe et XVIIIe siecle, 44 (June 1997): 93–110.

- ed. *William Blake*, An Island in the Moon. Cambridge: Cambridge University Press; Institute of Traditional Science, 1986.

- *William Blake: The Creation of the 'Songs'; From Manuscript to Illuminated Printing*. London: The British Library, 2000.

Plant, Majorie. *The English Book Trade*. London: Allen and Unwin, 1974.

Pollock, John. *Time's Chariot*. London: John Murray, 1950.

Popham, A.E., and Johannes Wilde. *The Italian Drawings of the XV and XVI Centuries in the Collection of his Majesty the King at Windsor Castle*. London, 1949.

Pressly, William. *The Artist as Original Genius: Shakespeare's 'Fine Frenzy' in Late-Eighteenth-Century British Art*. Newark: University of Delaware Press, 2007.

Preston, Kerrison, ed. *The Blake Collection of W. Graham Robertson*. London: Faber and Faber for The William Blake Trust, 1952.

- 'The Blake Collection of W. Graham Robertson.' *William Blake: Poet, Printer, Prophet*, catalogue of the exhibition, Whitworth Art Gallery, 14 May–21 June 1969.

Raverat, Gwen. *Period Piece: A Cambridge Childhood*. London: Faber and Faber, 1952; reprint 2003.

Remnant, G.L., and Francis W. Steer. *Misericords in Chichester Cathedral Chichester*. Chichester City Council, 1961.

Roberts, F. David. *The Social Conscience of the Early Victorians*. Stanford: Stanford University Press, 2002.

Roberts, M.J.D. *Making English Morals: Voluntary Association and Moral Reform in England, 1787–1886*. Cambridge: Cambridge University Press, 2004.

Robson, Lane, and Joseph Viscomi. 'Blake's death.' *Blake/An Illustrated Quarterly* 30, no. 2 (Fall 1996): 36–49.

Rogal, Samuel J. *John Wesley's London: A Guidebook*. Texts and Studies in Religion 34. Lewiston and Queenston: Edwin Mellen, 1988.

Rosenwald, Lessing J. *Recollections of a Collector*. Jenkintown, Pennsylvania: Rosenwald, 1976.

Salzman, L.F., ed. *A History of the County of Sussex*. Vol. 3. 1935. http://www.british-history.ac.uk/report.aspx?compid=41659.

Schuchard, Marsha Keith. *Why Mrs Blake Cried: William Blake and the Sexual Basis of Spiritual Vision*. London: Century, 2006.

Shorter, Alfred Henry. *Paper Making in the British Isles: An Historical and Geographical Study*. Newton Abbot: David & Charles, 1971.

Smith, J.T. *Nollekens and His Times*. 2 vols. London: Colburn, 1828.

St Clair, William. *The Reading Nation in the Romantic Period*. Cambridge: Cambridge University Press, 2004.

Stemmler, Joan K. 'Cennino, Cumberland, Blake and Early Painting Techniques.' *Blake/An Illustrated Quarterly* 17, no. 4 (Spring 1984): 145–9.

– 'Undisturbed Above Once in a Lustre: Francis Douce, George Cumberland and William Blake at the Bodleian Library and Ashmolean Museum.' *Blake/An Illustrated Quarterly* (Summer 1992): 9–19.

Stirling, A.M.V. *The Richmond Papers*. London, 1962.

Sullivan, Larry E., ed. *Vision of a Collector: The Lessing J. Rosenwald Collection in the Library of Congress*. Washington, DC: Library of Congress, 1991.

Sung, Mei-Ying. *William Blake and the Art of Engraving*. London: Pickering & Chatto, 2009.

Terry, Richard. *Mock-Heroic from Butler to Cowper An English Genre and Discourse*. Aldershot: Ashgate 2005.

Thompson, E.P. *Witness Against the Beast: William Blake and the Moral Law*. Cambridge: Cambridge University Press, 1994.

Thomson, Joseph John. *Recollections and Reflections*. New York: Macmillan, 1937.

Todd, Ruthven. *Tracks in the Snow: Studies in English, Science and Art*. London: The Grey Walls Press, 1946.

Townsend, Joyce. *Turner's Painting Techniques*. 5th ed. London: Tate Publishing, 2007.

Townsend, Joyce, ed., with Robin Hamlyn, consultant ed. *William Blake, The Painter at Work*. London: Tate, 2003.

Townsend, Joyce, J. Ridge, and S. Hackney. *Pre-Raphaelite Painting Techniques 1848–1856*. London: Tate Publishing, 2004.

Viscomi, Joseph. 'Blake after Blake: A Nation Discovers Genius.' In *Blake, Nation, Empire*. Edited by Steve Clark and David Worrall, 239–62. London: Palgrave 2006.

– *Blake and the Idea of the Book*. Princeton: Princeton University Press, 1993.

– 'Blake in the Marketplace 1852: Thomas Butts, Jr. and Other Unknown

Nineteenth-Century Blake Collectors.' *Blake/An Illustrated Quarterly* 29, no. 3 (1995): 40–68.

– 'Blake's 'Annus Mirabilis': The Productions of 1795.' *Blake/An Illustrated Quarterly* 41 (2007): 52–83.

– 'Facsimile or Forgery? An Examination of *America*, Plates 4 and 9, Copy B.' *Blake/An Illustrated Quarterly* 16 (Spring, 1983): 217–23.

– 'A "Green House" for Butts? New Information on Thomas Butts, His Residences, and Family.' *Blake/An Illustrated Quarterly* 30, no. 1 (1996): 4–21.

– 'The Myth of Commissioned Illuminated Books: George Romney, Isaac D'Israeli, and "ONE HUNDRED AND SIXTY designs of Blake's".' *Blake/An Illustrated Quarterly* 23 (Autumn 1989): 48–74.

– 'William Blake's "The Phoenix/to Mrs Butts" Redux.' *Blake/An Illustrated Quarterly* 29, no. 2 (1995): 12–15.

Walford, Edward. *Old and New London: A Narrative of Its History, Its People, and Its Places*. London: Cassell, 1878.

Ward, Aileen. *John Keats: The Making of a Poet*. Rev. ed. New York: Farrar, Strauss and Giroux, 1986.

– 'William Blake and His Circle.' In *The Cambridge Companion to William Blake*, edited by Morris Eaves, 19–36. Cambridge: Cambridge University Press, 2009.

Weiskel, Thomas. *The Romantic Sublime: Studies in the Structure and Psychology of Transcendence*. Baltimore: Johns Hopkins University Press, 1976.

Whitehead, Angus. '"I also beg Mr Blakes acceptance of my wearing apparel." The Will of Henry Banes, Landlord of 3 Fountain Court, Strand, the Last Residence of William and Catherine Blake.' *Blake/An Illustrated Quarterly* 39, no. 2 (Fall 2005): 78–99.

– 'Mark and Eleanor Martin, the Blake's French Fellow Inhabitants at 17 South Molton Street, 1805–21.' *Blake/An Illustrated Quarterly* 43, no. 3 (Winter 2009/10): 84–95.

– 'New Discoveries Concerning. William and Catherine Blake in Nineteenth Century. London: Residences, Fellow Inhabitants, Neighbours.' 2 vols. PhD thesis, University of York, 2006.

– '"this extraordinary performance": William Blake's Use of Gold and Silver in the Creation of His Paintings and Illuminated Books.' *Blake/An Illustrated Quarterly* 42, no. 3 (Winter 2008): 85–7.

Wilde, Johannes. *Italian Drawings in the Department of Prints and Drawings in the British Museum: Michelangelo and His Studio*. London: Trustees of the British Museum, 1953.

Williams, Mari E.W. *The Precision Makers: A History of the Instruments Industry in Britain and France, 1870–1939*. London: Routledge, 1994.

Woolfson, Jonathan, and Deborah Lush. 'Lambert Barnard in Chichester
 Cathedral: Ecclesiastical Politics and the Tudor Royal Image.' *The Antiquaries Journal* 87 (2007): 259–80.
Wright, Thomas. *Life of William Blake*. 2 vols. Olney Bucks: Thomas Wright,
 1929.
Zagaski, Chester A. *Environmental Risk and Insurance*. Chelsea, MI: Lewis, 1992.

Contributors

Karen Mulhallen is a professor in the English department at Ryerson University and the University of Toronto, and is a professor in the Joint Graduate Program in Culture and Communication, York University and Ryerson University.

David Bindman, recently retired professor of the history of art, University College London, is author of numerous works including *Blake as an Artist* (1977).

Robert Brandeis, chief librarian of Victoria University in the University of Toronto, has published, most recently, the catalogue for *William Blake and His Contemporaries: An Exhibition Selected from the Bentley Collection at Victoria University*.

Martin Butlin, retired keeper of Historic British Collection, Tate Gallery London, is author of the two-volume catalogue raisonné *The Paintings and Drawings of William Blake* (1981). He is also an expert on the works of J.M.W. Turner and many other British painters.

Mark Crosby, Leverhulme early career fellow at Queen's University, Belfast, has published articles on Blake in the *British Art Journal*, *Blake/ An Illustrated Quarterly*, and the *Huntington Library Quarterly*.

Keri Davies, an independent scholar, is vice-president of the Blake Society. He has written on Blake's parents and on the social and intellectual milieu of early Blake collectors and other friends and acquaintances of the painter-poet.

Robert Essick is distinguished professor of English emeritus at the University of California, Riverside. He has authored, co-authored, or edited nineteen books and over one hundred and thirty articles, notes, and reports on Blake and his circle. He has been an avid collector of Blake and all manner of Blakeana for over forty years.

Mary Lynn Johnson, special assistant emerita, president's office, University of Iowa, is the co-author of *Blake's Four Zoas: The Design of the Dream* (1978) and co-editor of the Norton Critical Edition *Blake's Poetry and Designs* (1979; 2nd edition, 2008).

Jerome McGann is a professor at the University of Virginia, critic, poet, founder of the Institute for Advanced Technology in the Humanities at the University of Virginia, creator of the Rossetti hyperarchive, editor of Byron, Swinburne, and Rossetti, and author of numerous works including *The Romantic Ideology* (1983), *The Textual Condition* (1991), and *The Point Is To Change It* (2007).

Morton D. Paley, professor emeritus, University of California, Berkeley, and co-editor of *Blake/An Illustrated Quarterly*, is author of numerous books and articles on Blake and other English Romantic poets, most recently *The Traveller in the Evening: The Last Works of William Blake* (2003) and *Samuel Taylor Coleridge and the Fine Arts* (2006).

Joyce Townsend and **Bronwyn Ormsby** are senior conservation scientists at the Tate Gallery London. Their specialty is the analysis of artists' materials.

Joseph Viscomi is James G. Kenan distinguished professor of English and comparative literature at the University of North Carolina at Chapel Hill. He is a printmaker, painter, and curator. His work in *Blake and the Idea of the Book* (1993) overturned much of the conventional wisdom about Blake's illuminated book medium. With Morris Eaves and Robert Essick, he is co-editor and co-creator of the William Blake Archive, a hypertext of Blake's poetry and art, based on approximately 5,500 images transferred to digital form. This was the first electronic edition to receive the MLA Prize for a Distinguished Scholarly Edition and to be designated An Approved Edition.

Angus Whitehead is assistant professor of English, National Institute

of English, Nanyang Technological University, Singapore. He recently contributed a chapter, entitled 'a wise tale of the Mahometans: Blake and Islam,' to *Blake and Conflict* (2008), edited by Jon Mee and Sarah Haggarty. He has had several articles published in the *British Art Journal* and *Blake/An Illustrated Quarterly*.

Index